TWENTIETH CENTURY ART THEORY

URBANISM, POLITICS, AND MASS CULTURE

RICHARD HERTZ
NORMAN M. KLEIN

PRENTICE HALL
Englewood Cliffs, NJ 07632

Library of Congress Cataloging-in-Publication Data

Twentieth century art theory: urbanism, politics, and mass culture/
[edited by] Richard Hertz. Norman M. Klein.
 p. cm.
Includes bibliographical references.
ISBN 0-13-933391-6
1. Art. Modern-20th century--Philosophy. 2. Art and society-
-History--20th century. 3. Politics in art. I. Hertz, Richard.
II. Klein, Norman M.
N6490.T88 1990
700'.1'030904--dc20 89-49332
 CIP

Editorial/production supervision and
 interior design: *Margaret Lepera*
Cover Design: *Ramone C. Muñoz—Associate Chair,*
 Graphic Design / Packaging, Art Center College of Design.
Manufacturing buyers: *Mike Woerner, Ed O'Dougherty*
Cover Photo: *Courtesy of the Academy of Motion Picture Arts and Sciences,*
"Things to Come."

Printed in the United States of America
10 9 8 7 6 5 4 4 3 2 1

ISBN 0-13-933391-6

Prentice-Hall International (UK) Limited, *London*
Prentice-Hall of Australia Pty. Limited, *Sydney*
Prentice-Hall Canada Inc., *Toronto*
Prentice-Hall Hispanoamericana, S.A., *Mexico*
Prentice-Hall of India Private Limited, *New Delhi*
Prentice-Hall of Japan, Inc., *Tokyo*
Simon & Schuster Asia Pte. Ltd., *Singapore*
Editora Prentice-Hall do Brasil, Ltda., *Rio de Janeiro*

CONTENTS

PREFACE

It has been said that history is a study of the present more than the past. In that spirit, this anthology about art between 1910 and 1950 has been adapted to take into account recent critical theory and postmodern revisions of modernism. By modernism we understand a plural tradition that extends beyond the fine arts to include architecture and design and important areas of mass culture. We want to demonstrate that modern art is at once a more complex as well as a more modest, less heroic process than that suggested in many art history texts.

The articles in this book emphasize the intimate connections between social history and the arts. In the main sections of the book, modern art is placed within three related conditions of modern life: the promise of new technologies; world wars and economic depression; and the institutionalization of culture. The work of modern artists is set within the frame of two world wars, the institutionalization of art by museums and galleries, the pressures of the machine age within industrial cities during the early twentieth century, utopian dreams of a new social order, and the invasions and alliances created by the growth of mass culture, the mass media, and the global marketplace.

We distinguish between what is properly art historical and what is extra-art historical by emphasizing how artists were vulnerable to the world at large, from the traumas to the fads. Modern art embodies in its formal structure the social codes, entertainment traditions, perceptual routines, and daily material culture of the year it was produced. Modern art is an inseparable part of the larger cultural, political, and social contexts of which it forms an integral part. We emphasize the complexities and discontinuities in the collapse of genteel nineteenth-century high culture into a pluralistic array of "culture industries"—the packag-

ing and marketing of culture both by private enterprise and government propaganda.

We wish to acknowledge the generous advice and encouragement of a number of our colleagues, in particular Sanda Agalidi, Jacki Apple, Yve-Alain Bois, Benjamin Buchloh, Pamela Burton, T.J. Clark, Louis Danziger, Jeremy Gilbert-Rolfe, and Inez Aidlin Klein. For research assistance, we thank Alison Holt, Sharon Somerfeld, and Diana Thater. For assistance in the preparation of the manuscript, we are grateful to Mary Morris.

Introduction

Much has been written about "truth to materials" in modern art, how the surface of an object must be made plain, or even exaggerated, as under a microscope. In late Cézanne paintings, the brush strokes look like hieroglyphs describing an image, while patches of unpainted surface show the weave and gesso on the canvas. In modern architecture, exposed steel and untreated concrete seem to accomplish much the same end—to display the material condition of the art surface. From a social-historical point of view, "truth to materials" refers more to economic relationships, markets, and politics. The material surface to be made plain becomes the modern city itself, street by street, and the objects found there.

For example, imagine the old Jewish ghetto in Prague, particularly as it was renovated (shall we say gentrified?) from the 1890s on. We see Kafka on his way to work, perhaps in 1912, walking past what was left of the ghetto, finding fewer old houses and narrow streets each year. The transition made an odd patchwork, no longer baroque or medieval, but rather bald in spots with antique sites replaced by warehouses and contemporary apartment buildings. Even in Prague, a city that modern artists generally considered backward and "claustrophobic," the modernizing process occurred. Landmarks from a preindustrial civilization lost their place; their immediate environments looked strangely interrupted, and then, as intimate memory at least, were erased altogether.

In the same sense, modern art from 1912 looks today like remnants of walks through a city torn down generations ago. It becomes difficult to piece together the daily experience of artists in these cities, much less the experience of the public at large. We tend to emphasize the modernist avant-garde, ignoring the more mundane values that governed these cities. Even to the sophisticated urbanite in 1912, modern artwork,

1

stripped of classical allegory, felt like an invasion, jarring even to those who welcomed it. As a cityscape, the urban neighborhoods of 1912 still had very few modern, functionalist buildings, except perhaps in Chicago or Manhattan. Many shops and apartments were still old enough to be preindustrial. The erosion of memories and landmarks was much harder to avoid than the presence of modern art.

The modernist vanguard in 1912 still quite small, numbered in the hundreds at most, and it sold to very limited markets. Their work was reported in newspapers as eccentric studio experiments, not so much shocking as out of touch with the general art market.

It appeared to be an art about dislocation and erasure. The human figure and the landscape were virtually removed from the canvas. Colors and shapes were distorted. Distances and light sources were collapsed. Modern art in 1912 seemed to resemble non-European art more than established painting.

The narrative structure in all of the arts was changing. In experimental fiction, the characters seemed to overwhelm the action to a standstill. Stories seemed to float in an uneasy world without tangible resolution. Without the usual metaphors and allegories, the language of poetry seemed erratic. Much of it was about city life in particular, invested with a convulsive sadness, or what the French poet Baudelaire had called ennui, in praise of spiritual alienation.

It was an art and literature fascinated with the daily agonies of city life, its new objects and smokestack industries, its massive train stations and tensions—and its lost opportunities. The French poet Apollinaire writes this of Paris in 1913:

> This morning I saw a pretty street whose name I have forgotten
> Shining and clean it was the sun's bugle
> Executives and workers and lovely secretaries
> From Monday morning to Saturday evening pass here four times a day
> In the morning the siren wails three times
> A surly bell barks around noon
> Lettering on signs and walls
> Announcements and billboards shriek like parrots
> I love the charm of this industrial street[1]

What sort of charm, and what sort of epic can one make out of an industrial street? What changes must the culture undergo to make an industrial street heroic, or tragic? Clearly, much had been written in the nineteenth century condemning factory towns. But this new urban experience was not simply a factory world; it was a world of enormous class separation, of fashionable gentry districts, and growing working-class neighborhoods with potential violence between the classes. Fully one

third of the residents in these cities came from small farming villages—uprooted, or forced to seek work.

Most of the architecture was not designed for railroads, trolleys, subways; or even for sanitation because of insufficient indoor plumbing and sewers. Electricity was so unreliable that house lights were usually equipped with gas and electric on the same lamp as a precaution.

Goods and services were still distributed erratically with a lot of spoilage and false advertising. Inventions we associate with the twentieth century were still difficult to explain, invested with mystery more than meaning. Electricity was touted in ads as a food preservative, as a way to make women's corsets health- giving, or in statuary as the consort to the goddess of hygiene—as anything, it seems now, but a rude power source for machines. Even a prescient critic like Henry Adams, when he saw the electric dynamo displayed at the Saint Louis World's Fair of 1876, sang its oracles rather than its applications as "a symbol of infinity." (Critics write of the computer today in much the same way, of course.)

Within these cities in the early stages of modern art from 1890 to 1914, the art galleries for this new work were still rather small. Architecture and design were still dominated by Art Nouveau decoration. But work that removed Art Nouveau ornament and the more abstract work of modern artists did, however, appeal to a small, progressive audience of the upper middle class.

Among this progressive bourgeoisie, there was a market for art that claimed to sabotage established values or fought for very contemporary subject matter. We might call it an upscale counterculture. These artists often were lionized, oddly enough, even in high society. But their bohemian theaters and cafes were largely ignored by powerful cultural institutions. There was virtually no government or university support for their work, though some powerful critics defended them in daily newspapers. At the same time, however, a gallery system had been growing steadily to show the work.

This isolation would end in the 1920s, when modern art actually became very fashionable, particularly in Paris and Berlin. In Germany, Expressionist art caught on even in rather conservative galleries. In popular German movies, Expressionist effects dominated and were received well by mass audiences, even in America. Colleges for modern art appeared. The most legendary were the Bauhaus in Germany and Unovis in the Soviet Union, but classes including modern art were added to many college curricula throughout Europe and America.

In Russia, abstract painting was virtually the official art of the Soviet Union from 1918 until 1922, promoted by government- sponsored retrospectives and competitions. For a time, new Russian cinema mod-

eled itself on Cubo-Futurist modern art, as did Soviet poster art and book design.

In the 1920s, mass culture also began to look stripped down, very much like modern art. Design, architecture, and cinema seemed to have shifted toward many of the same problems. Design, from print to movie sets, looked "cleaner," more reductive, or abstract. Unadorned surfaces—the nonfigurative—became as much a part of the so-called functional product as a part of experimental painting. Disjointed imagery and distorted figures, similar to Expressionist art, could be found in magazine advertising. Simplified linear styles were used in popular animated cartoons, as well as in experimental cinema.

Mass culture was adjusting, in its own way, as rapidly as the fine arts. In the 1920s, these two modernist markets crossed over much more than they had earlier—for example, Cubist design and the model T. Two parallel tracks intersect inside the same rapidly urbanizing world. Stated another way, the Ford assembly line, in place by 1912, was as much the model for simplified modern design as Cubist art. Warehouse architecture, as a functional solution to problems of storage, window light, and the need for open space were as crucial to modernist design as was Frank Lloyd Wright's work. Gropius' Fagus warehouse of 1910, a monument to early modernism, answers questions that rude or naive builders had been facing for generations—the practical need to design the rationalized, industrial space within a steel shell without interior bearing walls.

Plans were laid out for "modern" cities following principles of abstraction, functionalism, and truth to materials. But these cities would not be built until much later, for the most part not until the 1950s. In fact, the look of American suburbs, for better or worse, borrows considerably from the early industrial design and experimental fine arts of the 1920s. The downtown centers of glass curtain walls with adjoining cement plazas built in the 1960s also evolved from the modern art of the 1920s. In sum, these "modernias" are a rather chastening reminder how the best-laid plans can turn into stucco shopping centers, Levittowns, and dot-to-dot variations on the horizontal, sprawled tract home.

By the late 1950s, with art marketing centered now in New York (no longer Paris or Berlin), modern art had found its institutions: the Museum of Modern Art; a growing network of museums and galleries throughout the world, with curators keeping in touch through catalogues and journals; and Madison Avenue, which began to influence the promotion of modern art, including advertising campaigns.

It is a spectacular story about the progressive tastes of the rich and famous. It is also about a heroic struggle against repression. But most

importantly, when the glamour is set aside, it is a process of adaptation to the chronic problems of city life.

The cities where much of this art originated were traumatic places, except, of course, for the neighborhoods where the genteel middle class lived. There, one could pick up a maid, a nanny, and a butler very cheaply, out of a vast pool of labor pouring into cities.

What was so jarring about cities in 1900 that changed the look of everyday objects and attitudes, as well as everyday environments? Modernism in the arts is a master code about dislocation, disjunction, loss of a linear sense of time, about sudden forgetfulness.

We start with a few simple statistics. In the nineteenth century, the population of London and Paris both multiplied four times. Berlin's population multiplied ten times between 1810 and 1900, as rapidly as factory towns like Manchester. Budapest grew from 50,000 to 900,000 people.

In America, cities grew much faster. Chicago in 1830 was a mosquito-ridden fort town, with a dozen log cabins and one store. By 1836, its population rose to all of 4,000. By 1910, it had well over two million.

Philadelphia grew fifty times over in the nineteenth century. New York City grew by ninety times, to a population of about three and a half million by 1885; then it grew even more, to over eight million by 1920.

In 1895, four out of five residents in New York had no running water. It was much the same in virtually all the great cities. The wealthy and the upper middle class were well served. The rest suffered enormously, without unions, social security, or medical care.

Most of this feverish growth took place after 1860, in what has come to be called "the great industrial takeoff," when corporations and banking reached a threshhold for capital expansion that seemed to be dwarfing the world. While this movement brought new inventions and some general improvement in the standard of living, it also inflicted great pain.

The hunger for cheap markets took investors outside of Europe and America and launched a wave of imperialist expansion that even the Roman Empire never achieved. Within fifty years, the industrializing nations absorbed an empire three times larger than the old Roman Empire, and that had taken 900 years to put together. From 1870 to 1920, over 11 million square miles were absorbed by industrial nations; that is, most of Africa, Australia, the American West, Eastern Russia, most of China, and India. Whole regions of South America, central Africa, northern China, Alaska, Texas, California, and Hudson Bay that had never seen white people now were brought into world investment patterns.

The farming land in suburbs surrounding cities was swallowed up within a radius of 30 miles. The nineteenth-century city had been only two miles away from pastoral life. This was true of Paris in 1830, and of New York City as late as 1880. Now it took an extended train trip with pollution following close behind.

There was essentially no zoning and very little urban planning. Whatever could be bought and built on was permitted, without thought of protecting the environment or controlling traffic.

At the same time, new objects for sale in stores entered the everyday world. Until about 1850, all furniture was hand-carved. By 1920, it was almost entirely industrially carved. Until 1830, there were virtually no penny press daily newspapers. By 1900, a city as large as New York City might boast as many as 15 daily newspapers. Until 1880, virtually all clothing was tailored individually. London alone had over 200,000 people working in the tailoring business; off-the-rack clothing changed that. In the 1890s, the bicycle became the first consumer vehicle to be industrially made in nearly every detail.

In the 1880s, French schoolchildren were expected to learn how to draw everyday objects that were then being made industrially, from shovels to wheels. There was a general passion for the industrial object that influenced the fine arts, as well as:

The warehouse
The bridge
The skyscraper
The subway and trolley systems
The automobile
Refrigerators and other household appliances
Even the photograph, with box cameras, photo post cards, visiting cards
And finally, the airplane.

Of course, such items can be displayed picturesquely, without revealing the staggering human cost. In England in 1780, there were 43 legal holidays a year for workers, practically one every week. By 1840, only three holidays were still permitted by law. Many community traditions, festivals, and patterns of extended family life had vanished very quickly, and they were never replaced in quite the same way.

Beginning in 1845, world depressions sparked by financial panic occurred with awesome regularity: 1855–59, 1865–68, 1873–79, 1882–86, 1892–96, and a recession from 1900 to 1901. By 1914, after two decades of military buildups and short wars this uneven economic expansion was ignited into global conflict—the first industrial world war for a raw world economy. About 15 million soldiers died; at least as many civilians died as well.

By the end of that war, after a wave of revolutions from 1917 to 1921 and painful readjustments, Europeans and Americans were left to confront remarkably transformed relationships—diplomatically, militarily, and fiscally. It was like the classic statement in Yeats's poem, "The centre cannot hold; Mere anarchy is loosed upon the world." The weak middle parties, along with threats of general strike throughout Europe, created a political chasm that swung artists toward the left and brought national power to very conservative parties on the right, from Mussolini in Italy to a scandal-ridden Harding administration and gangster-run Prohibition in America.

From 1917 to 1921, the series of revolutions in Russia, Bavaria, Prussian Germany, and Hungary, along with the military responses in the West, initiated the politics known today as the Cold War.

From 1922 in Italy to 1933 in Germany, an anticommunist wave emerged which transformed into Fascism and Nazism. These movements were perverse twists on the modern with their exploitation of medieval nostalgia, fantasies of an organized state based on farming values and rigidly assigned classes while at the same time firmly allied with industrial capital. In Italy, Mussolini came to power to bring order during a general strike. In Germany, Hitler was brought in as chancellor to replace a reform chancellor who had threatened big business (with plans to bring down the 25 percent unemployment!). In the 1930s, the crises of military government, coupled with the Great Depression, destroyed much of the market for modern art in Europe.

By the 1920s, virtually all hand-crafted articles had vanished from everyday life. As well, this decade brought on a new wave of entertainment media that transformed the sending of information. Here is a partial list of what was in wide use by the 1920s (and continued to expand in use even during the Depression):

Roads and shopping specifically built for auto travel
The telephone
The movies
The phonograph record
Radio
Photo magazines
Electric appliances
Advertising agencies

Finally, after almost a decade of economic depression and renewed military rivalries, the world went to war again on September 1, 1939 (or as early as 1936, for those who fought in the Spanish Civil War). In the course of the war, America began its imperial era.

Our anthology does not go far beyond this point in time. However, this outline begins to suggest an answer to the question: Why has twentieth-century culture developed an art based on dislocation, erasure, and alienation? At the same time, is it any wonder that there should develop an infatuation with the machine itself? It was the machine of redemption, the labor saver. It was the machine of world war. It was the machine replacing the hand-crafted object. It was the machine of rapid travel, away from the simpler pedestrian life. "We declare that the splendor of the world has been enriched with a new form of beauty— the beauty of speed. A race automobile adorned with great pipes like serpents with explosive breath...is more beautiful than the Victory of Somothrace."[2]

Modern art came out of the world of smokestack industries, from the late nineteenth century to the post-World War II era. It announced very clearly the shocks one felt in leaving a world where farming imagery and hand-crafted objects still dominated in the arts to a world of interlocking industrial environments.

How can an anthology present background this vast and problematical in an efficient manner? We want to respect the art object but concentrate on the material conditions that determined, or influenced, modern art. Only a few examples can be used, or else we scatter what good we can accomplish. This is only one volume of readings, not a Summa Modernica. Often documents will seem to belong in more than one category simultaneously when parts of them veer suddenly into commentary on the world war, or urbanism, or mass culture, as a general collage of received experience.

Understanding the problems, we nevertheless divide the text into three distinct sections to provide an easier model for discussion. In the first section, we concentrate more on the artists' reception of urbanism, and of the machine (presumably a cure for urban chaos). For the second part, we collected responses to political crises, including sexual politics, from 1912 to the Second World War. And finally, in the third section, we focus on the growing power and parallel modernity of industrial popular culture and consumer marketing.

A few dozen articles cannot plumb these subjects in their entirety. In terms of content, therefore, we look instead for samples that introduce a problem (but not necessarily an answer), and try to avoid documents with mystifying or vague attempts to encapsulate the essence of art or the waves of history. The selections are highlights, based on a model that respects both the fine arts and mass culture as parallel kinds of modernism. They cannot pretend to be much different than a modernist walk through a city—a few remnants to stand in for a journey fractured by a century of political turmoil and transfigured memories.

Notes

1. Guillaume Apollinaire, "Zone," first published in 1913 in *Alcools,* reprinted in *Selected Writings,* translated by Roger Shattuck (New York: New Directions, 1971), p. 117.
2. Filippo Marinetti, "The Foundation and Manifesto of Futurism," 1908, reprinted in Herschel B. Chipp, *Theories of Modern Art* (Berkeley: University of California Press, 1968), p. 286.

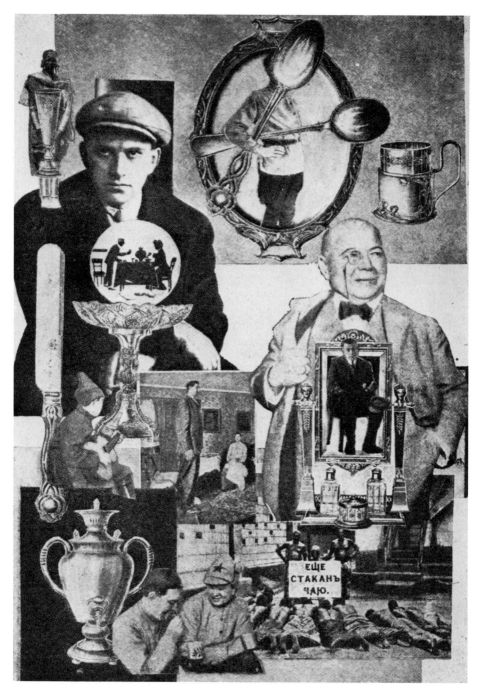

Photomontage, 1923 by Alexander Rodchenko (1891-1956). Photograph, California Institute of Arts Library.

PART ONE

Modern Art, Urbanism, and Mass Production

The nineteenth century was far less machine oriented than we might imagine. Objects for sale might arrive by train, and raw materials like cotton might be industrially refined, but the final product was generally wrought by hand, often in rather traditional modes. Steadily, however, in shop windows and in homes, the final stages of production were becoming less handmade. Even walking became less "natural." A tactile sensibility based on travel by horseback and by foot was clearly about to change to a sensibility based on watching the world through a window, while inside a rapidly moving train, trolley, or car.

Nineteenth-century cities looked much more rustic than they would later on, with rural areas rarely more than three miles away. Brooklyn, even in Whitman's day, provided the farms for Manhattan's urban center. Since food spoiled quickly, crops had to be cultivated close by and brought daily across the East River.

By the twentieth century, this rustic/urban world vanished, with some notable exceptions. Chicago still had farms in its northern suburbs in the early 1870s, and Los Angeles had farms only two miles away from downtown as late as 1915 (and it remained a farming center until the late 1950s). But during the late nineteenth century, for the first time, many cities were completely isolated from the natural environment and "nature" became something of an abstraction, divorced from material life.

Aesthetics based on nature became very problematical. Poetry, painting, and theater had always presumed that the term *nature* referred to both the soul and the land; and this trend continued uninterrupted into the nineteenth century. In fact, radical bourgeois culture prided itself on reinterpreting nature as a democratic experience, rather than an aristocratic one.

Experimental art, as understood in 1840, was very much linked to landscape painting and the discovery of "man in nature." To paint in the open air was a radical strategy, a slap at Academic rules. The act of leaving one's studio for nature, or disengaging from studio practice, helped define what was considered modern: to mix paint directly on the canvas, to show how the act of painting paralleled nature itself; to remove finish; to use "modern" media, like lithography, that sped up the ways first impressions could be put directly on the surface.

The city of 1840 often was painted as "nature," in the spirit of landscape, with sky and mist telling the viewer about how nature looked at that precise moment. And the city often was presented as visually purer than the factory town; the city was portrayed as an antidote to the worst of industrial bad taste.

In the early twentieth century, however, much as these attitudes survived, the realities of urban life made a mockery of the idea of a rustic city. Pollution screened out nature. In the downtown centers, grass and trees became rather exotic ornaments. One world was passing, and another visibly extending; as critic Matthew Arnold explained, artists felt themselves caught between two worlds, one dying, and one crying to be born.

It took generations for the birth, though, and at least that long for art to adjust to severe shifts in public and private experience. Although the machine was fascinating, it also seemed ruthless. Perceptions needed to change, with or without the support of the modern artist.

Consider how many machines became an intrinsic part of daily life after 1880, as in this sample list from an essay by Alan Bullock: the internal combustion engine, the diesel engine and the steam turbine; electricity, oil, and petroleum as new sources of power; the automobile, the motor bus, the tractor, and the airplane; the telephone, the typewriter, and the tape machine as the foundation of modern office technology; and the production by the chemical industry of synthetic material, dyes, fibers, and plastics.[1] Comparing changes in perception with the changes in cities, let us run through a few of the guiding issues.

Time

Something in the rhythm and the technological spirit of changing daily experience suggested new ways of depicting the passage of time. This already had been an area of profound debate in nineteenth-century science. If time was variable, then so was motion. If time was unfixed, any number of parallel versions of time could be imagined, even many versions occurring simultaneously.

In a textbook of 1883, Ernest Mach had rejected Newton's views of absolute time as an "idle metaphysical conception." Historian Stephen Kern writes:

> This passing shot at classical mechanics triggered a series of modifications that eventually culminated in the bold dismantling of it by Einstein...
> With the special theory of relativity of 1905, Einstein calculated how time in one reference system moving away at a constant velocity appears to slow down when viewed from another system at rest relative to it, and in his general theory of relativity of 1916 he extended the theory to that of the time change of accelerated bodies. Since every bit of matter in the universe generates a gravitational force and since gravity is equivalent to acceleration, he concluded that "every reference body has its own particular time."[2]

The work of Einstein evolved into the theory that space and time are not separate dimensions but are interdependent.

> Space is not three dimensional and time is not a separate entity. Both are intimately connected and form a four-dimensional continuum, "space-time"...All measurements involving space and time thus lose their absolute significance...Both space and time become merely elements of the language a particular observer uses for his or her description of the phenomena.[3]

A reference to Einstein seems apt for any introduction on modern art practice, although modern artists were for the most part unaware of Einstein's work until the 1920s. But they considered many of the same problems on their own terms. They did indeed try to manufacture events occurring simultaneously, in facets, or as collage or montage (not to mention new forms of theater, poetry, and cinema).

Of all the sciences working on the crisis of time, evolutionary biology was best known to the modernists of the early twentieth century. Darwin's notion of natural selection suggested random change, not progressive change or improvement so much as blind adaptation. It suggested process and synchronicity, in much the way that modern art did.

In any thumbnail introduction to science and modern art, Freud deserves special mention as the founder of psychoanalysis. The early psychiatric model of the unconscious as id, ego, and superego was a topology or conceptual map, like an imaginary drawing of the atom or of the universe. This model was based abstractly on the evidence gathered, since the objects involved are never seen. Freud's theories of dream narrative (condensation and displacement), of cathexis (emotional charges deflected from the unconscious to the preconscious), of tech-

niques like automatism (essentially free association) became for artists from the 1920s on something of a clinical bible for the anxiety (and mysteries) of modern experience. While Freud did not share in the redemptive theories of the Surrealists (to him, automatism was a tool, not an alternative reality), he did share the general concern of the age regarding the neurotic and psychotic patterns produced by modern life. Freud's writings were instrumental in promoting the idea that human reason itself is under the control of an unconscious which is entirely different from scientific rationality.

Space

If time is relative, then so is space. Current ideas about space were turned upside down by Henri Poincare, the French scientist and mathematician whose ideas were among the major influences on the work of Marcel Duchamp. Until the early 1900s, only the postulates of plane and solid Euclidean geometry were believed to have any validity. However, as Craig Adcock writes:

> The development of such mathematical constructs as complex numbers, quaternions, n dimensional geometry and non-Euclidean geometry during the course of the nineteenth century had forced mathematicians to reexamine a number of their fundamental assumptions. No longer could they believe that mathematics represented a true picture of the world—that mathematical progress was a matter of uncovering the hidden laws of nature. They were forced to admit that certain aspects of mathematics are the constructs of human reason.[4]

Consider how similar these premises seem to Russian artist Malevich's notions of an abstract space, defined by a geometric blueprint, or to El Lissitsky's *Proun* paintings, and of course to the ironic metaphysics in Duchamp's *Great Glass*. Finally, most crucially, theories of experimental cinema assume that space is completely the hostage of editing.

Both space and time became thought of as unpredictable, as well as manipulable and simultaneous, like the chance encounters inside an atom, or inside the unconscious, or in the city itself. André Breton writes of randomizing space as a Surrealist strategy:

> Perhaps life needs to be deciphered like a cryptogram. Secret staircases, frames from which the paintings quickly slip aside and vanish (giving way to an archangel bearing a sword or to those who must forever advance), buttons which must be indirectly pressed to make an entire room move sideways or vertically, or immediately change all its furnishings; we may

imagine the mind's greatest adventure as a journey of this sort to the paradise of pitfalls.[5]

Rural and urban spaces began to collide simultaneously as well, leaving neither in a fixed place. Consider the first interurban trolleys bringing workers into the city from proletarian suburbs. This was perceived as a crisis of simultaneity. Critics warned about the collapse of the rural into the urban, the disappearance of any clear distinction between the two.

Expanding communications at the turn of the century suggest much the same effect, as in this Marinetti quotation from Majorie Perloff's study, *The Futurist Moment:*

> An ordinary man can in a day's time travel by train from a little dead town of empty squares, where the sun, the dust, and wind amuse themselves in silence, to a great capital city bristling with lights, gestures, and street cries. By reading a newspaper the inhabitant of a mountain village can tremble each day with anxiety, following insurrection in China, the London and New York suffragettes, Doctor Carrel, and the heroic dog-sleds of the polar explorers. The timid, sedentary inhabitant of any provincial town can indulge in the intoxication of danger by going to the movies and watching a great hunt in the Congo...Then back in his bourgeois bed, he can enjoy the distant expensive voice of Caruso or a Burzio.[6]

Perloff continues: "To be, figuratively speaking, in two places at once now became a possibility; indeed, the new cinema (by 1913 there were two hundred cinemas in Paris) could transport the viewer from Senegal to Sidney in a split second."[7]

Speed

"The earth shrunk by speed" was hardly a theoretical expletive, but rather a statement of fact, not only about machinery, but about change itself—about breathtaking process, rather than progress. Lewis Mumford explained:

> Progress meant human being's increasing success in overcoming their physical limitations so as to impose their own machine-conditioned fantasies upon nature. By definition, technological change and human improvement were now coupled together, and, also by definition, the forces that made for advance were inevitable, inviolable, irresistible. The latest discovery, the latest invention, the latest fashion was ipso facto the best, and the more ruthlessly our industrial advances erased the monuments, and even the happy memories, of the past, the more acceptable (progressive) were the results.[8]

The spirit of "make it new" gathers a meaning unique to our century. The avant-garde strategy of constantly being at the "cutting edge," or being a "sentry into the future," suggests that change is more normal than rest, that the future invades the present extremely rapidly.

In the art of the Futurists, particularly in Italy, France, and Russia, the speed of moving objects was exaggerated through the fragmentation of narrative. By displaying the broken pieces of a story, artists forced their audiences to see the medium itself more clearly, as if there were no longer time for portraits, only for process.

Relative to the generations that preceded it, this world seemed blisteringly fast. Aesthetic commentary about its speed, and about rules rapidly losing their meaning, often sounded like an epic romance about free fall. And indeed, it was a world that fell deeply into world war and economic depression.

Industrial Method

By the 1920s, the initial anxiety brought on by rapid urbanization gave way to a fascination with the methods employed by urban industries themselves. Scientific planning and standardization were adapted to the canon of modernist aesthetics, not by all the modernists but by many linked to the Russian avant-garde, to the German Bauhaus, and to American industrial designers (in contrast to the nihilistic industrial imagery of the Dada artists before the 1920s).

Artists wanted to plan cities and home environments to perfect the world on behalf of the working class as an aesthetic extension of socialist politics of the 1920s. In that spirit, science was described as an ally of the creative process, praising industrial technology, clinical psychology (from Freud to Pavlov), and rational factory organization.

As Russian architect Arvatov explained: "The working class will construct its own art on the basis of scientific foresight and consciously planned and organized practical work, i.e. in the same way that it acts in politics and economics. The theory of production art offers the working class here and now the prospect of progressing from Utopia to Science."[9]

According to Moholy-Nagy, writing in America, but remembering the Bauhaus era:

> The multiplication of mechanical appliances, and new methods of research, required a new intellectual orientation, a fusion of clarity, conciseness, and precision...Not the single piece of work, nor the highest individual attainment must be emphasized, but instead the creation of the commonly usable type, development toward "standards"...The Bauhaus became the focal point of new creative forces accepting the challenge of technical progress with its recognition of social responsibility.[10]

In his essay "Art and Life," written in 1931, Mondrian reaffirmed his belief that "the perfectioning of science is one of the principal ways to human progress, enabling us to attain to a more equilibrated status." He argued that war will become an impossibility as modern armaments develop. More generally, he argued that the machine is a means necessary to human progress because it creates a new mentality in which "preciseness, exactitudes, cleanness" as well as "concentration, thinking, reflecting" become necessary. Art, he said, will not bother with natural appearances any longer but rather will exemplify this new mentality.[11]

In many ways, these modern artists were heirs to the Enlightenment, through their fascination with scientific planning. While science initiated much of what they found abhorrent, it also offered a utopian solution—to rationally design the world.

This was obviously a highly debatable theory with any number of positions, from the sociological to the metaphysical. The arguments continued into the 1930s, particularly with the shock of Nazism, around questions like the following: Is this obsession with industrial method simply a way to work more easily with big business? Has industrial method, on a political level, brought us mass movements like Nazism?

We look, almost nostalgically, at the models of the city of the future in Saint-Elia's notebooks from 1913, or the matte paintings for Lang's 1926 film *Metropolis*. A nest of roads and pedestrian ways rise above ground, with an encirclement of skyscrapers. If we then drive through downtown Los Angeles today, a cloverleaf of freeways marked by massive bank buildings, we see an homage to much the same industrially designed fantasy, but one which finally came out only in the 1960s and later. To make this downtown area, tens of thousands of people were displaced. A massive hill was leveled (and the tunnels kept, as if tunnels were more natural to a city than the hill itself). And now, the depopulated downtown awaits additional alchemy to reinvigorate it. Homeless sleep alongside the modernist, invented city, simply because very few paying tenants actually reside there at night.

The modern city is a dehumanized idea in poured cement and glass, and a very uneasy prospect to visit, because it seems to have finally erased any trace of what was there before. Passing through downtown Los Angeles can be just as unsettling for us as walking through the swollen cities of 1900 was for modern artists then. Today, however, the historical memories so threatening to modernists, the slough of nineteenth-century repression, have been rubbed out completely.

But the crisis that modernist artists felt is just as present, an eerie cross between industrial expansion and human agony. Somehow, the result feels just as Victorian, and just as problematical as the city did then. So we witness our world leaving the twentieth century from both ends—back to the same raw confusion of 1900, and forward toward a

world where consumer planning can erase memories more totally than industrial planning ever could.

Notes

1. Alan Bullock, "The Double Image," reprinted in Malcolm Bradbury and James McFarland, *Modernism* (New York: Penguin Books, 1978), p. 59.

2. Stephen Kern, *The Culture of Time and Space 1880–1918* (Cambridge, Ma. Harvard University Press, 1983), pp. 18–19.

3. Fritjof Capra, *The Tao of Physics* (New York: Bantam Books, 1975), p. 50.

4. Craig Adcock, "Conventionalism in Henri Poincare and Marcel Duchamp," *Art Journal* (Fall 1984), p. 250.

5. André Breton, *Nadja,* first published in 1978, translated by Richard Howard (New York: Grove Press, 1960), p. 112.

6. Marjorie Perloff, *The Futurist Moment* (Champaign: The University of Chicago Press, 1986), p. 57.

7. Ibid., p. 14.

8. Lewis Mumford, "Prologue to Our Time," *The New Yorker* (March 10, 1975), p. 44.

9. B. Arvatov, "Utopia on Science?" *Lef* (Volume 4, 1923) reprinted in *Screen* (Winter 1971–72) p. 48.

10. Laszlo Moholy-Nagy, *The New Vision,* originally published in 1928, English translation and publication 1930, reprinted by George Wittenborn, 1974, pp. 19–20; reprinted in this volume, pp. 63–64.

11. Piet Mondrian, "Art and Life," reprinted in H.L.C. Jaffe, *DeStijl* 1917–1931 (The Belknap Press of Harvard University Press, 1986), pp. 234, 236, 237.

"The Modern Spirit" 1918

LE CORBUSIER AND AMEDEE OZENFANT

Ignoring the destructiveness of the flying machines and bombs in the First World War, Le Corbusier the architect and Ozenfant the painter/theorist celebrate the male workers whose "simple minds" can take collective pride in working in automated factory environments. Writing in 1918, as founders of the Purist art group in Paris, the authors celebrate the harmony or beauty which comes from applying mathematical calculations to industrial construction, in particular to architecture. In a time of social chaos at the end of the First World War, the precision and rationality of numbers appear to be a kind of savior, or a code for the rebuilding of Europe.

In narrower terms, Purism is an aesthetic based on the functionalism of machinery, perceived initially in terms of easel painting. But the language of this document also refers to political assumptions hundreds of years older, in phrases very reminiscent of the old Enlightenment notion of "man the machine" (La Mettrie), a theory that the perfectability of craft and society can be achieved by a democratic application of the machine-like aspects of the human mind. Technology is separated from the evils of capitalism, as a humanistic instrument of scientific order. In Purism, the model of machine planning became a universal problem solver, like an Academic guidance system, particularly in the design of living space in the industrial city. Later, of course, Le Corbusier would apply many of these principles, much expanded after he and Ozenfant edited the journal *L'Esprit Nouveau* (1920), to his architecture and urban planning.

* * *

What is the state of modern life?
The nineteenth century gave us the machine.

When it revolutionized labor, the machine sowed the seeds of great social transformation; when it brought new conditions to bear on the mind, it paved the way for new spiritual developments.

In the past, men who created their handiwork from nothing grew attached to it and loved it as if it were their offspring; they loved their labor. It has to be admitted that, today, mechanical assembly-line production conceals the fruit of his efforts from the modern worker. Yet the rigorous program of the newer factories now produces manufactured goods of such perfection that they give the squads of workers collective pride. The worker whose contribution has only been a spare part then apprehends the full value of his labor; he perceives the power and clarity contained in the machines lined up on the shop floor and feels involved in a work of perfection to which his simple mind would ordinarily never have dared aspire. This collective pride has replaced the old artisan mentality and elevated it to a new plane of consciousness. We feel that this transformation is a progressive step; it is one of the important factors of modern life.

The current evolution of work leads to order and synthesis through usefulness.

This has been described pejoratively as "Taylorism." In fact, it was simply a matter of intelligently exploiting scientific discoveries. Instinct, groping and empiricism have been replaced by the scientific principles of analysis, organization and classification. Fifty years have not passed since the birth of industry and already fabulous things have been accomplished which have extended the frontiers hitherto ascribed to man to an as yet incommensurable degree. These achievements have brought us a vision of clear, spacious, generalized beauty. Since the time of Pericles, never has thought been so lucid.

Constructions of a new character, the embryonic forms of future architecture, are springing up all over; respect, a certain rigor and the application of laws give these buildings harmony. A precisely formulated intention is visible in the clarity of the conception. Considered as gigantic undertakings, these bridges, factories and dams contain the vigorous seeds of future development. One gets a feeling of Roman grandeur from such utilitarian edifices.

For the past hundred years, architecture has forfeited its sense of mission. It is now no more than an inferior sort of decorative art with nothing to offer other than futile prettification which would blemish the organism of the building if that organism existed. But the position of architecture is graver even than this. Since its aim is to make a house a viable organ whose objective is primarily utilitarian and only subsequently uplifting, if this is found to be appropriate, one can only conclude that architecture has completely lost this vocation. In its geriatric scholasticism, it is content to twine garlands around the lobbies of mansions

and "rent dives" and to decorate them with some flabby excretion taken from an architecture textbook. Architecture would be dead (for Academia has killed it) had not a happy detour put it back on its proper path; architecture is not dead because engineers and constructors have taken charge of its high destiny with a reassuring sense of enterprise.

One must look discerningly through the chaos of city suburbs for there we may see factories whose construction has achieved a certain harmony thanks to the application of pure principle. This appears to us to be close to beauty. The latest construction technique, reinforced concrete, has made the rigorous implementation of mathematical calculation possible for the first time; Number, which is the origin of all beauty, will henceforth have its own distinctive lineament.

On account of their numerical conditioning, machines have evolved more rapidly, to the point where they have now attained a remarkable purity. We feel a new sensation when we contemplate this purification, we feel a new sort of pleasure which requires some thought; it is a new factor in the modern concept of art.

It is impossible to remain unmoved by the intelligence which controls certain machines, by the symmetry of their organs so rigorously conditioned by calculation, by the precise working of their elements, by the upright beauty of their materials and by the sureness of their movements, in which may be seen a projection of natural laws. The halls in which they are housed are vessels of forthright limpidity. Factory buildings, with their great expressive order, set forth their serene immensity; order reigns because nothing is left to fantasy.

All of this is now achieving what the Greeks, who had so clearly perceived this spirit, had dreamed of without ever succeeding in achieving themselves because they lacked the methods and facilities available to modern industry. Today, we have constructors. We now have our own versions of the Pont du Gard and we will also have our Parthenon. Our time is better equipped to attain this ideal of perfection than was the time of Pericles.

"Constructivist Art" 1921

ALEXANDER RODCHENKO AND VARVARA STEPANOVA

Artists Alexander Rodchenko and Varvara Stepanova recommend "effective exploitation" of new industrial techniques by Marxists in order to link ideology with the lives of citizens in the new Soviet state. Studio art is replaced by technical science or faktura, using new construction techniques created by engineers and architects to produce works which are closer to design than to traditional ideas about fine art.

Rodchenko and Stepanova were both key members of the Productivist group in the 1920s in Russia, as well as contributors to *Lef*, a journal of art theory concentrating on the links between industrial methods and modern art.

As a married couple, Rodchenko and Stepanova collaborated on many projects and shared many of the same aesthetic concerns. And yet the uniqueness of each artist's vision must not be neglected (nor obscured by the easy classifications that can be made in any grouping of modern artists). Rodchenko's fascination with architectonic industrial composition would seem contradicted by Stepanova's use of shapes reminiscent of Russian folk design. And yet, they often shared the same text when explaining their work in the 1920s. Contrasts between theory and practice are often obscured when a single document stands in for two or more artists' work. Rodchenko, to cite an obvious contrast, taught and worked frequently with classroom versions of metallurgy and industry, while Stepanova was a master designer in fabric, even for factories. (Some of her designs were actually lifted by the New York fashion industry in the 1960s, and her techniques became common practice throughout the fashion world, making her something of a prophet in a field usually neglected in the histories of modern art.) The range of media and application, so common among the Russian avant-garde of the 1920s, makes a single text difficult to use as a model for work in

film, theater, posters, photography, and studio arts. Part of this range of media was due also to political changes at the time, shifting allocations, crises during the NEP period, even diminishing resources in one area and new opportunities in another. This document, then, was published as an explanation for a practice that was ongoing rather than a theory that was being tested.

<p align="center">* * *</p>

It is the task of the Constructivist group to direct materialist, constructivist work towards communist ends.

The group tackles this problem by means of scientific hypotheses. It stresses how necessary it is to attain a synthesis of ideological and formal aspects, so that studio work can be directed toward practical activity.

When the group started its work its programme included the following ideological tenets:

1. It is exclusively based on scientific communism which is itself based on the theory of historical materialism.
2. The knowledge of the endeavours of the Soviets has made the group change its experimental activities from abstract (transcendental) to real works.
3. The specific elements involved in the work of this group, that is *tektonika*, construction and *faktura*, provide ideological, theoretical and practical justification for the transposition of the material elements of industrial culture into volume, plane, colour, space and light.

The communist expression of materialist construction is based on these premises.

These three tenets create an organic link between the two spheres of ideology and form.

Tektonika has its origins in the structure of communism and the effective exploitation of industrial realities.

Construction is organisation. It uses the ready made substances of things. Construction is shaping, going after extreme solutions, yet it does make allowance for further "tectonic" work. *Faktura* is the name given by the group to carefully chosen and effectively used materials which neither hinder the progress of construction nor limit the *tektonika*.

The material elements are:

1. Materials generally. Knowledge of their origins and changes due to industrial and production techniques. Their nature and their significance.
2. Intellectual materials: light, plane, space, colour, volume. The Constructivists treat intellectual and concrete materials in the same way.

The group has the following future aims:

1. Ideological aims:
 a. To prove the incompatibility of artistic activity and intellectual production through word and deed.
 b. To make intellectual production truly participate in the building up of communist culture, as an element equal in value with others.
2. Practical aims:
 a. Press activities
 b. Production of plans
 c. Organisation of exhibitions
 d. Establishing contacts with all the productive centres and main bodies of the united Soviet institutions which make communist life a practical reality.
3. Propaganda aims:
 a. The group is committed to a merciless fight against art in general.
 b. The group proves that there cannot be any consistent development from the art forms of the past to the communist forms of constructive building.

Constructivist slogans:

1. Down with art, long live technical science.
2. Religion is a lie. Art is a lie.
3. Destroy the last remaining attachment of human thought to art.
4. Down with the conservation of artistic traditions. Long live the constructivist technician.
5. Down with art which only obscures the incompetence of the human race.
6. The collective art of today is constructive life.

"What is Constructivism?" 1924

EDITORS OF BLOK

Writing in 1924, the editors of *Blok* magazine present Constructivism as a collective, creative process which combines practical purpose with mechanization and economy. They felt that art production should be understood as an institution for the social good, including considerations of health, convenience, and the effect of art on mass culture. Their interest in architecture, cinema, and printing parallels the rise of "factography" in Russia, which is discussed by Benjamin Buchloh in his article in this section.

Poland was a major outlet for the dissemination of Constructivism into western Europe, particularly Germany. Since the mid-1970s, many articles on Polish design have appeared, as yet another "neglected" area has been discovered. With each generation, new areas in modern art have been discovered in much this way, as definitions of practice and complexity shift and as new documents arise. The history of modernism, as rigid as its chronology may seem, is often a reflection of present rather than past concerns, a multiple text about many eras at once.

* * *

What is Constructivism?

NOT any particular branch of art (e.g., a picture or poems) but art as a whole 1
NOT expressing one's personal experiences and moods, but looking for a PRACTICAL application for the creative drive, flowing from the original instinct of art, displayed in every product of human labour 2

BUILDING of things by all available means, with the practical
purpose of those things as the primary consideration 3
It does not mean that the constructivist programme cancels
disinterested creation in art
A SYSTEM of methodical collective work, controlled by a self-
conscious will, aiming at the perfection of the collectively
attained results of works, and also inventiveness 4
MECHANIZATION of the means of working 5
Hand-made forms contain graphological biases, characteristic
of individual artists; a mechanical performance offers an
absolute objectivism of form (*Blok* no 1).
ECONOMIC use of material 6
Exactly as much material as is indispensable
The properties of the created thing must DEPEND upon the
employed material 7
Constructional merits of the material—the types of its surface—its
colour—its different surface properties as dependent on the finish
—its peculiarities when exposed to light etc.
T van Doesburg said about colour as a property of building
materials: 'New architecture uses colour (not painting), throws it into
light, displays with it the change of shape and space.
Without colour we would have no play of shapes.
It is only by means of colour that we can attain a clear, optical
balance and balanced integration of each particular part in the
new architectural style.
To harmonize the whole (in the sense of space and time, and not in
the two dimensions) by colour—this is the task for a painter.
In some later stage of development, it will be possible to
substitute a transformed material for colour (the task of chemistry)...
Colour (it must be made clear to architects—enemies of colour) is
not an ornament or embellishment—it is an essential element,
organically belonging to architecture like glass and iron'.
('A Renewal of Architecture', *Blok* no 5).
BUILDING of a thing according to its own principles 8
Constructivism does not imitate the machine, but it finds its
equivalent in the machine's simplicity and logic 9
The problem of CONSTRUCTION, rather than the problem of
form 10
Construction determines the form.
Form has its origin in construction.
Application of the achievements of technology to expand the
range of formal opportunities 11
To focus the creative effort in the first place upon architecture—
cinema—printing and the so called world of fashion 12

Considerations of health and convenience have been often
overlooked by architects for aesthetic reasons—a constructivist
constructor takes them up as the problems of primary
importance.

To introduce art into life as a factor contributing to general social
development which in its turn is dependent upon changes
occurring in the other fields of human creative activity, particularly
technology 13

PROBLEMS OF ART AND SOCIAL PROBLEMS
ARE INDIVISIBLE

Constructivism does not aim at creating a style as unchanging
fixed pattern based upon forms once invented and accepted, but
it takes up problems of CONSTRUCTION that may and must be
subject to continuous changes and improvements, under the
pressure of the ever new and more complex requirements
imposed by general social development.

The Editors

"Futurism and the Automobile" 1985

GERALD SILK

Futurist preoccupation with speed and the technological revolution found its favorite symbol in the automobile, which redefined the time and space of everyday life. The experience of riding in an automobile is one of simultaneous impressions and fragmented stimuli, experiences which were recognized as emblematic of the new conditions of modern life.

This was a very common response to the auto in the early decades of the twentieth century. Even in the children's classic *The Wind in the Willows* (1908), Toad exclaims, on first seeing a car: "Glorious, stirring sight. The poetry of motion!...Here today—in next week tomorrow! Villages skipped, towns and cities jumped—always somebody else's horizon."[1] And later: "That swan, that sunbeam, that thunderbolt."[2]

Paul C. Wilson, in *Chrome Dreams: Automobile Styling Since 1893*, writes:

> The exhilaration of speed was not unknown, then, at the time when the automobile appeared. People who had enjoyed bicycles and fast horses took to automobiling immeditely. "The chief cause for the modern automobile is its speed," wrote one motorist in *The Horseless Age*, March 12, 1902. He assumed that most people shared his feelings: "There are few people who want a slow automobile after having ridden in a moderately fast one." There were few indeed who were unaffected by the experience, but some were upset by the force of their feelings. Was there a risk of mental derangement from the powerful emotions excited by a fast automobile ride? Some thought so; certainly there were disturbing signs of it in the behavior of many young "scorchers." Like any other intoxicant or narcotic, the euphoria of high speed was carefully examined for harmful side effects.[3]

Thus, the auto became a symptom of moral, sociological, even perceptual derangement (in the 1920s, it would be called the "devil's

workshop"—a suitable emblem for avant-garde blasphemy.) It was a further democratization of the train, but here without tracks, barreling along on rutted roads as yet unsuitable for the speed and dynamics of a machine on wheels. On small country roads, cars must have looked like patches of urbanization, thrown by centrifugal force into the landscape. The Sunday driver was an often-noted cultural phenomenon.

The speed of auto travel also inspired one unique aesthetic problem: how to represent aerodynamic design—how to surround the engine with a body that accounted for air resistance, either symbolically or literally. The aerodynamic concept was a camouflage, of sorts, the art of covering separate machine parts with an industrial equivalent of the wings of Mercury. This is yet another example of the contrary nature of modern art practice when placed in the frame of social history. Here we see the abstraction of speed as a form of machine ornamentation and of modern exoticism, the myth of travel updated. When the subject for the artist was a speeding automobile, the machine aesthetic was no longer true to its materials, nor even functionalist, at least not by any strict measure. Instead, the romance of speed was transformed into a new code of story and staging.

Notes

1. Kenneth Graham, *The Wind in the Willows* (New York: Scribners, 1908), p. 41.
2. Ibid, p. 44.
3. Paul C. Wilson, *Chrome Dreams: Automobile Styling Since 1893* (Radnor, PA: Chilton Book Company, 1976), p. 140.

* * *

Within myself I sensed new beings full of dexterity
Building up and organising a new universe
A shopkeeper of untold wealth and prodigious size
Was arranging an extraordinary display-window
And gigantic shepherds were leading
Great dumb herds that browsed on words
And around whom all the dogs in the road were barking
And passing that afternoon by Fontainebleau
We arrived in Paris
At the moment when the mobilisation posters were going up
And my comrade and I understood then
That the little motor-car had brought us into a new Epoch
And though we were both mature men
We had just been born.
—Guillaume Apollinaire, *The Little Motorcar*

In 1909, the Italian poet and propagandist Filippo Tommaso Marinetti founded Futurism, an art movement that extolled modern technology. True to their name, the Futurists believed that technology represented the wave of the future. An embrace of the most modern phenomena was a necessary antidote to Italy's devotion to its past because this devotion, especially to its Classical and Renaissance heritage, was impeding cultural development. In the mid-nineteenth century, Italy had achieved political unification, which the nation hoped would lead to a general Italian *risorgimento,* or rebirth. By the early twentieth century, this new renaissance had yet to materialize. Futurism was in part tied to Italian nationalism, and Marinetti coopted the political device of the manifesto to announce a cultural program designed to rejuvenate Italian society.

Working in various mediums—painting, sculpture, architecture, design, literature, music, and theater—the Futurists used the automobile as an important symbol and favored subject matter. Inspired by the revolutionary effects of developing technology, the Futurists regarded the auto as a paradigmatic innovation that was physically altering the environment and changing man's perception of the world; it thus symbolized Futurist ideas about modernity and technological progress. Capable of rapid movement that intensified a rider's experiences of urban environments, the automobile could induce a sense of power, exhilaration, and emancipation.

Certain tenets in Futurist thought were determined by actual experiences related to the automobile; the artists did not simply arrive at an ideology and then seek objects to symbolize its principles. Observing or riding in a speeding car confirmed the Futurist belief that dynamic, simultaneous sensations were among the basic forces of reality. The Futurists promoted the physical and emotional experiences of potency, intoxication, and liberation produced by car travel, and the automobile helped to shape the violent, frenetic, and anarchistic nature of much Futurist art.

The Futurist artist Giacomo Balla executed over one hundred works using as primary subject matter either the image of a speeding automobile or a visual record of its effects. Images of motorized vehicles, including automobiles, electric trams, and motorcycles, are also present in the works of the other major Futurist artists Luigi Russolo, Gino Severini, Umberto Boccioni, and Carlo Carrà, and in the works of the lesser-known Futurists Mario Sironi, Achille Funi, and Gino Galli. The image of the automobile recurs throughout Futurist literature and poetry, especially in the manifestos and verse of F. T. Marinetti. Attempting to distinguish Vorticism, a technological British art movement, from Futurism, the artist and writer Wyndham Lewis somewhat derogatorily labeled the Italian movement mere "automobilism." Nonetheless, he was

acknowledging the fact that Italian Futurism was the first major modern art movement to adopt the automobile and to explore car-related experiences as suitable subject matter.

The automobile first appeared as a symbol of the Futurist movement in F. T. Marinetti's "Founding and Manifesto of Futurism" of 1909. The often-cited broadside proclaimed that "the world's magnificence has been enriched by a new beauty; the beauty of speed. A racing car whose hood is adorned with great pipes, like serpents of explosive breath—a roaring car that seems to run on grapeshot—is more beautiful than the *Victory of Samothrace.*" Marinetti's aesthetic analogy between a contemporary technological object and the museum-enshrined classical masterpiece boldly and belligerently announced the rejection of the past and its artifacts in favor of the objects and ideas of the modern world. Marinetti selected the automobile as the object most representative of the contemporary world because he felt that it best expressed the concept of dynamism. In a world animated by the principle of dynamism, all objects are thought to be in a state of motion—even those appearing to be at rest are in motion by virtue of their own internal movements. All things, either mobile or immobile, constantly interact with one another and with their surroundings. Speed amplifies dynamism, and together they change experiences of time and space.

Influenced by the contemporary French philosopher Henri Bergson, who theorized that reality is in constant flux, the Futurists intuited that speed and dynamism, manifestations of new technology and the new urban environment, constituted the essence of reality. In their analysis of speed and motion, the Futurists believed that they had discovered insights into the underlying nature of existence. "Speed," Severini stated, "has transformed our sensibility...has led to the majority of our Futurist truths...has given us a new conception of space and time itself." "Dynamism," claimed Boccioni, "constitutes reality....There is no such thing as rest, only motion." The concepts of rapidity and flux were ideally suited to Futurist ideology because they embody parallel notions of forward motion and continual change. The concept of dynamism is also conveniently antithetical to the classical canons of stability and order, against which the Futurists rebelled.

Futurist art invariably depicted the automobile in motion. In a series of images of swiftly moving motorcars, Giacomo Balla concentrated on the speed and dynamism rather than the form or design of the auto. Done mostly between 1911 and 1915, the titles of these works indicate Balla's focus: *Speeding Automobile, Abstract Speed, Dynamism of an Automobile, Wake of a Speeding Automobile.* By superimposing a repeating, diminishing image of the car from right to left and overlaying a network of lines and forms, Balla was able to emphasize the appearance of directional energy and activate the space surrounding the car.

The technique nearly obliterates the shape of the auto, creating an impression of velocity and mobility.

These converging vectors and churning whirlpools suggest violent struggle. The phalanx of V-shaped forms alludes to what the Futurists called "force-lines"—basic units of force that constitute the dynamic core of all objects. The coils of spiraling shapes also signify kinetic qualities and symbolize dynamic forces that penetrate and scatter the static environment. Balla's work represents the battle between Futurism and the past: the automobile, incarnation of speed and dynamic forward movement, becomes symbolic of Futurism itself; the inert environment, now fragmented, is symbolic of the vanquished past.

Balla's sketches and preliminary drawings reveal that he began with the image of a single immobile car, working from the Fiat Types I and II of 1909–12, and overlapped additional images slightly ahead of the original vehicle. As the image multiplies, abstract patterns materialize. By inserting force-lines and whorls, and by flattening the car's form, Balla was able to metamorphose his stodgy prototype into something sleekly suggestive of intense movement.

Balla's methodology was closely connected to experimentation in the photography of locomotion, to the studies of phases of movement by Eadweard Muybridge, and particularly to the chronophotography of Etienne-Jules Marey and the Futurist photodynamism of his friend and colleague Anton Giulio Bragaglia. Muybridge arranged a series of cameras along a path to be followed by moving animals or people; as the figures moved forward, they tripped the shutters of the successive cameras, each of which captured a phase of the figure's motion. Employing a single camera and a strip of film loaded in a mechanism similar to the revolving chamber of a pistol, Marey recorded the sequential and overlapping positions of moving objects. Bragaglia's photodynamism represented an attempt to register the continuity of an action in space, but he did not shoot images at different moments. Instead, he exposed single plates that recorded movement over a longer period of time, ending up with blurred, smeared, nearly apparitional forms.

Dynamism of an Automobile, a painting executed by fellow Futurist Luigi Russolo between 1911 and 1912, parallels Balla's formula of a fast-moving car as symbolic of the dynamic present disrupting the static past. Russolo portrays the image of an automobile moving from right to left. The car seems to slice through space; motion is expressed by a progression of crimson force-lines that overlay the indigo-colored auto, and become closer, blunter, and more vertical as they move from right to left. Bits of architecture, noticeable at the top of the composition, seem bent and warped by the force and pressure of the force-lines. *Dynamism of an Automobile* suggests formal similarities to Russolo's painting of 1912, *Rebellion.* In *Rebellion,* a wave of recurring blood-red wedges,

representing a mass of humanity, dominates the composition. The work was exhibited at the Sackville Gallery in London with an accompanying description: *"Rebellion:* The collision of two forces, that of the revolutionary element made up of enthusiasm and red lyricism against the force of inertia and reactionary resistance of tradition. The angles are the vibratory waves of the former force in motion. (The perspective of the houses is destroyed just as a boxer is bent double by receiving a blow in the wind.)" The compositional similarities between *Rebellion* and *Dynamism of an Automobile* suggest that the automobile, like the surging marchers in *Rebellion,* functions within the painting to symbolize a dynamic destruction of the past.

Speeding along in a fast-moving car produced a feeling of physical liberation and power that the Futurists wished to transfer, ideologically, to the movement as a whole. Marinetti panegyrized: "The intoxication of great speeds in cars is nothing but the joy of feeling oneself fused with the only *divinity.*" The automobile's ability to provide a sense of physical freedom made it an ideal symbol for a movement that promoted the emancipating capabilities of new technology. The car's association with power, force, and *machismo* was ideally suited to a movement bent on destruction of the established order. The car became a cultural "getaway" vehicle, commandeered by artists who, in their assault on the status quo, functioned as cultural race car drivers.

Identification of the automobile with the technological revolution directly influenced the style of Futurist art. In Balla's later works, such as *Abstract Speed* and *Lines of Speed,* he removed the car's image from the composition but retained the abstract patterns that resulted from a pictorial analysis of the speeding auto. Balla attempted to present a pure and abstract signification of speed and dynamism that was more suggestive of inner, absolute, and universal forces. As Futurist colleague Fortunato Depero explained in 1915, "By studying the speed of automobiles and in so doing discovering the laws and essential force-lines of speed," Balla was encouraged to develop and adopt an abstract visual language. These first abstract compositions inspired a group of three-dimensional constructions called "plastic complexes" by Balla and Depero in their joint manifesto entitled "The Futurist Reconstruction of the Universe" (1915). The plastic complexes were to serve as models for restructuring the environment. The automobile became the source, and art the intermediary for the discovery, analysis, and distillation of universal and abstract dynamic principles that could be applied to create a better world.

Futurist art was affected by other automobile-related phenomena, especially by the experiences of simultaneous sensations. The concept of simultaneity was formulated and widely discussed during the first two decades of the twentieth century, particularly in France and Italy.

As Marinetti defined the term, simultaneity implied that to a perceiver, a multitude of events seemed to be happening at once, or simultaneously. Simultaneity was a function of the increasing speed and motion characterizing contemporary existence, as the Futurist Ardengo Soffici remarked: "External velocity, by intensifying our mental action, has modified our perception of space and time. As a result, we have the contiguousness and contemporaneity of things and events, or the simultaneity of sight and emotions."

The automobile and other motorized forms of transportation provided ideal opportunities to experience these sensations. The car significantly heightened the general bustle and confusion of rapidly developing urban centers, and automobile travel intensified the impression that contemporary life was characterized by overwhelming amounts of fragmented, imbricated stimuli.

Several Futurists portrayed the automobile as a component of urban pandemonium. Many of the works in Balla's automobile series depict the car interacting with the environment and include pictorial signs representing speed, light, and noise—an attempt at suggesting simultaneous sensory impressions. In *Speeding automobile + lights* (c. 1913), *Rhythm + noise + speed of an automobile* (1913–14), and *Speeding automobile + lightnoise* (c. 1913), Balla created a vocabulary of abstract ciphers: meander patterns for sound, and luminous circles and arcs for light, almost completely disintegrating the form of the motorcar itself.

Futurist art also expressed the notion of simultaneity as something produced by actual auto travel. In Gino Severini's painting *Autobus* (1912), translucent figures are seated in a moving bus. A series of intersecting diagonals, punctuated by fragments of architecture, store signs, and billposters, conveys a sense of movement and of inundation by a kaleidoscopic mélange of sensory information. As the artist described it, *Autobus* was "...an endeavor to produce by means of lines and planes the rhythmic sensation of speed, of spasmodic motion and of deafening noise. The heavy vehicle pursues its headlong career from Montmartre to Montrouge along the crowded streets of Paris, dashing across the path of other motors, grazing their very wheels and hurling itself in the direction of the houses so that 'the houses seem to enter the motorbus and the motorbus the houses.'" Severini implied that the physical and psychic sensations of motorized travel had a direct effect on artistic style; the tumultuous nature of contemporary experience could not be portrayed in a conventional manner and thus led the artist to adopt a new visual idiom of expression.

The vocabulary of French Cubism played an important role in the Futurist effort to develop a style appropriate to the modern world. The Futurist debt to Cubism varied from artist to artist. Balla, for example, was probably influenced least by the French movement. As the oldest

Futurist artist, he had already developed a coherent style before the advent of both Futurism and Cubism. Severini, who had settled in Paris in 1906, was affected more strongly by Cubism. In 1911, Severini urged his Futurist colleagues to visit Paris in order to encounter Cubism firsthand; Russolo, Boccioni, and probably Carrà made the trip, while Balla remained in Italy.

Cubist devices—fragmentation and dematerialization of form, solidification of space, use of transparency and overlapping—were adopted by the Futurists to express speed, dynamism, aggression, and simultaneity. According to the Futurists, the Cubists were squandering a radical and potentially dynamic style on staid, traditional subjects. The Futurist assertion about Cubism was not completely accurate; although the best-known Cubists, Pablo Picasso and Georges Braque, showed little interest in modern technological motifs, others such as Robert Delaunay, Fernand Léger, and Marcel Duchamp dealt with technological and mechanical themes. The Futurists, borrowing Cubist formal innovation and adding vibrant colors, were more outspoken and programmatic in connecting the most revolutionary aspects of modern art to the most revolutionary aspects of modern life.

Futurist poetry endeavored to recreate experiences that had been affected by the automobile. Poets tried to convey a sense of silmultaneity, for instance, by evoking the excitement of the rapidly changing metropolis in which the automobile was a critical factor. In Luciano Folgore's "Automobile Quasi Te," disparate images and abrupt shifts of place and time are strung together:

> All around me the world in in motion
> All around me the city—no longer immobile
> my trip
> moving
> headlong
> of leaveshousesparapetsstreetlamps
> of tired men traveling on foot
> and of dust
> from the times
> flurrying.

As in most of these works, the automobile is represented as one of many discrete yet interconnected elements within a composition.

Futurist writers and poets were compelled to abandon traditional approaches and discover or invent languages more appropriate to the expression of the transformations in contemporary society. Marinetti, recognizing the need for a new literary form, created what he called "words-in-freedom," intermingling words, letters, and images, replacing customary punctuation with mathematical symbols, and using composi-

tionally arranged, diverse, and expressive typography. "My reformed typesetting," exclaimed Marinetti, "allows me to treat words like torpedos and to hurl them forth at all speeds." He chopped, elongated, and twisted words and letters, producing frenetic and fluid arrangements. In one of his best-known "words-in-freedom," *After the Marne, Joffre Visited the Front in an Automobile,* written in French in 1915, Marinetti enlarges and distorts the letters "M" and "S," converting them into shapes suggestive of mountains and winding roads. These and other letters, along with mathematical symbols, dismembered and onomatopeic words, dance wildly across the page. The "ta ta ta ta..." of artillery is mixed with the "dynamic verbalization of the route," "xx = spirals 5 spirals spiral pneumatic" and "vitessssssssssxxxxxxssssssss."

In Respiration of the Earth (c. 1915), Marinetti sketched the image of a speeding car whose back wheels trail off into repeating letters suggestive of the car's noise. *Speeding Automobile* (1915) spells out its contents as "the sum of colors, forms, analogical psychic impressions of a fast landscape," and exploits unconventional typography and words, rather than an unusual layout, to convey these sensations. In *Zang Tumb Tumb* (1914), the section "Correction of proofs + desires in speeds" compares and interweaves revised manuscript with a variety of modern phenomena: electricity, and boat, train, and car travel. In the account of the "speeding cars," each stanza is embraced by words indicating the car's velocity. At "70 km. per hr. trrrrrrrrrrr," the driver is half-thrown back beneath the enormous wheel that "spins like a planet"; as the car accelerates to "85," "95," and then "100" kilometers per hour, the "trrr's" of the text grow physically larger. A final "stop" issued in bold, black letters brings "(instinctive braking tremors of the driver) ⅛ of the car 3 wheels nibbling tranquil fodder blondness ironies of a village 306 years old."

The automobile thus encouraged the formulation of novel aesthetic vocabularies in both art and literature. As Umberto Boccioni argued:

> The means of artistic expression handed down to us by the culture are worn out and no longer capable of receiving and interpreting the emotions that have come to us from a world that has been completely transformed by Science. The new conditions of life have created an infinity of completely new, natural elements, which therefore had never entered previously into the domain of art, and for which the Futurists intend to discover a new means of expression at any price."[1]

Despite the Futurist movement's disavowal of the past, many of its attitudes toward the automobile were borrowed from earlier sources. Futurist ideology held that the vital aspects of modern life, the true origin of artistic inspiration, superseded the power of traditional works

of art. This idea had already been expounded by Octave Mirbeau in *La 628-E8:*

> Machines appear to me, more than books, statues, paintings, to be works of the imagination. When I look at, when I hear the life of the admirable organism that is the motor of my automobile, with its steel lungs and heart, its rubber and copper vascular system, its electrical nervous system, don't I have a more moving idea of the imaginative and creative human genius than when I consider the banal, infinitely useless books of M. Paul Bourget, the statues, if one can call them that, of M. Denys Puech, the paintings—a euphemism—of M. Detaille?[2]

Mirbeau believed that a good motorist proudly loves his car as one does a beautiful woman, and that "a car-driver, always speeding across space, like a tempest or a cyclone, is something of a superman." The infatuation with the automobile, and the belief that the car enhanced man's power, encouraged interpretations of the relationship between man and machine as intimate and often sexual. Consequently, the car was invested with human or animal qualities, and in this union between man and motor, the two joined forces to create a supernatural being, what might be called a "mechanical centaur." This concept of "mechano-morphism" circulated widely in the literature of the day.

Alfred Jarry wrote for Marinetti's periodical *Poesia;* his proto-Dada play *Ubu Roi (King Ubu)* was the model for Marinetti's own drama *Le Roi Bombance.* In *Le Surmâle (The Supermale),* Jarry introduced an extraordinary creature capable of surpassing all known limits of love-making and locomotion. Jarry attributed a variety of animal associations to the automobile, ranging from the erotic description of its "immodest organs of propulsion" to instinctual characterization—"metallic beast, like a huge beetle [that] flattened its wingsheath, scratched the ground, trembled, agitated its feelers and departed."[3] Jarry's expressions of mechanomorphism and ideas on violence, anarchism, and deformation all infiltrated the Futurist program.

In *The New Weapon—The Machine* of 1905, Mario Morasso, Italian nationalist thinker and writer, prefigured many of Marinetti's ideas. Morasso described the car as "an iron monster, awed by the heartbeat of its motor...breaking loose a repressed vibration and trembling." To Morasso, the machine "lives in continuous communion with man, so that unavoidably he becomes accustomed to considering it a living part of himself," resulting in an "amazingly strong being, a strange species, a centaur of flesh and metal and of wheels and limbs."[4] Marinetti would later develop the notion of synergy between man and machine in the "Founding and Manifesto of Futurism," as artist and auto undertake an erotic and aggressive joyride.

Even before the manifesto, Marinetti developed a similar theme in his 1905 poem "To the Automobile," also called "To My Pegasus" and "To the Racing Automobile." Since Pegasus is sometimes regarded as a symbol of poetry itself, Marinetti, in his identification of Pegasus with the automobile, seems to be casting the car in the role of modern muse for the modern world. The poem, a bizarre mixture of symbolist analogy, anarchic violence, and proto-Futurist technological exaltation, describes a car journey in which man and machine achieve an intimate and sensual union in a battle against the forces of nature. The driver erotically entreats his auto: "I am at your mercy...Take me!/.../ I become inflamed with the fever and desire/ of the steely breaths from your full nostrils!" While urging it onward, "I finally unleash your metallic bridle...You launch yourself,/ intoxicatingly, into the liberating Infinite!" The car, "a vehement God of a race of steel," becomes a modern-day Pegasus, possessing mechanical power analogous to the supernatural forces of the mythological winged horse, "an automobile drunk with space,/ pawing the ground with anguish, strident teeth biting at the bit." In concert with man, the car transcends the conventional bounds of nature: "Hurrah! No longer contact with the impure earth!.../ Finally, I am unleashed and I supplely fly/ on the intoxicating plentitude/ of the streaming stars in the great bed of the sky!"

Adventures of man and motorcar continue in Marinetti's "Founding and Manifesto of Futurism." The first part of the manifesto, "The Founding," is the story of a turbulent car ride in which artist and auto share energy: "We went up to the three snorting beasts to lay amorous hands on their torrid breasts. I stretched out on my car like a corpse on its bier, but revived at once under the steering wheel, a guillotine blade that threatened my stomach." When the journey falters and the car dives into a ditch, the car must inspire man "When I came up—torn, filthy, and stinking—from under the capsized car, I felt the white-hot iron of joy deliciously pass through my heart!" In turn, man must rejuvenate the auto: "They thought it was dead, my beautiful shark, but a caress from me was enough to revive it; and there it was, alive again, running on its own powerful fins!" This joyride serves as a metaphor for the inspiration and predicted development of Italian Futurism. The opening passages of "The Founding" captures the sense of Italy's cultural deterioration: "the old canal muttering its feeble prayers and the creaking bones of sickly palaces." Technology's role as guide and means of emancipation is personified by the motorcar: upon hearing "the famished roar of automobiles," artist and auto embark on a violent and sensual "journey," fleeing the past ("Let's go! Mythology and the Mystic Ideal are defeated at last") and forging into the future ("We're about to see the Centaur's

birth and, soon after, the first flight of Angels!"). In Futurist symbology, the Centaur represented a hybrid of artist and machine that was to become the basis of a new cultural order fusing art and technology. To accomplish this union, the artist would investigate and learn to understand the machine, as Marinetti argued in a later manifesto: "Through intuition we will conquer the seemingly unconquerable hostility that separates our human flesh from the metal of motors."

According to Marinetti, interaction between man and machine would culminate in a new species. This strange evolutionary fantasy is elaborated in his manifesto "Multiplied Man and the Reign of the Machine":

> ...if we grant the truth of Lamarck's transformational hypothesis we must admit that we look for the creation of a non-human type in whom moral suffering, goodness of heart, affection and love, those sole corrosive poisons of inexhaustible vital energy, sole interrupter of our powerful bodily electricity, will be abolished. We believe in the possibility of an incalculable number of human transformations, and without a smile we declare that wings are asleep in the flesh of man...Man...will master and reign over space and time.[5]

This theory reflects the Futurist's naively utopian belief in technological progress and its potential to transmute the psychology and physiology of the human race.

Expressions of mechanomorphism in the first decades of the twentieth century are far more frequent and convincing in literature, poetry, and even theater and performance than in painting and sculpture. Undoubtedly, the difficulty posed by representing organicized machines and mechanized men accounts for their relative rarity in the visual arts. There are, however, some examples: Balla's automobile series, Russolo's *Dynamism of an Automobile* (1911–12), Severini's *Speeding Automobile* (1913), Achille Funi's *The Motorcyclist* (1914), and Gino Galli's *Mechanical and Animal Dynamism* (1914). All attempt to express a bond between man and machine by intermingling figures with their automobiles. Marinetti's eugenic fantasies may have had a visual counterpart in Boccioni's famous sculpture *Unique Forms of Continuity in Space* (1912), which in its resemblance to the *Victory of Samothrace,* to Etienne-Jules Marey's models of birds in flight, and to Marinetti's neo-Lamarckian "non-human" type, unites the development and progress of technology, biology, and aesthetics.

The relationships between man and machine found their richest expression in Futurist poetry. Mario de Leone's *Fornication of Automobiles* anthropomorphizes the car, likening a car crash to an act of copulation:

tra...ta...ra...ta...mbu
Involuntary collision,
furious fornication
of two automobiles—energy,
embrace of two warriors
bold of movement
syncopation of two "heart-motors,"
spilling of "blood-gas."
Stopping of the coming and going
stagnation immobile of curiosity,
moaning. Moaning of the wounded.
Coagulation of business.
Cumbersome remainder
of the two dead machines,
rapidly swept
from a heat of hands,
sweeping of the enormous misshapen skeletons.

In *Heartbeats of an Automobile,* Auro d'Alba animalizes a car in imagery reminiscent of work by Jarry, Morasso, and Marinetti:

Saturated with red gas
 pawing
 trembling
I break loose
I open up columns of atmosphere
doors of liberty
The streets—intoxicated bloodsuckers
they suck me suck me
 at the heels
the cadavers of miles
devoured by the cannibal motor.

In performances of Futurist theater and music, machines occupy a particularly important position. The technology that was imitated or evoked in Futurist art and literature could play an actual role in Futurist theater and music. As projections of the artists' visions of the world, Futurist theater, much of it designed by architects, included functioning and architectural sets, often based on unrealized proposals for objects and architecture. Enrico Prampolini's *Magnetic Theatre,* though never performed, was not meant to include actors; the movements of an elaborate machine constituted the performance. When actors did participate in Futurist theater, they often mimicked machines. Giacomo Balla's performance entitled *Printing Press* (1914) consisted of twelve performers. Two pairs of two players jerked to and fro like surging pistons. Connected to each pair was a third player whose arms spun like a cog

wheel, and the two arms of the human cogs, in turn, meshed like gears. Futurist music—everyday sounds, sometimes mixed with more conventional music—comprised the production. In 1914, during the most famous of his *intonarumori* (noise machine) concerts, Luigi Russolo performed *Meeting of Airplanes and Automobile,* regaling his audience with the sounds of backfiring motors, droning engines, and other noise from the world of machines.

In all these works of Futurist art, literature, and performance, representations of a communion between man and machine, organicized machines, and mechanized men, symbolized the belief that intuition of the internal workings of machines would provide a more profound understanding of the forces characterizing contemporary existence. This theme, combined with the introduction into art of images and devices from the technological world and the urban environment, embodied the Futurist ideal of a total integration of art and life. By bringing their art into closer, more direct contact with the revolutionary advances of contemporary civilization, the Futurists wished to invigorate and stimulate their artistic production. Believing that technological growth would inevitably affect every aspect of society, the Futurists hoped that their art, as technology's major aesthetic proponent, would achieve parallel significance. The Futurist introduction of mechanical subject matter into art, especially the inclusion of machinery and mechanical noises into theater and performance, was part of a general assault on traditional artforms, and an attempt to bridge the actual dichotomy between art and life.

The Futurist artists, operating in many mediums, gathered and concentrated a variety of sentiments about the automobile. In selecting it as the symbol of the movement, the Futurists chose well. As the iconography of the automobile developed in modern art, nearly all later themes concerning it had origins in Italian Futurism. Outside Futurism, most European artists who utilized automobile imagery eschewed the Italian movement's "autolatry" and its euphoric, somewhat naive faith in the total beneficence of new technology. These other artists demonstrated a more critical, less romantic attitude, diverging from Futurist principles and expanding upon ways in which mechanical imagery could be used in art.

Notes

1. Umberto Boccioni, "The Circle is Still Open," *Lacerba,* March 1, 1914; quoted in Raffaele Carrieri, *Futurism,* Milan: Edizioni del Milione, 1963, p. 127. (translated from the Italian by Leslie van Rennselaer White).
2. Octave Mirbeau. *La 628-E8.* Paris: Charpentier, 1907, p. xiv–xv. (translation by the author.)
3. Alfred Jarry. *Le Surmâle.* 1902; (Ralph Gladstone and Barbara Wright translation, *The Supermale.* New York: New Directions, 1964, p. 28).

4. Mario Morasso. *La Nuova Arma-La Macchina*. Turin: Fratelli Bocca, 1905, p. 45–48; 69–72. quoted in Edoardo Sanguineti, *Poeti e poetiche del primo Novecento*, Turin: Giappichelli, 1966, p. 279; 287. (translation by the author)

5. F. T. Marinetti, "Multiplied Man and the Reign of the Machine," from *War, The World's Only Hygiene*. Milan: Edizioni futuriste di Poesia, 1915; (translation in R. W. Flint, ed., *Marinetti: Selected Writings*, New York: Farrar, Strauss, and Giroux, 1972, p. 91).

"The Machine Aesthetic I: The Manufactured Object, the Artisan" 1924

FERNAND LEGER

Painter Fernand Leger compares modern art practice to the color and precision of machines, to the spectacle of store windows, and to laws of supply and demand in the business world. In effect, all arts are applied arts, producing objects which combine utility and beauty. He imagines the end of elitism among those who produce beautiful objects, whether in design, engineering, or on the canvas, each judged simply as artisans in an industrial world.

In developing these principles within his work, Leger abandoned nonobjective painting for a metallic, volumetric style where industrial or urban objects were represented as if in Cubist space, in facets. His was a solution on the canvas, not in the industrial arts, of course. But the problem he grappled with was both troubling and fascinating to him, and to many other artists of his generation as well. The perceived crisis can be simplified as follows: industrially-made objects were replacing handicrafts so totally that the old handicrafts needed protection, like an endangered species, or needed to be modernized into the factory itself. Perhaps as nostalgia, or as projection of their own dilemma, modern artists often presented the handicrafts ideal as a salvation for the industrial arts, and for studio art as well. And these statements were being made long after the arts and crafts movement of the late nineteenth century. Even an artist like Leger, who was still essentially a formalist in the materials he used, imagined the crafts businesses as liberating. Perhaps the modern easel painter felt a bit like an old craftsman pitted against the rude efficiency of a factory mold. And to defend against invasion, the image of the craftsman was not described as antiquated, but rather as progressive, as a strategy for making art about the industrial city itself.

* * *

Modern man lives more and more in a preponderantly geometric order.

All mechanical and industrial human creation is subject to geometric forces.

I want to discuss first of all the *prejudices* that blind three-quarters of mankind and totally prevent it from making a free judgment of the beautiful or ugly phenomena that surround them.

I consider plastic beauty in general to be completely independent from sentimental, descriptive, and imitative values. Every object, picture, architectural work, and ornamental arrangement has an intrinsic value that is strictly absolute, independent of what it represents.

Many individuals would be *unintentionally* sensitive to beauty (of a visual object) if the preconceived idea of the *objet d'art* did not act as a blindfold. Bad visual education is the cause of it, along with the modern mania for classifications at any price, for categorizing individuals as if they were tools. Men are *afraid of free will,* which is, after all, the only state of mind possible for registering beauty. Victims of a critical, skeptical, intellectual epoch, people persist in wanting to understand instead of giving in to their sensibilities. "They believe in the *makers of art,"* because these are professionals. Titles, honors dazzle them and obstruct their view. My aim is to try to lay down this notion: that there are no categories or hierarchies of Beauty—this is the worst possible error. The Beautiful is everywhere; perhaps more in the arrangement of your saucepans in the white walls of your kitchen than in your eighteenth-century living room or in the official museums.

I would, then, bring about a new architectural order: *the architecture of the mechanical.* Architecture, both traditional and modern, also originates from geometric forces.

Greek art made horizontal lines dominant. It influenced the entire French seventeenth century. Romanesque art emphasized vertical lines. The Gothic achieved an often perfect balance between the play of curves and straight lines. The Gothic even achieved this amazing thing: moving architectural surfaces. There are Gothic façades that shift like a dynamic picture. It is the play of complementary lines, which interact, set in opposition by contrast.

One can assert this: a machine or a machine-made object can be beautiful when the relationship of lines describing its volumes is balanced in an order equivalent to that of earlier architectures. We are not now confronting the phenomenon of a new order, properly speaking; it is simply one architectural manifestation like the others.

Where the question becomes most subtle is where one imagines mechanical creation with all its consequences, that is, its *aim.* If the goal

of earlier monumental architecture was to make Beauty predominate over utility, it is undeniable that in the mechanical order the dominant aim is *utility,* strictly utility. Everything is directed toward utility with the utmost possible rigor. *The thrust toward utility does not prevent the advent of a state of beauty.*

I offer as a fascinating example the case of the evolution of automotive form. It is even curious because of the fact that the more the car has fulfilled its functional ends, the more beautiful it has become. That is, in the beginning, when vertical lines dominated its form (which was then contrary to its purpose), the automobile was ugly. People were still looking for the horse, and automobiles were called horseless carriages. When, because of the necessity for speed, the car was lowered and elongated, when, consequently, horizontal lines balanced by curves became dominant, it became a perfect whole, logically organized toward its purpose; and it was beautiful.

This evidence of the relationship between the beauty and utility of the car does not mean that perfect utility automatically leads to perfect beauty; I deny it until there is a conclusive demonstration to the contrary. I have seen frequent examples, though I cannot offhand recall them now, of the loss of beauty through the accentuation of function.

Chance alone governs beauty's occurrence in the manufactured object.

Perhaps you regret the loss of fantasy; the state of geometric coldness that has not agreed with you is offset by the play of light on bare metal. Every machine object possesses two qualities of materials: one, often painted and light-absorbent, that remains static (an architectural value), and another (most often bare metal) that reflects light and fills the role of unlimited fantasy (pictorial value). So it is light that determines the degree of variety in the machine object. Another aspect of color leads me to consider a second plastic occurrence connected with the machine: *the occurrence of polychromed mechanical architecture.*

Here, certainly, we find ourselves witnessing the birth of a fairly obscure, but nevertheless definite plastic taste: *a rebirth of the artisan* or, if you prefer, the birth of a new artisan.

The absolutely indispensable manufactured object did not need to be colored for either functional or commercial purposes; it sold anyway, in response to an absolute need. *Before this occurrence, what do we see?* Putting color on the useful object has always more or less existed, from the peasant who decorated his knife handle to the modern industries producing "decorative art." The aim was and still is to create a hierarchy of objects and thus increase commercial and artistic value for the object.

This is the area exploited in the production of objects (decorative arts). It is done with the aim of creating *the deluxe object* (which is a mistake, to my mind) and strengthening the market by creating a

hierarchy of objects. This has led us (the professional artists) to such decadence in the "decorative object" that the few people who have sure and healthy taste become discouraged and quite naturally turn to the mass-produced object in plain wood or unpolished metal, which is inherently beautiful or which they can work on or make work to their taste. *The polychromed machine object is a new beginning. It is a kind of rebirth of the original object.*

I know that the machine itself also creates ornaments. However, since it is condemned by its function to work within the geometric order, I put more confidence in it than in the gentleman with long hair and windsor knot in his tie, intoxicated with his own personality and his own imagination.

The charm of color works; this is by no means a negligible point. Commercially, in terms of sales, the manufacturer knows this very well. It is so important that we must examine the question from this aspect: *"the public's reaction to a given object."* How does the public judge an object offered to it? Does it judge beauty or utility first? What is the sequence of its judgment? Personally I think that the initial judgment of the manufactured object, particularly among the masses, frequently concerns its degree of beauty. It is indisputable that the child judges beauty, so much so that he puts the thing he likes in his mouth and wants to eat it in order to show his desire to possess it. The young man says: "The good-looking bicycle," and only afterward does he examine it from the viewpoint of usefulness. One says: "The beautiful automobile" about the car that passes by and disappears (the birth, consequently, of the judgment of beauty, free will above and beyond professional aesthetic prejudices).

The manufacturer has become aware of this value judgment and uses it more and more for his commercial ends. He has gone so far as to put color on strictly utilitarian objects. We are now witness to an unprecedented invasion of the multicolored utilitarian object. Farm machinery itself has developed an attractive character and is decked out like a butterfly or a bird. Color is such a vital necessity that it is recapturing its rights everywhere.

All these colored objects compensate for the loss of color that can be observed in modern dress. The old, very colorful fashions have disappeared; contemporary clothing is gray and black. The machine is dressed up and has become a spectacle and a compensation. This observation leads us to envisage the *inherently beautiful* manufactured object as something of ornamental value in the street. For, after the manufacturer, who has used color as a means of making the object attractive and salable, there is the retailer, the shopkeeper, who in turn arranges his store window.

We arrive at *the art of window display,* which has assumed substantial importance over the last several years. The street has become a permanent spectacle of increasing intensity.

The display-window spectacle has become a major source of anxiety in the retailer's activity. Frantic competition reigns there: *to be looked at more than the neighboring store is the violent desire* that animates our streets. Can you yourself doubt the extreme care that goes into preparing these displays?

My friend Maurice Raynal and I have witnessed this labor of ants. Not even on the boulevards in the brilliance of the streetlights, but at the end of a badly lit arcade. The objects were modest (in the famous hierarchical sense of the word); *they were waistcoats,* in a haberdasher's small display window. This man, this artisan, had seventeen waistcoats to arrange in his window, with as many sets of cufflinks and neckties surrounding them. He spent about eleven minutes on each; we timed him. We left, tired out, after the sixth item. We had been there for *one hour* in front of that man, who would come out to see the effect after having adjusted these things one millimeter. Each time he came out, he was so absorbed that he did not see us. With the dexterity of a fitter, he arranged his spectacle, brow wrinkled, eyes fixed, as if his whole future life depended on it. When I think of the carelessness and lack of discipline in the work of certain artists, well-known painters, whose pictures are sold for so much money, we should deeply admire this *worthy craftsman,* forging his own work with difficulty and conscientiousness, which is more valuable than those expensive canvases; they are going to disappear, but he will have to renew his work in a few days with the same care and the same keenness. Men like this, such artisans, incontestably have a concept of art—one closely tied to commercial purposes, but one that is a plastic achievement of a new order and the equivalent of existing artistic manifestations, whatever they may be.

We find ourselves in the presence of a thoroughly admirable rebirth of a world of creative artisans who make joy for our eyes and transform the street into a permanent and endlessly varied spectacle. I really believe that the entertainment halls would empty and disappear, and people would spend their time outside, if there were no *hierarchical prejudices in art.* On the day when the work of this whole world of laborers is understood and appreciated by people who are free from prejudices, who will have eyes to see, we will truly witness an extraordinary revolution. The false great men will fall from their pedestals, and values will finally be put in their proper place. *I repeat, there is no* hierarchy of art. A work is worth what it is worth in itself, and it is impossible to establish a criterion. That is a matter of taste and of individual emotive capacity.

In the face of these artisans' achievements, what is the situation of the so-called professional artist?

Before considering the situation in question, I will allow myself a backward glance at a monstrous plastic error that still weighs heavily on people's artistic judgments.

The advent of mechanical beauty, with all its beautiful objects not intending to be art, justifies my making a quick examination of the traditional values of intention that were once considered definitive.

The Italian Renaissance (the *Mona Lisa,* the sixteenth century) is considered by the whole world as an apogee, a summit, an ideal to strive for. The École des Beaux-Arts bases its reason for existence on the slavish imitation of that period. *This is the most colossal error possible.* The sixteenth century is a period of nearly total decadence in all the plastic areas.

It is the error of *imitation,* of the servile copy of the subject, as opposed to the so-called primitive epoch that is great and immortal precisely because it invented its forms and methods. The Renaissance mistook means for ends and believed also in the beautiful subject. It thus combined two major errors: the spirit of imitation and the copy of the *beautiful subject.*

The men of the Renaissance have been considered superior to their predecessors, the primitives. In imitating natural forms instead of seeking their equivalents, they produced immense pictures that complacently described the most striking and theatrical gestures and actions of their epoch. *They were victims of the beautiful subject. If a subject is beautiful,* if a form is beautiful, it is a value absolute in itself, rigorous, intangible.

A beautiful thing cannot be copied; it can be admired, and that is all. At the very most, one can, through one's talent, create an equivalent work.

The Renaissance is responsible for engendering that malady that is the École des Beaux-Arts, which runs ecstatically after *the beautiful subject.* They wanted something that is even materially impossible; a beautiful subject is uncopiable. It cannot be reproduced in the scientific sense of the word. The everyday experience of thirty students in front of a beautiful object, all in the same light at the same time, but each producing a different copy, is conclusive enough. Scientific methods of imitation such as casting or photography are not the most successful. Every manifestation of beauty, whatever it may be, contains an unknown element that will always be mysterious for the admirer. It is already there for the creator, who, caught between his conscious and his unconscious, is incapable of defining the boundaries of these two realms; the objective and the subjective continually collide with each other, interpenetrating in such a way that the creative event remains always a

partial enigma for the artist. *The beautiful machine* is the modern *beautiful subject;* it too is uncopiable.

Two producers then face each other. Are they going to destroy each other?

I believe that the need for beauty is more widespread than it appears to be. From childhood to adult life, the demand for Beauty is considerable; three-quarters of our daily gestures and aspirations are plagued with the desire for it. Here, too, the law of supply and demand functions, but at the present time, it is directed mostly toward *the professional artist,* thanks to the prejudice I mentioned earlier, from which he benefits and which keeps people's eyes still barely open to the very beautiful object manufactured by the artisan, because it is not the work of an "artist."

I have just seen the Paris Fair, a spectacle where invention boils over at every step, where a prodigious effort is made to emphasize the quality of execution.

I am amazed to see that all these men who arranged, for example, those admirable panels of mechanical parts, those astonishing fountains of letters and lights, those powerful and awesome machines, do not understand, do not feel that they are true artists, that they have overturned all the received conditions of modern plasticity. They ignore the plastic quality they create; they are unaware of it.

In such a case, perhaps ignorance is healthy, but it is truly a sad matter—this most disturbing lack of consciousness in artistic creation—and it will disturb those who evoke the mystery for a long time to come.

Let us suppose all the same, as I just said, that this whole, immense world of engineers, workers, shopkeepers, and display artists became conscious of all the beauty they create and in which they live. The demand for beauty would almost be satisfied by them; the peasant would be satisfied with his beautiful colored mowing machine, and the salesman with his melody of neckties. *Why is it necessary for these people to go into ecstasies on Sunday over the dubious pictures in the Louvre or elsewhere? Among a thousand pictures are there two beautiful ones? Among a hundred machine-made objects, thirty are beautiful,* and they resolve the problem of Art, being beautiful and useful at the same time.

The artisan regains his place, which he should always have kept, for he is the true creator. It is he who daily, modestly, unconsciously creates and invents the pretty trinkets and beautiful machines that enable us to live. His unconsciousness saves him. The vast majority of professional artists are detestable for their individual pride and their self-consciousness; they make everything wither. In these periods of decadence one always observes the hideous hypertrophy of the individual in false artists (the Renaissance).

Take a tour of the Machine Exhibitions, for the machine has its annual exhibitions, just like those fine gentlemen the artists. Go to see the Automobile Show or the Aviation Show, the Paris Fair, which are the most beautiful spectacles in the world. Look at the work very carefully. Every time its execution is the work of an artisan, it is good. Every time it is desecrated by a professional, it is bad.

It should never be necessary for the manufacturers to leave their own terrain and address themselves to professional artists; *that is where all the mischief comes from.* These fine men believe that there is a category of demigods above them who make wonderful things, much more beautiful than theirs, who annually exhibit these immortal masterpieces at the Salon des Artistes Français, at the Salon de la Nationale, or somewhere else. They go to these openings in evening dress and humbly throw themselves into raptures over these imbeciles who should not be mentioned in the same breath with themselves.

If they were able to destroy their stupid prejudice, *they would know that the most beautiful annual salons of plastic art are their own.* They would have confidence in the admirable men who surround them, *the artisans,* and they would not go out looking for the pretentious incompetents who massacre their work.

What definitive conclusion can be drawn from all that? That the artisan is everything? No. I think there are some men above him, very few, who are capable of elevating him through their plastic concept to a height that towers over the primary level of Beauty. Those men must be capable of viewing the work of the artisan and of nature as raw material, to be ordered, absorbed and fused in their brains, with a perfect balance between the two values: the conscious and the unconscious, the objective and the subjective.

The plastic life is terribly dangerous; its ambiguity is perpetual. No criterion is possible, no tribunal of arbitration exists to settle contentions about the Beautiful.

When the impressionist painter Sisley was shown two of his own pictures that were not quite identical, he could not tell which one was a fake. We must live and create in a perpetual turmoil, in this continuous ambiguity. Those who deal in beautiful things ignore it. In this connection, I will always remember that one year, showing at the Salon d'Automne, I had the advantage of being next to the Aviation Show, which was about to open. Through the partition, I listened to the hammers and the mechanics' songs. I jumped over the barrier, and never, in spite of my familiarity with these spectacles, had I been so impressed. Never had such a stark contrast assailed my eyes. I left vast surfaces, dismal and gray, pretentious in their frames, for beautiful, metallic objects, hard, permanent, and useful, in pure local colors; infinite vari-

eties of steel surfaces at play next to vermilions and blues. The power of geometric forms dominated it all.

The mechanics saw me come in; they knew that they had artists as neighbors. They in turn asked permission to go to the other side, and these worthy men, who had never seen an exhibition of painting in their lives, who were clean and fine, brought up amid beautiful raw materials, fell into raptures over works that I would not want to comment on.

I will always see a sixteen-year-old with fiery red hair, a new blue canvas coat, orange pants, and a hand spattered with Prussian blue blissfully contemplating the nude women in gold frames; without the slightest doubt, he—in his clothes of a modern worker, blazing with color—killed the whole exhibition. Nothing more remained on the walls than vaporous shadows in old frames. The dazzling kid who looked as though he had been fathered by a piece of farm machinery was the symbol of the neighboring exhibition, of the life of tomorrow, when Prejudice will be destroyed.

Bulletin de l'Effort Moderne, Paris, 1924

"The Machine Aesthetic II: Geometric Order and Truth" 1925

FERNAND LEGER

Sounding like a Futurist (and later in the essay, like a Purist), Leger declares the state of war more desirable than the state of peace. By state of war, Leger means life at top speed, life at an accelerated rhythm, as well as the intensification of detail found in photography and film. Everything has become valuable in itself, and the artist can choose between making "art objects" or creating a "new plastic order in which to live."

This essay marks the earlier stages of transition by Leger back toward representation, toward a machine abstraction of resemblance that clearly refers to film and photography, as well as to Cubist composition, the *L'Esprit Nouveau* of Ozenfant and Le Corbusier, and the urban setting itself (circus, theater, street life).

* * *

Each artist possesses an offensive weapon that allows him to intimidate tradition. In the search for vividness and intensity, I have made use of the machine as others have used the nude body or the still life. You must never be dominated by the subject. You are in front of the canvas and not above it or behind it. Otherwise, you are out of date. The manufactured object is there, a polychrome absolute, clean and precise, beautiful in itself; and it is the most terrible competition the artist has ever been subjected to. A matter of life or death, a tragic situation, but how new! I have never enjoyed copying a machine. I invent images from machines, as others have made landscapes from their imagination. For me, the mechanical element is not a fixed position, an attitude, but a means of succeeding in conveying a feeling of strength and power. The painter is caught between a *realistic* figure and an *invented* figure, which become

the objective and the subjective. It is a question of focusing with his head, as it were, in the clouds and his feet on the ground. It is necessary to retain what is useful in the subject and to extract from it the best part possible. I try to create *a beautiful object* with mechanical elements.

To create the beautiful object in painting means breaking with sentimental painting. A worker would not dare to turn in a part that was anything less than cleaned, polished, and burnished. There nothing is wasted; everything is unified. The painter must seek ways to achieve a clean picture with *finish*. The primitives dreamed of these things. *They had professional conscientiousness:* painting is judged down to a tenth of an inch, while the mechanical is measured to the ten-thousandth of an inch. The artist puts his sensibility at the service of a job. There are workers and engineers. Rousseau is a worker, Cézanne a little engineer.

Pure tone implies absolute candor and sincerity. One does not play tricks with it. At the most, a neutral tone is reborn under the influence of a pure tone if they are adjacent in one of my canvases. Since I seek to give the impression of movement in my canvases, I oppose flat surfaces to volumes that play against them. I have collaborated in doing some architectural designs, and have then contented myself with being decorative, *since the volumes were provided by the architecture and the people moving around.* I sacrificed volume to surface, the painter to the architect, by being merely the illuminator of dead surfaces. In works of this kind, it is not a question of hypnotizing through color but of refining the surfaces, of giving the building, the town *a joyful countenance.* For us French painters, our epoch is escaping us. In Germany, the collaboration between architects and painters is close. Only there does the plastic life exist. It is nothing in Paris, and it will be nothing so long as the possibility of *illuminating the walls* is not recognized.

In *Ballet,* I thought only in terms of the decorative, of simple surfaces covered with flat colors. I did that for *Skating Rink* and for *The Creation of the World.* In collaboration with Darius Milhaud and Blaise Cendrars, I created an African drama. Everything was transposed in it. As a point of departure, I used African sculpture from the classical period; as documents, the original dances. Under the aegis of three Negro gods twenty-six feet tall, one witnessed the birth of men, plants, and animals.

Plastic beauty is totally independent of sentimental, descriptive, and imitative values. Each object, picture, architectural work, and decorative arrangement has a value in itself, absolute and independent of what it may represent. Every *created object* can contain an intrinsic beauty, like all the phenomena of the natural order, which the world has admired since time began. There is no classification or hierarchy of the

beautiful. The beautiful is everywhere, in the arrangement of a set of saucepans on a white kitchen wall as well as in a museum. Modern beauty is almost always combined with practical necessity. Examples: the steam engine, which is coming closer and closer to the perfect cylinder; the automobile chassis, which, because of the need for speed, has been lowered, elongated, *streamlined,* and which has become a balanced relationship of curved and horizontal lines, born from the *geometric order.*

Geometric form is dominant. It penetrates every area with its visual and psychological influence. The poster shatters the landscape, the electric meter on the wall destroys the calendar.

These new values must all be plastically utilized in searching for equivalence. I conceive of two modes of plastic expression:

1. *The art object* (picture, sculpture, machine, object), its value rigorous in itself, made out of concentration and intensity, antidecorative, the opposite of a wall. The coordination of all possible plastic means, the grouping of contrasting elements, the multiplication of variety, radiance, light, brought into focus, life force, the whole united, isolated, and embodied in a frame.
2. *Ornamental art,* dependent on architecture, its value rigorously relative (almost traditional), accommodating itself to the necessities of place, respecting live surfaces and acting only to destroy dead surfaces. (A materialization in abstract, flat, colored surfaces, with the volumes supplied by the architectural and sculptural masses.)

It is necessary to distract man from his enormous and often disagreeable labors, to surround him with a pervasive new plastic order in which to live.

I find the state of war much more normal and more desirable than the state of peace. Naturally, everything depends on the position from which you look at it—whether hunter or prey. From the sentimental point of view, I seem to be a monster. *I want to ignore that viewpoint all my life.* It is an intolerable burden for anyone who does plastic work. It is a drug, a negative value as rhyme is for poetry. If I stand facing life, with all its possibilities, I like what is generally called the state of war, which is nothing more than *life at an accelerated rhythm.* The state of peace is life at a slack rhythm; it is a situation of getting into gear, behind drawn blinds, when everything is really happening in the street where the *creator* must be. There life is revealed at top speed, profound and tragic. There, men and things are seen in all their intensity, their hyperactive value, examined from all sides, strained to the breaking point.

Before the war, my father took his cattle to Villette, guarded by dogs who snapped at their heels. Now that a steer costs six thousand francs, there are no more dogs. A while ago, a drink cost three sous. Today it costs three francs. Every object has become valuable in itself. There is no more waste.

A nail, a stub of candle, a shoelace can cost a man's life or a regiment's. In contemporary life, if one looks twice, and this is an admirable thing to do, *there is no longer anything of negligible value.* Everything counts, everything competes, and the scale of ordinary and conventional values is overturned. A nervous officer is finished and a cool-headed noncom replaces him. The valuable man, the valuable object, the valuable machine ruthlessly assume their natural hierarchy. Contemporary life is the state of war—that's why I profoundly admire my epoch. It is hard and sharp, but with its immense senses it sees clearly and always wants to see more clearly, whatever may happen. It is the end of obscurity, of chiaroscuro, and the beginning of the state of enlightenment. Too bad for those with weak eyes. The nebulous, the composition of nuances, is about to perish, and painters too must go through some change.

My literary preferences are for the men who have enough of a visual angle to see the whole spectrum of human drama without *blinders. Balzac, Dostoevsky* are two whom I always reread with the same fascination. Their work is a sphere, and one aspect of it is always hidden from me. It must be turned in order to be seen; so I turn it and there is always something new. They have a sense of the "close-up." Their work also contains the cinema of the future; there too, moving toward *personification through enlarged detail,* the individualization of the fragment, where the drama begins, is set, and stirs. The cinema competes with life in this way. The hand is an object with multiple, changeable meanings. Before I saw it in the cinema, I did not know what a hand was! The object by itself is capable of becoming something absolute, moving, and dramatic.

Specialization in literature, in the plastic arts, can offer nothing. Art produced exclusively from mind and taste occupies a considerable place in France. Even though I am French, these works escape me. I prefer works that have "dimension." Whitman, Rimbaud, Cendrars, in spite of the mistakes they do not always avoid, give us the "close-ups" that will express contemporary life in the future.

Propos d'artistes, Paris, 1925

"The New Vision" 1928

LASZLO MOHOLY-NAGY

Laszlo Moholy-Nagy describes the Bauhaus as an attempt to remedy human problems brought about by the imposition of technological manufacturing processes upon systems of production. Biological needs for work, recreation, and for leisure must be balanced by a new understanding of nutrition, housing, industry, and "physical culture," a balance of professional work with personal needs. The Bauhaus attempted to educate the emotional, sensory, and intellectual capacities of students who learned to work together in collective labor to create standardized prototypes for a new technological society. Art was integrated into a system for reshaping daily life.

The Bauhaus is often portrayed with a singularity that belies the various debates that occurred in the school during the 14 years of its existence (1919–33) over the role of the artist, the relationship between art and industry, and over the crises that finally overthrew the Weimar Republic. Within these debates, Moholy-Nagy represented a middle ground between abstract formalism and Constructivism, although overall, considering his writing after the Second World War, he depoliticized many of the issues that plagued the Bauhaus.

* * *

Introduction

At any given moment man's position is defined by everything he does. This position is determined by his biological nature and by his participation in a given culture. This is quite apart from his personal satisfaction, which is grounded in the successful expression of his emotional

pattern. This expression will be fruitful if it carries with it an "objective" meaning for all people. Upon this depends his contribution to the development of culture.

The more he can approximate the standards which actualize that objective quality, the greater his contribution will be. The individual's emotional existence flows here into historical continuity; the actual and momentary are transcended in the permanent structure of civilization.

In art education at present we are striving toward those timeless biological fundamentals of expression which are meaningful to everyone. This is the first step to creative production before the meaning of any culture (the values of an historical development) can be introduced. We are not, therefore, immediately interested in the personal quality of expression which is usually called "art," but in its primordial, basic elements, the ABC of expression itself.

This does not mean that "art" is put aside, nor that the values within its domain are to be questioned. On the contrary, it is precisely these values which are firmly anchored in the biological. Still, for the majority of people this fact is obscured by a tendency to regard art as something unique and entirely individualistic.

We observe art because of its basic and common roots permeating life. We shall attempt to clarify them—at least in their essential points—without distressing ourselves unduly if at times we must make a detour in approaching the center of the problem, i.e., articulating the means of expression. From there we may then proceed to their individual interpretation.

Sectors of Human Development

A human being is developed by the crystallization of the whole of his experience. Our present system of education contradicts this axiom by emphasizing single fields of activity.

Instead of extending our realm of action, as primitive man was forced to do, since he combined in one person hunter, craftsman, builder, and physician, we concern ourselves with a single specific vocation, leaving other capacities unused.

Today tradition and authority intimidate man. He no longer dares venture into other fields of experience. He becomes a man of one calling; he has no longer first-hand experience elsewhere. His self-assurance is lost. He no longer dares to be his own healer, nor trust his own eyes. Specialists—like members of a powerful secret society—block the road to many-sided individual experience, the need of which arises from man's biological existence.

The choice of a calling is often determined by outside factors: a man becomes a candy-maker or a cabinet-maker because there is a shortage of apprentices in those trades; he becomes a lawyer or a manufacturer because he can take over his father's business.

The accent lies on the sharpest possible development of a single vocation, on the building of specialized faculties. "Market demand" is the criterion. A man becomes a locksmith or a lawyer or an architect (working inside a closed sector of his faculties), and if, after he has finished his studies, he strives to widen the field of his calling, aspires to expand his special sector, he is at best a happy exception.

Here our system of education has been found wanting, despite vocational guidance, psychological testing, and I.Q.'s.

A "calling" today means something quite different from following one's own bent, something quite different from solidarity with the aims and needs of a community. Everything functions—and functions alone—on the basis of a production system which only recognizes motives of material gain. One's personal life must, then, go along outside one's "calling," which is often a matter of compulsion, and regarded with aversion.

The Future Needs the Whole Man

Specialized training cannot yet be abandoned at a time when production is being put on an economic basis. But it should not begin so soon or be carried so far that the individual becomes stunted—in spite of his highly prized professional knowledge. A specialized education becomes meaningful only if an integrated man is developed in terms of his biological functions, so that he will achieve a natural balance of intellectual *and* emotional power. Without such an aim the richest differentiations of specialized study—the "privilege" of the adult—are mere quantitative acquisitions, bringing no intensification of life, no widening of its breadth. Only men equipped with clarity of feeling and sobriety of knowledge will be able to adjust to complex requirements, and to master the whole of life.

The Present System of Production

Our modern system of production is imposed labor, a senseless pursuit, and, in its social aspects, without plan; its motive is to squeeze out profits to the limit. This in most cases is a reversal of its original purpose.

The chase after money and power influences the form of life, even the individual's basic feelings. He thinks of outward security, instead of

his inner satisfactions. On top of this is the penning up of city people in treeless barracks, in an extreme contraction of living space. This cramping of living space is not only physical: city life has brought, with its herding into barren buildings without adequate open space, an emotional choking of the inhabitants.

Today neither education nor production springs from inner urges, nor from urges to make goods which satisfy one's self and society in a mutually complementary way.

The educational system is the result of the economic structure. During the frenzied march of the industrial revolution, industrialists set up specialized schools in order to turn out needed specialists quickly. These schools in very few instances favored the development of men's power. They offered them no opportunity to penetrate to the essence of things, or to the individual himself. But—to tell the truth—no one was concerned with this because no one could foresee the destructive results.

Not only the working class finds itself in this position today; all those caught within the mechanism of the present economic system are, basically, as badly off. At best the differences are material ones.

But How about Technical Progress?

It might be easily supposed therefore that the present system of industrial production, and especially our technical progress, ought to be condemned. Numerous writers and politicians suggest this. But they mix effect with cause. In the XIXth century attempts were made to reach a correct diagnosis, but suggested a wrong therapy. Gottfried Semper declared in the 1850's, for example, that if iron ever was to be used in building it would have to be used (because of the real nature of iron) in the fashion of the transparent spider-web. But, he continued, architecture must be "monumental," and thus "we never shall have an iron-architecture." A similar mistake was made by the Ruskin-Morris circle in the 1880's. They found that industrial mass production killed quality of craftsmanship. Their remedy was to kill the machine in turn, and go back to handwork. They opposed machines so strongly that, in order to deliver their hand-made products to London, they ran a horse coach alongside the hated railway. In spite of this rebellion against the machine, technical progress is a factor of life which develops organically. It stands in reciprocal relation to the increase in number of human beings. Here is its real justification. Despite its distortion by profit interests, by struggle for mere accumulation and the like, we can no longer think of life without technical progress. It is an indispensable factor in raising the standard of living.

The possibilities of the machine—its abundant production, its ingenious complexity on the one hand, its simplification on the other, have

necessarily led to a mass production which has its own significance. The task of the machine—satisfaction of mass requirements—must be held in the future more and more clearly in mind. The true source of conflict between life and technical progress lies at this point. Not only the present economic system, but also the process of production call for improvement from the ground up. Invention and systematization, planning and social responsibility must be applied to this end.

A common error today is to view questions of efficiency from a technical and profit standpoint. The Taylor system, the conveyor belt, and the like remain misinterpreted as long as they turn man into a machine, without taking into account his biological requirements—work, recreation, and leisure.

Not Against Technical Progress, But with it

The solution lies, accordingly, not in working against technical advances, but in exploiting them for the benefit of all. Man can be freed through techniques, if he finally realizes their function: i.e., a balanced life through full use of our liberated energies.

Only when it is clear to the individual that he has to function as a productive entity in the community of mankind will he come closer to a true understanding of the significance of technical progress. We should not be blinded by the intricacies of the amazing technical process of production, but should engage our main interest on the sound planning of our lives.

Today we are faced with nothing less than the reconquest of the biological bases of human life. When we recover these, we can then reach a maximum utilization of technical progress in the fields of physical culture, nutrition, housing, and industry—a thorough rearrangement of our present scheme of life. Even today it is believed that less importance needs to be attached to biological requirements than formerly, thanks to our technically exact and calculable ways of dealing with them. It is thought that securing sleep by veronal, relieving pain by aspirin, and so on, can keep pace with organic wear and tear. In this direction the "progress" of civilization has brought with it dangers. Apparent economies may easily deceive. For technical progress should never be the goal, but instead the means.

Biological Needs

In this book the word *biological* stands generally for the laws of life which guarantee an organic development. If the meaning of *biological* were conscious, it would protect many people from damaging influences.

Children usually act in accordance with biological laws. They refuse food when ill, they fall asleep when tired, and they don't show courtesy when uninterested. If today's civilization would allow one more time in order to follow biological rhythms, lives would be less hysterical and less empty.

The basic biological needs are very simple. They may change or be deformed by social and technical processes. Great care must be taken that their real significance should not be distorted. This often happens through a misunderstood luxury which thwarts the satisfaction of biological needs. The oncoming generation has to create a culture which does not weaken, but which strengthens genuine biological functions.

Efforts toward Reform

The creative human being knows (and suffers from it) that the inherent values of life are being destroyed under the pressure of moneymaking, competition, and trade. He suffers from the materialistic evaluation of his vitality, from the flattening out of his instincts, from the impairing of his biological balance.

And yet, though the present social structure is a thoroughly unsuitable medium for the balanced outlet of human capacities, in the private life of individuals some glimpses of a functional understanding have already appeared.

The advances in art, literature, the theater and the moving-picture in our time, and various educational movements give important indications of this fact. So does the interest in physical culture, in recreation and leisure, and in treatment by "natural" rather than chemical methods.

Such efforts, taken as a whole, portend a new world. But no small unit of this growth should be studied as an isolated fact. The relations of various subjects (science, art, economics, technical knowledge, educational methods) and their integration must be constantly clarified within the social whole.

Not the Product, But Man, is the End in View

Proceeding from such a basic readjustment we may work out an individual plan of life, with self-analysis as its background. Not the occupation, not the goods to be manufactured, ought to be put in the foreground, but rather recognition of man's organic function. With this functional preparation, he can then pass on to action, to a life evolved from within. We then lay down the basis for an organic system of production whose focal point is man, not profit.

Everyone is Talented

If he is deeply interested in his work, every healthy man has a deep capacity for developing the creative energies in his nature.

Everyone is equipped by nature to receive and to assimilate sensory experiences. Everyone is sensitive to tones and colors, everyone has a sure "touch" and space reactions, and so on. This means that everyone by nature is able to participate in all the pleasures of sensory experience, that any healthy man can become a musician, painter, sculptor, or architect, just as when he speaks, he is "a speaker." That is, he can give form to his reactions in any material (which is not, however, synonymous with "art," which is the highest level of expression of a period). The truth of this statement is evidenced by actual life: in a perilous situation or in moments of inspiration the conventions and inhibitions of daily routine are broken, and the individual often reaches an unexpected plane of achievement.

The work of children and of primitive peoples offers other evidence. Their spontaneous expressions spring from an inner sense of what is right, as yet unshaken by outside pressure. These are examples of life governed by inner necessities. If we consider that anyone can achieve expression in any field, even if it is not his best outlet, or essential to society, we may infer with still greater certainty that it must be possible for everyone to comprehend works already created in any field.*

Such receptivity develops by stages, according to disposition, education, mental and emotional understanding. If the broad line of organically functioning life is once established, the direction of all human production is clearly indicated. Then no work—as is often the case today with industrial production and its endless subdivisions—could be felt as the despairing gesture of a man being submerged. All would emerge as an expression of organic forces.

Conclusions

In conclusion we may say that the injuries caused by a technical civilization can be combatted on two fronts:

1. By a purposeful observation and a rational safeguarding of organic, biologically conditioned functions—through art, science, technology, education, politics.

*Further evidence will be furnished by reference to the basic writings of Heinrich Jacoby, who has made this problem his life-work. He concentrated particularly on the problem of musical and non-musical persons. His writings are among the valuable sources upon which educational work can draw.

2. By relating the single results to all human activities.

In practice these two approaches interlock, though logically step 1 must prepare for step 2.

The Responsibility for Carrying Out the Plan Lies with Each Individual

There is no more urgent problem than that of realizing our desire to use fully man's constructive abilities. For the last 180 years or so, we have been thinking about the problem, talking about it, and attempting to act on it. Even today our practice is at best a statement of belief, and not a realization. Partial solutions cannot be recommended; we are now too involved in the problems of industrial society. Partial rebellion is only evidence of monstrous pressure, a symptom. Only the person who understands himself, and cooperates with others in a far-reaching program of common action, can make his efforts count. Material motives may well provide the occasion for an uprising or revolution, but they can never be the deciding cause if constructive changes are to be hoped for.

The revolutionist should always remain conscious that the class struggle is, in the last analysis, not about capital, nor the means of production, but actually about the right of the individual to have a satisfying occupation, a life-work that meets inner needs, a balanced way of life, and a real release of human energies.

Utopia?

Utopia? No, but a task for pioneers. We need Utopians of genius, a new Jules Verne, not to sketch the broad outlines of an easily imaginable technical Utopia, but to prophesy the existence of the man of the future, who, in the realm of the instinctive and simple, as well as in the complicated relations of life, will work in harmony with the basic laws of his being. Leonardo da Vinci, with his gigantic plans and achievements, is the great example of the integration of art, science and technology. It seems that our time will be able to create similar basic conditions, a similar atmosphere, and to produce a similar personality. Our time is one of transition, one of striving toward a synthesis of all knowledge. A person with imagination can function now as an integrator. Of course he has to push aside the desire for the complexity which only a mature epoch can offer. He must be a pioneer in the vast and unbroken territories of our period, where every action could lead to creative solutions. If one doubts that an individual can ever achieve so much, it may be that it will not be individuals alone, but working communities

who do. Scientists have already built an international system of research. The next step must be the solidarity of all cultural workers and their conscious collaboration—the major obligation of those who have already arrived at consciousness of an organic way of life. Pioneer work with this aim in view: man's functional capacities must be safeguarded, but not only safeguarded; the outward conditions for their realization must be put at his disposal. At this point the educational problem merges into the political, and is perceptible as such, so far as the student goes into everyday life, and must make an adjustment to the existing order.

The Bauhaus

The Bauhaus, an art university, founded by Walter Gropius in 1919 in Germany, attempted to meet the needs of group work. Although for reasons of convenience a division into semesters was retained, the old concept and content of "school" was discarded, and a community of workers established. The powers latent in each individual were welded into a free collective body. The pattern of a community of students was worked out by students who learned "not for school, but for life."

Such a community implies practice in actual living. Its individuals learn to master not only themselves, but also the living and working conditions of the environment. Their work, although starting out with the arts, must be a synthesis. This is what is meant when Gropius speaks about the "fatal legacy from a generation which arbitrarily elevated some branches of art above the rest as 'fine art' and in so doing robbed all arts of their basic identity and common life. But art is not one of those things that may be imparted..."

The educational program of the Bauhaus, or more exactly, its working program, rests upon this.

The first year in the Bauhaus is of decisive importance, especially for those young people who, as a consequence of customary education, have brought with them a sterile hoard of textbook information.

The first year their training is directed toward sensory experiences, toward the enrichment of emotional values, and toward the development of thought. The emphasis is laid, not so much on the differences between the individuals, as on the integration of their common biological features, and on objective scientific and technological facts. This allows a free, unprejudiced approach to every task. After this first year begins the period of specialized training, based on free vocational selection within the workshops. During this period the goal remains: man as a whole. Man—when faced with all the material and spiritual problems of life—can, if he works from his biological center, take his position with instinctive sureness. Then he is in no danger of intimidation by industry,

the haste of an often misunderstood "machine culture," or by past philosophies about his creative ways.

Objectives and Methods of Bauhaus Education

The twentieth century overwhelmed man with its inventions, new materials, new ways of construction, and new science. The boundaries of given callings were burst. New problems required more exact knowledge, greater control of far-reaching relations and more flexibility than the rigid schemes of tradition permitted.

The multiplication of mechanical appliances, and new methods of research, required a new intellectual orientation, a fusion of clarity, conciseness, and precision.

It is historically interesting that everywhere in the world outstanding new industrial products emerged, but mainly unintentionally, that is, in fields where not tradition, but function determined form; in engineering construction, for instance, in acoustic, optical, chemical and medical instruments, and in machinery, railway and electrical equipment. But basically it was not industry, nor technical experts, but the artist pioneers who dared to proclaim the conception of "functional rightness." "Form follows function," Sullivan and Adler said. This created an atmosphere, stimulating a new understanding of form on the basis of changed technical, economic, and social conditions.

In Germany various groups concerned themselves with the problem of the creative; such as the Darmstadt artists' colony at Matildenhöhe; the "youth style"; the industrial art school movement (Peter Behrens, Josef Olbrich, Van de Velde); and, above all, the *Werkbund*.

Buildings were constructed to house these movements, exhibitions arranged, periodicals and yearbooks published. All had in view the establishing of an organic tie between creative forces and industry. In America, Richardson, Sullivan, and Wright struggled toward a solution. They recognized the creative spirit in the use of the machine brought about by bold and genuine inventors. In spite of that, industry kept on pouring out products, ignorant of its own creative potentialities, and for the most part following traditional prototypes developed by the handicrafts.

Out of the welter of rejection and approval, of demand and intuition, a principle slowly crystallized: *Not the single piece of work, nor the highest individual attainment must be emphasized, but instead the creation of the commonly usable type, development toward "standards."*

To attain this goal, scattered individual efforts proved insufficient. There had to be a general concept; instead of solutions in detail, there had to be a serious quest for the essential, for the basic and common

procedure of all creative work. In other words, all design had to be approached with the same questions concerning its function, material, production processes, social significance, etc. The recognition of this led to a significant mental attitude. Gropius declared that the designer has to think and act in the terms of his time. He wished to abolish the supremacy of intellectual work over handwork. He pointed out the great educational value of craftsmanship. "The machine cannot be used as a short cut to escape the necessity for organic experience" (Lewis Mumford).

In the Bauhaus, on the technically simple level of handwork, students could watch a product grow from beginning to end. Their attention was directed to an organic entity, and they were responsible for its entire production, as well as for its function. In the present factory process, the worker is directed only to parts of the whole, the ultimate relationships being known to him merely by description and illustration, not through experience.

Thus the manual training in the Bauhaus was not an aim in itself, but a means of education, and in part a necessary tool for the industrial model. This was the reason why the handicrafts were supplemented in the Bauhaus with the basic machines of various industries, enabling mass production.

The Bauhaus became the focal point of new creative forces accepting the challenge of technical progress with its recognition of social responsibility. It became the experimental shop, the laboratory of the new movement.

Gropius reintegrated artists into the daily work of the nation. The results were surprising. By uniting artistic, scientific and workshop training—with tools and basic machines—by keeping in constant touch with advanced art and techniques, with the invention of new materials, and new methods of construction, the teachers and students of the Bauhaus were able to turn out designs which had decisive influence on industrial mass production, and in the reshaping of daily life. The invention of tubular furniture, modern lighting fixtures, practical household appliances, new types of hardware, electrical contrivances, textiles, new typography, modern photography, and so on, were the functional results of this work.

"Art Out into Technology" 1932

VLADIMIR TATLIN

Late in his career, long after his model for a "Monument to the Third International" (1920), Vladimir Tatlin summarizes the aesthetic of Constructivism, not simply as art construction but as a broad program where the artist's work complements that of the engineer. By 1932, however, even as a major retrospective of Tatlin was being shown in Moscow, much of the initial energy of Constructivism had been dissipated, along with government support of Constructivist work. This essay was apparently part of an abortive attempt by Tatlin to win government sponsorship of his new invention called Letatlin, a single-seater flying machine powered like a bicycle, by pedaling, without an industrial motor. We find the master of "real materials in real space" enagaged in the twilight of the Soviet avant-garde in a quixotic enterprise, a project that is ironic, whimsical, and nostalgically utopian.

* * *

During the epoch of reconstruction
technology determines everything.
—Stalin

The existing forms used in the art of building (architecture), in technology, and above all in aviation have assumed something of a locked and schematic character. There is normally a tension between simple rectilinear forms and forms determined by the simplest curves.

In architecture, the use of curves and forms, determined by complicated curvatures created by a complicated movement by a straight line or curve, is still of a fairly primitive character; the whole thing is limited to a common section of the simplest forms. This leads to monot-

ony in the constructive and technical solution; it shuts in the artist, as it were, in a narrow circle of accepted building materials. This is clearly reflected in projects for world-wide competitions in modern architecture. In the case of the "small forms," a little group of formal results from the past—nonobjective elements—have completely dominated artistic creation, even though they were the results of primitive forms of artistic thinking: they have not developed in any more complicated manner into synthetic, vital things.

A comment. The "Constructivists," in inverted commas, also operated with material, but secondarily, for the sake of their formal tasks, in that they mechanically attached also technology to their art. "Constructivism," in inverted commas, did not reckon in its work with the organic connection between material and concentration. In reality, it is only as a result of these dynamic relationships that a form necessary to life emerges. It is not very remarkable that the "Constructivists," in inverted commas, threw themselves upon decoration and graphic art.

Work in the field of furniture and other articles of use is only just beginning: the emergence of new cultural institutions, vital in our daily lives, institutions in which the working masses are to live, think and develop their aptitudes, demands from the artist not only a feeling for the superficially decorative but above all for things which fit the new existence and its dialectic.

The conditions of aviation (the mobility of the machines and their relationships to their environment) create gradually a greater variation of forms and construction than static technology. All this excited my attention, and caused me to make the closer acquaintance of flight.

After studies, I drew the conclusion that in the qualitative sense there really exist certain other variations of curved forms and tension in the material in this field than there do in the forms of architecture.

I believe, however, that the use of curved surfaces, and experimental work on this, are also inadequately developed.

Therefore:
1. The lack of variation in the forms (which is not in reality necessitated by technical requirements) leads to a limitation in the use of materials, to a monotonous use of materials, and creates to some extent a ready-made attitude to the cultural and material shaping of objects; this in its turn leads to monotonous solutions to the constructive tasks set.
2. An artist with experience of a variety of different materials (who, without being an engineer, has investigated the question which interests him) will inevitably see it as his duty to solve the technical problem with the help of new relationships in the material, which can offer new opportunities of concentration; he will try to discover a new, complicated form, which in its further development will naturally have to be technically refined in more detail. The artist will in his work, as a counterpart to technology, present

a succession of new relationships between the forms of the material. A series of forms determined by complicated curvatures will demand other plastic, material and constructive relationships—the artist can and must master these elements, in that his creative method is qualitatively different from that of the engineer.

The further consequences are these:

1. I have selected the flying machine as an object for artistic composition, since it is the most complicated dynamic form that can become an everyday object for the Soviet masses, as an ordinary item of use.
2. I have proceeded from material constructions of simple forms to more complicated: clothes, articles of utility in the environment—as far as an architectural work to the honour of the Comintern. The flying machine is the most complicated form in my present phase of work. It corresponds to the need of the moment for human mastery of space.
3. As a consequence of this work, I have drawn the conclusion that the artist's approach to technology can and will lend new life to their stagnating methods, which are often in contradiction with the functions of the epoch of reconstruction.
4. My apparatus is built on the principle of utilizing living, organic forms. The observation of these forms led me to the conclusion that the most aesthetic forms are the most economic. Art is: work with the shaping of the material, in this respect.
5. Work has been completed in accordance with my project. I have consulated Comrades M. A. Geyntse, surgeon, and A. V. Lsev, pilot instructor.

The apparatus has been built in the experimental scientific laboratory for "the culture of material" with the assistance of A. S. Sotnikov and J. V. Pavilionov.

"Dada—Constructivism" 1984

DAWN ADES

Dawn Ades views Dada and Constructivist artists as working at the opposite ends of the spectrum, between order/construction and disorder/destruction. She develops a broad model for discussing the range of opinions among modern artists in the 1920s.

Dadaism came to stand for nihilistic whimsy in art, like a pathology of resistance. Theo van Doesburg, hardly a Dadaist, writes admiringly when he calls it "the denial of the conventionalism of daily life," an art process seeking to get rid of the "atavistic and fetishistic" sentiments of people. By contrast, novelist André Gide found the movement childish, even a bit simple-minded, and a hazard to literary subtlety. The same range of opinion is true of Constructivism when it was broadened into general use. In criticism of the 1920s, Constructivism became a banner for the architectonic in modern art, for the art construction instead of the easel painting. But the nuances were often lost within the generic.

In some German magazines, the two terms were pitted against each other, Dadaism as the descent into chaos and Constructivism as a foreign product from the new Bolshevik state. And yet the Berlin Dadaists claimed a kinship with the Soviet avant-garde, even while some mainstream German art magazines declared a pox on both houses and tried to steer a middle course away from extremes. The broad uses of a term do reveal much about the dissemination, even the misunderstanding, of an art movement and also about the anxieties of a specific moment. In the 1920s after World War I, Europeans were overwhelmed by the sense of loss, by the need either for a phoenix arising, or for a wake. These two art strategies expressed the problems internally, as states of mind as well as art objects with the Constructivists as the Bolshevik threat and promise and the Dadaists as the childlike dance of death.

* * *

This is a preliminary and tentative investigation of a subject that needs closer attention than it has so far received: the relations between Dada and Constructivism. It is not difficult to see why this topic has engaged neither the attention of historians of Dada nor of Constructivism, except in special cases where there is an obvious overlap—that of Theo van Doesburg and his rogue review *Mecano,* for instance, or of Kurt Schwitters. Dada and Constructivism have at best been seen as the opposing poles of the international avant-garde in the period immediately following the First World War. This view has been reinforced by the insistence on the Dada-Surrealism inheritance, with Surrealism's well-known antipathy to most forms of abstraction, an antipathy which has, with a certain justice, been mapped back onto Dada. But Dada has not always been granted the status of an "opposing pole" to Constructivism, and has quite frequently been presented, often by Constructivists, as performing something of the role of an enema, a destructive but cleansing convulsion preceding the great task of reconstruction. In 1922 El Lissitsky and Ehrenburg wrote in an editorial in the first issue of their review *Veshch / Gegenstand / Objet:* "The negative tactics of the "dadaists", who are as like the first futurists of the pre-war period as two peas in a pod, appear anachronistic to us. Now is the time to build on ground that has been cleared."[1] Naum Gabo even denied Dada a separate identity, presenting it rather as the death throes of the Cubist revolution:

> There were moments in the history of Cubism when the artists were pushed to these bursting points; sufficient to recall the sermons of Picabia 1914–16 (sic), predicting the wreck of Art, and the manifestos of the Dadaists who already celebrated the funeral of Art with chorus and demonstrations. Realizing how near to complete annihilation the Cubist experiments had brought Art, many Cubists themselves have tried to find a way out...Our generation did not follow them since it has found a new concept of the world represented by the Constructive idea.[2]

More recently critics have recognised the positive and radical nature of the Dada challenge:

> During the First World War the dadaists had initiated an international movement that subverted the traditional categories and supposed "laws" of art. With the conclusion of the War, it seemed imperative to many artists that the dada critique be accepted and the laws of art reformulated from firm and objective bases.[3]

It is possible to take this point further, and see the Dada critique not only as a crucial precedent to the objectives of International Con-

structivism but to see Dada as a continuing and active force in its own right during the early 1920s.

Richard Sheppard ends his thorough chronology of the Dada movement with two events, both of which took place towards the end of 1924: the publication of the first *Surrealist Manifesto* by André Breton, and the closure of the Bauhaus in Weimar (it was to move to Dessau in October 1925.)[4] Both of these events then, standing apparently at opposite ends of the artistic spectrum, were of significance in relation to the cessation of Dada activity. By then, most Dada artists had already or were soon to enter into other allegiances. Dada's permanent state of ironic revolt was impossible to sustain, and yet most Dadaists remained nostalgically loyal to it. Arp wrote in 1927:

> dada is the basis of all art. dada is for the senseless which doesn't mean nonsense…i exhibited along with the surrealists because their rebellious attitude toward "art" and their direct attitude toward life were as wise as dada…[5]

In spite of the fact that Arp exhibited at the first surrealist exhibition in 1925, his continued relations with constructivists confirm the strength of the links constructivism once had with Dada. In 1924 he collaborated with El Lissitsky to write the first 'dictionary' of Modernism, *The Isms of Art*, and towards the end of the decade worked with van Doesburg and Sophie Täuber on the Aubette cafe in Strasbourg. None of them compromised their style and the now destroyed cafe, its severe geometrical designs side by side with Arp's free organic forms, stood as a memorial to the creative oppositions and collaborations between the two movements. While Arp joined the Surrealists (although this barely affected his work) Richter, a fellow Zurich Dadaist, took the opposite path of Constructivism. He still saw Dada as an essential element though, in the constitution of the review he founded in 1923, *G*.

> G as it finally appeared had the traits of Dadaism as well as of Constructivism, two seemingly unrelated movements. It offered articles by Mies van der Rohe as well as Tristan Tzara, by Gabo, Pevsner, Malevich, Lissitsky, Doesburg as well as by Arp, Schwitters, Hausmann, George Grosz, Man Ray. The fact is that the tendencies of Constructivism, or more generally speaking of structure, appeared in Dada itself; though they were not, as in Russian Constructivism, a program or the single aim of Dada. Dada as a movement had no program. But the tendencies for an order, a structure, appeared nonetheless as a counterpart to the law of chance which Dada had discovered. In this way the Constructivist involvement in Dada and vice versa may be understood. That is how Doesburg from *de Stijl* was at the same time a Dadaist. Eggeling made his *Generalbass* in Dada times, Richter's black and white counterpoint and even Duchamp's

discs and "roto-reliefs" (all with structural tendencies) were connected with and appeared in Dada. The aims of the new and unrestricted (Dada) and the aims of the enduring (Constructivism) go together, and condition each other. To embrace and integrate these two tendencies was the purpose of the magazine *G*.[6]

This positive statement concerning the mutual involvement of Dada and Constructivism is confirmed in the avant-garde reviews which proliferated at this period. Not only in the relatively late *G*, but in *Ma*, for instance, the review founded and largely edited by Kassak, first in Budapest and then in Vienna, which ran from 1919–1925, or the Belgrade review *Zenit* (1921–26) Dadaists and Constructivists appear side by side.[7] Although their contributions mostly remained distinct, there were particular planes where their interests and experiments coincided and collided—machine aesthetics, the practice of collage and photomontage, object-construction. Moholy-Nagy, who had become by 1923, when he began teaching at the Bauhaus, one of the most influential of the International Constructivists, was represented in the September 1921 issue of *Ma*, and some of the works, montages for example, show strong Dada affinities. Arp is frequently present (an 'arpaden' is on the cover of the March 1922 issue) as are Hausmann and Schwitters. The presence of the Paris Dadaists is rarer, though Picabia does appear. One of the most ubiquitous presences in these reviews is the Black Square of Malevich. In *Zenit,* in *Ma,* in Lissitsky's *Veshch / Gegenstand / Objet,* in the issue of Schwitters' *Merz* "Nasci", coedited by El Lissitsky, the Black Square has a prominent place. Obviously as the initial Suprematist form it has a close relationship with Constructivism, but at the same time it is probably not fortuitous that it is in those reviews which relate to Dada that the *Black Square* most commonly appears. It is as though it could stand as an icon of both destruction and construction, representing a primary urge to recreate form from scratch, a kind of Ur-form. In some respects it could be compared to the phonetic poetry of Hausmann, in which language is reduced orally to pure sound and visually to the letters of the alphabet. Both van Doesburg and his "Letter Sound Poems" and Schwitters, whose "Ursonate" was based on Hausmann's *FMSBW*, were closely indebted to him.

Before examining the "structural tendencies" Richter found in Dada on the one hand, and further points of intersection between Dada and Constructivism on the other, it would be useful to attempt to define, a little belatedly, what is being understood here by *Constructivism.* Unlike *Dada,* the terms *constructive* and *construction* became part of the aesthetic terminology of postwar progressive (or would-be progressive) artists before being adopted as the name for a movement. This is one of the causes of the confusion surrounding the term, and of the various and

even conflicting theories and practices of artists associated with Constructivism. Osip Brik had to deal with the abuse of the term attendant on widespread use:

> there are artists who have rapidly adopted the fashionable jargon of constructivism. Instead of "composition" they say "construction"; instead of "to write" they say "to shape"; instead of "to create"—"to construct". But they are all doing the same old thing: little pictures, landscapes, portraits.[8]

Such traditional art had nothing to do with 'constructivism' as it was properly understood. The term stood for an artistic practice which eschewed both the reproduction of the external world and the individualist tendencies of expressionist abstraction. (Theo van Doesburg used *Constructivist* in direct opposition to *Impulsivist*.) The emphasis was on the study of form and material for its own sake in both two and three dimensions, on the use of pure geometric form in mass (cubes, etc.) and in line. The first group to define themselves officially under this name in Russia, and to have a specific programme was the First Working Group of Constructivists, formed in March 1921, including Alexei Gan and Rodchenko.[9]

However, this group, although retaining the term *constructive* from their earlier purely formal and laboratory experiments, now rejected art altogether. They redefined the artist as a worker engaged in 'material—intellectual production' whose special skills would be put to use in the task of social reconstruction following the Revolution. Besides posters and books, etc., for propaganda and didactic purpose, they were to shape utilitarian objects—stands, furniture, fabrics etc. It is important to distinguish between this Russian Constructivism and the International Constructivism of the West, which remained primarily an aesthetic movement, and maintained even at its most extreme an ambiguous relationship between the useful and the artistic. As Lissitsky wrote in the editorial in *Veshch:*

> No-one should imagine...that by objects we mean expressly functional objects. Obviously we consider that functional objects turned out in factories—airplanes and motorcars—are also the product of genuine art. Yet we have no wish to confine artistic creation to these functional objects. Every organised work—whether it be a house, a poem or a picture—is an "object" directed toward a particular end.

This is obviously very different from the position of Rodchenko and other artists associated with the Productivist wing of Constructivism.

It was with the International Constructivists that Dada was largely concerned, and the list of names given earlier by Richter more or less covers those involved.

Richter's point about the Constructive within Dada needs to be examined a little more closely. He said that a tendency to structure arose as a counterpart to the law of chance discovered by Dada. However, the relationship between structure and chance during the early manifestations of Dada, in Zurich between 1916 and 1918 especially, was more complex than that, and operated as dynamic paradox. In one of Dada's key texts, Tzara's *Dada Manifesto 1918,* published in *Dada* (December 1918) there are passages embedded within the apparently nihilistic philosophy of Tzara, which refer directly to the impersonal abstractions of Zurich Dada artists in terms which are prophetic of Constructivism but which spring from the Dada belief in a creative energy engineered by opposites:

> the new painter creates a world, whose elements are also its means, a sober and defined work, without argument. The new artist protests: he no longer paints/symbolic and illusionistic representation/but creates directly in stone wood iron...Order = disorder, ego = on-ego, affirmation = negation: supreme radiations of an absolute art. Absolute in the purity of ordered and cosmic chaos.[10]

Parallels can be drawn here between the Dada artist "creating directly in stone wood iron" and the earliest manifestations of Constructivism in Russia, in the post-Cubist nonutilitarian constructions of Tatlin, especially, constructed in wood and metal. It would be interesting to compare these with Janco's lost constructions of c. 1917, which similarly are working directly in given materials, explored for their own sake. In *Construction 3* the freely curling, spiraling and tangling wire creates a drawing in space.

But there are also in Tzara's text puzzling and seemingly nonsensical phrases like "ordered and cosmic chaos." This phrase can, however, be understood if it is set in the context of Arp's exploration of chance, which, far from being a random opposite to "structure," became a "law" on which a natural, as opposed to a mechanical or man-made order could be based. Arp introduced the concept of the 'law of chance' in relation to his geometrical collages of 1916–17

> since the disposition of planes, and the properties and colours of these planes seemed to depend purely on chance, I declared that these works, like nature, were ordered according to the "law of chance", chance being for me merely a limited part of an unfathomable *raison d'etre,* of an order inaccessible in its totality.[11]

If man tries to impose order, according to his own necessarily partial measure, as, Arp says, he has done with disastrous effect since the Renaissance, he will cut himself off from understanding the laws of

nature ("ordered and cosmic chaos") of which he is only a part rather than ruler. Chance is one of the means by which he can regain a sense of the "unfathomable" laws of nature, and by which he can recover an equilibrium. After the impersonality of the geometrical collages, Arp actually introduced chance procedures into his work, though very differently from Duchamp, who used it among other things to test the laws of causality. In c. 1917–18, Arp discovered a nature-based organic abstraction in his woodcuts and drawings, which have the appearance of a spontaneity free of individual gesture, a dynamic equilibrium based on the balance of figure/ground, black/white.

Arp and Sophie Täuber were working in isolation from the developments in Russia and especially in Holland, where the emphasis on a vertical and horizontal geometry of line and plane in the Neo-Plasticism of the de Stijl artists, Van Doesburg, Mondrian and van der Leck, has at first sight close similarities to Arp and Sophie Täuber's collages and embroideries. However, Arp's collages have attained an all-over surface in which no distinction between colour plane and line exists, whereas in Mondrian's paintings surface tensions continue between these elements and the ground, while van der Leck's pure colour rectangles were quickly readapted to represent once again specific objects, like bottles or people. Arp perceived a quite different intention between his own works and theirs which "though treated in an abstract manner…retain a base of naturalism…"[12] More fundamentally, he saw the work of the de Stijl artists and the Constructivists in Russia as "in fact a homage to modern life, a profession of faith in the machine and technology."

Dada did not share the Constructivists's faith in progress and the advance of machine technology. But they did not turn their backs on the machine—it was part of the world and could not be ignored. It could, however, be treated with humour and thereby integrated into life. Duchamp in his *Large Glass,* Picabia in his machine paintings, created a machine aesthetic as an ironic counterpart to Futurism, in which the machine was forced to take its place within the erotic and the irrational. Duchamp went on to pursue his interest in optics with the Rotary Glass Plates of 1920 and the Rotary Demisphere of 1925, achieving as Richter put it "a synthesis between scientific and artistic endeavour."[13]

It is in the context of the playful, ironic and aesthetic use of the machine, initiated by Dada, that one of the oddest and most direct collaborations between Dada and Constructivism can be seen: the review *Mecano,* edited by the Dada persona of the de Stijl editor van Doesburg, 'I. K. Bonset.' Five issues were published between 1922–23 (the last was a double issue largely devoted to describing the Dada performances in Holland put on by Schwitters and van Doesburg early in 1923.) This review was announced in *de Stijl* as "an international periodical for spiritual hygiene, machine aesthetics and neo-Dada."[14] The works re-

produced clearly reveal the bias of the review, for they concentrate on the abstract-machine aspects of Dada to the exclusion of, for example, Arp, or the political montages of Grosz or Heartfield. Of Ernst it reproduces a *Photo-Mechanical Composition,* of Man Ray the glass painting with machine elements, *Danger/Dancer.* Beside these are reproduced constructivist works: Moholy-Nagy's *Nickel-Plastik* is reproduced in irreverent juxtaposition to Charchoune's drawing *Cigarette Dada*—partly, certainly, in a spirit of playful parody, but also, as another juxtaposition, that of Hausmann's *Mechanical Head* and a relief of Moholy-Nagy's using ready-made machine elements suggests, to argue that "their apparently opposed ideas were not irreconcilable."[15] Certainly from this publication the Dada works stand up to the formal claims made by the constructivist ones, and also have something to teach Constructivism in terms of the potential flexibility of human-machine relations.

Van Doesburg, with a foot in both camps, played a leading role at the Dusseldorf Congress of Progressive Artists (May 1922), where Constructivists and Dadaists came together for the first time. Here "Hausmann (dadaist) read a protest...declaring that he was neither for the progressives nor for the artists, and that he was no more international than he was a cannibal" (De Stijl no. 4, 1922), while van Doesburg, Lissitzky and Richter led a breakaway group (the International Faction of Constructivists), nucleus of a further Congress of Constructivists and Dada at Weimar in September 1922, with Tzara, Arp and Schwitters in attendance. Van Doesburg's motives were complex, and partly inspired by antagonism for certain elements in the Bauhaus. The anonymous "Chroniek" of the Congress (Mecano Red) commented maliciously on Tzara's visit to "The Hotel of sick artists, the 'Bauhaus'."[16]

Berlin Dada is something of an exception to the general argument concerning the relations of Dada with International Constructivism, for it deliberately took up a position of sympathy with Russian Constructivism.

At the First International Dada Fair of 1920 Grosz and Heartfield exhibited a large placard bearing the slogan "ART IS DEAD. Long live the new machine art of Tatlin."

Hausmann's photomontage *Tatlin at Home* depicts Tatlin (it was not in fact Tatlin, but an anonymous man cut from an illustrated paper) with a machine mounted in place of a brain. Heartfield described himself as a "monteur," engineer, rather than artist, and a number of his and Grosz's photomontages at the time are stamped (rather than signed) "mont." (montiert) or "construiert." How much, however, of the developments in Russian Constructivism were actually known about in any detail is very hard to determine.[17]

Grosz's and Heartfield's use of the term *construct* was clearly a means of distancing themselves from the conventions of art. Grosz's text

of 1921[18] proclaiming that art as such was a secondary consideration, and was only of value when put directly at the service of the proletariat is perfectly in line with his Communist commitment, and not necessarily ascribable to any specific influence of Russian Constructivism, though obviously the art of the new Soviet State was an object of absorbing curiosity and sympathy, even though little was known of it until 1922.

But Grosz, looking back in 1925, in *Art is in Danger,* while criticising Dada for failing to attack the system that underlay the absurdity of the capitalist world, nonetheless praised it as "the only essential art movement in Germany for decades," while of Constructivism he said that in spite of its objectivity and clarity, its love of the circle and the line, and its dismissal of the antiquated and metaphysical, it had failed because it remained in the realm of purely artistic activity.

Photomontage is the most important area in which Berlin Dada and the Russian Constructivists meet. Priority in its invention is claimed by both Klucis and Hausmann, and, without entering this question again, it is probably the case that it was discovered independently and at about the same time in Russia and in Berlin. While in the work of Klucis and of Rodchenko photomontage was used mainly for didactic and propaganda purposes, Heartfield and Grosz turned it to political-satirical ends—a difference that obviously arises from the different conditions under which they were working. In the hands of Klucis and Rodchenko, or of Szczuka in Poland, the montage of photographs was still ordered according to the dynamic geometry of Constructivism, with the characteristic diagonal still dominant, legacy of the Suprematism of Malevich and of El Lissitsky. The Berlin Dadaists on the other hand used a more or less anarchic type of juxtaposition in their earliest montages, to get as close as possible to the vitality of modern life. This gave way gradually in the work of Grosz and Heartfield to a more dialectical system of contrast. The essential point, I think, is that both in Berlin and among the Russian Constructivists there was an urgent need to move away from the limitations of abstraction without slipping back into antiquated illustrational or figurative modes. The photograph obviously has a special and privileged place in relation to reality, and is also susceptible of being manipulated to reorganise or disorganise that reality. It is for this reason that in Russia, and in Berlin, where the impetus away from a basically aesthetic movement towards social concerns was most marked, photomontage made its appearance.

One montage from the unpublished anthology *Dadaco* deserves to be mentioned, for its characteristically paradoxical and subversive spirit; it probably contains an element of parody though, as so often with Dada, it is impossible to tell for certain. A headless and footless man is set within the circles and straight lines that would seem to be a by-word for Constructivism, though here they are also probably intended as an

anti-Expressionist device. They are the lines that construct the new world and at the same time bar the way to the "otherwordly," to the individualistic, and metaphysical speculation. However, this model of the impersonal scientific New Man is supported on "dada" feet and spouts nothing from his neck but "dadadadada."

A common aim *was* perceived all the same, at certain points in the trajectories of Dada and Constructivism, and this led to a number of shifting alliances. The Manifesto "The Call for an Elementarist Art" was signed by a group of highly diverse artists: Hausmann, Arp, Puni, and Moholy-Nagy. It is couched in general terms that nonetheless reveal something of Dada's principle of creative opposition:

> Seized by the dynamism of our time, we proclaim the revision in our outlook brought about by the tireless inter-play of the sources of power that mould the spirit and the form of an epoch and that allow art to grow as something pure, liberated from usefulness and beauty...[18]

The statement on the cover of the issue of Schwitters' *Merz* (which ran from 1923–32) entitled "Nasci," and jointly edited by El· Lissitsky and Schwitters, has something of the same dynamism, and also suggests to what extent Schwitters, in spite of his increasing adoption of a Constructivist clarity in his collages and reliefs, did not wholly abandon Dada. "Nature, from the Latin Nasci, signifies to become, to spring, that is to say everything which by its own force develops, forms, moves." "Nasci" opens with a full page reproduction of Malevich's Black Square, and goes on to include reproductions of a Rayograph by Man Ray, a building by Mies van der Rohe, and a series of other juxtapositions such as a painting by Mondrian and a merz relief by Schwitters, as well as natural forms. The issue is intended to extend, perhaps, the definition of Constructivism given by Arp and Lissitsky in the *Isms of Art,* that it proves "that the limits between mathematics and art, between a work of art and a mechanical invention are not to be fixed." The definition continues: It is an irony fitting Dada's ambiguous and paradoxical relationship with Constructivism that this is a direct quotation from Tzara's 1918 *Dada Manifesto.* "(Constructive artists) don't want to give an illusion by the means of colour on canvas, but work directly in iron, wood, glass, etc...."

Notes

1. El Lissitsky and Ilya Ehrenburg, "The Blockade of Russia is coming to an end", *Veshch / Gegenstand / Objet,* Berlin no. 1–2, 1922 Trans. Stephen Bann in *The Tradition of Constructivism* (Thames and Hudson, 1974).
2. Naum Gabo, "The Constructive Idea in Art" *Circle* ed. J.L. Martin, Ben Nicholson, N. Gabo, London 1937.
3. Stephen Bann, *The Tradition of Constructivism* op. cit. p. 51.

4. "Dada: A Chronology," *New studies in Dada. Essays and Documents.* (Hutton Press, 1981).

5. Jean Arp, "dear monsieur brzekowski" (1927) 1st pub. *L'Art Contemporain* n.d. *Collected French Writings,* London, 1974, p. 35.

6. Hans Richter, Introduction "Great Little Magazines no. 3, *G,*" *Form* no. 3, December 15, 1966.

7. It would be interesting to consider *Zenit* in relation to the Zagreb Dada reviews *Dada-Jazz, Dada-Tank, Dada-Jok* (1922, single issues).

8. Osip Brik, "into Production!" *Lef* 1, March 1923, in Bann p. 84.

9. See M. Rowell and A. Rudenstine, *Art of the Avant-Garde in Russia,* Guggenheim Museum, New York, 1981 and C. Lodder, *Russian Constructivism,* Yale University, 1983.

10. Tristan Tzara, "Dada Manifesto 1918" reprinted in Tristan Tzara *Seven Dada Manifestos and Lampisteries* London: John Calder, 1977, p. 6-7.

11. Jean Arp, "Dadaland" *XXe Siècle* 1, Paris, 1938, trans. *On My Way,* Documents of Modern Art, Wittenborn Schülz, N.Y. 1948, p. 40.

12. Ibid.

13. Hans Richter, *Dada: Art and Anti-Art,* London: Thames and Hudson, 1965.

14. *De Stijl,* January 1922. For a detailed account of van Doesburg, de Stijl, and Dada, see Jane Beckett, "Dada, Van Doesburg and De Stijl", *Dada: studies of a movement,* ed. R. Sheppard, Alpha Academic, 1979.

15. Jane Beckett, p. 20.

16. Accounts of the more or less hostile reception of Dada at the Bauhaus vary. See Beckett, op.cit. On September 25 Tzara gave an important lecture on Dada which made no concessions to Constructivism, and omitted the positive comments on the "new artist" contained in his 1918 Manifesto in favour of a stress on Dada's indifference, and on the fact that it was not modern.

17. see Martin Kane, "George Grosz: Constructivism Parodied," in Sheppard, *New Studies in Dada* for an interesting interpretation of Grosz' work in the early 1920s, which, however, suffers from a generalized use of the term *constructivism.* See also *The First Russian Show* (Annely Juda Fine Art 1983), a commemoration of the Berlin 1922 exhibition. For contacts between Dutch Constructivism and Russia during this period, see Ger Harmsen "De Stijl and the Russian Revolution" *De Stijl: 1917–31, Visions of Utopia,* ed. Mildred Friedman, Walker Art Center, Minneapolis, Abbeville Press, New York, 1982.

18. "Zu meinen neuen Bildern," *Das Kunstblatt,* January 1921, quoted in Kane, reprinted in this book.

19. Raoul Hausmann, Hans Arp, Ivan Puni, Laszlo Moholy-Nagy "A call for Elementarist Art" *De Stijl* 4, 10, 1922, in Bann, p. 52.

"From Faktura to Factography" 1984

BENJAMIN H. D. BUCHLOH

Benjamin Buchloh outlines the different stages that Russian artists went through between 1912 and 1931. From 1913 to 1923, many artists shifted from easel painting toward industrial techniques, as identified in the term *Faktura,* meaning the ideological and aesthetic uses of material in art production. What began as the empirical study of painting techniques and procedures developed as well into a reevaluation of how art is used in industrial markets.

Emphasis was also placed on how the process of production related to the reception of art by its audience, particularly the need to communicate the values of the new Soviet state to the Soviet people. In order to reach this mass audience, photomontage was introduced, incorporating photographic fragments into painting and art, a technique which along with new methods of typography, advertising, and propaganda "redefined the representational systems of the new society."

Factography, the second key term examined in this essay, refers to the photograph's ability to represent reality in a more "direct" manner than painting or constructions. By the early 1930s, the single monumental print became the paradigm for the artistic activity of El Lissitzky and Rodchenko, a practice which increasingly converged with conventional methods of propaganda.

The period covered in this essay has presented unique political problems for art historians and critics. After Lenin's death in January 1924, many of the NEP policies (similar to *perestroika*) continued until the first five-year plan began in 1928, the year when Stalin assumed control of party policy. Along with these shifts came a growing disenchantment with Soviet avant-garde art, so extreme by the mid-1930s that it became wrapped into the horror of the Moscow purge trials. Thus, the decline of Soviet modern art becomes linked directly with Stalinism

and Cold War arguments against totalitarianism. By 1938, if not earlier, certain artists had been purged, or severely restricted.

Still, the transitions must be studied in a relatively dispassionate manner to arrive at an understanding of how artists survive moments of reaction in any modern state, and to separate blind assumption from documented relationships between modernist aesthetics and the state. Similar work has been done on American abstract expressionism during the McCarthy era, and for that matter French art during the years of harsh press censorship in the 1850s. One might also review how cuts in federal support for the arts during the 1980s have altered "postmodern" aesthetics. The levels of repression will vary phenomenally from one example to the next, from outright persecution to the simple withdrawal of salary or grant support. One simple lesson can be drawn overall: Modern artists cannot become so comfortable with official policy that they ignore its existence and proceed as if the avant-garde existed in a "state of nature."

* * *

As the first director of the Museum of Modern Art, Alfred Barr largely determined the goals and policy of the institution that was to define the framework of production and reception for the American neo-avant-garde. In 1927, just prior to the founding of the museum, Barr traveled to the Soviet Union. This was to have been a survey journey, like the one he had just completed in Weimar Germany, to explore current avant-garde production by artists working in the new revolutionary society. What he found there, however, was a situation of seemingly unmanageable conflict.

On the one hand, he witnessed the extraordinary productivity of the original modernist avant-garde (extraordinary in terms of the number of its participants, both men *and* women, and in terms of the variety of modes of production: ranging from Malevich's late suprematist work through the Laboratory Period of the constructivists, to the Lef Group and the emerging productivist program, as well as agitprop theater and avant-garde films screened for mass audiences). On the other hand, there was the general awareness among artists and cultural theoreticians that they were participating in a final transformation of the modernist vanguard aesthetic, as they irrevocably changed those conditions of art production and reception inherited from bourgeois society and its institutions. Then, too, there was the growing fear that the process of that successful transformation might be aborted by the emergence of totalitarian repression from within the very system that had generated the foundation for a new socialist collective culture. And last of all, there was Barr's own professional disposition to search for the

most advanced, modernist avant-garde at precisely the moment when that social group was about to dismantle itself and its specialized activities in order to assume a different role in the newly defined process of the social production of culture.

These conflicting elements are clearly reflected in the diary that Barr kept during his visit to the Soviet Union:

> ...went to see Rodchenko and his talented wife....Rodchenko showed us an appalling variety of things—suprematist paintings (preceded by the earliest geometrical things I have seen, 1915, done with compass)—woodcuts, linoleum cuts, posters, book designs, photographs, kino set, etc. etc. He has done no painting since 1922, devoting himself to the photographic arts of which he is a master....We left after 11 p.m.—an excellent evening, but I must find some painters if possible.[1]

But Barr was no more fortunate in his search for painting during his visit with El Lissitzky: "He showed also books and photographs, many of them quite ingenious....I asked whether he painted. He replied that he painted only when he had nothing else to do, and as that was never, never."[2]

And, finally, in his encounter with Sergei Tretyakov, it became clear that there was a historical reason for the frustration of Barr's expectations. For Tretyakov enunciated the position these artists had adopted in the course of transforming their aesthetic thinking in relation to the emerging industrialization of the Soviet Union: the program of productivism and the new method of literary representation/production that accompanied it, *factography*. "Tretyakov," Barr's diary tells us, "seemed to have lost all interest in everything that did not conform to his objective, descriptive, self-styled journalistic ideal of art. He had no interest in painting since it had become abstract. He no longer writes poetry but confines himself to reporting."[3]

This paradigm-change within modernism, which Barr witnessed from the very first hour, did not make a strong enough impression on him to affect his future project. He continued in his plan to lay the foundations of an avant-garde art in the United States according to the model that had been developed in the first two decades of this century in western Europe (primarily in Paris). And it was this perseverance, as much as anything else, that prevented, until the late 1960s, the program of productivism and the methods of factographic production from entering the general consciousness of American and European audiences.

In 1936, when Barr's experiences in the Soviet Union were incorporated in the extraordinary exhibition *Cubism and Abstract Art,* his encounter with productivism was all but undocumented. This is particularly astonishing since Barr seems to have undergone a conversion towards the end of his journey, one which is not recorded in his diary,

but which he publicly expressed upon his return in "The Lef and Soviet Art," his essay for *Transition* published in the fall of 1928. Surprisingly, we read in this article, illustrated with two photographs of Lissitzky's exhibition design for the 1928 *Pressa* exhibition in Cologne, the following, rather perspicacious appraisal of the ideas and goals of the Lef Group:

> The *Lef* is more than a symptom, more than an expression of a fresh culture or of post-revolutionary man; it is a courageous attempt to give to art an important social function in a world where from one point of view it has been prostituted for five centuries. The *Lef* is formed by men who are idealists of Materialism; who have a certain advantage over the Alexandrian cults of the West—the *surréaliste* wizards, the esoteric word jugglers and those nostalgics who practice necromancy over the bones variously of Montezuma, Louis Philippe or St. Thomas Aquinas. The *Lef* is strong in the illusion that man can live by bread alone.[4]

But western European and American interests in the modernist avant-garde refused to confront the implications seen so clearly by Barr. Instead, what happened at that moment, in the process of reception, was what had been described in 1926 by Boris Arvatov, who along with Alexei Gan, Sergei Tretyakov, and Nikolai Tarabukin made up the group of productivist theoreticians. Arvatov wrote about the painters who refused to join the productivists, "Those on the Right gave up their positions without resistance....Either they stopped painting altogether or they emigrated to the Western countries, in order to astonish Europe with home-made Russian Cézannes or with patriotic-folkloristic paintings of little roosters."[5]

It is against this background that I want to pursue the following questions: Why did the Soviet avant-garde, after having evolved a modernist practice to its most radical stages in the postsynthetic Cubist work of the Suprematists, Constructivists, and Laboratory Period artists, apparently abandon the paradigm of modernism upon which its practice had been based? What paradigmatic changes occurred at that time, and which paradigm formation replaced the previous one?

For the sake of detail and specificity I will limit myself in what follows to a discussion of only some aspects of the respective paradigms that generated the crucial concern for *faktura* in the first period, and that made *factography* the primary method in the second period of Russian avant-garde practice.

Faktura was first defined in the Russian context in David Burliuk's futurist manifesto, "A Slap in the Face of Public Taste," of 1912, and in Mikhail Larionov's "Rayonnist Manifesto" of the same year. In the works of Malevich from 1913–1919 *faktura* was a major pictorial concern, as

it was at that time for painters such as Lissitzky, Popova, and Rozanova, who had their origins in synthetic cubism and who had been profoundly influenced by Malevich's suprematism. Further, it remained the central concept in the nonutilitarian objects produced by Rodchenko, Tatlin, and the Stenberg brothers, sometimes referred to as the Laboratory constructivists. During an extremely hectic period of approximately seven years (from 1913–1920) the essential qualities of *faktura* were acquired step by step and developed further by the individual members of that avant-garde.

By 1920 it seemed to them that they had brought to their logical conclusion all the major issues that had been developed during the preceding fifty years of modernist painting. Therefore the central concern for a self-reflexive pictorial and sculptural production was abandoned after 1920—gradually at first, then abruptly—to be replaced by the new concern for factographic and productivist practices that are indicative of a more profound paradigmatic change.

Faktura

Attempts are being made in the recent literature to construct a genealogy for the Russian vanguard's concern for *faktura,* claiming that it originates in Russian icon painting. Vladimir Markov's 1914 text "Icon Painting"—after Burliuk and Larionov the third to address *faktura* explicitly—had established this specifically Russian source, arguing that "through the resonance of the colors, the sound of the materials, the assemblage of textures (*faktura*) we call the people to beauty, to religion, to God....The real world is introduced into the icon's creation only through the assemblage and incrustation of real tangible objects and this seems to produce a combat between two worlds, the inner and the outer...."[6]

But the specifically Russian qualities of *faktura* are nonetheless challenged by other details of this production. For the religio-transcendental function assigned by Markov to the term *faktura* is just too close to the essential pursuit of collage aesthetics as defined in 1914 by, for example, Georges Braque. Braque argued, "That was the great adventure: color and shape operated simultaneously, but they were completely independent of each other." Similarly, Tatlin's request in 1913 that "the eye should be put under the control of touch" is too close to Duchamp's famous statement that he wanted to abolish the supremacy of the retinal principle in art. And, in the contemporaneous discussions of the term, any references to specifically Russian or religious functions are too rapidly jettisoned to maintain the credibility of Markov's argument. Already in 1916 Tarabukin wrote a definition of *faktura* that would

essentially remain valid for the entire period of Laboratory constructivism to follow. "The form of a work of art," he declared, "derives from two fundamental premises: the *material* or medium (colors, sounds, words) and the *construction,* through which the material is organized in a coherent whole, acquiring its artistic logic and its profound meaning."[7]

What qualifies the concern for *faktura* as a paradigmatic feature (differentiating it at the same time from previous concerns for facture in the works of the cubists and futurists in western Europe) is the quasi-scientific, systematic manner in which the constructivists now pursued their investigation of pictorial and sculptural constructs, *as well as* the perceptual interaction with the viewer they generate. The equation between colors, sounds, and words established by Tarabukin was no longer the neoromantic call for *synaesthesia* that one could still hear at this time from Kandinsky and Kupka. Running parallel with the formation of structural linguistics in the Moscow Linguistic Circle and the Opoyaz Group in Petersburg in 1915 and 1916 respectively, the constructivists developed the first systematic phenomenological grammar of painting and sculpture. They attempted to define the separate material and procedural qualities by which such constructs are constituted with the same analytic accuracy used to analyze the *interrelationships* of their various functions—what Saussure would call the syntagmatic axis—which are equally relevant for the constitution of a perceptual phenomenon. Furthermore, they addressed the apparatus of visual sign production, that is, production procedures as well as the tools of these procedures. It was precisely the systematic nature of this investigation that led Barr in 1927 to see "an appalling variety of things" in Rodchenko's work.

When, in 1920–21, Rodchenko arrived more or less simultaneously at his sculptural series *Hanging Construction* (a series subtitled *Surfaces Reflecting Light*) and at the triptych *Pure Colors: Red, Yellow, Blue,* he had developed to its logical conclusion that separation of color and line and that integration of shape and plane that the cubists had initiated with such excitement. With some justification he declared, "This is the end of painting. These are the primary colors. Every plane is a plane and there will be no more representation."[8]

Even at this point in Rodchenko's development *faktura* already meant more than a rigorous and programmatic separation of line and drawing from painting and color, more than the congruence of planes with their actual support surface, more than emphasizing the necessary self-referentiality of pictorial signifiers and their contiguity with all other syntagmatic functions. It already meant, as well, more than just the object's shift from virtual pictorial/sculptural space into actual space. We should not take the reference to *Surfaces Reflecting Light* as anything less than an indication of the potential involvement of these

artists with materials and objects in actual space and the social processes that occur within it.

Faktura also meant at this point, and not for Rodchenko alone, incorporating the technical means of construction into the work itself and linking them with existing standards of the development of the means of production in society at large. At first this happened on the seemingly banal level of the tools and materials that the painter employs—shifts that still caused considerable shock thirty years later with regard to Pollock's work. In 1917 Rodchenko explained his reasons for abandoning the traditional tools of painting and his sense of the need to mechanize its craft:

> Thenceforth the picture ceased being a picture and became a painting or an object. The brush gave way to new instruments with which it was convenient and easy and more expedient to work the surface. The brush which had been so indispensable in painting which transmitted the object and its subtleties became an inadequate and imprecise instrument in the new non-objective painting and the press, the roller, the drawing pen, the compass replaced it.[9]

The very same conviction about laboratory technology is concretized in Rodchenko's systematic experimentation with pictorial surfaces as *traces* or immediate results of specific procedures and materials: metallic and reflective paint are juxtaposed with matte gouaches; varnishes and oil colors are combined with highly textured surfaces.

It is this techno-logic of Rodchenko's experimental approach that seems to have prevented aesthetic comprehension for even longer than did Duchamp's most advanced work of 1913, such as his *Three Standard Stoppages* or his readymades. With its emphasis on the material congruence of the sign with its signifying practice, on the causal relationship between the sign and its referent, and its focus on the *indexical* status of the sign, Rodchenko's work has defied a secondary level of meaning/reading.[10]

Further, this emphasis on the *process qualities* of painting was linked to a serially organized configuration, a structure that resulted as much from the commitment to systematic investigation as from the aspiration toward science with which artists wanted to associate their production. It is this nexus of relationships that tied these essential features of the modernist paradigm eventually to the socially dominant modes of control and management of time and perceptual experience in the Soviet Union's rapidly accelerating process of industrialization.

Faktura is therefore the historically logical aesthetic correlative to the introduction of industrialization and social engineering that was imminent in the Soviet Union after the revolution of 1917. For that

reason *faktura* also became the necessary intermediary step within the transformation of the modernist paradigm as we witness it around 1920. When in 1921 A. V. Babichev, the leader of the Working Group for Objective Analysis (of which Rodchenko and Stepanova were members), gives a definition of art production, his statement is strikingly close to ideas of Taylorism, social engineering, and organized consumption, as they became operative at that time in both western European and American society. "Art," he wrote, "is an informed analysis of the concrete tasks which social life poses....If art becomes public property it will organize the consciousness and psyche of the masses by organizing objects and ideas."[11]

Finally, the notion of *faktura* already implied a reference to the *placement* of the constructivist object and its interaction with the spectator. To emphasize spatial and perceptual contiguity by mirror reflection—as hinted in Rodchenko's project for constructions whose reflective surfaces would mirror their surroundings—means, once again, to reduce the process of representation to purely *indexical* signs:[12] matter seemingly generates its own representation without mediation (the old positivist's dream, as it was, of course, that of the early photographers). Contiguity is also incorporated in the *kinetic* potential of Rodchenko's *Hanging Constructions,* since their movement by air currents or touch literally involves the viewer in an endless phenomenological loop made of his or her own movements in the time/space continuum.

In the discussions of the Group for Objective Analysis from 1921, *construction* was defined as the organization of the kinetic life of objects and materials which would create new movement. As such it had been juxtaposed with the traditional notion of *composition,* as Varvara Stepanova defines it:

> Composition is the contemplative approach of the artist in his work. Technique and industry have confronted art with the problem of construction as an active process, and not a contemplative reflection. The "sanctity" of a work as a single entity is destroyed. The museum which was a treasury of this entity is now transformed into an archive.[13]

If these lines sound familiar today it is not because Stepanova's text had considerable impact on the thinking and practice of her peers, but rather because, more than ten years later, precisely the same historical phenomenon is described and analyzed in a text that is by now rightfully considered one of the most important contributions to twentieth-century aesthetic theory. I am speaking, of course, of Walter Benjamin's 1935 essay "The Work of Art in the Age of Mechanical Reproduction," and the following excerpt might be compared with Stepanova's 1921 statement:

What they [the dadaists] intended and achieved was a relentless destruction of the aura of their creations, which they branded as reproductions with the very means of production....In the decline of middle-class society, contemplation became a school for asocial behavior; it was countered by distraction as a variant of social conduct....[Dada] hit the spectator like a bullet, it happened to him, thus acquiring a tactile quality....(Thus the dada work restores the quality of tactility to the art of the present day, a quality which is important to the art of all periods in their stages of transformation.)[14]

The historical observations by Stepanova and their subsequent theorization by Benjamin have another correlative in the work of Lissitzky from the period 1925–27. Already in 1923 in his *Prounenraum* for the Grosse Berliner Kunstausstellung, Lissitzky had transformed tactility and perceptual movement—still latent in Rodchenko's *Hanging Construction*—into a full-scale architectural relief construction. For the first time, Lissitzky's earlier claim for his *Proun-Paintings,* to operate as transfer stations from art to architecture, had been fulfilled.

It was, however, not until 1926, when he designed and installed in Dresden and Hannover what he called his *Demonstration Rooms*—room-sized cabinets for the display and installation of the nonrepresentational art of his time—that one finds Stepanova's analysis fully confirmed in Lissitzky's practice. The vertical lattice relief-construction that covers the display surfaces of the cabinet and that changes value from white, through gray, to black according to the viewer's position clearly engages the viewer in a phenomenological exercise that defies traditional contemplative behavior in front of the work of art. And the moveable wall panels, carrying or covering easel panels on display, to be shifted by the viewers themselves according to their momentary needs and interests, already incorporate into the display system of the museum the function of the archive that Stepanova predicted as its social destiny. In the late 1920s Lissitzky wrote a retrospective analysis of his *Demonstration Rooms,* and once again it is crucial to compare his ideas with those of both Stepanova and Benjamin in order to realize how developed and current these concerns actually were in the various contexts:

...traditionally the viewer was lulled into passivity by the paintings on the walls. Our construction/design shall make the man active. This is the function of our room....With each movement of the viewer in space the perception of the wall changes; what was white becomes black, and vice versa. Thus, as a result of human bodily motion, a perceptual dynamic is achieved. This play makes the viewer active....The viewer is physically engaged in an interaction with the object on display.[15]

The paradox and historical irony of Lissitzky's work was, of course, that it had introduced a revolution of the perceptual apparatus into an

otherwise totally unchanged social institution, one that constantly reaffirms both the contemplative behavior and the sanctity of historically rooted works of art.

This paradox complemented the contradiction that had become apparent several years earlier when Lissitzky had placed a suprematist painting, enlarged to the size of an agitational billboard, in front of a factory entrance in Vitebsk. This utopian radicalism in the formal sphere—what the conservative Soviet critics later would pejoratively allude to as formalism—in its failure to communicate with and address the new audiences of industrialized urban society in the Soviet Union, became increasingly problematic in the eyes of the very groups that had developed constructivist strategies to expand the framework of modernism. It had become clear that the new society following the socialist revolution (in many respects a social organization that was comparable to the advanced industrial nations of western Europe and the United States at that time) required systems of representation/production/distribution which would recognize the collective participation in the actual processes of production of social wealth, systems which, like architecture in the past or cinema in the present, had established conditions of *simultaneous collective reception*. In order to make art "an informed analysis of the concrete tasks which social life poses," as Babichev had requested, and in order to "fill the gulf between art and the masses that the bourgeois traditions had established," as Meyerhold had called for, entirely new forms of audience address and distribution had to be considered. But around 1920 even the most advanced works among the nonutilitarian object-constructions—by Rodchenko, the Stenberg brothers, Tatlin, and Medunetsky—did not depart much further from the modernist framework of bourgeois aesthetics than the point of establishing models of epistemological and semiotic critique. No matter how radical, these were at best no more than a negation of the perceptual conventions by which art had previously been produced and received.

With sufficient historical distance it becomes clearer that this fundamental crisis within the modernist paradigm was not only a crisis of representation (one that had reached its penultimate status of self-reflexive verification and epistemological critique). It was also, importantly, a crisis of audience relationships, a moment in which the historical institutionalization of the avant-garde had reached its peak of credibility, from which legitimation was only to be obtained by a redefinition of its relationship with the new urban masses and their cultural demands. The Western avant-garde experienced the same crisis with the same intensity. It generally responded with entrenchment in traditional models—the "Rappel à l'ordre"—and the subsequent alignment of many of its artists with the aesthetic needs of the fascists in Italy and Germany. Or, other factions of the Paris avant-garde re-

sponded to the same crisis with an increased affirmation of the unique status of a high-art avant-garde, trying to resolve the contradictions of their practice by reaffirming blatantly obsolete conventions of pictorial representation. In the early 1920s the Soviet avant-garde (as well as some members of the de Stijl group, the Bauhaus, and Berlin Dada) developed different strategies to transcend the historical limitations of modernism. They recognized that the crisis of representation could not be resolved without at the same time addressing questions of distribution and audience. Architecture, utilitarian product design, and photographic factography were some of the practices that the Soviet avant-garde considered capable of establishing these new modes of simultaneous collective reception.[16] Arvatov gives a vivid account of the gradual transition from the modernist position in the Russian avant-garde to the factographic and utilitarian aesthetic:

> The first to retire were the expressionists, headed by Kandinsky, who could not endure extremist pressure. Then the suprematists, headed by Malevich, protested against the murder of the sanctity of art, since they were convinced of the complete self-sufficiency of art. They could not comprehend any other form of art production but that of the easel....In 1921 the Institute for Artistic Culture, which had once united all the Left artists, broke up. Shortly thereafter the Institute started to work under the banner of productivism. After a long process of selection, after an obstinate fight, the group of nonrepresentational constructivists crystallized within the group of the Left (Tatlin, Rodchenko, and the Obmochu-Group), who based their practice on the investigation and treatment of real materials as a transition to the constructive activity of the engineer. During one of the most important meetings of the Inchuk a resolution was passed unanimously to finish off with the self-sufficient constructions and to take all measures necessary in order to engage immediately with the industrial revolution.[17]

Photomontage: Between Faktura and Factography

The relatively late discovery of photocollage and montage techniques seems to have functioned as a transitional phase, operating between the fully developed modernist critique of the conventions of representation, which one sees in constructivism, and an emerging awareness of the new need to construct *iconic* representations for a new mass audience. Neither Lissitzky nor Rodchenko produced any photocollage work before 1922; and only as late as 1919—when these artists had already pushed other aspects of postcubist pictorial and sculptural problems further than anyone else in Europe (except, of course, for Duchamp)—did the collage technique proper enter their work at all. It seems credible that

in fact Gustav Klucis, a disciple of Malevich and a collaborator with Lissitzky, was the first artist to transcend the purity of suprematist painting by introducing iconic photographic fragments into his suprematist work in 1919, the very date that Heartfield and Grosz, Hausmann and Höch have claimed as the moment of their invention of photomontage.

Since by 1919 photomontage was widespread and commonly used in both advertising and commercial photography, the question of who actually introduced the technique into the transformation of the modernist paradigm is unimportant.[18] What is far more crucial is in what way the artists (who might very well have simultaneously "discovered" the technique for their own purposes quite independently of one another) related to the inherent potential and consequences of the reintroduction of (photographic) iconic imagery at precisely the moment when mimetic representation had seemingly been dismantled and definitively abandoned.

Announcing his claims to priority, Klucis also underlines the essential difference between the Soviet type of photomontage and that of the Berlin dadaists when he writes in 1931:

> There are two general tendencies in the development of photomontage: one comes from American publicity and is exploited by the Dadaists and Expressionists—the so called photomontage of form; the second tendency, that of militant and political photomontage, was created on the soil of the Soviet Union. Photomontage appeared in the USSR under the banner of LEF when non-objective art was already finished....Photomontage as a new method of art dates from 1919 to 1920.[19]

The hybrids that Klucis, Lissitzky, and Rodchenko created with their first attempts at collage and photomontage reveal the difficulty of the paradigmatic transformation that is inherent in that procedure, and the concomitant search, in the period 1919–23, for a solution to the crisis of representation. But beyond this, they suggest where the answer to these questions would have to be found, and they define the qualities and functions which the new procedures that legitimize iconic representation would have to offer. At the same time, it would seem that these artists did not want, on the one hand, to sacrifice any of the supreme modernist virtues they had achieved in their pictorial and sculptural work: the transparency of construction procedures; the self-referentiality of the pictorial signifying devices; the reflexive spatial organization; and the general emphasis on the tactility, that is, the constructed nature of their representations. But, on the other hand, photocollage and photomontage reintroduced into the aesthetic construct—at a moment when its modernist self-reflexivity and purification had semiotically reduced

all formal and material operations to purely indexical signs—unlimited sources for a new *iconicity* of representation, one that was mechanically produced and reproduced, and therefore—to a generation of media utopians—the most reliable. Looking at the photomontage work of 1923, such as Rodchenko's series *Pro Eto,* or Hausmann's work, one might well wonder whether the exuberance, willfulness, and quantity of the photographic quotations and their juxtapositions were not in part motivated by their authors' relief at having finally broken the modernist ban on iconic representation. This, in extreme contrast to the Parisian vanguard's collage work, in which iconic representation ultimately reappeared, but which never made use of photographic or mechanically reproduced iconic images.

But the rediscovery of a need to construct iconic representations did not, of course, result primarily from the need to overcome the strictures of modernism. Rather it was a necessary strategy to implement the transformation of audiences that the artists of the Soviet avant-garde wanted to achieve at that time. "Photomontage," an anonymous text (attributed by some scholars to Rodchenko) published in *Lef* in 1924, not only traces the historic affiliation of photomontage's conglomerate image with the strategies of advertising, juxtaposing photomontage's technique and its iconic dimension with the traditional techniques of modernist representation, but also introduces the necessity of *documentary* representation in order to reach the new mass audience:

> By photomontage we understand the usage of the photographic prints as tools of representation. The combination of photographs replaces the composition of graphic representations. The reason for this substitution resides in the fact that the photographic print is not the sketch of a visual fact, but its precise fixation. The precision and the documentary character give photography an impact on the spectator that the graphic representation can never claim to achieve....An advertisement with a photograph of the object that is being advertised is more efficient than a drawing of the same subject.[20]

Unlike the Berlin Dadaists who claimed to have invented photomontage, the author of this *Lef* text does not disavow the technique's intrinsic affiliation (and competitive engagement) with the dominant practices of advertising. Quite the contrary, the author seems to invite that competition by defining photomontage from the start as an agitational tool that addresses the Soviet Union's urban masses. It is with this aspect in mind that the practitioners of photomontage could not accept the confinement of the medium to the forms of distribution they had inherited from collage: forms limited by the single, rectangular

sheet of paper, its format, scale, and size of edition entirely determined by the most traditional studio notions of unique, auratic works of art.

While (with the exception of the work of John Heartfield) most western European photomontage remains on the level of the unique, fabricated image—paradoxically folding into the singularity of this object fragments of a multitude of technically reproduced photographic images from mass-cultural sources—the strategies of the Soviet avant-garde seem rather rapidly to have shifted away from a reenactment of that historical paradox. The productivist artists realized that in order to address a new audience not only did the techniques of production have to be changed, but the forms of distribution and institutions of dissemination and reception had to be transformed as well. The photomontage technique, as an artistic procedure that supposedly carries transformative potential *qua* procedure, as the Berlin Dadaists seem to have believed, therefore, in the work of Rodchenko and Lissitzky, becomes integrated as only *one* among several techniques—typography, advertising, propaganda—that attempted to redefine the representational systems of the new society.

From Modernism to Mass Culture

In 1926 Lissitzky developed a theory of contemporary art production that not only associated aesthetic practice with the needs of audience and patron class as prime determinants of the forms that production would assume, but also linked standards of modernist practice to distribution developments occurring in other communications media: books, graphic design, film. Although his beliefs were buoyed by the same naive optimism towards the enlightening power of technology and the media that would ten years later limit the ultimate relevance of Walter Benjamin's essay, Lissitzky's is not a mere "machine aesthetic." Rather, it is an attempt to establish an operative aesthetic framework that could focus attention simultaneously on the existing needs of mass audiences and on the available techniques and standards of the means of artistic production. Like Benjamin in his later essay, Lissitzky considers aesthetic forms and their procedures of production in the light of history rather than in terms of universal categories. Yet unlike Benjamin, he perceives the ensuing transformations as a product of needs and functions rather than as a result of technological changes. The text is important for the clarification of Lissitzky's motivation in the following years, as he decided to abandon almost all traditional forms of graphic and photographic, let alone painterly or sculptural, production, and to concentrate exclusively on those practices that establish the new "monumentality"—the conditions of simultaneous collective reception:

It is shortsighted to suppose that machines, *i.e.,* the displacement of manual by mechanical processes, are basic to the development of the form and the figure of an artifact. In the first place it is the consumers' demand that determines the development, *i.e.,* the demand of the social strata that provide the "commissions." Today this is not a narrow circle anymore, a thin cream, but everybody, the masses....What conclusions does this imply in our field? The most important thing here is that the mode of production of words and pictures is included in the same process: photography....[In America] they began to modify the relation of word and illustration in exposition in the direct opposite of the European style. The highly developed technique of facsimile electrotype (half-tone blocks) was especially important for this development; thus photomontage was born....With our work the Revolution has achieved a colossal labor of propaganda and enlightenment. We ripped up the traditional book into single pages, magnified these a hundred times,...and stuck them up as posters in the streets....The innovation of easel painting made great works of art possible, but it has now lost its power. The cinema and the illustrated weekly have succeeded it....The book is the most monumental art form today; no longer is it fondled by the delicate hands of a bibliophile, but seized by a hundred thousand hands....We shall be satisfied if we can conceptualize the epic and the lyric developments of our times in our form of the book.[21]

The degree to which Lissitzky focused at that time on the question of audience as a determinant of form, and on the perspective of creating conditions for simultaneous collective reception, becomes even more obvious in the essay's at-first surprising equation between the reading space of the printed page and the space of dramatic experience in the theater. According to Lissitzky the page (and its traditional layout and typography) shares conventions of confinement with the theater—the peep-show as he calls it—where the spectator is separated from the performers, and the spectator's gaze is contained—as in traditional easel painting—in the central perspective of the proscenium stage. The revolutionary transformation of book design ran parallel in Lissitzky's work to the revolution of the theatrical space, for example, as he would produce it in 1929 for Meyerhold's theater and its central, open-stage construction. Already in his 1922 book *Of Two Squares* (reading lessons for children, as he called it), he said that "the action unrolls like a film" and the method of typographical montage generates the tactility of experiencing the reader's movement through time and space.[22]

This integration of the dramatic experience of theatrical/cinematographic space and the perceptual experience of static signs of graphic/photographic montage and typography is successfully achieved in 1928 in Lissitzky's first major exhibition project for the International Press Exhibition, *Pressa,* in Cologne. Not surprisingly, we find on the first page of the catalogue that Lissitzky created to accompany the

design of the USSR Pavilion the announcement, "Here you see in a typographic kino-show the passage of the contents of the Soviet Pavilion."[23]

Rather than thinking of Lissitzky's involvement with the design of exhibitions merely as a task-oriented activity that remains marginal to the central concerns of his work (as have most authors considering these projects), it seems more adequate to see them, along with Lissitzky's subsequent involvement with the propaganda journal *USSR in Construction,* as a logical next step in the development of his own work, as well as in the radical transformation of modernist aesthetics and art production as it had been occurring within the Soviet avant-garde since 1921 and the rise of productivism. We have no reason to doubt the sincerity of one of the last texts Lissitzky wrote, shortly before his death in 1941, a table of autobiographical dates and activities, where the entry under the year 1926 reads, "In 1926 my most important work as an artist began: the design of exhibitions."[24]

In 1927 Lissitzky had been commissioned to install his first "commercial" exhibition design in the Soviet Union, the exhibition of the Polygraphic Union, a relatively modest project in Moscow's Gorky Park. Unlike the 1926 design for the *International Contemporary Art Exhibition* in Dresden, or the cabinet design for the Hannover Landesmuseum in 1927, this project was conceived and produced as a set for a trade show rather than an exhibition of contemporary art; furthermore, it was the result of the collaboration of a group of artists.

Klucis, the "inventor" of photomontage, Lissitzky's colleague and disciple from Vitebsk, where both had struggled to come to terms with the legacy of Malevich's suprematism in 1919–20, was one of the collaborators in the project, as was Salomon Telingater, later to emerge as one of the major figures in the revolution of Soviet typographic design. It is in the catalogue of this exhibition—a book design project that was jointly produced by Lissitzky and Telingater—that we find Lissitzky's essay "The Artist in Production."

This text is not only Lissitzky's own productivist manifesto (Rodchenko and Stepanova's text, officially entitled "Productivist Manifesto," had appeared already in 1921, and Ossip Brik's manifesto "Into Production" had appeared in *Lef* in 1923), but it is also the text in which Lissitzky develops most succinctly his ideas about the uses of photography in general and the functions of photomontage in particular:

> As a result of the social needs of our epoch and the fact that artists acquainted themselves with new techniques, *photomontage* emerged in the years following the Revolution and flourished thereafter. Even though this technique had been used in America much earlier for advertising, and the dadaists in Europe had used it to shake up official bourgeois art, it

only served political goals in Germany. But only here, with us, photomontage acquired a clearly socially determined and aesthetic form. Like all other great art, it created its own laws of formation. The power of its expression made the workers and the Komsomol circles enthusiastic for the visual arts and it had great influence on the billboards and newspapers. Photomontage at its present stage of development uses finished, entire photographs as elements from which it constructs a totality.[25]

Lissitzky's 1927 text not only traces an astonishingly clear history of the technique of photomontage and its origins in advertising technology, but it also gives us a clear view of his awareness that the functions of the technique within the historical context of the Soviet avant-garde are entirely different from that of the Berlin dadaists, that the technique is only valid if it is bound into the particular needs of a social group. That is to say, he disavows photomontage as a new artistic strategy that has value *qua* artistic operation and innovational mode of representation/production. The nucleus of the inherent potential of photomontage, that is, the production of iconic, documentary information, already addressed in the anonymous text from *Lef* of 1924, is fully developed in Lissitzky's definition of the functions of the technique in 1927: the morphology of the products of that technique has changed substantially by comparison with its original manifestations in 1919–23. Those features that the technique of photomontage had inherited from its origins in collage and the cubist critique of representation were gradually abandoned. Also abandoned was the overlap of photomontage with the techniques of modern advertising. These techniques seemed to have generated, in the dada context, the extreme procedures of juxtaposition and fragmentation by which the origins in advertising were inverted and where the constructed artificiality of the artifact destroyed the mythical nature of the commodity. This shift became apparent in the gradual return to the *iconic* functions of the photograph, deleting altogether the *indexical* potential of the photograph (as still visible in Lissitzky's photograms of the 1920s) as well as the actual indexical structure of the agglomerated fragments of the photomontage itself, where the network of cuts and lines of jutting edges and unmediated transitions from fragment to fragment was as important, if not more so, as the actual iconic representation contained within the fragment itself.

Thus *faktura,* an essential feature of the modernist paradigm that underlay the production of the Soviet avant-garde until 1923, was replaced by a new concern for the *factographic* capacity of the photograph, supposedly rendering aspects of reality visible without interference or mediation. It was at this moment—in 1924—that Rodchenko decided to abandon photomontage altogether and to engage in single-frame still photography, which transforms montage through the explicit choice of

camera angle, the framing of vision, the determinants of the filmic apparatus, and the camera's superiority over the conventions of human perception. In Lissitzky's essay this change is clearly indicated in the phrase arguing that "photomontage in its present stage of development uses finished entire photographs as elements from which it constructs a totality." From this we see that homogeneity in the single print is favored over fragmentation, iconic representation of an absent referent is favored over the indexical materiality of the trace of a verifiable process, tactility of the construction of incoherent surfaces and spatial references is exchanged for the monumentality of the camera-angle's awesome visions and the technological media optimism that it conveys. Yet while it is evident that at this moment the premises of the modernist paradigm were vacated, and that a programmatic commitment to new audiences entirely changed the nature of artistic production, it seems no more appropriate to neglect or condemn as *propaganda* Lissitzky's or Rodchenko's work from this period (nor their subsequent involvement with Stalin's State Publishing House in the 1930s) than it would be to condemn certain Surrealist artists (those in particular who developed what Max Ernst was to call the technique of the "painted collage") as being responsible for providing advertising's visual and textual strategies, operative to this very day.

Between Photomontage and Propaganda: the *Pressa*

Partially as a response to his first successful exhibition design in Moscow in 1927, a committee chaired by Anatoly Lunacharsky decided to ask Lissitzky (together with Rabinowich, who later withdrew from participation) to design the Soviet Pavilion at the forthcoming *International Exhibition of Newspaper and Book Publishing* in Cologne, the first exhibition of its kind. Since the decision of the committee was made on December 23, 1927, and the exhibition was to begin in the first week of May 1928, Lissitzky and his collaborators had four months to plan and produce the design of the exhibition. Apparently just two days after the committee had appointed him, Lissitzky submitted a first general outline that foresaw the formation of a "collective of creators" with himself as the general coordinator of the design. Among the approximately thirty-eight members of the collective, only a few, among them the stage designer Naumova, had previously participated in exhibition design and the decoration of revolutionary pageants.[26] The largest group within the collective consisted of agitprop graphic designers, shortly thereafter to become some of the most important graphic designers of the Soviet avant-garde. The majority of the 227 exhibits were produced and assem-

bled in the workshops for stage design in the Lenin Hills in Moscow. The other elements were designed in Moscow as well, but produced and assembled in Cologne under the supervision of Lissitzky and Sergei Senkin, who had traveled to the site of the exhibition to supervise and install the Soviet Pavilion.

The centerpiece of the exhibition was in fact the large-scale photomontage that Lissitzky had designed with Senkin's assistance. This *photofresco,* as Senkin called it, measured approximately seventy-two by eleven feet and depicted, in constant alternation of camera angles, of close-ups and long-shots, the history and importance of the publishing industry in the Soviet Union since the revolution and its role in the education of the illiterate masses of the newly industrialized state. Thus the photofresco, *The Task of the Press Is the Education of the Masses* (its official title), functioned as the centerpiece of an exhibition that was devoted to documenting the achievements of the Revolution in the educational field for a skeptical, if not hostile western European public.

The actual structure of the photofresco followed the strategies that Lissitzky had laid out in the essay that accompanied the catalogue of his first exhibition design in 1927. Large-scale photographic prints were assembled in an irregular grid formation and the visual dynamic of the montage resulted from the juxtaposition of the various camera angles and positions, but no longer from a jagged linear network of seams and edges of heterogeneous photographic fragments.

While the scale and size of the photomontage—it was installed on the wall at a considerable height—aligned the work with a tradition of architectural decoration and mural painting, the sequencing of the images and their emphatic dependence on camera technology and movement related the work to the experience of cinematic viewing, such as that of the newsreel. In their mostly enthusiastic reviews, many visitors to the *Pressa* exhibition actually discussed the theatrical and cinematic aspects of the photofresco. One critic reminisces that one went through "a drama that unfolded in time and space. One went through expositions, climaxes, retardations, and finales."[27] Reviewing both the Dresden *Hygiene Exhibition* design by Lissitzky and the Cologne *Pressa* design, a less well-disposed critic still had to admit the design's affiliation with the most advanced forms of cinematic production:

> The first impression is brilliant. Excellent the technique, the arrangement, the organization, the modern way it has been constructed....Propaganda, propaganda, that is the keynote of Soviet Russian exhibitions, whether they be in Cologne or in Dresden. And how well the Russians know how to achieve the visual effects their films have been showing us for years![28]

Even though Lissitzky did not meet Dziga Vertov until 1929 (inaugurating a friendship that lasted until Lissitzky's death in 1941), it is very likely that in 1927–28 he was drawing not only upon the collage and montage sources of Cubism, Dadaism, and Constructivism, but equally upon the cinematic montage techniques that Vertov had used in the first *Kino-Pravda* films, and used still more daringly and systematically in his work after 1923.

In his manifesto "We," published in *kinofot* in 1922 and illustrated by a compass and ruler drawing by Rodchenko from 1915, Vertov had called film "an art of movement, its central aim being the organization of the movements of objects in space." Hubertus Gassner speculates that this manifesto had considerable influence on Rodchenko, as well as the Constructivists, and led him away from drawing and painting into the photographic montage production that Rodchenko published two issues later in the same journal.[29] It seems, however, that Vertov only voiced a concern that, as we saw earlier in several instances, was very much at the center of the Constructivist debate itself, to make "construction" and "montage" the procedures that would transform the passive, contemplative modes of seeing. Sophie Küppers argues that it was Vertov who learned the montage technique from Lissitzky's earliest experiments with the photogram and the photomontage, and that it was primarily Lissitzky's transparency technique and the double exposure as photographic montage technique that left a particularly strong impression on Vertov's own work in the mid-1920s. Only in the later work produced by Lissitzky for the magazine *USSR in Construction* can we recognize, according to Küppers, the influence of Vertov's *Kino-Pravda*.

In spite of the obvious parallels between the cinematographic montage and the photomontage, and leaving aside the question of historical priority and influence, it is important to clarify in this context the specific differences that existed between the mural-sized photomontages and exhibition designs of Lissitzky and the montage of Vertov's *Kino-Pravda*. Clearly the still photograph and the new photomontage, as Lissitzky defined it, offered features that the moving imagery of the film lacked: aspects of the same subject could be compared and contrasted and could be offered for extensive reading and viewing; complicated processes of construction and social transformation could be analyzed in detailed accounts that ran parallel with statistics and other written information; and the same subject could, as Rodchenko argued, be represented "at different times and in different circumstances." This practice of "realistic constructivism" as the critic Gus called Lissitzky's exhibition design, had in fact wrought a substantial change within collage and photomontage aesthetics. What in collage had been the strategy of *contingency,* by which material had been juxtaposed, empha-

sizing the divergence of the fragments, had now become the *stringency* of a conscious construction of documentary factographic information.

In an excellent recent study of Russian Constructivism, Christina Lodder has argued that it was the failure of the Constructivists actually to implement their Productivist program (due to shortage of materials, lack of access to industrial facilities, disinterest on the part of the engineers and administrators of the state manufacturing companies) that drove these artists into the field of typography, publication and poster design, agitational propaganda and exhibition design.[30] The emergence of a strong antimodernism, backed by the party as a result of Lenin's New Economic Policy in 1921, required the return to traditional values in art and laid the foundations for the rise of socialist realism. Lodder argues that it was as a result of these changes and as an attempt at competition with these reactionary forces that Lissitzky's and Rodchenko's work at that time employed iconic, photographic representation and abandoned the radical syntax of the montage aesthetic. The problem with this criticism, however—as with all previous rejections of the later work of Rodchenko and Lissitzky—is that criteria of judgment that were originally developed within the framework of modernism are now applied to a practice of representation that had deliberately and systematically disassociated itself from that framework in order to lay the foundations of an art production that would correspond to the needs of a newly industrialized collective society. Because, as we have seen, these conditions required radically different production procedures and modes of presentation and distribution, any historical critique or evaluation will have to develop its criteria from *within* the actual intentions and conditions at the origin of these practices.

Lissitzky's exhibition design does overcome the traditional limitations of the avant-garde practice of photomontage and reconstitutes it within the necessary conditions of simultaneous collective reception that were given in the cinema and in architecture. Further, in his new practice of montage, Lissitzky incorporated the method of "systematic analytical sequence," as Tretyakov was to define it shortly afterwards. Tretyakov wrote in 1931 that the photographer/artist should move from the single-image aesthetic to the systematic photographic sequence and the long-term observation:

> If a more or less random snapshot is like an infinitely fine scale that has been scratched from the surface of reality with the tip of the finger, then in comparison the photoseries or the photomontage lets us experience the extended massiveness of reality, its authentic meaning. We build systematically. We must also photograph systematically. Sequence and long-term photographic observation—that is the method.[31]

Modernism's Aftermath

In spite of the fact that even the most conservative international newspapers reported enthusiastically on Lissitzky's *Pressa* design, and that he received a medal from the Soviet government in recognition of the success of this project as well as having been named an honorary member of the Moscow town Soviet, he seems to have been personally dissatisfied with the results. This is evident in a letter that he wrote on December 26, 1928, to his Dutch friend, the de Stijl architect J. J. P. Oud. "It was a big success for us," he mused, "but aesthetically there is something of a poisoned satisfaction. The extreme hurry and the shortage of time violated my intentions and the necessary completion of the form—so it ended up being basically a theater decoration."[32]

We will, however, find in neither Lissitzky's letters nor his diary entries any private or public disavowal of or signs of regret about having abandoned the role of the modernist artist for that of the producer of political propaganda in the service of the new Communist state. Quite the opposite: the letters we know Lissitzky to have written during the years of his subsequent involvement with both the design of exhibitions for the government and his employment by Stalin's State Publishing House on the magazine *USSR in Construction* clearly indicate that he was as enthusiastically at work in fashioning the propaganda for Stalin's regime as were Rodchenko and Stepanova, who were at that time involved in similar tasks. Clearly Lissitzky shared the naive utopianism that also characterizes Walter Benjamin's later essay, an optimism that Adorno criticized in his response to the text, saying,

> Both the dialectic of the highest and the lowest [modernism and mass-culture] bear the stigmata of capitalism, both contain elements of change....Both are torn halves of an integral freedom, to which however they do not add up. It would be romantic to sacrifice one to the other, either as the bourgeois romanticism of the conservation of personality and all that stuff, or as the anarchistic romanticism of blind confidence in the spontaneous power of the proletariat in the historical process—a proletariat which is itself a product of bourgeois society.[33]

But it is also clear by now that both Lissitzky's and Benjamin's media optimism prevented them from recognizing that the attempt to create conditions of a simultaneous collective reception for the new audiences of the industrialized state would very soon issue into the preparation of an arsenal of totalitarian, Stalinist propaganda in the Soviet Union. What is worse, it would deliver the aesthetics and technology of propaganda to the Italian Fascist and German Nazi regimes. And only a little later we see the immediate consequences of Lissitzky's new montage techniques and photofrescoes in their successful adapta-

tion for the ideological needs of American politics and the campaigns for the acceleration of capitalist development through consumption. Thus, what in Lissitzky's hands had been a tool of instruction, political education, and the raising of consciousness was rapidly transformed into an instrument for prescribing the silence of conformity and obedience. The "consequent inrush of barbarism" of which Adorno speaks in the letter to Benjamin as one possible result of the undialectical abandonment of modernism was soon to become a historical reality. As early as 1932 we see the immediate impact of the *Pressa* project in its adaptation for the propaganda needs of the Fascist government in Italy. Informed by the members of the Italian League of Rational Architecture, in particular Bardi and Paladini (who was an expert on the art of the Soviet avant-garde), the architect Giuseppe Terragni constructed an enormous mural-sized photomontage for the *Exposition of the Fascist Revolution*.[34] It would require a detailed formal and structural analysis to identify the transformations that took place within photomontage aesthetics once they were put to the service of Fascist politics. It may suffice here to bring only one detail to the attention of the reader, a detail in which that inversion of meaning under an apparent continuity of a formal principle becomes apparent, proving that it is by no means simply the case of an available formal strategy being refurbished with a new political and ideological content.

The detail in question is the representation of the masses in Terragni's photomural, where a crowd of people is contained in the outlines of a relief shaped like the propeller of a turbine or a ship. Clearly it was one of the most difficult tasks, in constructing representations for new mass audiences, not only to establish conditions of simultaneous collective viewing, but further, actually to construct representations of the masses themselves, to depict the collectivity. One of the most prominent examples of this necessity is an early photomontage poster by Klucis, which in fact seems to have been so successful that Klucis used the same visual configuration for two different purposes.[35] The subject of the poster in both versions is the representation of political participation in the decision-making processes of the new Soviet State. In Klucis's poster participation is encouraged by an outstretched hand within which hundreds of faces are contained: thus the individuation resulting from the participation in political decisions and subordination under the political needs of the collectivity seem to be successfully integrated into one image. In Terragni's photomural the same structure has been deployed; this time, however, the overall form of the outstretched hand of the voting individual is replaced by the outlines of the machine (the propeller, the turbine) which contains the image of the masses of people. And it is clear that the Fascist image means what it unknowingly conveys: that the subordination of the masses under the

state apparatus in the service of the continued dominance of the political and economic interests of the industrial ruling class has to be masked behind the image of technological progress and mastery. Abstracted as it is, however, from the interests of those who are being mastered, it appears as an image of anonymity and subjugation rather than one of individual participation in the construction of a new collective.

It is significant that the principles of photomontage are completely abandoned once the technique of the photomural is employed for the propaganda purposes of the German fascists. In the same manner that they had discovered Eisenstein's films as a model to be copied for their purposes (Leni Riefenstahl studied his work thoroughly for the preparation of her own propaganda movies), they had also recognized that the achievements of the Russian artists in the field of exhibition design could be employed to serve their needs to manipulate the urban and rural masses of Germany during the crisis of the post-Weimar period. When the German Werkbund, which had just been turned into a fascist organization, put together a popular photography show in 1933 called *The Camera,* the organizers explicitly compared their exhibition design with that of the Russians (without, of course, mentioning Lissitzky's name):

> If you compare this exhibition with the propaganda rooms of the Russians that received so much attention during the last years, you will instantly become aware of the direct, unproblematic, and truly grandiose nature of the representation of reality in this room. These pictures address the spectator in a much more direct manner than the confusion of typography, photomontage, and drawings....This hall of honor is so calm and grand that one is almost embarrassed to talk any longer about propaganda in this context.[36]

To erase even the last remnant of modernist practice in photomontage, the seams and the margins where the constructed nature of reality could become apparent—and therefore its potential for change obvious—had now become a standard practice in totalitarian propaganda, and construction was replaced by the awe-inspiring monumentality of the gigantic, single-image panorama. What had once been the visual and formal incorporation of dialectics in the structure of the montage—in its simultaneity of opposing views, its rapidly changing angles, its unmediated transitions from part to whole—and had as such embodied the relationship between individual and collectivity as one that is constantly to be redefined, we now find displaced by the unified spatial perspective (often the bird's-eye-view) that travels over uninterrupted expanses (land, fields, water, masses) and thus naturalizes the perspective of governance and control, of the surveillance of the rulers' omnipresent

eye in the metaphor of nature as an image of a pacified social collective without history or conflict.

It remains to be determined at what point, historically as well as structurally, this reversal takes place within the practices of photomontage during the 1930s. Unification of the image and its concomitant monumentalization were—as we saw—already operative in Lissitzky's work for the *Pressa* exhibition. These tendencies were of considerable importance for the success of his enterprise. And according to Stepanova's own text, Rodchenko abandoned photomontage principles as early as 1924, replacing them by single-frame images and/or series of single-frame images with highly informative documentary qualities. At what point these factographic dimensions turned into the sheer adulation of totalitarian power, however, is a question that requires future investigation. That this point occurs within Rodchenko's work, if not also in Lissitzky's, for the journal *USSR in Construction* is a problem that modernist art historians have tried to avoid by styling these artists as purist heroes and martyrs who had to sacrifice their commitment to the spiritual realm of abstract art by their enforced involvement with the state. A revision of this comforting distortion of history is long overdue. It is a distortion that deprives these artists—if nothing else—of their actual political identity (their commitment to the cause of Stalinist politics was enthusiastic and sincere and came unforced, as is evident from the fact that an artist such as Tatlin, who did not work for the state agencies, continued to live his private, if economically miserable existence without harassment), as it deprives us of the understanding of one of the most profound conflicts inherent in modernism itself: that of the historical dialectic between individual autonomy and the representation of a collectivity through visual constructs. Clearly the history of photomontage is one of the terrains in which this dialectic was raised to the highest degree of its contradictory forces. Thus it is not surprising that we find the first signs of a new authoritarian monumental aesthetic defined through the very rejection of the legacy of photomontage in favor of a new unified imagery. In 1928 Stepanova could still trace this terrain's development through an apparently neutral political terminology in characterizing the climax of the productivist factographic position:

> Within its short life, photomontage has passed through many phases of development. Its first stage was characterized by the integration of large numbers of photographs into a single composition, which helped bring into relief individual photo images. Contrasts in photographs of various sizes and, to a lesser extent, the graphic surface itself formed the connective medium. One might say that this kind of montage had the character of a planar montage superimposed on white paper ground. The subsequent

development of photomontage has confirmed the possibility of using photographs as such...the individual snapshots are not fragmented and have all the characteristics of a real document. The artist himself must take up photography....The value of the photograph itself came to assume primary importance; the photograph is no longer raw material for montage or for some kind of illustrated composition but has an independent and complete totality.[37]

But two years later, from within the Soviet Russian reflection upon the purposes and functions of the technique of photomontage itself we witness the rise of that concern for the new monumentality and heroic pathos that was the prime feature of the German Fascist attack on the legacy of photomontage quoted above. In 1930, in his text "The Social Meaning of Photomontage," the critic O. L. Kusakov writes,

...the solution to the problem of the proletarian, dynamic photomontage is inherently connected to the simultaneous solution of the question for a monumental style, since the monumentality of the tasks of the construction of socialism requires a heroic pathos for the organization of the consciousness of the spectators. Only in a successful synthesis of dynamics and monumentality—in conjunction with the constitution of a dialectical relationship between the levels of life—can photography fulfill the functions of an art that organizes and leads life.[38]

Thus it seems that Babichev's original, utopian quest and prognosis for the future functions of a postmodernist factographic art to become "an informed analysis of the concrete tasks which social life poses," one that will "organize the consciousness and psyche of the masses by organizing objects and ideas," had become true within ten years' time, although in a manner that was perhaps quite different from what he had actually hoped for. Or we could say that the latent element of social engineering, inherent in the notion of social progress as a result of technological development which art could mediate, had finally caught up with modernism's orientation toward science and technology as its underlying paradigms for a cognitively and perceptually emancipatory practice.

This historical dialectic seems to have come full circle in Rodchenko's career. In 1931 he worked as artist-in-residence on the site of the construction of the White Sea Canal in order to document the heroic technological achievements of the Stalin government and to produce a volume of photographic records. But apparently in the first year alone of his stay more than 100,000 workers lost their lives due to inhuman working conditions. While it is unimaginable that Rodchenko would not have been aware of the conditions that he photographed for almost two years, his subsequent publications on the subject only project

a grandiose vision of nature harnassed by technology and the criminal and hedonistic impulses of the prerevolutionary and counterrevolutionary personality mastered through the process of reeducation in the forced labor camps of the White Sea Canal.[39]

While it is undoubtedly clear that at this time Rodchenko did not have any other choice than to comply with the interest of the State Publishing House if he wanted to maintain his role as an artist who participated actively in the construction of the new Soviet society (and we have no reason to doubt this to be his primary motive), we have to say at least that by 1931 the goals of factography had clearly been abandoned.

However, the contempt meted out from a Western perspective at the fate of modernist photomontage and factographic practice in the Soviet Union during the 1930s or at its transformation into totalitarian propaganda in Fascist Italy and Germany seems historically inappropriate. For the technique was adapted to the specifically American needs of ideological deployment at the very same moment. Once again, the tradition of photomontage itself had first to be attacked in order to clear the ground for the new needs of the monumental propaganda machines. Here is Edward Steichen's American variation on the theme of an antimodernist backlash in favor of his version of a "productivist" integration of art and commerce in 1931:

> The modern European photographer has not liberated himself as definitely [as the American commercial photographer]. He still imitated his friend, the painter, with the so-called photomontage. He has merely chosen the *modern* painter as his prototype. We have gone well past the painful period of combining and tricking the banal commercial photograph....It is logical therefore that we find many modern photographers lined up with architects and designers instead of with painters or photographic art salons.[40]

Ten years later Steichen staged his first project at the Museum of Modern Art, the exhibition *Road to Victory.* Once again its propagandistic success depended almost entirely, as Christopher Phillips has shown, on a debased and falsified version of Lissitzky's exhibition designs.[41] In this case it was Herbert Bayer who provided American industry and ideology with what *he* thought Lissitzky's ideas and practice had attempted to achieve. Bayer was well suited to this task, having already prepared an elaborate photomontage brochure for the National Socialists' *Deutschland Ausstellung* of 1936, staged to coincide with the Berlin Olympics. When asked by Christopher Phillips about his contribution to this project for the Nazis, Bayer's only comment was, "This is an interesting booklet insofar as it was done exclusively with photogra-

phy and photomontage, and was printed in a duotone technique."[42] Thus, at the cross-section of politically emancipatory productivist aesthetics and the transformation of modernist montage aesthetics into an instrument of mass education and enlightenment, we find not only its imminent transformation into totalitarian propaganda, but also its successful adaptation for the needs of the ideological apparatus of the culture industry of Western capitalism.

Notes

1. Alfred Barr, "Russian Diary 1927–1928," *October*, no. 7 (Winter 1978), p. 21.
2. *Ibid.*, p. 19.
3. *Ibid.*, p. 14.
4. Alfred Barr, "The Lef and Soviet Art," *Transition*, no. 14 (Fall 1928), pp. 267–270.
5. Boris Arvatov, *Kunst und Produktion*, Munich, Hanser Verlag, 1978, p. 43. All translations from the German, unless otherwise noted, are my own.
6. Yve-Alain Bois, in his essay "Malévich, le carré, le degré zéro" (*Macula*, no. 1 [1976], pp. 28–49), gives an excellent survey of the original discussion of the question of *faktura* among the various factions of the Russian avant-garde. More recently Margit Rowell has added references such as Markov's text, quoted here, that had not been mentioned by Bois. In any case, as Bois has argued, it is pointless to attempt a chronology since the many references to the phenomenon appear simultaneously and often independently of one another.

 As early as 1912 the question of *faktura* is discussed by Mikhail Larionov in his "Rayonnist Manifesto," where he calls it "the essence of painting," arguing that the "combination of colors, their density, their interaction, their depth, and their *faktura* would interest the truly concerned to the highest degree." A year later, in his manifesto "Luchism" he argues that "every painting consists of a colored surface, its *faktura* (that is, the condition of that colored surface, its timbre) and the sensation that you receive from these two aspects." Also in 1912 we find David Burliuk differentiating between "a unified pictorial surface A and a differentiated pictorial surface B. The structure of a pictorial surface can be I. *Granular*, II. *Fibrous*, and III. *Lamellar*. I have carefully scrutinized Monet's *Rouen Cathedral* and I thought 'fibrous vertical structure.'…One can say that Cézanne is typically *lamellar*." Burliuk's text is entitled "Faktura." Bois also quotes numerous references to the phenomenon of *faktura* in the writings of Malevich, for example, where he calls Cézanne the inventor of a "new faktura of the pictorial surface," or when he juxtaposes the *linear* with the *textural* in painting. The concern for *faktura* seems still to have been central in 1919, as is evident from Popova's statement that "the content of pictorial surfaces is *faktura*." Even writers who were not predominantly concerned with visual and plastic phenomena were engaged in a discussion of *faktura*, as is the case of Roman Jakobson in his essay "Futurism," identifying it as one of the many strategies of the new poets and painters who were concerned with the "unveiling of the procedure: therefore the increased concern for *faktura*; it no longer needs any justification, it becomes autonomous, it requires new methods of formation and new materials."

 Quite unlike the traditional idea of *fattura* or *facture* in painting, where the masterful facture of a painter's hand spiritualizes the *mere* materiality of the pictorial production, and where the hand becomes at the same time the substitute or the totalization of the identifying signature (as the guarantee of authenticity, it justifies the painting's exchange value and maintains its commodity existence), the new concern for *faktura*

in the Soviet avant-garde emphasizes precisely the mechanical quality, the materiality, and the anonymity of the painterly procedure from a perspective of empirico-critical positivism. It demystifies and devalidates not only the claims for the authenticity of the spiritual and the transcendental in the painterly execution but, as well, the authenticity of the exchange value of the work of art that is bestowed on it by the first.

For the discussion of the Markov statement and a generally important essay on the phenomenon of *faktura*, see also Margit Rowell, "Vladimir Tatlin: Form/ Faktura," *October*, no. 7 (Winter 1978), pp. 94ff.

7. Nikolai Tarabukin, *Le dernier tableau*, Paris, Editions Le Champ Libre, 1972, p. 102, cited in Rowell, p. 91.

8. Alexander Rodchenko, "Working with Maiakovsky," manuscript 1939, published in excerpts in *From Painting to Design*, exhibition catalogue, Cologne, Galerie Gmurzynska, 1981, pp. 190–191.

9. Alexander Rodchenko, exhibition pamphlet at the exhibition of the Leftist Federation in Moscow, 1917, cited in German Karginov, *Rodchenko*, London, Thames and Hudson, 1975, p. 64.

10. The terminological distinction is of course that of C. S. Peirce as Rosalind Krauss has first applied it to Duchamp's work in her essay "Notes on the Index," *October*, nos. 3 and 4 (Summer and Fall 1977).

11. A. V. Babichev, cited in Hubertus Gassner, "Analytical Sequences," in *Alexander Rodchenko*, ed. David Elliott, Oxford, Museum of Modern Art, 1979, p. 110.

12. Krauss, "Notes," *passim*.

13. Varvara Stepanova, quoted in Camilla Grey, *The Russian Experiment*, New York, Thames and Hudson, 1971, pp. 250–251.

14. Walter Benjamin, "The Work of Art in the Age of Mechanical Reproduction," in *Illuminations*, trans. Harry Zohn, New York, Schocken Books, 1969, p. 238. The last sentence of this quotation, set into parenthesis, is taken from the second version of Benjamin's essay (my translation).

15. El Lissitzky, "Demonstrationsräume," in *El Lissitzky*, ed. Sophie Lissitzky-Küppers, Dresden, VEB-Verlag der Kunst, 1967, p. 362.

16. The problem of the creation of conditions of simultaneous collective reception is dealt with in an essay by Wolfgang Kemp, "Quantität und Qualität: Formbestimmtheit und Format der Fotografie," *Foto-Essays zur Geschichte und Theorie der Fotografie*, Munich, Schirmer/Mosel, 1978, pp. 10ff.

17. Arvatov, *Kunst*, p. 43.

18. The two essays that trace the history of photomontage in the context of the history of photography and the history of emerging advertising technology are Robert Sobieszek, "Composite Imagery and the Origins of Photomontage," Part I and II, *Artforum*, September/October 1978, pp. 58–65, and pp. 40–45. Much more specifically addressing the origins of photomontage in advertising techniques is Sally Stein's important essay, "The Composite Photographic Image and the Composition of Consumer Ideology," *Art Journal*, Spring 1981, pp. 39–45.

19. Gustav Klucis, Preface to the exhibition catalogue *Fotomontage*, Berlin, 1931, cited in Dawn Ades, *Photomontage*, London/New York, Pantheon, 1976, p. 15.

20. Anonymous, *Lef*, no. 4 (1924), reprinted in *Art et Poésie Russes*, Paris, Musée national d'art moderne, 1979, pp. 221ff (my translation).

21. El Lissitzky, "Unser Buch," in *El Lissitzky*, pp. 357–360.

22. Yve-Alain Bois, "El Lissitzky: Reading Lessons," *October*, no. 11 (Winter 1979), pp. 77–96.

23. Lissitzky, *Katalog des Sowjet Pavillons auf der Internationalen Presse-Ausstellung*, Cologne, Dumont Verlag, 1928, p. 16.

24. Lissitzky, *Proun und Wolkenbügel*, Dresden, VEB Verlag der Kunst, 1977, p. 115.

25. Lissitzky, "Der Künstler in der Produktion," *Proun*, pp. 113ff.

26. For a detailed description of the history and the procedures of the work for the *Pressa* exhibition design, see Igor W. Rjasanzew, "El Lissitzky und die *Pressa* in Köln 1928," in *El Lissitzky*, exhibition catalogue, Halle (GDR), Staatliche Galerie Moritzburg, 1982, pp. 72–81.

27. Rjasanzew, p. 78.

28. Cited in Rjasanzew, p. 79.

29. Hubertus Gassner, *Rodchenko Fotografien*, Munich, Schirmer/Mosel, 1982, p. 121.

30. Christina Lodder, *Russian Constructivism*, New Haven and London, Yale University Press, 1983.

31. Sergei Tretyakov, "From the Photoseries to the Long-Term Photographic Observation," in *Proletarskoje Foto*, IV (1931), 20, reprinted in German translation in *Zwischen Revolutionskunst und Sozialistischem Realismus*, ed. Hubertus Gassner and Eckhart Gillen, Cologne, Dumont Verlag, 1979, pp. 222ff.

32. Lissitzky, *Proun*, p. 135.

33. Theodor W. Adorno, Letter to Walter Benjamin, London, March 18, 1936, reprinted in *Aesthetics and Politics*, London, New Left Books, 1977, pp. 120ff.

34. Herta Wescher wrote in 1968 in her history of collage that P. M. Bardi's work *Tavola degli orrori* had been modeled upon Lissitzky's montage work published in Western journals. For Paladini, Wescher argues, the relationship was even more direct since he had been born in Moscow of Italian parents and had developed a strong interest in the Soviet avant-garde. In response to the exhibition of the Soviet Pavilion at the Venice Bienale in 1924, he published a study *Art in the Soviet Union* (1925). See Wescher, *Collage*, Cologne, Dumont Verlag, 1968, pp. 76ff.

35. Gustav Klucis's first version of the photomontage poster in 1930 reads, "Let us fulfill the plan of the great projects," and it was an encouragement to participate in the five-year plan of 1930. The second version of the poster is identical in its image of an outstretched hand which in itself contains a large number of outstretched hands and an even larger number of photographic portraits, but this time the inscription exhorts the women of the Soviet Union to participate in the election and decision-making process of their local soviets. This poster seems to have also had an influence on John Heartfield, who transformed Klucis's outstretched hand into an outstretched arm with a fist, giving the salute of the Communist International under the slogan, "All fists have been clenched as one," on the cover of the *AIZ*, no. 40 (1934). Here, as well as in Klucis's and Terragni's work, the image of the masses is contained in the synecdochic representation. In Klucis's and Heartfield's photomontages it is, however, the synecdoche of the human body as a sign of active participation, whereas in the Terragni montage it is the synecdoche of the machine that subjugates the mass of individuals. The inscription in Terragni's photomontage mural reads accordingly, "See how the inflammatory words of Mussolini attract the people of Italy with the violent power of turbines and convert them to Fascism."

36. Kemp, *Foto-Essays*, p. 14.

37. Stepanova, "Photomontage" (1928), English translation in *Alexander Rodchenko*, ed. Elliott, pp. 91ff.

38. O. L. Kusakov, "Die soziale Bedeutung der Fotomontage," *Sovetskoe Foto*, Moscow, 1930, no. 5, p. 130. Quoted from the German translation in *Zwischen Revolutionskunst und Sozialistischem Realismus*, pp. 230ff.

39. Gassner makes a first attempt at assessing these facts with regard to Rodchenko's career at large in his doctoral thesis on the artist, *Rodchenko-Fotografien*, especially pp. 104ff, and n. 475. The problem is, however, that he seems to base his information on the working conditions at the White Sea Canal and the number of victims on the "testimony" of Alexander Solzhnytsyn's writings, clearly a source that would have to be quoted with extreme caution in a historical study. The main work on Lissitzky's, Rodchenko's, and Stepanova's collaboration with Stalin's State Publishing House remains to be done.

40. Edward Steichen, "Commercial Photography," *Annual of American Design,* New York, 1931, p. 159.

41. Christopher Phillips, "The Judgment Seat of Photography," *October,* no. 22 (Fall 1982), pp. 27ff, provides detailed information on Steichen's history and practice of exhibition design at the Museum of Modern Art in New York. Allan Sekula's essay, "The Traffic in Photographs" (reprinted in *Modernism and Modernity,* Halifax, The Press of the Nova Scotia College of Art and Design, 1983), gives us the best discussion of the *Family of Man* exhibition by Steichen and also touches upon the issues of exhibition design in general.

42. I am grateful to Christopher Phillips for providing me with this information and for his permission to quote from his private correspondence with Herbert Bayer, as well as for his lending me the brochure itself. *Deutschland Ausstellung 1936* was also published as an insert in the design magazine *Gebrauchsgraphik,* April 1936.

"The Artist and the Machine" 1932

PAUL T. FRANKL

Paul Frankl addresses the question of the place of the creative artist in a machine age and argues that until the turn of the twentieth century, art always served some practical utility. He says that the mission of contemporary fine artists is to help control the machine by becoming a new kind of artist, a designer to be precise, who will bring aesthetic research and experimentation into industrial processes.

This is one of many surveys of the political role of the artist as understood in the early 1930s. Once again, certain facts are adjusted to suit the spirit of the age. The desire to assign a populist, instrumental role to the artist was deeply felt in the early 1930s as part of the utopian impulse of the era. The events of the Depression had not yet overtaken this impulse, and the political hazards of the early 1920s had already seemed to vanish. Within two years, however, they would reappear again, even more venomously. Afterward, as the world passed into the threshhold of the Second World War, the history of art and the machine from 1900 to 1932 would again have to be revised.

* * *

"To me, the depths and refinement of mathematical and physical theories are a joy; by comparison, the æsthete and the physiologist are fumblers. I would sooner have the fine mind-begotten forms of a fast steamer, a steel structure, a precision-lathe, the subtlety and elegance of many chemical and optical processes, than all the pickings and stealings of present-day 'arts and crafts,' architecture and painting included."
—OSWALD SPENGLER, *The Decline of the West.*

That preference is what makes our Machine Age what it is. It is a revulsion of feeling that may lead to perversion. But it is true "that the industrial arts have been undergoing a change of type, such as the followers of Mendel would call a mutation." So Thorstein Veblen asserted in *The Theory of Conspicuous Waste.* In the course of this mutation the workman and his part in the course of industry has suffered as great a *dislocation* as any of the factors involved. Among the "workmen" in the industries of the handicraft eras, the most important was undoubtedly the craftsman, the designer to whom we owe the enduring beauty of the finished product. The designer stood in immediate, personal relationship with both the clients and the craftsmen who carried out his orders.

The industrial revolution and the replacement of handmade goods by machine-made products have destroyed this relationship. They have divorced the designer from his ultimate client no less than from the artisans—now become complicated machines—who formerly did his bidding. In previous ages, the designer mastered his tools. Nowadays those tools have, in a sense, become his dictator. Whereas in earlier centuries the artisan was primarily interested in the beauty and integrity of his creation and in his tools only in so far as they were instrumental in the achievement of his purpose, the engineer of today is first and foremost interested in the development of the tool—*viz.,* his machinery—toward the end of ever-increasing *quantity* production. The tool (machine) is his creation. His creative genius is not expressed in the product she produces, but in her ability to produce and to reproduce. The perfect machine is his aim—perfection for its purpose. To the engineer it is immaterial what form or color the final product may be. Creative impulse in the industrial arts has suffered a distinct split. On the one hand, we have the engineers and scientists; on the other the "fine art" artists, who have been cast adrift "on their own."

The great problem that confronts our civilization at the present moment is this: *Can the creative artist be reintegrated in the machine process?* What is the artist's place in our civilization? Is he a vital factor in the process of machine multiplication? Is this reintegration necessary and desirable? If it is, how is it to be effected? It is my aim in the present chapter to answer these questions.

From the outset of the Renaissance, the designer was not merely an artist, he was an industrialist and tradesman combined. In business for himself, he conducted a shop and directed the activities of a numerous staff of artisans and apprentices. He enjoyed none of the excessive prestige he claims today. His trade was often handed down from generation to generation, as notably in the great dynasties of armorers and makers of the Limoges enamels. In his shop might be carved chests or *cassone,* on the panels of which—incidentally—were painted master-

pieces of Italian art! Or he might be called in by the Medici, as was Paolo Uccello, to devise martial decorations for the walls of specified rooms. He prided himself no less upon sound materials and the good workmanship that came out of his *bottega* than upon the excellence of his designs. Wedding-chests, jewelry, armor, tapestries—these were primarily the stock-in-trade of the artist-craftsman. In these shops or factories, after years of patient apprenticeship, the best craftsman won the privilege of painting pictures and of sculpturing statues. Upon these today rests the enduring glory of that great creative blossoming of beauty.

Until the nineteenth century, almost, it would have been inconceivable that the painter should be divorced from his crafts. Even architects were primarily engineers, preoccupied with problems of stress and thrust and strength of materials, rather than of "style" as superficial aesthetic ornamentation.

Let us recognize that our period—the Machine Age—is practically the only one in the long history of humanity, during which there has been so sharp and distinct a division between the "industrial arts" and the so-called "fine arts." This division has worked to the detriment of the full and satisfying maturing of the creative spirit. Turn again to the Renaissance, that epoch which best exemplifies the flowering of the creative impulse in literature and painting. The great painters of that period were not primarily painters; they were goldsmiths, medallion-makers, engineers, and, sometimes, bad architects.

Their delicate tools, became in their hands as musical instruments in the hands of virtuosi. Were not Pollaiuolo, Botticelli, and Verrocchio schooled as goldsmith apprentices? Was not Pisanello a maker of medals? Was not the great Leonardo first and foremost an inventor and an engineer, interested in great projects of military construction or in probing like a scientist into the mysteries of nature? "Fine" art was incidental. It was the bud that flowered from a tree solidly planted in the earth of everyday life and labor.

Most of the great works of art we admire today were "commercial" art when created. Not because he submitted an "artistic" rendering, but because of his scheme to erect the scaffold of this daring, wide span, did Brunelleschi win the reward for his design of the dome of Santa Maria dei Fiori. Brunelleschi's audacious plan, based on the most advanced knowledge of engineering, filled all minds with unbounded enthusiasm. Every great blossoming of architectural activity, like the Gothic centuries, went the limit of engineering knowledge in the methods of construction. *Structural daring always becomes in the end aesthetically most satisfactory.* The architect who is not at the same time an engineer is merely a "paper" architect trimming the Christmas tree.

The advent of the machine has created an unprecedented situation. In "dislocating" the working class, mechanization of industry has to a

far greater extent dislocated the artist. He, poor wight, is left high and dry to his own devices, his own personal and often irrelevant "self-expression." Has the engineer taken over with him the only truly creative power which, in centuries past, found its outlet in the "fine arts"? This is not beyond belief. Indeed, we find a critic in the London *Times* asserting that it is next to certain that neither Michelangelo nor Leonardo da Vinci would have been an artist in the conventional sense at the present day—or even an architect, as the term has come to be understood, though both might have been engineers. The contemporary demand for engineering absorbs a wider range of faculties than that for architecture, this English critic is convinced. To him architecture has come to mean little more than putting a good face on things. "Most probably they would have been engineering architects of a kind which false conceptions of both engineering and architecture have so far prevented from evolving."

It may be, the same critic suggests, that art, in the true sense, has faded out of such things as pictures and statues, and masquerades today in what we call engineering—"that with our eyes fixed on the mortal forms which pass we are overlooking the essence which never dies." Moreover, from time to time the activity we call art has been, or appeared to be, a form of magic, an aid to religion, the servant of history, a pander to vice, an advertisement of prosperity, a guide to conduct, and finally, a "free and disinterested activity." Ignoring for the moment minor fluctuations in the relationship, it would seem that up to a certain point in history, art served some practical utility, material or moral, and then, for some reason, it became emancipated—the ratio between the free and the utilitarian phases being about a hundred and fifty to several thousand years.

The conception of fine art as a "free and disinterested activity" with no responsibility save that of self-expression has come into existence only in our modern world, with the divorce of the professional artist from industry. No longer is the work of art called into being by the pressing and immediate exigencies of life. It aims to satisfy no everyday necessity, but only at awakening some lively emotion—be it pleasure, curiosity, or vicarious pleasure. It is not made to answer any pressing demand. Most often it is merely a skilled performance in technical accomplishment, and, as such, engrossing only to the averted and sophisticated followers of that particular sport.

The very words *art* and *beauty* have become catchwords to which the public, with orthodox and hypocritical piety, automatically reacts. They intimidate us just as we are intimidated by flag-waving in wartime, and "Mammy" songs in movies. "Art" is a club with which one can beat the uncertain into submission. Until recently, as Clutton-Brock pointed out, the great mass of people believed that all ornament is beautiful, and

that without it nothing could be beautiful. But we know now—at least most of us, I hope—that when ornament is plastered on any object to conceal cheapness of material and the faults of design, it can be nothing but added ugliness. Most people accept ornament as a substitute for that beauty which can only come of good design, material, and workmanship. They fail to recognize these things when they see them, except in objects like motor-cars, which they prefer plain because we do unconsciously enjoy their real beauty.

There can be slight doubt that this division of labor, this dislocation, was brought about by the industrial revolution, and the substitution of the machine-made for the hand-made. In the nineteenth century, the machine exercised a blind power of endless and incessant proliferation, overriding conscience and consciousness. It was a veritable dinosaur without ethical or æsthetic sense. This fact explains that universal disdain of the "machine-made" which persists to our own day. To the earlier exploiters of machinery, greedy for gain, it never occurred—even though the process was already in operation under their eyes—that the rapid evolution of machinery in complexity required a corresponding evolution in the skill and discipline of the men who controlled it.

Every new invention, every population change, every sweeping economic advance of any sort, inevitably upsets this equilibrium of æsthetic ideas. Certain minds are likely to be affected unfavorably, and through them, in a widening circle of interdependence, other relationships and opinions are dislocated. Nevertheless, our minds love their ruts as our bodies do their habits.

In the earlier ages, when men needed few things, they expended both the time and the energy to make those few things beautiful—that is to say, to mold them into shapes which alone satisfy the instinctive demands of our nature. But during the nineteenth century the well-to-do suddenly acquired a passion for desiring many things without any corresponding aptitude to attain beauty at an equally rapid rate. Consequently, all their things were ugly...."In the nineteenth century the artists who cultivated beauty were merely dreamers, with no organic relation to their age; they were kept as pets, in the same way as at that time canaries were kept in cages, and often proved tyrannical, as pets will."[1] So Havelock Ellis pointed out more than a quarter of a century ago.

The creative impulse cannot develop and mature in the prison of the cage. If he is to leave the imprint of his talent upon the civilization of his time, the creative stylist must function in a real world with real problems. He cannot exist forever in a realm of caprice and irresponsibility, battening on the flattery of puerile admirers. Yet such has become more or less the lamentable position of the "pure" artists of our century. Has it not been this childish vanity which has led the astringent analyst

of civilization, Oswald Spengler, to declare that "in any shareholders' meeting of any limited company, or in the technical staff of any first-rate engineering works, there is more intelligence, taste, character, and capacity than in the whole music and painting of present-day Europe."[2] An exaggeration—maybe. Yet who can doubt that, bereft of his logical position in the social organism, the creative artist, adrift in the clouds above a world where success is measured by popular acclaim and expressed in bank accounts, must automatically degenerate into a "sport"—a botanical specimen, deprived of sunlight and soil that organic health demands?

Artists are compelled, as Spengler expresses the situation, "to produce something for the market, something that will 'catch on' with a public for whom art and music and drama have ceased to be spiritual necessities...Today we have only these superfluities, and ten thousand of them, working art 'for a living' as if that were a justification!" Who can honestly reject Spengler's condemnation of all the theoretical babble, the pretentious fashionable artists, those "weight-lifters with cardboard dumbbells?"

No wonder that in ever-increasing numbers honest artists, seeking real expression for potent creative personalities, are today rebelling against imprisonment in the "art" cage. Intolerable to spirits truly and energetically creative have become the unreality and the loneliness of that caged existence—the condescending patronage of the rich, the ignominy of misunderstanding, the endless repetition of the same lyric, the neurotic disease of existing only in a world of one's own creation. They prefer to share the workaday world of their fellow men, to jostle each other in the democracy of communal effort; to work for a more visually satisfying world. A more manly attitude than dwelling in the ivory tower or the canary cage, praised but restricted in the exercise of one's powers!

Hence we find a new type of artist emerging, an artist who speaks a new language and seeks a new direction for his talents. My friend Lucian Bernhard has aptly expressed it:

These men believe that a tin container should be as carefully designed as a precious jewel-case, and that all commodities, whether they fall into the luxury or the everyday class, should be so considered....The ideal artist of this sort should combine in himself the eyes of a painter, the sensitiveness for shape of a sculptor, the love for materials of a craftsman, the feeling for construction of an engineer, together with a knowledge of the æsthetic possibilities of new materials. He differs from the 'fine arts artist' very decidedly; he seeks no escape from life. He is not interested either in portraying existing beauty he finds in nature or in picturing his dreams on a canvas. Quite on the contrary, he wants his dreams to come true; he wants to build up a new world where every little thing is pleasingly shaped

and which tells not only of efficiency, but of love and care as well, such a world as existed for centuries in old China before the big wall was broken down by the inferior European civilization. He is a lover of life in all its phases—he knows how to appreciate the natural beauty of a stone and how to bring out the intrinsic æsthetic quality of a sheet of cork or a plate of steel.[3]

Designers who accept the new world of the machine share little of the Utopian spirit of the idealist who, with blue eyes fixed on supramundane peaks, seeks to escape from workaday reality. Nor do they shirk the foundation facts of modern life. They do not indulge the view that machinery, "a vulgar, vile affair," has caused all our modern ills. Like adults, they face the fact that steam and electricity, printing-press and typewriter, can endure and are capable of true service. They have a larger vision which perceives that the disease of modern design and creative expression is due not to machinery, but to imperfect comprehension of its hidden potentialities. They see that if modern design is frankly conditioned by the special capability of the *de facto* agent of production, fine art and craftsmanship are now quite compatible with machine-made goods. The chief obstacle is the still uneducated taste of the manufacturers as well as the public and the distributors. But the designer whose goal is efficiency, to whom perfect integrity in every detail is sacred, to whom the material in which he works possesses a personality to be humored, to be explored, and to be used to its finest possibilities, such a designer must make things which in honesty and dignity and fitness will make the house or the city that holds them beautiful. If in everything he does he grapples with a vital problem, if he perfects and invents with the aim of making his work sound, lucid in thought, significant in form, and stimulating in character, he is to be deemed a truly creative artist.

The union of the artist with the machine-process may become the most significant event of the next century. Vision and imagination are required by the artist, engineer, manufacturer, and business man to be successful. Analysis and calculation do not make the poet as they make the mathematician. But the alliance that is creative is yet to come. Formidable obstacles must be overcome. The artist trained in art schools or academies is as helpless today in the industrial arts as an explorer armed with a map of Hollywood would be at the North Pole. Most contemporary artists are still too egotistic, too lacking in self-discipline, too deficient in diplomacy, to adjust themselves to the delicate complexities of this new situation. Often they are apt to overestimate their importance to the manufacturer, just as the manufacturer most often is inclined to undervalue the necessity of their cooperation. Yet great industries will develop and serve their own need, as the automotive

industry already has, by way of developing their own designers and stylists, rather than calling dictators from without.

During the nineteenth century art ceased to be what it has been through all the great periods of history. No longer an expression of our relation to God and the universe, it must now be stated in terms of nature; it must now become a mere enhancement of bourgeois prosperity. There will always be a place in the world for the great creative artists who are not conditioned by the material facts of life—mystics of painting and the lyricists of color. But these creators are few and far between. Moreover, in the vital sense, art is not exclusively limited to their activities. Beauty invariably grows out of the fundamental soil of communal life. It cannot be confined to the virtuosi. So, already, we find tangible evidence that as the development of machinery is achieved on its main lines, as the purely mechanical side of life becomes more and more automatic, an immense and increasing amount of energy is being released for finer ends. Freed from the fetters it has worn, the instinct of beauty is reviving with increased vigor under our own eyes. For the moment its suppression has been inevitable as the condition of its healthy growth. Encouraging signs of this new and significant alliance between art and the machine are evident to all observant eyes.

Certain basic points must be emphasized. Art consists of much more than the mere following of rules or the application of certain formulæ and prescriptions learned from science. Technique—even machine technique—may be learned, but not art. Art is not a matter of intellect; it begins where intellect leaves off. Even if all rules applying to art were known, merely to follow them would not produce a work of art. All slavish copies, even when the same means are employed, remain hollow and lifeless. Nor does mere novelty spell progress. What appears original today may be commonplace tomorrow. If it reveals no inherent merits, it cannot stand the strain of continuous repetition.

The creative artist must bring a vision, unique and valuable, to machine production. How is this vision to be incorporated? The old conception of the artist as an individual of eccentric and egocentric characteristics, hidden away in an obscure, untidy studio, handicapped by lack of facilities, and merely tolerated by his clients, must give way to efficiently farsighted research capable of anticipating the designing problems of tomorrow. The new artist must be equipped to foresee and solve them. Thus only may be justified the confidence placed in him.

This artist is as essential to mass production as the scientist or the research analyst. Now to all who are studying twentieth-century industries it is evident that during the last decade research and experimentation have progressed as never before. The number of industrial organizations maintaining research facilities has more than doubled. Another important development is the increasing amount of research

work conducted in universities and technical institutions. This research is directly sponsored and financed by industrial organizations. Manufacturers are combining their efforts by maintaining organizations engaged in laboratory experimentation and development work, in addition to market studies and business research. This tendency, incidentally, speaks highly for modern business methods. Cooperation and exchange of ideas are displacing secrecy and distrust, and a great amount of unnecessary duplication is thus avoided.

As a result of this research, important discoveries are made from time to time, discoveries that justify a large investment of capital. Thus, more than a fifth of the total income received by General Electric was for electric apparatus which only ten years ago was either unknown or of negligible commercial importance. Reference to the radio industry and invention has been so wonderful that the word "impossible" is gradually being eliminated from the vocabulary. Limitations imposed by time and space are being pushed back.

By such activities the ordinary man is being relieved from toil and drudgery, and is attaining a higher standard of living, with increased time for leisure and for the enjoyment of the better things in life. Yet few organizations have been wise enough to give experienced designers a free hand for æsthetic research and experimentation in design. This is the crying need at the present moment.

Industry is also gradually learning that curtailment of research activities during times of adversity is as weak a policy as cutting down advertising during a business slump. If such activities in a time of prosperity return full value for money invested, discontinuance during a period of depression, when every avenue for income should be left open and every chance of adding to the profit should be exploited, is nothing short of folly. Not long ago a general order to cut expenses would result in the immediate suspension of research and investigation work. Today this policy is discarded. Some concerns even go so far as to meet such conditions with intensified research. A great amount of purely scientific investigation is undertaken by many of the larger industrial organizations in the United States. Sometimes the returns from this work may be difficult to find in the financial statements, but nevertheless, this addition to human knowledge is usually converted into cold cash where no such returns were expected.

Yet, with few exceptions, the æsthetic quality of much that is offered to the ultimate consumer is so deplorable in design and style that the question bites acidly our consciousness as to whether all this research and effort has not been in vain. Many who are thus encouraging scientific research countenance by indifference the lamentable practice of piracy of design. The manufacturer cannot offer as a valid excuse that there is any dearth of genius and talent. What is lacking is coordination

and preparation. Few art students are equipped to enter modern industries. As a rule they obtain not the slightest conception of its processes and its aims. The artist today is encouraged by the critics to assume an air of condescension toward commerce, or to restrict his negotiations with the art dealers, rapacious middlemen of notoriously low ethical standards and questionable methods.

The only possible vindication of machinery as the instrument of true civilization must be in our complete mastery of its powers and the full realization of its innate potentialities, æsthetic as well as material. This realization is impossible without the reintegration of the creative artist in the industrial process.

Notes

1. Havelock Ellis, *Studies in the Psychology of Sex,* New York: F. A. Davis Co., 1905.
2. Oswald Spengler, *The Decline of the West,* New York: Alfred A. Knopf, 1926.
3. Lucian Bernhard, *Advertising & Selling,* January 8, 1930.

"Art and the Machine: Background in Art and Industry" 1936

SHELDON CHENEY AND MARTHA CHENEY

Sheldon and Martha Cheney trace the antecedents of industrial design in the way that "men, machines, and money" combine with the modernist aesthetic, that is, with abstract art as the theoretical foundation for contemporary industrial design. They regard Cézanne and Picasso as the prophets of artistic investigation into abstraction for all the arts. They describe how this aesthetic simplifies relationships within an object down to the essential elements of the use of basic materials, primary color, different textures, and so on.

This document questions one fairly rigid assumption about modern art that has been repeated for generations concerning the emphatic separation of design from studio art, defining one as commercial necessity, the other as an experimental journey. This assumption also is institutionally based, since museum curators and art historians often are expected to assign priority to gallery art over design. But in the frame of social history, such hierarchies are difficult to sustain, because there are so many business details and political necessities that shape the working conditions and privacy of any working artist.

* * *

No new art comes into being without its own legitimate ancestry. This may be outside the traditional art stream. Historically, in fact, significant new movements appear as revolt against traditional theories and practices persisting after the life blood has drained out of the forms they produce. If American industrial design is such a significant new manifestation; if it has arisen as we assume where technological evolution within American mass production united with abstract art; if it is

aesthetic expression grounded on functional mechanized form, then its antecedents are to be sought along two lines of influence:

1. The machine itself, regarded as a marvelous phenomenon, a new tool epochally brought to man's service, understood first as an instrument of material power, and then increasingly as symbol of a new universally applicable way of life.
2. A new art spirit and a contemporary aesthetic, made manifest in so-called Modernist art in the half-century from 1880 to 1930—a spirit and an aesthetic which were themselves a revolt against current realistic painting and sculpture and the accompanying crafts movements.

In the process of even a brief survey of the two main influences, the first misconceived art as "applied to" the machine and machine products is revealed as a mere dead-end product, a phase of nineteenth-century deteriorated eclecticism, making no significant contribution to the development of art or the machine, though evidences of it persist in practice and in products throughout everyday life. Students of industrial design can dismiss the alien ornaments applied to conceal the nature of stoves and radios.

We now generally accept the machine's coming as a major evolutionary advance. The wonder of the machine need no longer be stressed. The thrill felt in its harnessed power, the admiration for its marvelously precise functioning, its adaptability, its capacity for multiplying commodities, are part of a common experience. We even begin to be surprised that poets and artists could not earlier see in the machine materials for epic literature and for an art fresh, strong, and vital, forgetting that the processes of cultural evolution are slow, that the history of industrial mechanization has been brief.

American machine industry is barely a hundred and forty years old. The practical utilization of the first wool-carding machine and the Whitney cotton gin, in 1794 and 1795, found the country "at zero," according to Chauncey M. Depew, industrialist and historian of "the first hundred years." At the opening of the nineteenth century, the building of machines had begun, and a start had been made toward industrial organization and financing. The close of the century saw completion of what we shall venture to call America's first industrial revolution. The whole period was, in perspective, one of unification of industry and science. Chronological accounts of American inventions for the century record a steady refinement of machine processes and multiplication of machine functions, a stepping up of machine speeds, and a spread of factory centers.

The water turbine, the high-pressure steam boiler, the fabrication of steel, perfection of the motor and the dynamo: these were factors.

Morse, Bessemer, Roebling, Edison were figures. Inventions, discoveries, experiments, with always greater consolidation of capital, greater efforts toward industrial expansion, with more inventions, more discoveries, more experiments following each advance, ultimately inspired that first colossal dream of the machine in which it became instrument of unparalleled material power, a national dream of an empire of steel and concrete. Men—machines—money: these were the components. There were thoughts of art but they were of a New World culture to be realized out of Old World traditions and paid for out of what the machine produced. That out of the machine itself a new world culture might come was still undreamed.

The twentieth century was to bring America's second industrial revolution, more momentous than the first and accompanied by consequences not yet fully to be grasped. It came as mass production, if we are to define mass production as arrival of everyday life at a stage where it is commonly implemented and sustained by the machine. Machine is both means and end, the giver of work and the bringer of recreation after work. The American populations, rural to the end of the nineteenth century, became predominantly urban. The era of technological advance, of machine utilitarianism, merged into what we now see as the beginning of the age of machine-implemented culture. The way had been prepared for the present acceptance of the machine as a precision instrument sufficiently delicate and responsive to take an artist product and multiply it, by millions when desirable, without obscuring the artist touch and without losing even in the millionth reproduction the artist's design integrity.

The Ford automobile affords a convenient epitome of the twentieth century in industry. It may be taken as symbol of the change in the machine's basic motivation from mass to quality. Within its story is the story of industrial design's inception. Henry Ford's now famous early aphorism that he would not give a nickel for all the art in the world was coined out of the currency of industry's realistic era, when art everywhere failed to interpret life significantly, and when buyers of the little, cheap, early automobile had still not arrived at an appreciation of the machine as beauty. His later aphorism concerning art was to come out of the new era.

The Ford automobile of 1908, meantime, gave the world its first demonstration of a fine mechanism (not so different, after all, in complexity, ingenuity, and precision, from the product of the Swiss watchmaker) mass produced by the methods which had already multiplied cheap clothes and furniture. The Ford plant perfected a system. By that system, Henry Ford became the richest man in the world, and his plant became the largest factory. More pertinent, this was the same system which, through a process of orderly evolution, created a necessity for the

complete redesign of the product to bring it up to an appearance standard. That was in 1927.

Mass fabrication of materials, mass production of parts, mechanical assembly, division of labor by specialization: these were the components of the system. But it was a system that could be employed elsewhere. Competitors came into the field, paid increasing attention to smartness of appearance, and even while charging more for their products began claiming the market established by the mechanical efficiency, durability, and cheapness of the automobile made by the Ford factories.

In 1927, at the end of the Ford plant's nineteenth year, the fifteen millionth "tin Lizzie" was completed, and the Ford plant was closed down. It reopened shortly afterward, enlarged, retooled, at a total cost reported to have run into billions. Since then, the long succession of new designs from the 1928 Model A to the 1936 have held their own in the market and on the highways, in the endless streams of long, low-hung, quiet-running, bright-colored motors. Thus, Henry Ford arrived at the end of the old era and the beginning of a new, and reversed his judgment as expressed in the earlier aphorism, substituting for it this saying: "Design will take more advantage of the power of the machine to go beyond what the hand can do, and will give us a whole new art."

Ford has shown that all mass production is crude in its early stages, and that a standard of quality is introduced gradually as the processes are perfected. Technological evolution not only opens the way thus to appearance design but permits ultimately a considerable range of models. Today's automobile buyer is given a wide choice of color and style combinations in all the lowest cost cars, because the prefabrication of interchangeable features has been perfected, where earlier the attempt to produce more than one combination would have upset the system.

To complete the story out of the experience of the one plant, it may be added that Ford went on to industrial design in the modern sense in the construction of his many factories, and even dramatized, at world expositions, the spirit of mechanized industry which is at the heart of the new art. The one example summarizes the history of twentieth-century manufacture and accounts for the machine consciousness which is one root of the new industrial design. One cycle was at an end, another initiated.

When the point was reached at which industry needed art, and artists were being found who could interpret machined industry in its own spirit, a few people remembered that an American prophet of the 1880s had asked for a new art out of engineering and out of the new building methods and materials. Louis Sullivan was far more than author of an overquoted axiom about form and function. He and Cézanne were brother prophets crying out simultaneously in the wilderness of sterile, imitative, nineteenth-century architecture and

painting. Cézanne heralded the new way of seeing. Sullivan saw the new way of *doing.*

Louis Sullivan demanded honest expression of function and of materials. He asked for *organic* building and foreshadowed today's ideal: that there is to be constructed out of industrial forms such an expression of industrial America's life as will become the American machine-age architecture. His follower, Frank Lloyd Wright, was to save the ideal from obscurity and daringly carry it on in his own architectural works, and in his insurgent gospel that has been a formative force in the field we call industrial design. In 1905, Wright pointed out that the conception of the machine as spreader of the blight of ugliness prevailed because creative artists failed to accept the machine as an instrument for producing its own legitimate and vital art. He spoke of the machine as man's peerless creative tool, and challenged the artist to new beginnings with machine understanding, machine loyalty.

Sullivan and Wright were architects. America's rediscovery of them in the 1920s came with acceptance of the machine, at last, as source and instrument of the characteristic and virile art of the age. It was particularly significant because it was now seen that the second industrial revolution was destined to transform not only the manufactured product but the building art as well. Sullivan had embodied in his philosophy an aesthetic of all things that man contrives in mass for man's uses, with only a difference of degree between airplane and ash tray, streamline train and toy cart, and vanity case and skyscraper.

More remote from the machine is that other figure that influences the designer of today's industrial products. Cézanne, a half-century ago, initiated the train of study, experiment, and practice which eventuated in the abstract art of Cubists, Constructivists, and Purists. From them our own leading designers learned directly, both the native products of American life and schools, Geddes, Deskey, Sakier, and the European-trained "radicals," Lescaze and Kiesler. Any well-informed art student will be able to point out certain common principles of form relationship and expressiveness of materials, in Sakier's plumbing fixtures and Brancusi's sculptures, in Geddes's block-unit gas stove and Mondrian's or Hélion's abstract paintings. At least one widely publicized exhibition has been planned to emphasize the commonly shared principles in abstract art and in work of the industrial-design profession. It was the "Dynamic Design" exhibition held in 1934 by the Philadelphia Art Alliance.

Cézanne's *new way of seeing* was to penetrate through to some underlying structural form of all created things. His search involved a resolute laying aside of traditional ideas of art. In his water colors he arrived at an almost abstract statement of what he saw or divined. In his oil paintings he slurred over natural elements and forms to fix an

approximation of absolute form. Above all, he gave a starting point to the Cubists, who glimpsed in his pictures a sort of mathematical statement of structure and order.

It was Picasso, however, whom we shall permanently acknowledge as the first user of machine forms and mechanical laws in living art creations. Like Cézanne, he denied visible nature as the only or chief source of pictorial materials and pushed behind aspects to find a more fundamental order for design. These two brought painting (and sculpture) to a concern with elemental form relationships. Picasso absorbed a new set of impulses and impressions out of the machine-age environment, and utilized them according to principles now recognized as underlying Modernist painting. His abstract study, "The Guitarist," might serve as an architect's drawing for assembling the elements of building construction. Commenting on this, Frederick Kiesler, in *Contemporary Art Applied to the Store and Its Display,* says: " 'The Guitarist' is almost a skeleton of horizontals and verticals, rather like a modern building of glass, steel, and brick—the strokes of the brush are carefully laid beside each other like stones, and help the building up of the picture...brush strokes are especially massed and thickened as they approach a vertical or an angle as if to support it by their weight, and to emphasize unmistakably the firmness of the composition."[1] He poses on the same page with the Picasso picture one of his own studies for window-display fixtures which were made and used, noting that both rely strongly upon the same characteristic use of horizontals and verticals.

Picasso ventured further, actually building three-dimensional forms that stand free as a building construction would, and exploring the aesthetic possibilities of sculptures where the conventional surface and texture effects (as in skin and in silk) were supplanted by the natural grain or polish of the new industrial material employed. He foreshadowed much that was done by the generation of artist-scientists that followed: in using elemental materials, in exploring the tactile possibilities of those materials and making them aesthetically expressive, and in using simple colors directly and in few values.

The effort was, in essence, the clearing away of traditional symbols that had grown sterile and meaningless, and making fresh beginnings. A new set of visual truths valid to express the new age of the machine was being realized. It had to make its way slowly against all that had been done since the beginning of the Renaissance to reduce art to a science of surface appearance; against the old conventions of perspective, truth to anatomy, the eye's account of coloring.

Alexander Archipenko, Paris-educated, Americanized Russian artist, world figure in the small group of significant abstract sculptors, is one of the most exciting connecting links between early abstractionist experimenters and today's industrial designers. He went even further

than Picasso in testing materials for basic sculptural values. He carried experiments in pure plastic composition to where, some sensitive beholders witness, they seem to live and leap till the human figure becomes an abstraction of the upward aspiring life principle, objectifying in sculptural form the mystical component in a characteristic El Greco painting. Then he turned to practical work.

Archipenko made wooden female sculptures and draped them with the latest style clothes, in one of the most arresting of those early three-dimensional window displays of the Fifth Avenue department stores. Thus, with a group of artists, he pioneered in giving the American public its first shock of consciousness that there was a new sort of creative worker busy behind the scenes, not only in art galleries but in stores. The mechanics of modern stage setting and lights and color design were employed for achieving a dramatic unification in a window. The artist set the scene as he would a play, often using a single merchandise item or fashion motif as focal point of interest. Nor was the abstract element greatly modified in these early practical applications. Several of today's industrial designers were among the artists experimenting with window staging: Donald Deskey, Norman Bel Geddes, Frederick Kiesler, Raymond Loewy. Some of the Archipenko designs are still in use, as are three-dimensional display effects by the other men.

Meantime, the Constructivists in Europe had been exploring the potentialities of basic materials in relation to such mechanical fundamentals as balance and dynamics. They experimented especially with the elements of the machine, with wheels and steel bars, and gears, and wires. They achieved constructions with so precise a sense of equilibrium and expressive rightness that the slightest shifting of a block or fulcrum destroyed the appearance of ordered form. Their discoveries in the fields of static equilibrium and kinetic forces carried the understanding of abstract art one step nearer to use in practical design.

One group was building nonutilitarian equivalents of horses—and even of human females—using industrial materials and substituting principles of mechanical construction for physiological formations. At the same time the Neoplasticists were seeking a fresh aesthetic realization out of more exact adjustments of volumes, areas, and tactile values. The Constructivists and the Neoplasticists we may today regard as experimenters approaching the problem from different angles, and prematurely cut short in their efforts everywhere by social or political upheavals. The end arrived at by the several groups was a new understanding of the relationship between pure sculptural form and industrial-design form.

In Germany, theory and experimental practice were brought together in one laboratory as has never been done in America (or any other country). At Weimar first, then Dessau, the Bauhaus group established

school and shop for tests of materials, principles, and machine tools. The various theories of abstract art were brought to focus in one sustained experiment, and mass-production machinery was called upon to prove its ability to duplicate the form creations of the dually trained mechanic-artists. In that most notable of machine-age educational experiments (unfortunately discontinued in 1931 under political pressure), three of the world's most gifted abstract painters, Kandinsky, Klee, and Feininger, sat in council with architects, with engineers, and with mechanics.

The juxtaposition is a symbol of the world development of which American industrial design as treated in this book is an instance. At the Bauhaus a new synthesis was made evident: abstract Modern art, the new industrial design, and the new world architecture were shown to be inseparable aspects of one machine-age aesthetic achievement. Whether the twentieth-century type development in painting and sculpture is called merely post- Impressionism, or, more reasonably, Expressionism, it is linked in deepest principle with the industrial and architectural design of Geddes and Lescaze, of Sakier and Neutra.

Occasionally—lending emphasis to the connection—an outstanding abstractionist painter actually steps over into the industrial field. In America, Charles Sheeler, a painter long known as a Purist, capable of creating almost unearthly beauty in the ordering of a few simple forms in space, has been turning his hand recently to experiments in coffeepot form and soupspoon form as well as to new sorts of designs for textiles.

Critics and observers hostile to abstract art would deny the identification of the Cézanne-Cubist-Constructivist development in the fine arts as one of the two main sources of modern industrial design. But even without the example of the Bauhaus, its eloquent assembly of experimental art schools and machine shops under one roof, there would be the testimony of the pioneer leaders among today's artists in industry. Deskey and Dreyfuss, Geddes and Sakier, Lescaze and Kiesler, all speak the language of the Modern art studio, and all, to some degree, have practiced in painting and sculpture. They bring the essence of Cézannism and Abstractionism to the practical job of designing for the machine. They acknowledge an indebtedness to Moholy-Nagy and van der Rohe and Lissitzky, though not audibly in the presence of industrialists who are fearful of aesthetic theory and studio talk, and likely to be nervous in the presence of "pure" art.

Considering the somewhat perilous if not anomalous position of the painter today, there is an element almost ironic in the spectacle of the industrial designer taking the results of a half century of purist experiment and turning them to his own and industry's profit.

Two apparently irreconcilable and antithetical extremes of human ingenuity meet and are reconciled in this new figure: heavy, commercial,

systematized technics and theoretical, abstract, pure art. When the definitive history is written, we believe, the chapters on background will deal with the two phenomena, the rise of the machine as a factor in civilization, and the revolution of aesthetic along the line marked out by Cézanne.

Notes

1. Frederick Kiesler, *Contemporary Art Applied to the Store and Its Display*, New York: Brentano's, 1930.

"Selling the Machine Age" 1986

RICHARD GUY WILSON

Advertising is seen as the vehicle by which the practice of the modernist aesthetic was translated to a mass audience. Wilson outlines the development of "advertising art" through the efforts and influence of artists like Edward Steichen, Moholy-Nagy, Herbert Bayer, Rene Clark, and Norman Bel Geddes. How were modernist graphics translated by the art director, the advertising illustrator, or even the character animator and movie set designer? Clearly, advertising design matured very early, and with remarkable complexity. By the first decade of the century, advertising posters displayed elements that resembled modern art (a similarity well noted in Cubist and Futurist collage, and above all in the work of Duchamp). Also, industrial logos and product displays of the period may remind the viewer of an El Lissitzky *Proun,* for example. The art of packaging a product, even in store windows, and the art of sculptural abstraction both worked off a figure-ground illusion common to all the arts of the time. This illusion is something many skilled designers like Louis Rhead, Mackintosh, and Van de Velde had known since the era of Art Nouveau (1890s), decades before techniques like streamlining and Moderne.

* * *

Advertising was fundamental to machine age America. Through it Americans learned that even if Norman Bel Geddes did not design the Chrysler *Airflow,* he approved of it. The line between industrial design and advertising was frequently very thin, and many industrial designers got their start in advertising. Advertising helped to create and popular-

ize the iconography of the machine age. José Arentz's advertisements for B. F. Goodrich brought Hugh Ferriss's *Metropolis of Tomorrow* to millions. If a person could see, it was hard to escape the impact of Otis Shepard's or A. M. Cassandre's billboard designs. Through the ephemera of a commercial culture—insurance brochures, sales catalogues, magazine advertisements, and packages: a virtual public museum of modern art—Americans learned about modern design.

In the 1920s advertising emerged as a significant formulator of public opinion and as an essential component of mass production. Calvin Coolidge, addressing the American Association of Advertising Agencies in 1926, linked the "preeminence of America in industry" to advertising, "the most potent influence in adopting and changing the habits and modes of life, affecting what we eat, what we wear, and the work and play of the whole nation." Coolidge's view was not shared by all; negative opinions about inflated product claims; misstatements of fact, and manipulative appeal were frequently aired. In spite of the naysayers, however, advertising as an institution grew tremendously and began to take on a distinctive character, claiming at times the status of an independent art form.[1]

The question of whether advertising could be really considered an art was approached gingerly by the American art establishment. Portraying commercial products could debase art. But advertising did provide employment, and some proponents claimed that through advertising public taste might be improved. The defensiveness of the artist engaged in commercial work can be easily seen in Carl Sandburg's book on Edward Steichen, his brother-in-law, published in 1929. Steichen had been an "art" photographer, a founding member of the Photo-Secession, and a frequent exhibitor at Alfred Stieglitz's gallery, "291." After World War I he became the chief photographer of the Condé Nast publications *Vogue* and *Vanity Fair*; soon he began doing advertising work for J. Walter Thompson and, in time, other agencies. Steichen's work now was commercial: celebrity portraits, abstract patterns for silk, new clothing fashion, and hands peeling potatoes for Jergens lotion. Sandburg pointed out that artists such as Michelangelo, Leonardo, and Rembrandt also worked commercially. Steichen agreed, claiming that all great art was the product of either commerce or the revolutionaries opposed to that commerce, and saying that he "welcome[d] the chance to work in commercial art...we live in a commercial age." "Art for art's sake," according to Steichen, was "still-born."[2]

Of course, not every photographer or critic agreed with Steichen's aggrandizement of commercial art. Incensed, Paul Strand denied any

value in "the passionate penetration of life gleaming on the billboard of the young Adonis who would walk a mile for a Camel!" Nonetheless, the list of artists who worked in advertising or lent their names is impressive, and includes practically all the machine age photographers, painters such as O'Keeffe and Ernest Fiene, architects such as Richard Neutra and Ferriss, and of course all the industrial designers.[3]

The concept of advertising as art was promoted by Earnest Elmo Calkins of the New York agency Calkins and Holden. Until 1900 most advertising agencies simply acted as space brokers, and copy was randomly produced by manufacturers, printers, or writers. A prolific writer and public speaker, Calkins argued that just as in the fifteenth century, the church offered great artistic opportunity, now in the twentieth century, business offered a new field for art. In 1920 Calkins helped found the Art Directors Club of New York, which through its annual exhibitions attempted to improve the status of advertising art. He also supported *Advertising Arts,* an important periodical of the 1930s devoted to promoting modern design in advertising. Modernism, Calkins felt, "afforded the opportunity of expressing the inexpressible, of suggesting not so much a motor car as speed, not so much a gown as style." Yet, he noted, advertising should never get too far ahead of the buying public. The Calkins and Holden stable of artists included Joseph Leyendecker of Arrow collar fame, Earl Horter, who used *Arts Décoratifs* motifs, and Walter Dorwin Teague, who popularized decorative borders. René Clarke—born James A. Clark in Springfield, Massachusetts—became Calkins's art director, well-known for a flat, abstract style. His design for the Snowdrift shortening can—related by one critic to Matisse's reductionism—contained pure white abstractions of boiling fat on a blue background. The package design was praised as attention-grabbing and responsible for converting many housewives from cooking fat to purchasing canned shortening. In the late 1920s Calkins established a division of "Industrial Styling" headed by Egmont Arens to provide design services for clients.[4]

Vaughn Flannery, the art director at the Philadelphia agency of N. W. Ayer & Son, also helped to promote innovative modern ads in the 1920s. Flannery hired his friend Charles Sheeler to take photographs of the Ford River Rouge complex as part of a campaign for the introduction of the *Model A* in 1927. (Sheeler also worked on advertisements for Ford, Canada Dry, and Koehler plumbing.) The Flannery Ford campaign was the first to portray a beauty and heroism in the manufacturing process in order to spur sales. The Rouge ads started a fad, as many advertisers found that industrial views could be used in popular, mass-circulation

magazines as well as in trade journals. Other Flannery advertising campaigns at Ayer included the modernist George Gershwin ads with illustrations by the Mexican artist Miguel Covarrubias, and Earl Horter for Steinway pianos. Vibrant in their Art Deco motifs, the Ayer advertisements caused considerable comment. Flannery left Ayer in 1930, but the agency continued to produce modern ads for Climax Molybdenum and for Ford.[5]

The J. Walter Thompson Agency of New York, headed by Stanley and Helen Resor, was the largest agency of the period and one of the most innovative. The Resors hired the psychologist John B. Watson in the early 1920s, although Watson later claimed his ideas on behavior modification had no value to advertising. The Resors also hired Edward Steichen, whose photographs caused a small revolution in advertising. Reflecting a cubist sensibility, Steichen's advertising photographs were composed of simple forms and backgrounds of either deep black pools, or layers of shadows. To advise clients on design and also to design some new interiors for the Thompson offices in the Graybar Building, the Resors engaged Norman Bel Geddes in 1928. All but one of Bel Geddes's pre-Depression clients came through the Thompson Agency contact. His interior design for Thompson included an auditorium and conference room complex done in the severely geometrical modernistic idiom. Round, tublike chairs in the conference room contrasted with angular, zig-zag paneling with strips of black Vitrolite glass. Wall lighting was concealed behind frosty glass and controlled by twenty-second dimmers. Radiators and air-conditioning ducts were concealed behind brass grills. Colors were subdued grays, greens, and blues, and black and white. Bel Geddes claimed the interior space was "machine-like in its efficiency, in its ability to help its occupant get through his day's work with the minimum of interference and distractions." (While Helen Resor personally was committed to modern art, her agency had to appear ecumenical: the decoration of the executive dining room imitated that of a seventeenth-century New England keeping room, with pine paneling and an iron kettle for the fireplace.)[6]

The visual shift in American advertising closely follows the development of the various machine aesthetics. Modernistic raylines and flat Cubistic forms began to appear in the mid-1920s as foreign-trained artists, both European and American, swarmed through the breach. Features of the new trend were sans-serif type, little black dots, the air brush, and dynamic symmetry. From the obvious modernistic quality of a 1928 Chrysler advertisement by the McCann-Erickson agency emerged a new, flat geometry of shape, where text was treated as block.

This same design structure was picked up by the Austin Company advertisements of the early 1930s by Fuller, Smith and Ross. These energy-charged ads, portraying the company as fully up-to-date with the machine age, helped to change the company's architectural image. A large design-build firm, the Austin Company had been stylistically conservative. The success of the modern ads, however, induced the president, George A. Bryant, to have a company architect, Robert Smith, Jr., produce models of contemporary styled structures for advertisements. From these ads, the Austin Company obtained commissions for buildings such as the NBC headquarters in Los Angeles, 1938.[7]

In quick succession and overlapping with the flat geometry of machine purity, streamlining and biomorphism also made an appearance in advertising in the early and mid-1930s. Streamlined ads generally illustrated streamlined designs, while biomorphism was applied to many different products. Leo Rackow's design for the American Car and Foundry Company booklet used a multicontoured protoplasmic shape. Sans-serif type became mandatory, and while type designs by Bauhaus artists like László Moholy-Nagy and Herbert Bayer were well-known, several American types became popular as well. Lucian Bernhard, an immigrant from Germany in 1923, designed for the American Type Founders Company a variety of sans-serif types ranging from very thin, delicate, and angular, to a heavier, rounded style known as "Bernhard Gothic."[8]

Advertising art—which includes subject, illustration, layout, and type—cannot be considered the only, or even the consummate maker of public taste and opinion. Obviously, a dialectic exists between what the public wants—and will accept—and what advertising provides. Even the best advertisement will not cause one product to totally dominate a market; many other factors are involved, including the excellence of the product and customer preference. Yet advertising does present a fantasy world wherein the consumer becomes part of a vast, nationwide, social group. Individual differences are subsumed to the group, and ideas become slogans and snappy phrases. It can be inferred that the American public was willing to accept the machine as an image as well as modern design from the great number of advertisements which either explicitly or implicitly carried these messages. Comparison of an early 1920s advertisement with one from around 1940 suggests the visual revolution America had accepted. That the country looked different in 1940 has to some degree to be credited to advertising.[9]

Notes

1. Quoted in Frank S. Presbrey, *The History and Development of Advertising* (Garden City: Doubleday, Doran & Co., 1929), pp. 619–25; Susman, *Culture and Commitment*, pp. 142–43; Stephan Fox, *The Mirror Makers: A History of American Advertising and Its Creators* (New York: Morrow, 1984), pp. 120–26. Fox's book is the best history of American advertising.

2. "Commercialism in Art," *The American Magazine of Art*, 15 (February 1924), p. 92; Carl Sandburg, *Steichen the Photographer* (New York: Harcourt, Brace, 1929), p. 51; Paul Rosenfield, "Carl Sandburg and Photography," *The New Republic*, 62 (January 22, 1930), pp. 251–52.

3. Paul Strand, "Steichen and Commercial Art," *The New Republic*, 62 (February 19, 1930), p. 21.

4. Earnest Elmo Calkins, *Business the Civilizer* (Boston: Atlantic Monthly–Little, Brown, 1928), p. 136. This book is a collection of many of Calkins's articles and speeches. Calkins, *"and hearing not—," Annals of an Adman* (New York: Scribner, 1946), p. 201. See also, Calkins, "Beauty the New Business Tool," *The Atlantic Monthly*, 140 (August 1927), p. 146; Calkins, "Art as a Means to an End," *Advertising Arts* (January 8, 1930), pp. 17–23. Leon Clark, "René Clarke," *Advertising Arts* (July 15, 1930), pp. 57–62; James D. Herbert, "Come into the Kitchen," *Advertising Arts* (April 2, 1930), pp. 30–31.

5. Ralph M. Hower, *The History of an Advertising Agency* (Cambridge: Harvard Univ. Press, 1949). Susan Fillin Yeh, "Charles Sheeler and the Machine Age" (Ph.D. Dissertation, City Univ. of New York, 1981), pp. 137–38; *The Rouge; The Image of Industry in the Art of Charles Sheeler and Diego Rivera* (Detroit: Detroit Institute of Arts, 1978), p. 11; Charles W. Millard III, "Charles Sheeler, American Photographer," *Creative Photography*, VI, no. 1 (c. 1968), n.p.; Samuel M. Kootz, "Ford Plant Photos of Charles Sheeler," *Creative Art*, 8 (April 1931), pp. 264–76. Photographs by Sheeler used as advertisements for the Ayer Agency appear in Art Director's Club, *Seventh Annual of Advertising Art* (New York: Book Service Co., 1928), pp. 18, 132. Charles T. Coiner, "How Steinway Uses Modern Art," *Advertising Arts* (April 2, 1930), pp. 1–8; *A. M. Cassandre Posters* (St. Gall, Switzerland: Zollikofer and Co., 1948), n.p.

6. *Edward Steichen* (Millerton, N.Y.: Aperture, 1978), p. 8; Fox, *The Mirror Makers*, pp. 90–94; Jennifer Davis Roberts, *Norman Bel Geddes; An Exhibition of Theatrical and Industrial Designs* (Austin, Texas: Univ. of Texas at Austin, 1979), p. 27; Meikle, *Twentieth Century*, pp. 51–52; Norman Bel Geddes, "Designing the Office of Today," *Advertising Arts* (January 8, 1930), p. 48; Walter Rendell Story, "The Decorator as a Minister of Trade," *The New York Times Magazine* (June 23, 1929), p. 19. See also, "A Modern Room for a Modern Purpose," *The American Architect*, 136 (July 20, 1929), pp. 96–102; "A Dramatic Background for Modern Business," *Theatre Arts Monthly*, 13 (September 1929), p. 712.

7. Nathaniel Pousette-Dart, "The Evolution of American Advertising Art," *Art Director's Club: Twentieth Annual of Advertising Age* (New York: Watson-Guptill, 1941), pp. 9–15; M. F. Agha, "Graphic Arts in Advertising," *Modern American Design*, R. L. Leonard and C. A. Glassgold, eds. (New York: Ives Washburn, 1930), pp. 139–40; Ray Sullivan, "Modern Layout in Advertising," *Western Advertising*, 18 (February 5, 1931), pp. 16–17; Charles Everett Johnson, *The Six Essentials of Advertising Art* (Palms, Calif.: Walter T. Foster, 1931); Interview, author with H. E. B. Anderson, Austin Company (April 23, 1984); and Martin Greif, *The New Industrial Landscape: The Story of the Austin Company* (Clinton, N.J.: Main Street Press, 1978), pp. 103–5.

8. L. Sandusky, "The Bauhaus Tradition and the New Typography," *PM*, IV (July 1938), pp. 1–35; M. F. Agha, "Sans-serif," *Advertising Arts* (June 1931), pp. 41–47; Leonard

and Glassgold, eds., *Modern American Design,* pp. 152–53; "Lucian Bernhard," *PM,* III (April 1937), pp. 33–38.

9. Michael Schudson, *Advertising: The Uneasy Persuasion* (New York: Basic Books, 1984).

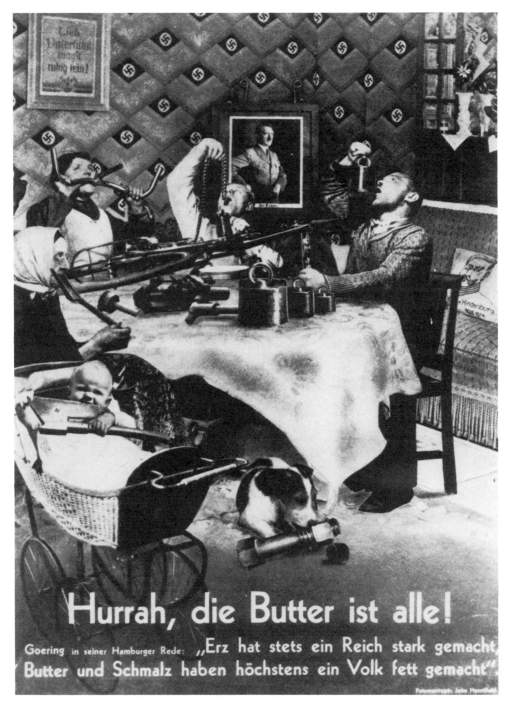

Hurrah, the Butter is Finished!, 19 December 1935 by John Heartfeld (1891-1968). Photo-montage, Photo Akademie de Künste der DDR, Berlin.

PART TWO

Modern Art, War, and Politics

Artists' careers can be utterly changed by major political crises—war, revolution, economic depression. While governments tremble or are overthrown, art institutions collapse and then are restored, but never as they were. Art markets fall; individual artists are politicized in their private lives and later in their work. A stone hits the water, and its circles continue to radiate for years afterward.

Urbanism is clearly a crisis on that scale; but in terms of lightning and thunder, no political shock hit as totally as the two world wars. Within four years, the First World War condensed what otherwise might have taken a generation. Mainstream cultural institutions were left fractured. Modern artists were thrown into political action more than at any time since the Paris Commune (1871), or even the revolutions of 1848. Gertrude Stein wrote:

> Really the composition of this war, 1914–1918, was not the composition of all previous wars, the composition was not a composition in which there was one man in the center surrounded by a lot of other men but a composition that had neither a beginning nor an end, a composition of which one corner was as important as another corner, in fact the composition of cubism.[1]

It was as if normal codes of meaning (speech, sociability, government) had suddenly become ludicrous. Robert Hughes writes:

> In the Somme Valley (site of one of the bloodiest battles of the war, with hundreds of thousands of casualties), the back of language broke. It could no longer carry its former meanings. World War I changed the life of works and images in art, radically and forever.[2]

The war left essentially two strategies for modern artists: Either to imagine their work as a phoenix rising out of the ashes, or as a glorification of the "death of art," a nihilistic rain dance on what was left of the bourgeois state systems created after 1850, and now seemingly about to fall.

Today it strikes us as curious to consider how "new" those industrial governments were in 1914 and how impermanent many felt they were. France had a "provisional" republic, begun in 1871, which lasted 69 years! The German Reich had been federated that same year and seemed still a recent power. The Austrian Empire creaked mightily and continued to fail in its attempts to modernize even the bureaucracy. The Russian Empire had been failing internationally since the era of the Crimean War (1852–1856). England still was governed by an alliance between old gentry families and powerful commercial interests; and those in power were extremely uneasy about sharing government with the "democratic" classes. For the English, the Boer War (1899–1909) damaged public morale in ways similar to the Vietnam conflict: many saw it as a prologue to imperial decline. Italy, also incorporated only recently (1848–1871), was shaken regularly by the hazards of general strike (in Milan particularly, where Futurism, not entirely by coincidence, also began).

The United States had provided a terrifying portent to industrial warfare, in the awesome destruction of its Civil War (1861–65). In the period afterward, 1865–1918, America experienced more labor violence than Russia. American cities were overwhelmed by massive immigration, approximately 40 million new arrivals within two generations. Its political movements were often held hostage to racism and ethnic prejudice.

The industrial state was still regarded as an experiment that might not survive much more economic expansion, whatever the believers in progress might say. From legal systems to simple amenities (from plumbing and lighting to social insurance and education), it seemed unable to throw itself loose of its problems. To many, in fact, the First World War came as a relief because it stopped the brewing crisis between socialism and industrial management. The struggle against a foreign enemy united political parties. Besides, many assumed it would be a short war, over in a few months, a healthy purgative and not the continental suicide it became.

Even before the war (1912–1914), there were already symptoms of political rupture. For example, a few of the radical leaders suddenly decided to join proto fascist causes. Georges Sorel, leader of the Anarcho Socialists, converted in 1913 to monarchism. Mussolini, former anarchist, became an interventionist, trying to persuade Italians to enter the war, while arguing also for a military state to overthrow the elected

government. During the course of the war, quite a few modern artists as well swung toward eccentrically conservative practice, giving up abstract art and returning to classical figurative painting.

For many, the war erased what was "artificial" about the nineteenth-century world—its obsession with clear moral boundaries and historical continuity. For a period of over thirty years (until the early 1950s), the industrial states of Europe seemed constantly on the edge of elimination.

Imagine a young male artist living through the First World War, experiencing the devastation as a draft dodger, or as a soldier angered by the meaninglessness of rat-infested trenches and profiteering back home. How might this experience manifest itself in the artist's work?

He might become involved in a comic dance of death. He might write Futurist *syntesi*, short vaudevilles about world destruction. He might organize a Dada manifestation, a mock military demonstration, with modernist poetry and radical installations.

He might become fascinated by the psychotic breaks at the front or at home (Breton's interest in Freud begun while working as a military orderly). In Paris, one strange young man named Jacques Vaché paraded in a uniform sewn as half German, half French; he went into theaters and parties playing ruthless, suicidal games with a loaded pistol, to the delight of the Parisian Dadaists, who called it "the cerebral pistol shot."

He might try to adapt prewar modernism to what remained. How should abstraction or collage operate next? Among modernists like Tatlin, Rodchenko, Duchamp, and Schwitters, in work produced from New York to Moscow, the era of the war gave permission to leave the canvas altogether. One might even imagine art as a humble craft, in a world of military waste and bad public planning. Cubist techniques, which had developed on canvas before the war, seemed easier to apply to real space, like a radical notation about industrial life, from found objects to Cubo-Futurist environments, and finally to graphic design.

Or the apocryphal young artist might simply enter the world of political action directly. Historian Helena Lewis writes:

> In the past, it was not uncommon for individual artists to become activists but with World War I, a new phenomenon appeared. Avant-garde movements committed themselves *en bloc* to political parties as enthusiastically as they espoused particular theories of art and, at least in this century, art and politics have been inseparable. In the 1920s and 1930s, it was taken for granted that art has a social content and that artists ought to work for social change. The German Expressionists took part in the street fighting in Germany after the war, demanding a proletarian revolution and, like the German Dadaists, were forced into exile when the Nazis came to power. The Futurists in the Soviet Union and Italy were also, in very different ways, politically committed. Vladimir Mayakovsky and his circle

in the USSR were dedicated to the Bolshevik Revolution, while the Italian Futurists, led by Filippo Marinetti, published manifestoes glorifying war and nationalism and some became ardent supporters of Mussolini.[3]

Surrealists (from 1922 or 1924 and after) were particularly committed to combining art practice with a consistent ideological program, but the changes in government policies in Europe created embarrassing contradictions for them. This was particularly so when both Germany and the Soviet Union, very much models for radical art/politics in the 1920s, went through frightening reversals in the 1930s. André Breton and Louis Aragon carried on extensive maneuverings with the French Communist Party and later with the politics of Stalin's Russia. In 1930, Aragon signed his name to a document published by the International Union of Revolutionary Writers which affirmed: "We wish to make clear that we believe strictly in dialectical materialism and repudiate all idealist ideologies, notably Freudianism."[4]

In 1938, Breton wrote with the Russian revolutionary Trotsky, who had been expelled from Russia by Stalin:

> If, for the better development of the forces of material production, the revolution must build a socialist regime with centralized control, to develop intellectual creation an anarchist regime of individual liberty should from the first be established. No authority, no dictation, not the least trace of orders from above.[5]

The uneasy alliance between collective social action and individual freedom characterizes most political statements and activity by artists outside of the Soviet Union, where after 1930 there was effectively no opportunity for the isolated individual voice to be heard above the collective.

In America, during the 1930s, a group of young artists (and the critics who defended them) went through a series of political conversions that helped initiate what became the Abstract Expressionist or New York School of the 1940s. Two shifts seem to parallel each other: (1) in art production, from social realism to abstract formalism; and (2) in political discourses, leftist movements in the 1930s withdrew from radical politics by 1940, particularly after the Non-Aggression Pact between the USSR and Germany (and a series of purge trials of intellectuals and artists in Moscow after 1935).

Art historian Serge Guilbaut writes:

> No longer was the interest of the leading painters and intellectuals focused, as it had been during the thirties, on the issue of the artist's relation to the masses. From social concerns the center of attention had shifted to individual concerns owing to the disappearance of any institutional struc-

ture for political action. After 1940 artists articulated individualized styles, yes, but styles that were invariably rooted in a simulacrum of the social. The artist's attachment to the public was still a central concern, but that concern had evolved and had changed targets, as it were. Whereas the target had once been the masses, thanks to such social programs as the WPA, now, with the recent growth of an open private market for art, the target became the elite. In regaining his alienation, the artist abandoned his anonymity: "Toward the late 30s a real fear of anonymity developed and most painters were reluctant to join a group for fear of being labeled or submerged."[6]

For the era between the wars, a few key terms should be noted:

1. *Agit-Prop* (agitational propaganda) refers to radical theater, and to mural (even railroad art) of the day, but also refers to a spirit of political caricature that is much more evident in the 1920s than earlier.
2. *Montage,* the juxtaposition and overlapping of visual and verbal imagery, was very widely used as political commentary, as photomontage by John Heartfield in Germany, as cinema-eye montage or dialectical film montage by Russian directors Vertov and Eisenstein, and as Futurist literary montage by the Russian poet, Mayakovsky.
3. *Defamiliarization* was the attempt to make the familiar look strange, to distance it, in order to encourage a more critical vision of the world. Versions of defamiliarization were common in Expressionist and Agit-Prop theater in Berlin (a movement led by the producer Erwin Piscator) and culminated in the plays of Berthold Brecht. The Surrealist art of the 1920s and 1930s often defamiliarized everyday objects and turned political adages into visual parody. This was not simply to evoke "the miraculous" or the dream of hyperreality, but also to reveal the problematical disguise beneath the obvious, to show how perverse the politics of the day were.

In terms of the links between politics and modern art before and after the world wars, a few more explanations follow.

Avant-garde

Avant-garde is one of the most presumptive and misapplied terms related to modern art. Originally it was a military expression, as in vanguard (front) of the army, or a corps of advance military scouts. As a literary term, *avant-garde* refers to the radical journalism coming out of liberal revolutions of the first half of the nineteenth century. Also the title of an anarchist journal during the Paris Commune (1871), *avant-garde* was not applied to the arts consistently until the 1880s. In Europe, the term suggests art engaged to radical political and moral questions; in the United States, *avant-garde* suggests more of a personal liberation from mass culture or political action and is sometimes connected with

the "sublime" and existential autonomy. The term became linked to the beatnik and antiwar movements in the 1950s and 1960s, and then seemed to get lost in the consumer blur of the 1970s. By the late 1970s, among upscale optometrists, *avant-garde* was a line of customized sunglasses advertised in fashion magazines (in the photo ads, smiling middle-class professionals enjoy feeling avant-garde).

Generally, the term is more aptly used to describe a strategy, as a way of promoting radical art, and organizing communities of radical artists.

Revolutionary Art

The achievements in the Soviet Union from 1917 until the 1930s cast a long shadow in German and French circles and were carefully reexamined by American and European artists and critics in the mid-1960s and afterward. The Soviet avant-garde before 1930 was extremely resourceful in the number of areas it developed: graphic and industrial design, cinema, theater, literary theory, poetry, and cinema. The Soviet modernists also provide a widely discussed, alternative definition of the role of the artist as a "constructor" or industrial craftsman.

The Mexican Revolution (1910–1920) left an aesthetic heritage of profound importance throughout Latin America. The work of Orozco, Rivera, and Siqueiros concentrated on the role of monumental or public art, especially the mural, and set a significant example which has been emulated but never equaled.

The November Revolution in Germany (1918) brought with it a series of artist collectives, including the Berlin Dada group (1920). Their links with mass printing and political action separated them profoundly from the Zurich Dadaists, in their use of media, their intentions, and techniques (most crucially in their use of political caricature and photomontage). The Dadaists became the gadflies of the emergent art market of the early 1920s in Germany.

The Events of 1968

Even failed revolutions, however short or humiliating, can politicize artists and intellectuals deeply, as did the revolutions of 1848, even though each of them ended up with conservative, even reactionary governments in power. In 1968, a series of radical youth movements threatened governments in France, Mexico, and China, and altered the course of politics in the United States and Japan. By the mid-1970s, although most of these political movements had run down, they left a deep mark in the arts, even in the way art is remembered.

The political failures (and enthusiasms) of 1968 were sublimated into guerrilla art movements, conceptual art, installation art, performance art, and a wide range of critical theory from structuralism to deconstruction.

In the wake of 1968, the work of modern artists of the 1920s (and modern art generally) was reevaluated, and definitions of modernism were adjusted to include more politically determined material. Film historian Sylvia Harvey writes:

> The impetus which the May events offered to the development of a radical film practice and to the critical examination of all aspects of the existing system of film production had certain consequences, also, for the development of various theories of cultural production. The desire to make a radical intervention within the existing modes of cultural production led, necessarily, to a re-thinking of the various assumptions underlying that practice and led, in particular, to a re-examination of some of the debates around the development of new forms of art which had been conducted in Russia in the decade or so following the Revolution of 1917, and in Europe in the thirties by writers like Bertolt Brecht and Walter Benjamin.[7]

After 1968, aspects of Dadaism and Surrealism were linked to the radical student movement in France in pursuit of "rejuvenated language" or subversive antiart. With this came a renewed interest among art theorists in Brecht, in Russian Productivism, in Heartfield, in French Structuralism, and in the work of German Marxist humanist critics associated with the Frankfurt School, including Adorno, Horkheimer, Benjamin, and Marcuse. The cycle concludes by the late 1970s but leaves a large body of criticism referring directly to the modernism of the 1920s and involved in the deconstruction and reconstruction of modern art, much of which is still being written.

The Other

The other is an expression for social groups given something of a backhanded compliment: honored as unique, as pure or natural while at the same time to be excluded utterly from the social practice itself. In the history of modern art, two variations of *the other* must be mentioned here.

Imperialism is a term translated more often in art history books as *primitivism,* but it is laden with racist connotations, the artist seen as primitive and free as the natives. From Delacroix's journey to North Africa in 1830, or public fascination with Byron in Greece (1823–1824), the nineteenth century is filled with references to exotic journeys by artists, journeys that offer the wild spirit of nature untouched by Euro-

pean civilization. In the art that emerges from these trips, nature tends to be embodied by exotic races, often set in regions that were not free from European civilization at all. In fact, they tended to be regions being colonized by Europe or the United States.

For a modern artist, to honor the colonial African was something of a vote of no confidence in Western culture, but it also validated the conquest of Africa, by turning masks taken by force from villages into art. It "aestheticized" these objects, much the way graffiti art in galleries aestheticized the world of the ghetto and barrio.

The art from the colonized countries was absorbed by European artists in their own work and transformed into modernism. The idea of the "primitive" could serve as romantic escape from urban realities; it became the "other" at the same time that it was being crushed and absorbed. The idea of the primitive also became a way for artists to criticize their own culture.

> The interest in the Primitive as a critical instrument—as a countercultural battering ram, in effect—persisted in a different form when early twentieth century vanguard artists engendered a shift of focus from Primitive life to Primitive art...The Cubist artist's notion that there was something important to be learned from the sculpture of tribal peoples—an art whose appearance and assumptions were diametrically opposed to prevailing aesthetic canons—could only be taken by bourgeois culture as an attack upon its values.[8]

Imperialism/primitivism is a very thorny subject. These non-European artifacts do indeed have a profound importance for modern artists, in particular as antidote to the ills of the industrial city. They also stand in for the lost landscape and for art about ritual and inner process. But they are essentially booty from the same industrial expansion that leads to world war—artifacts from markets that nations fight over.

Feminism

The woman's body signifies nature in hundreds of paintings and is the most merchandised object in modern advertising. At the same time, women artists were marginalized by modern male artists. Women's liberation has a rather tangential role in the patriarchal histories of modern art, although art criticism in recent decades has tried to rectify that problem. Obviously, there were many brilliant modernists who were women: Popova, Stepanova, Kobro, Kahlo, Hoch, and many more. But the political exclusion of women by the modern male art world stands out just as profoundly, as testimony to what women modernists had to confront in the avant-garde of the early twentieth century.

For modern artists, liberation of the woman's body in paintings and photos became one way to shock the Victorian middle class, a rediscovery of the nude as a modern subject. What was less apparent to the dominant patriarchies was the extent to which women were colonized as well, treated as landscape or like an article of nature. Art historian Griselda Pollock writes:

> From the inception of the women's movement, one of the major targets of political activity has been the representation of women in advertising, cinema, photography, and the fine arts. Art history has a particular, if overlooked, role in all this. On the one hand, art history takes as its object of study a form of cultural production and ideology—art. On the other hand, the discipline itself is a component of cultural hegemony maintaining and reproducing dominative social relations through what it studies and teaches and what it omits or marginalises, and through how it defines what history is, what art is, and who and what the artist is. For instance, the major figure in art historical discourse is the artist, the singular, solitary genius whose creativity is recorded almost exclusively in a biographical or autobiographical mode in monographs and catalogues raisonnes. This figure functions, however, as a social idea, a complement to and embodiment of the prime bourgeois myth of the universal, classless Man.[9]

Myths of the Avant-Garde and Progress

The avant-garde, which began with a link between artistic bohemias and leftist politics has gradually been depoliticized, particularly since the Cold War began in the 1950s. In the 1920s, however, the ideas of scientific progress, social revolution, and the artistic avant-garde still seemed viable. In 1922, Moholy-Nagy wrote about Constructivism and the proletariat. Before the machine, he said, everyone is equal.

> This is the root of socialism, the final liquidation of feudalism, it is the machine that woke up the proletariat. In serving technology, the worker discovered a changed world. We have to eliminate the machine if we want to eliminate socialism. But we all know there is no such thing. This is our century—technology, machine, socialism. Make your peace with it. Shoulder its task.[10]

World wars and revolutionary politics raised important issues regarding the proper role of artists and their proper audience. The increasing interdependence of the avant-garde with the commercial interests of governments, dealers, and corporations brought into high relief the question of the proper audience for art. Should artists address their work to the working class or to the moneyed middle class? Or does avant-garde

art demand a culturally elite audience? For most artists, political commitments are primarily verbal or symbolic. For the Surrealists, as an example, "the task is not one of realizing abstract ideals but of liberating human beings, beginning with a series of very concrete liberations: that of the faculties, tendencies, or elements that have been repressed, concealed, or perverted."[11] For most Western artists, the aesthetics of transcendence was, in the final analysis, a personal transgression made urgent by social chaos.

Notes

1. Gertrude Stein, *Picasso* (1938, reprinted New York 1959) p. 11, cited in Stephen Kern, *The Culture of Time and Space 1880–1918* (Cambridge, Ma.: Harvard University Press, 1983), p. 288.

2. Robert Hughes, *The Shock of the New* (New York: Alfred A. Knopf, 1980), p. 57.

3. Helena Lewis, *The Politics of Surrealism* (New York: Paragon House, 1988) IX.

4. Cited in Helena Lewis, *The Politics of Surrealism* (New York: Paragon House, 1988), pp. 105–106.

5. André Breton and Leon Trotsky, "Manifesto: Towards a Free Revolutionary Art," reprinted in Herschel B. Chipp, *Theories of Modern Art* (Berkeley: University of California Press, 1968), p. 485. Cited in Helena Lewis, p. 147.

6. Serge Guilbaut, *How New York Stole the Idea of Modern Art* (Chicago: University of Chicago Press, 1985), pp. 46–47.

7. Sylvia Harvey, *May '68 and Film Culture* (British Film Institute, 1978), p. 45.

8. William Rubin, "Modernist Primitivism: An Introduction" in William Rubin, editor, *"Primitivism" in 20th Century Art* (The Museum of Modern Art, New York, 1984), pp. 6–7.

9. Griselda Pollock, "Women, Art and Ideology," reprinted in Hilary Robinson, editor, *Visibly Female* (New York: Universe Books, 1988), p. 205.

10. Laszlo Moholy-Nagy, "Constructivism and the Proletariat," first published in the Hungarian magazine *MA* (May 1922), reprinted in Richard Kostelanetz, ed., *Moholy-Nagy* (New York: Praeger Publishers, 1970), p. 185.

11. Alfred Willener, *The Action-Image of Society: On Cultural Politicization* (London: Tavistock Publications, 1970), p. 227.

"Notes on Cubism, War and Labour" 1985

ROGER D. CRANSHAW

In early Cubist collages, Picasso and Braque often used newspaper columns. The collages were produced in the years immediately preceding the First World War, a period of considerable labor strife and uneasiness over the mounting diplomatic initiatives that led to the war, particularly the Balkan crises. According to art historian Roger Cranshaw, newsprint about these political events was aestheticized within the collages. They commented on the political wars of modern art, on the anonymity and alienation of the artist, and the need to remove decorative ornamentation from the art surface.

Many political issues can be located directly within these collages, for example, about the politics of media. During this period, nationalistic propaganda in newspapers became something of a scandal of misinformation and cover up, with mass publishing playing a central role. Like media in our era, it intercepted and virtually restaged diplomatic reports, fracturing events into simplified headlines and "plainspeak." The abstraction of political news by media was increasing at the same time that the strategies of abstraction and collage were developing in the fine arts.

* * *

I am writing at the end of 1984. The end of a preordained *annus mirabilis* in which many of Orwell's presentiments have been fulfilled, if only in the vulgar and debased form of caricature. The world in 1984 has been haunted by the fear of war.

My aim is to align the cubism of Braque and Picasso with the struggles of the French working class movement during the years prior

to World War I. In France during that period, the vanguard of the working class sought peace as the means to protect its livelihood, its communities, and its human dignity.

I wish to insist upon, and to celebrate, the naked *violence* of Braque's and Picasso's cubism. A violence aimed—through pacific action to be sure—at every preconception of the nature of pictorial production that was, and is, inscribed within the bourgeois discourse on 'Art' and its 'History'. Many writers have described *Les Demoiselles d'Avignon* as an embodiment of such a will to violence. I believe that the violence was maintained and intensified in the joint practice of Braque and Picasso until, at least, the autumn of 1912; that their violence was informed and sustained by their identification with the aims of the (potentially) revolutionary syndicalism of the French labour movement during and up to the same approximate date.

Normal art historical discourse does not attempt to account for a violence that it does not (and maybe cannot) acknowledge. Instead, Cubism in general is described as a celebration of innocence, as an optimistic art free of the anxieties born of World War I and the Bolshevik revolution. Cubism, in other words, is described as a characteristic product of 'la belle époque'. John Berger, for example, describes Cubism as the expression of the spirit of an epoch which in fact only seemed 'beautiful' in retrospect:

> Dadaism and Surrealism were the result of the 1914 war. Cubism was only possible because *such a war had not yet been imagined*. As a group *the Cubists were the last optimists in Western art*...They expressed their...*enthusiasm for the future* in terms which were justified by modern science. And they did this in *the one decade in recent history when it was possible to possess such enthusiasm and yet ignore, without deliberate evasion, the political complexities and terrors involved*. They painted the good omens of the modern world. [My emphasis throughout.][1]

I can do no better than contrast this representative example of the art historical construction of the period prior to 1914 with a typical social-historical account of the same period:

> During the immediate pre-war years the social climate deteriorated seriously. The big strikes of miners in 1906, postworkers in 1909, and railway employees in 1910 were severely repressed by Clemenceau and Briand but paralysed the economy for a time. Syndicalism even infiltrated the civil service despite government warnings of the incompatibility of syndicalism and service to the state...the foundations of society seemed to have been shaken during these years which, for the bourgeoisie, were years of fear.[2]

The same author adds, however, that: "Nevertheless, after the catastrophe of World War I, this same period became known as 'la Belle époque.' "

(Though not, one must add, simply because of the weather—that "Indian Summer"—but because it was a period of low inflation and "safe" money).

We can, it seems, disinvest ourselves of the notion that the cubists were able to express an imputed "optimism" for the future "without deliberate evasion" of social and political realities. Indeed, a new question arises, namely: to what extent does the Cubism of Braque and Picasso acknowledge the tensions and anxieties not of a "belle époque" but of the "avant-guerre"?

A version of Robert Rosenblum's paper titled *Picasso and the Typography of Cubism,* published in 1973, is prefaced by a full-page reproduction of Picasso's *Glass and Bottle of Suze* (DR523). Rosenblum argues that commentators should not remain indifferent to the 'potential verbal meaning or associative value' of the newspaper texts, advertisements, logos, and other printed ephemera that are a feature of cubist paintings. Nowhere, however, does Rosenblum choose to confront the issues raised by the contents of the newspaper columns that make up most of the surface of *Glass and Bottle of Suze.* In line with the notion of Cubism as an essentially "optimistic" art, Rosenblum describes only those uses of the printed word which contribute to a "clandestine and witty" process of punning jokery.[3]

There is nothing "clandestine" about the contents of the newspaper texts on *Glass and Bottle of Suze.* But they do serve to puncture the idea of a "belle époque" Cubism. With the exception of the text at the extreme left of the work (and the placing of the column is significant), the texts (most of which are applied upside down) refer to events taking place in the (Second) Balkan War. The 'Left' column, however, describes the staging of a large antiwar demonstration, staged by the French labour movement, to protest and to guard against the possible spread of the war by way of the system of Big Power alliances (something which was not to happen, and then with terrifying rapidity, until the summer of 1914). The demonstration took place at the Pré-Saint Gervais, during the afternoon of November 17, 1912. An arrow, which is also the rim of an 'Analytical Cubist' wine glass, points to a column heading titled 'L'ordre du jour.' The latter describes how the meeting agreed to support a policy of pacifism and international proletarian solidarity. Four days after this demonstration, which numbered between 20,000 and 50,000 people (the former according to the police, the latter according to the organisers—nothing changes!), a special congress of the Section Française de

l'Internationale Ouvrière demanded that in the event of the war in the Balkans spreading to encompass the whole of Europe, the response should be:

> ...a recourse to revolutionary means, general strike or insurrection in order to forestall the conflict and to seize power from the ruling classes who would have unleashed such a war.

The Confédération Générale du Travail also held a conference in November to consider "the organisation of the resistance to the war," and was committed "in the case of war between the powers" to respond with a "revolutionary general strike."[4] In this context, when the fear of war was, in the words of Jean Jaurès, a "spectre rising from its grave every six months to terrify the world," it is surely permissible to suggest that in *Glass and Bottle of Suze*, Picasso invites us to drink to (the wineglass/arrow) an "ordre du jour" which embodies a commitment to proletarian internationalism, antimilitarism, and world peace. Indeed, one can force the issue in order to counter the notion that the painting is merely a celebration of bohemian café society: Suze is an apéritif concocted from the herb "gentiane" (as the label on the painting tells us). The herb, according to Pliny, was named after Gentius, king of Illyria (i.e. the name given to the Balkan states in Classical times). Are the events that the texts on the painting refer to an "apéritif", an "opener," to war or to revolution?

Several other less complex works from the autumn of 1912 use newspaper cuttings which refer to the Balkan war, all of them by Picasso. Picasso's pacifism in later life has been widely chronicled, and we also know that he was associated with anarchist and syndicalist circles in Barcelona and in Paris. We can, then, begin to construct an argument which suggests that, for Picasso at least, the will to violence which was the decision to make Cubism was motivated in part by identification with the aims and ideals of the French labour movement during the "avant-guerre."

When we attempt to situate both Picasso and Braque on the broad spectrum of often antagonistic political views that characterised the extremely volatile world of petty-bourgeois bohemian opinion during the period, it becomes clearer that, *whatever* their personal opinions may have been, the two men would have been situated on the "Left" of the political divide, in a world where the political "Centre" had collapsed. This is especially the case if we consider the nature of Braque's and Picasso's relationship to the art market. Their dealer, that is, was—in the eyes of the political "Right"—a combination of "the enemy within" and "the enemy without." Daniel Henry Kahnweiler was Jewish and German. Not only was he a member of the two main 'race enemies' of

the French "family," according to the perverted doctrines of the pro-
tofascist groups that clustered round Charles Maurras and Action
Française, but he was also—as was Picasso—a *métèque,* a foreign
worker.

But in a much more intimate and immediate way the relationship
of Braque and Picasso to Kahnweiler would have encouraged them to
redefine their role as "artists," and in so doing to identify themselves as
"proletarians." By 1912, Kahnweiler had become the sole purchaser and
agent of the total oeuvre of Braque and Picasso. By 1912, the two
painters were no longer using their dealer as a vendor (maybe among
others) of particular works. Instead, they were selling to a single agent
the total control of their labour-power as artists, and were doing so for a
period of three years. Such a dealer-artist relationship was sufficiently
novel that we can suggest that Braque and Picasso may have situated
themselves in the ranks of "alienated labour" quite self-consciously. That
they did so is confirmed by Kahnweiler himself, who remembered that:

> ...at the end of the month...they were coming to get their money. They
> arrived, *imitating labourers,* turning their caps in their hands: 'Boss, we've
> come for our pay' [My emphasis throughout.][5]

What did it mean to be a pacifist, to be situated to the 'Left' of the
political divide, and to identify oneself (however playfully) as a 'worker'
in 1912? Annie Kriegal says that:

> ...one cannot present anti-militarism of the period before 1914 as a mar-
> ginal current of some dreamers and déclassés; quite the contrary, anti-
> militarism is at the heart of the political thought of the world of labour.[6]

It would appear, then, that the situation of Braque and Picasso, in
1912 and probably for several years previously, coincided with what Tim
Clark has called "the meanings of the dominated." But what were the
effects of that coincidence?

The violence of their practice is the answer. A violence contained
and intensified by their remorseless silence. Braque's and Picasso's
refusal to speak, to explain, their Cubism was itself a sign of their refusal
to signify those objects, concepts, themes and values deemed to be
significant within the bourgeois art historical discourse. This is not the
place to explore the full extent of their refusal, but I will mention three
elements of it which are particularly relevant to my argument.

Anonymity: against the demand that the work of art should signify the
integrity of the creative consciousness of an individual artistic subject,
Braque and Picasso posited a joint practice which aimed at anonymity

(Braque made this clear in several statements made after the cubist period, he also said that their decision not to sign their canvases was deliberate and programmatic). The principle of anonymity had a specific resonance in the tradition of "Left" avant-gardism in France. It certainly played a part in the development of Neo-Impressionism (and we should note Signac's pacifist revulsion against the war-hysteria of 1914). But as a principle which aligned avant-garde practice with the needs of a newly-enfranchised proletariat it was stated most cogently by Mallármé. Looking forward to the "utopia" which was, in his view, to follow the installation of a "Republic of the Republicans," the poet wrote in 1876 that the new art would be made by 'new and *impersonal* men,' each one of whom would be "an energetic modern *worker*" who would "consent to be an *unknown unit* in the mighty numbers of a universal suffrage."[7]

Alienation: writing of Cubism in 1917, Braque insisted that it is "the means employed...that determine the style, engender new form and impel to creation." No longer was it enough merely to represent the condition of alienation, as Picasso's early work had done. Now the very act of representation, and the nature of what could be represented (including the imputed "self " of the artist) were to be subordinated to the "limits and limitations" of the "means employed"—which is to say, of the means of production. In opposition to the notion that the artist is the only person in the modern world who is not alienated, due to the nature of the work, Braque and Picasso, especially in the period of High Analytical Cubism, made of the *work* of art an alienated labour. The very hermeticism of their labour, its silent introversion, reminds one of Jarry's monstrous 'Painting Machine,' which 'after there was no one left in the world':

> ...revolved in azimuth in the iron hall of the Palace of Machines, the only monument standing in a deserted and razed Paris...[and] dashed itself against the pillars, swayed and veered in infinitely varied directions, and followed its own whim in blowing onto the wall's canvas the succession of primary colours ranged according to the tubes in its stomach.[8]

Elsewhere Jarry wrote that "it is the Machine that may achieve the great *Geste Beau* in spite of our aesthetic will" (a strange vision which haunts our nightmares in 1984: how will the computers amuse themselves after they have fulfilled the logic of Mutually Assured Destruction?). From the summer of 1910 to the summer of 1912, Braque and Picasso locked themselves within the mechanics of their joint mode of protection. I do not believe that they enjoyed the experience. Part of the violence of their Cubism—its extremism—is contained in the violence the two men were prepared to do their selves.

Anti-décoration: décoratif, the word describes many aspects of a painting, but it characterises a work of art as, above all, a sedative, as a salve to the jaded nerves of the bourgeois. In the privacy of his 'drawing room' the bourgeois could use his *décorations,* said Monet, as a 'refuge of peaceful meditation', where 'nerves exhausted by work' (by bourgeois work) could relax. Matisse also dreamed of:

> ...an art of balance, purity and serenity devoid of troubling or depressing subject matter, an art which might be for every mental worker, be he businessman or writer, like an appeasing influence, like a mental soother, something like a good armchair in which to rest from physical fatigue.[9]

With the emergence of a bourgeois clientèle, the heroic vision of Courbet and Manet of a popular and public art celebrating the experience of the masses had been "privatised." One should not forget that Clemenceau, throughout the war, but also during his premiership (1906–9) (which was marked by the use of state violence against the trade unions, including the killing of strikers by police and army) used Monet's paintings, and his house and gardens at Giverny, as a "mental soother." Only a case of extreme critical myopia could describe the work of Braque and Picasso as *décoratif* in the sense in which the term was used during the cubist period. The use of a very dull, even muddy palette, the coarseness of technique, the adulteration of materials, the use of waste materials, the radical "unfinish" of the paintings, combined to produce a profoundly *in-affective* and offensive art.

That the Cubism of Braque and Picasso did not effect very much "offence" does not detract from its offensiveness. Avant-garde art had been marginalised, critical controversy no longer served as a screen behind which political positions could be signified, as was the case during the first three quarters of the nineteenth century. From this purview, *Glass and Bottle of Suze* would appear to be a critically significant work. Critical in the sense that it embodies resistance to a particular mode of bourgeois cultural discourse, but critical also in the sense that it stands as a meditation on the marginality of avant-garde art, and of the role of avant-garde artist, in the modern world. For in order to signify *anything beyond* its own coming into being, the work has to rely on alternative, nonpictorial means of signification: the linguistic sign in general, the newspaper text in particular. In *Glass and Bottle of Suze* the signs of bohemian café life are framed by the struggles of the international working class movement. In 1912, Picasso as a pacifist with syndicalist leanings could identify with that struggle. But as an artist he could not en-form, transfigure, or even illustrate the "meanings of the dominated," all he could do was to *indicate* them with a toast—the arrow/glass rim is a very poignant sign.

To pursue the Cubism of Braque and Picasso beyond *Glass and Bottle of Suze* would be to see the retreat from the more extreme implications of the work of 1910–12 become a rout. Indeed some of the signs of that retreat are already evident in *Glass and Bottle of Suze*. That day in August 1914, when Braque travelled north to join his regiment, marks the symbolic ending of everything that was vital in Cubism, and in French avant-garde painting in general. Similarly, the very fact that the war began marked the end of the credibility of the parliamentary socialism of the Second International. It also profoundly damaged the credibility of an ideal which we all need now, maybe as never before: the notion of international working class solidarity.

For a while, however, maybe from 1907, certainly from the summer of 1910 to the autumn of 1912, Braque and Picasso, through the sustained force of their violence—which was not violence at all, of course, but *counterviolence*—became the instruments of what was a very circumscribed and marginalised "revolution," but one which remains the most destructive and the most extreme in the history of Western art. The extremism of their refusal to signify can only be understood in the contexts of the anxieties of their time, anxieties which sadly, and maybe fatally, still haunt the world in 1984.

Notes

1. John Berger, *Success and Failure of Picasso,* London, 1965, pp. 70, 71.
2. Georges Dupeax, *French Society 1789–1970,* (trans. Wait), London 1976, p. 181.
3. Robert Rosenblum, *Picasso and the Typography of Cubism,* in Penrose and Golding (eds.) *Picasso 1881–1973,* London, 1973, pp. 48–75. Rosenblum dates *Glass and Bottle of Suze* 1913; Daix and Rosselet date it Autumn 1912. This makes it one of the earliest cubist collages. It also carries more text than any other collage, and I cannot help believing that Rosenblum's blindness to the contents of the texts is a case of wilful suppression of 'embarrassing' information.
4. John Schwartzmantel, 'Nationalism and the French Working Class Movement, 1905–1914,' in Cahm and Fisera (eds.), *Socialism and Nationalism,* Nottingham, 1979, p. 76.
5. Kahnweiler and Crémieux, *My Galleries and Painters,* London, 1961, p. 45.
6. Annie Kriegel, 'Les inscrits au carnet B,' in *Le Pain et les Roses,* Paris, 1968, p. 180.
7. Georges Braque, "Thought and Reflections on Art," 1917, reprinted in Herschel B. Chipp, editor, *Theories of Modern Art,* Berkeley: Univ. of California Press, 1968, p. 260.
8. Alfred Jarry, 'Exploits and Opinions of Doctor Faustroll, Pataphysician,' in Shattuck and Watson-Taylor (eds.), *Alfred Jarry, Selected Works,* London, 1965, p. 238.
9. Henri Matisse "Notes of a Painter," 1908, reprinted in Herschel BiChipp, editor, *Theories of Modern Art,* Berkeley: University of California Press, 1968, p. 134.

"Zurich 1916, As It Really Was" 1928

RICHARD HUELSENBECK

Zurich as a center for the development of Dada ideas, theories, and performances is described by Richard Huelsenbeck as a refuge where the claims of church and state could be assessed without being put into jail. Dada is portrayed as a purely political response to the conditions of war and the collapse of "postclassical middle-class culture."

Zurich would seem a curious choice for a politically charged movement like Dadaism, a withdrawn city in neutral Switzerland. But in 1916 it became a haven for draft evaders from central Europe, who made up the core of the movement. Dada began at the Cabaret Voltaire, while the most costly battle of the war raged in France at Verdun. Every time the location for Dadaist activities shifted, whether to Berlin, New York, or Paris, and each time the war news changed or the "peace" afterward grew more violent, Dadaism was redefined to the point where Dadaists who went to Berlin (like Huelsenbeck) tended to harbor resentment toward Dadaists who stayed in Zurich. And yet, despite the variety of Dadaism, it all operated with at least one common proviso: to invent "antiart" for the morning after the death of bourgeois civilization.

* * *

I first met Hugo Ball in Munich in 1912. He was then dramaturg with the Kammerspiele. He immediately impressed me by his superior intelligence and his profound knowledge of things. We became friends. With the help of Hans Leybold and Klabund we founded the *Revolution*,[1] which was our form of resistance to Imperial Germany. Ball wrote a poem against the Virgin Mary which brought about the journal's downfall. Several law-suits were launched against us and we were scheduled for the same fate as Panizza. But they failed to realize that we were

much younger, more resilient and aggressive. Invective, threats, bureaucratic unpleasantness poured off our backs. The measures taken against us could never be as bad as our worst imaginings. We knew the "blimps" and bureaucratic antiques behind their desks and ink-wells before they even let fly at us with their decrees. No verdict against us could match the level of hatred we felt for them. It's still interesting that it was Ball who wrote against the Virgin Mary.[2] Later, in Ticino, he would have considered it a deadly sin, but in Munich he would have nothing to do with religion.

Shortly before the outbreak of war we met in Berlin. If I'm not mistaken, Ball was editor of Reclam's *Universum*[3] at the time. Or maybe it was some other illustrated journal. The life he led was miserable, but he was unremitting in his efforts to grasp the intellectual values and underlying spirit of the age. When war broke out our hatred for official Germany changed and everything associated with it changed into a kind of paroxysm of rage. We couldn't see a uniform without clenching our fists. We considered our most practical course. Revolutionary resistance to the well-oiled war machines would have been madness, Pfemfert's *Aktion* could offer some intellectual consolations, it is true, but no way to freedom. My reaction against the "spirit" which I identified with Imperial German postclassical culture began. Side by side with the sabre-swinging officers strode the German University Professor, a volume of Goethe clutched to his heart like a charm. The Manifesto of the German Men of Letters seemed to me the height of hypocrisy. It is completely grotesque to reproach us and say we should have worked for the proletariat then, for there was no proletarian organization, legal or illegal. For the pure-minded pacifist there was only one solution: to leave a country whose actions and politics one could not accept. Was Germany guilty of starting the war? No? Then stay in your country and fight. Is she guilty? Yes? Then leave for Switzerland and try to deepen your knowledge of the situation from a neutral standpoint and take action when the time comes. To a certain extent we were misinformed because we thought Germany and its leaders at the time far more cunning than they really were. We thought it was all cold calculation, we saw the Emperor, the Victory Allee, the gleaming uniforms, the Krupp factories, we heard the demand to shoot at fathers and brothers and we sensed a deep-seated plot aimed at all the fundamental values of humanity. We saw the Generals as a kind of intellectual advance party of the Devil. We dragged men who were probably mindless idiots up to our own level and made them morally responsible.

On the other hand, we considered it morally right, valuable, and absolutely essential to turn our back on Germany because for one reason it was dangerous to do so. Anybody could let himself be called up and keep up a stream of critical comment. But they did nothing to stop the

war machine. Our aim was to record our insight into the real causes of the war. Often we were unsure. Was it really Germany's fault? Is it possible for a country, such a great country and one that was our spiritual fatherland after all, to set the world alight? In Zurich a pamphlet appeared which claimed to have proved this beyond the shadow of a doubt. Not *Entente* propaganda. A German had sat down and written a confession of the things he knew. It shatters me to this day when I think how anguished we were over the truth. Bowed down and heavy with such ideas we arrived in a city in which the scum of international profiteering had begun to settle. I saw very little of the Swiss themselves during the war. We had the feeling they didn't like us, that they felt we might disturb their peace, and the really important things we had to say ran completely counter to what they thought. Among the whores, speculators and *petit bourgeois* (who gaped with red-rimmed eyes at the relaxed moral standards) moved the uniforms of captured French and German officers. When they became aware of each other they went as stiff as ramrods, but they still saluted each other. That made a deep impression on us.

And would it have been better for us to join a workers' organization instead of founding a cabaret? Anybody who argues in this way knows nothing of the conditions as they were then in Zurich and reveals a surprising lack of insight into the human psyche. Personally, I have stopped making demands on people and what they should do till I know the facts. A fundamental precept in World History seems to me to be "Shoemaker stick to your last." I have never been a politician and even today I don't see myself as one. I am simply not cut out to be one. My *métier* is writing; there will always be people like that. I'm in favour of everybody realizing what he is capable of and pursuing what he is best at. This seems to me a fundamental principle which cannot be qualified by any political or economic theory, it's more of a precept of human tolerance without which relationships between men are wicked, unbearable and morally perverted. I have no reason for holding back with my confession of faith. I shall never deny that I am a Socialist, but my socialism has a humane basis. I am what orthodox party members contemptuously call an "emotional Communist." I have an inherent watchful instinct that protects against anything brutal, mean and socially unjust. I am ready to fight tooth and nail with heart and soul to see justice done, but it is impossible for me to believe that the world can be summed up in one party programme. I am perhaps not the revolutionary one has to be. I understand that there have to be politicians who look different, are differently constructed psychologically from me. I just am what I am. I know where my goal lies and where I can accomplish something. In those days I associated with the Cabaret Voltaire and Dadaism because I realized that some form of cultural protest (and

Dadaism was never anything more) was necessary and that this was where I could accomplish something. I devoted myself to Dadaism first in Zurich and later in Germany with such intensity that it undermined my health and my so-called literary career. That was no joke. In the term *Dada* we concentrated all the rage, contempt, superiority and human revolutionary protest we were capable of. Had I joined a political party, no matter which, I should have accomplished far less at the time. After all, several million people must have heard the word *Dada* resounding in their ears and a few tens of thousands must have realized that Dada was the ironic and contemptuous response to a culture which had shown itself worthy of flame-throwers and machine-guns.

Ball's case is much more difficult. While I grew more and more convinced that the world should and could be changed, Ball believed that no compromise could be found between the feeling for what was right and just and the force necessary to bring about social order. To be truthful, one must admit that there is an intellectual stand which simply does not fit in with the world as it is. One must also admit that sources of intellectual energy do exist whose effects lie on a plane completely different from the calculations and considerations which physical and political events arrange themselves into. Ball is one of the most sensitive and spiritual men I have ever met in my life. His path from the painful protest of Dadaism to belief in a spiritual power which works according to its own laws is one I can understand though not necessarily approve. That Ball should call his Cabaret "Voltaire" indicated that he was obsessed by cultural criticism. He fought Germany and Protestantism because he considered these powers unethical, socially inferior and culturally corrupt. He detected a connection between Protestantism and Hegelianism and became suspicious of all exploiters of dialectics as a result. He dreamed his way into a spiritual sphere which, knowing neither "yes" nor "no," had room for the absolute. The enormous, almost exasperated sincerity with which Ball fought for his truths places him far above many of my literary acquaintances who simply clung to some comfortable traditional conviction and steered a steady course towards comfort and security. Ball was so poor he often starved for days on end, but this didn't bother him. He saw only the path before him, the decisions to be taken. The Cabaret Voltaire and Dadaism were as serious and important to him then as his devotion to the Church was to become to him later. I have always rejected this piety, I do not understand it, religious dogmatists are even more alien to me than political ones, but I am prepared to accept that Ball fought his way through to his conviction with uncommon sincerity and that no one is entitled to tell him what he ought to have done. If in those Zurich days Ball had wanted to play politics or if he had joined a party he would not have been Ball. All his political ideas, all his economic and ethical thinking was concen-

trated into the founding of the Cabaret and into his cultural criticism. Any other attitude would have placed him in an impossibly ambiguous position, reduced his achievement to nil, and would have exterminated him as leader and human being. The Cabaret Voltaire in which Dadaism was born was nothing like the usual run of crude comedy (this is the picture our latter-day critics seem to have of it); no, it was a cultural platform on which everybody could give free expression to his opinion. Germany has never seen anything like it. Even if only for the reason that no deals were made there. This was where people were prepared to express opinions which could not be expressed elsewhere. That these opinions were mainly on cultural matters was simply because we are intellectuals. They can do what they like to us, but that's what we are. Shoemaker stick to your last. Ball did in fact once become active in politics when he took over the *Freie Zeitung*[4] in Berne, but then the reaction against an activity which by his very nature left him cold must have set in, and he fled to Ticino and that was the beginning of his Catholic fiasco. Ball was far less of a politician than even I was; he was incapable of making compromises. He simply could not adapt to changing trends and differing opinions. He was inflexible. He would have died rather than go along merrily with the stream. He did die—of starvation, debility, poverty, bitterness, isolation. I reject Ball's Catholicism; I demand that the world be changed, I find popery abhorrent; I consider it a disaster that Ball became entangled in religious mysticism. But I respect the man of the spirit; I respect his fate; I know what it means to die for one's convictions. It is infinitely more difficult to die for one's convictions than for an armed power.

Zurich 1916 as it really was?[5] It was exactly like our ideas. There weren't any Swiss around in Zurich in those days. There were crooks, whores, international rabble and our spiritual hunger for truth. Were there any workers' organizations? Yes! A totally fossilized, scared Social Democrat Party, no Communists. A group of discontented Social Democrats who gathered round the "rebel," Brupbacher, who in those days called himself an anarchist and who is now a Communist member of parliament. We had contacts with all of them, exchanged opinions. There was also one great man who was later to revolutionize one part of the world: Lenin. He lived in the street where we had our Cabaret, directly opposite.

Seeing the racketeers on the terraces of the Baur au Lac one had the feeling that decadent European culture stank to high heaven. People moved like puppets, like projections on a screen. Whoever said anything worth listening to? What was there to stir anyone's feelings? Where could one see any escape from the spiritual and physical pressures of war? Neither Brupbacher nor the "rebels" nor the orthodox SPD members were capable of making any decisive impression on us. Lenin, who

shared the same street with us, was silent. The emigré Marxist Russians who lived in Zurich fought out their battles behind closed doors. Nobody broke these down for long, least of all the Zurich Socialists who were rightly regarded by the Russians as insignificant. Zurich could never be the starting point of a world cleanup, this was only an intermediate stage for hunted men, a cover, a temporary lodging to get one's breath back. Lenin was biding his time. The Zurich Socialists' time has still not come.

Social differences are not very extreme in Switzerland. Only in the large cities is there a class barrier and even there the connections with the favourable conditions of the countryside are so prevalent that party programmes tend to peter out into compromise. No, Swiss social conditions were no concern of ours. The cultural protest we put on was a beacon for all in Europe with eyes to see. Portrayal and reminder of the collapse of postclassical middle-class culture. Revelation of a new emotional, primitive path. In this work we have given of our best, expended all our energies. It would be ridiculous if after the event we were to claim to be something different from what we were. The collapse was something we experienced collectively as a group of intellectuals who stayed at their posts and knew what they were doing. Afterwards Ball left for Ticino, I myself went back to Germany towards the end of 1916. Here conditions made action imperative. The people were starving, the soldiers were beginning to revolt. The Naval Mutiny had just been put down with draconic severity. This was it. There's nothing I said or did then I want to take back. The German Revolution did not fail because I appeared in a Cabaret. It did not fail because certain people who felt competent on cultural issues took part. It did not fail of a surfeit of romanticism, but of a lack of romanticism, a missing impetus, a pathological lack of revolutionary temperament. In my opinion it failed because of the small-minded, timid and therefore malicious spirit of the mediocre type of German who, incapable of any heroic gesture, is frequently found among party officials. If the German Revolution, German Social Democracy had known how to attract more men like us, it would not have failed. Every movement which despises the spiritual is bound to get bogged down. This has all been said before, but the Germans cannot be told often enough.

Note on the text: *Zürich 1916, wie es wirklich war.* Published in *Die Neue Bücherschau*, Vol. 6 (1928), 12, pp. 611–17. This is a reply to Hugo Ball's diary published 1927 called *Die Flucht aus der Zeit*, inspired by Kurt Kersten, who in the same journal, Vol. 6, 1928, 10, pp. 538–40, reviewed Ball's work and wrote: "The high-light [in Zürich] was a literary cabaret. Ball, whose creation it essentially was talks about it. The basic message was defeatism, but it was also destructive and subversive

in every respect. Ball has a lot to say about it. It would be nice if Huelsenbeck would talk freely about this period sometime. He would possibly be able to add something to Ball, probably even put him right." Huelsenbeck (b. April 23rd, 1892 in Frankenau/Hessen) studied medicine in the winter semester 1913–14 and in the summer semester 1914 in Munich. In Zurich along with Hugo Ball, Hans Arp, Tristan Tzara and Marcel Janco he became the co-founder of the Cabaret Voltaire. He brought Dada to Berlin. Early Expressionistic and Dadaistic publications: *Phantastische Gebete. 1916; Schalaben, Schalomai, Schalamezomai. 1916; Verwandlungen.* Novella. 1918; *Azteken oder Die Knallbude.* 1918; *Dada siegt.* 1920 *Deutschland muss untergehen!* 1920; *Doctor Billig am Ende.* 1921. In 1920 he edited the *Dada-Almanach.* Huelsenbeck has written variously about his association with Dada. In addition to the present passage in which Huelsenbeck, writing from the situation of 1928, passionately swears allegiance to Dada, the corresponding passages from his essay *Die dadaistische Bewegung (Die neue Rundschau.* Vol. 31, 1926, pp. 972–79) are given as follows:

In the year 1916 in a gloomy little alley in Zürich, Hugo Ball and Emmy Hennings founded the Cabaret Voltaire which was to become the cradle of Dadaism. The Cabaret Voltaire soon became the literary centre for all those whom the war had flung outside the frontiers of their own country. Here poems were recited, there was singing and dancing, and discussions on the possibilities of modern art. The Cabaret Voltaire became an experimental theatre for all problems of modern aesthetics. Among the intimate associates of the Cabaret Voltaire, apart from the author of these lines, were the Roumanians Marcel Janco and Tristan Tzara, and the German painter Hans Arp. Arp had come from Paris and brought from there a precise knowledge of those ideas of Picasso and Braque which have since become world-famous under the heading of Cubism.

Tzara was very well-versed in international art and literature and had connections with all parts of the world. We corresponded with the Futurists in Italy and knew Boccioni's *Pittura e Scultura futuriste.* In Munich, Ball had been very close friends with Kandinsky and his circle with whom he had been on the point of starting an "Expressionist Theatre" when war broke out. In the Cabaret Voltaire pieces and impressions from various countries became the object of intensive discussions. In general the tendency was to favour abstract, nonrepresentational art. Kandinsky and Picasso were recognized as outstanding personalities, while Marinetti with his Futurism and his furious Nationalism was not so much in accord with the whole radically pacifistic atmosphere of the Cabaret Voltaire. Arp, in particular, was an opponent of the Futurist concept which he said was like a little dog sitting up to beg. We were quite overwhelmed by the thought that a tree was not a living object with trunk, leaves and blossoms, but was really only the realisation of an idea to which one had to relate. The Cubists solved the practical problem of representation by simply

abandoning perspective; they simply brought the picture forward out of space as it were, made it into a relief and reduced it to mathematical symbols, which were supposed to be immediately expressive.

Notes

1. The *Revolution* was ed. 1913 by Hans Leybold (one number by Franz Jung). Among the contributors were Hugo Ball, Richard Huelsenbeck etc.
2. The poem *Der Henker* by Hugo Ball appeared in the first number of the *Revolution* October 15th, 1913 and caused the number to be confiscated.
3. Ball worked temporarily in the editorial office of *Zeit im Bild*.
4. *Die Freie Zeitung* in Berne was ed. by Ball 1917–20. A selection was published under the title: *Almanach der Freien Zeitung*. Ed. Hugo Ball. Berne 1918.
5. Hugo Ball's *Die Flucht aus der Zeit* (Munich, Duncker and Humblot 1927) p. 77 ff. can be taken as a reliable source for the course of events in Zurich 1916–17. Also his letters: *Briefe* (Zurich, Bentiger 1957).

"My New Pictures" 1920

GEORGE GROSZ

Art is characterized by George Grosz as a way of examining not the individual psyche but that of class struggle. Describing his work as a "hard workout," Grosz believes that artists should nourish all humanity, not just the rich and powerful.

Grosz was a founder of the Berlin Dada group and in the early 1920s produced art that centered on issues of social determinism and class conflict. After Grosz emigrated from Germany to America, thousands of miles from the emerging battle lines, his personal politics grew more introspective and less like the populist image of art he proposes here.

* * *

Today art is absolutely a secondary affair. Anyone able to see beyond their studio walls will admit this. Just the same, art is something which demands a clearcut decision from artists. You can't be indifferent about your position in this trade, about your attitude toward the problem of the masses, a problem which is no problem if you can see straight. Are you on the side of the exploiters or on the side of the masses who are giving these exploiters a good tanning?

You can't avoid this issue with the old rigmarole about the sublimity and holiness and transcendental character of art. These days an artist is bought by the best-paying jobber or maecenas—this business of commissions is called in a bourgeois state the advancement of culture. But today's painters and poets don't want to know anything at all about the masses. How else can you explain the fact that virtually nothing is exhibited which in any way reflects the ideals and efforts, the will of the aspiring masses.

The artistic revolutions of painters and poets are certainly interesting and aesthetically valuable—but still, in the last analysis, they are studio problems and many artists who earnestly torment themselves about such matters end up by succumbing to skepticism and bourgeois nihilism. This happens because persisting in their individualistic artistic eccentricities they never learn to understand revolutionary issues with any clarity; in fact, they rarely bother with such things. Why, there are even art-revolutionary painters who haven't freed themselves from painting Christ and the apostles; now, at the very time when it is their revolutionary duty to double their efforts at propaganda in order to purify the world of supernatural forces, God and His angels, and thereby sharpen mankind's awareness of its true relationship to the world. Those symbols, long since exhausted, and the mystical raptures of that stupid saint hocus-pocus, today's painting is full of that stuff and what can it possibly mean to us? All this painted nonsense certainly can't stand up to reality. Life is much too strong for it.

What should you do to give content to your paintings?

Go to a proletarian meeting; look and listen how people there, people just like you, discuss some small improvement of their lot.

And understand—these masses are the ones who are reorganizing the world. Not you! But you can work with them. You could help them if you wanted to! And that way you could learn to give your art a content which was supported by the revolutionary ideals of the workers.

As for my works in this portfolio, I want to say the following: I am again trying to give an absolutely realistic picture of the world. I want every man to understand me—without that profundity fashionable these days, without those depths which demand a veritable diving outfit stuffed with cabalistic and metaphysical hocuspocus. In my efforts to develop a clear and simple style I can't help drawing closer to Carra.* Nevertheless, everything which is metaphysical and bourgeois about Carra's work repels me. My work should be interpreted as training, as a hard workout, without any vision into eternity! I am trying in my so-called works of art to construct something with a completely realistic foundation. Man is no longer an individual to be examined in subtle psychological terms, but a collective, almost mechanical concept. Individual destiny no longer matters. Just as the ancient Greeks, I would like to create absolutely simple sport symbols which would be so easily understood that no commentary would be necessary.

I am suppressing color. Lines are used in an impersonal, photographic way to construct volumes. Once more stability, construction, and

*Carlo Carra, Italian painter. After a period as a Futurist he became during the 1920s a leader in the trend toward a new realism in painting.

practical purpose—e.g., sport, engineer, and machine but devoid of Futurist romantic dynamism.

Once more to establish control over line and form—it's no longer a question of conjuring up on canvas brightly colored Expressionistic soul-tapestries—the objectivity and clarity of an engineer's drawing is preferable to the uncontrolled twaddle of the cabala, metaphysics, and ecstatic saints.

It isn't possible to be absolutely precise when you write about your own work, especially if you're always in training—then each day brings new discoveries and a new orientation. But I would like to say one thing more: I see the future development of painting taking place in workshops, in pure craftsmanship, not in any holy temple of the arts. Painting is manual labor, no different from any other; it can be done well or poorly. Today we have a star system, so do the other arts—but that will disappear.

Photography will play an important role; nowadays a photographer can give you a better and cheaper picture of yourself than a painter. Besides, modern artists prefer to distort things after their own fashion— and they have a peculiar aversion to a good likeness. The anarchism of Expressionism must stop! Today painters are forced into this situation because they are unenlightened and have no links with working people. But a time will come when artists—instead of being scrubby bohemian anarchists—will be clean, healthy workers in a collectivistic community. Until this goal is realized by the working class the intellectual will remain cynical, skeptical, and confused. Not until then will art be able to break out of its narrow and shallow confines where it flows anemically through the life of the "upper ten-thousand," not until then will it become a great stream capable of nourishing all of working humanity. Then capitalism's monopoly of spiritual things will be ended.

And here also communism will lead to a truly classless society, to an enrichment and further development of humanity.

"The Deutscher Werkbund from 1907 to 1933 and the Movements for the 'Reform of Life and Culture' " 1977

JOACHIM PETSCH

The German Werkbund was a movement of architects and business people who attempted to understand the new conditions of mass production and to apply them to the needs of the whole society, thereby creating improved living conditions for everyone. Through adoption of standardization, it hoped to transform the arts for an industrial age, a goal more fully realized by the Bauhaus. Joachim Petsch describes German social movements which ran counter to this aim of international, standardized systems of production, movements which emphasized racial renewal, national art, antiurbanism, and anticapitalism. The internationalism of the Werkbund was ultimately submerged by the antideluvian policies of the Nazis.

The Werkbund began by promoting variations of late Art Nouveau and ended at a time when its members had become committed to functionalist modern art. Its history reveals a transition that was probably less clear than the mystique of modernism might have us believe. There were very strong historical affinities between abstracted ornamentation (that is, Art Nouveau) and abstract nonobjective art. These were not simply affinities based on contempt, although modern artists often attacked Art Nouveau as a primary example of decayed sentimentalism.

* * *

From an examination of the interrelationships that grew up between the Deutscher Werkbund and the numerous movements inspired by the "reform of life and culture," and from a study of the relevant journals in

which these views were published in the period between 1907 and 1933, there emerges the possibility of analyzing this broad panorama in detail. It represents the most important reformist phenomena that could be observed against the background of economic and social restructuring for which it was partly responsible at the time of the Kaiser's Germany.[1] This is partly because such movements—before 1914, therefore in contrast to the "cultural battle" of the Weimar Republic—present no elements of conflict but can be seen instead as a succession of similar stages in a development that was basically homogeneous. The focus of this present contribution is therefore concentrated on the historical substratum, instead of on a criticism of the programmatic lines of the Werkbund and other reforming groups.

The Kaiser's Germany is characterized by the second phase of the process of industrialization, the stage when monopolies came into being (the end of free competition) inside the largest economic groups—for example, the groups of heavy industry, metallurgy, chemicals and electrotechnology—and when there was a tendency toward both mechanized industrial production and an enforced rationalization in vast sectors of these branches; and where, as a result of these tendencies, there was also present a notable increase of industry in relation to artisan production, while the related phenomenon of urbanization grew more and more acute. In comparison with the branches of industry just mentioned, the building sector seems far behind:[2] it is only now that the move toward the manufacturing stage and the mechanization of production is taking place. But the development of the relationships of production and even the objective situation of the productive forces, with its consequent embittering of the class struggle, represent a threat mainly to the pre-capitalist strata, who see their economic position compromised and so, too, their social position—by the progressive disintegration of relationships of production among the lower middle class and the poorer peasant class, and by proletarization. To be included among the category of the middle-class sectors of the population concerned in this process are small businessmen and craftsmen, civil servants in the middle and lower grades, teachers, artists, and peasants, to whom must be added the new category of employees of industry at the lower and middle levels.[3] A middle class composed of these elements is now beginning, moreover, to see its own cultural tradition under threat. This crisis of identity brought about by industrialization led to considerable modifications in the consciousness of these classes and was at the same time the source of the multiple movements directed toward the reform of society, life, education and culture, at the end of the nineteenth and beginning of the twentieth centuries.

The Program of the Deutscher Werkbund

Without underestimating the traditional tendencies present in the Deutscher Werkbund, it must be said that among the movements operating in the years before the First World War this was the group the majority of whose members most clearly understood the laws already imposed by the system of modern capitalist-industrial production. And the reason these laws were understood was that the association had already realized that artisan means of production would not suffice to meet the needs of the masses; it therefore set itself to solve the contradiction that had opened up between the stage attained by the forces of production and the stylistic mode wherein art was unfolded, to develop a typology of artistic forms that would be appropriate also—and, indeed, especially—to the mass product itself.

The majority of the members of the Werkbund (among them F. Naumann) supported the liberal view of public control, where a predominant role was assigned to the development of industry and technology by singling out a basic factor for the advancement of society and its culture. Compared with other reforming forces—where the vocabulary employed and the formal imagery were often identical ("conformity with the material, construction and function," "objective architecture")—the essential difference lies in the acceptance of the productive process, which the Werkbund wanted to see industrialized. By this means, and especially through the adoption of typology and standardization, it hoped to achieve its objective, which was to change the practice of industrialized artistic production ("the ennobling of industrial labor"). In actual fact, the industrialization of the building sector acquired greater significance only after the mid-1920s, although from the very first everyone was absolutely clear about the need to transform the professional methods employed and even the basis of an architectural qualification.

Neither the Werkbund's desire to bring about reforms nor the similar intentions of other groups can be detached from nationalistic and imperialistic aims. In fact, in the view of the Werkbund there was only one explanation for the economic and political supremacy of England: it was the product of the cooperation between the artistic and the industrial intelligentsia. Consequently, the "ennobling of industrial labor," within general cultural work, should lead to a national, that is, German, art and produce German quality goods that would be competitive in relation to foreign products. By encouraging and increasing exports, it was hoped to achieve and assure for Germany a supremacy that would be at one and the same time economic, political and cultural.

Movements for the Reform of Life

Even though in the architectural scene the movements for the "reform of life" were less important than those that set themselves to redefine culture, nevertheless, I believe it would be appropriate to devote a few words to the first ones, because, on the one hand, it seems to me that certain fundamental ideological motives and recurrent images conditioned the consciousness of the middle class—especially the cultured bourgeoisie—not only in the years before the First World War but also, and especially, during the Weimar Republic, and, on the other hand, they found a welcome, though a partial one, in the Deutscher Werkbund itself. The figures of reformers who appeared on the German scene after the end of the last century with their ideas and their publications—physiocrats, reformers of diet, vegetarians, naturists, and adherents of the movement for the construction of Siedlungen[4]—all had one thing in common: they all rejected the large city, the urban-industrial civilization, in favor of a return to nature, to rural life and crafts, and at the same time they wished to "change the world by means of an individual reform of life." Their reflections did not touch upon state structures, and the family, with its internal authoritarian structure, assumed a central position. Indeed, the family represented the bridge leading to that model of society that thought itself composed of various social groups. Because social Darwinism and anti-Semitism had left a bitter heritage, these were thoughts that were particularly widespread among the reformers. There was no way to stop the process of destroying the landscape by the expanding capitalist industrialization, and the consequent discovery of the *Heimat,* the fatherland or native land with its heritage of traditions and culture, linked these reformers to the Heimatschutzbund. The ecological problem had been understood in its full significance. The reformers followed lines of thought that were already fixed: the hoped-for creation of a new national basis had to come about through a national renewal—and a racial renewal—in the Nordic Aryan man—and this renewal would lead to a bond of unity among all social classes; obviously, no value was assigned to the transformation of the economic order. The essential element inherent in this unity was seen in a new German art, which was to arise as a product of the racial renewal. The concepts employed of "people" and "nation" denied class differences, and, because of the importance soon invested in the German spirit, in the creative force of the Germanic race, no time was lost in imbuing this same race with a "redemptive mission" (pan-Germanism). For identical racist motivations, the nationalist groups and circles also rejected Christianity, as being "non-German," and turned to a popular religiosity of Nordic derivation. The rural population was accorded particular importance,

since it was considered the "personification of the active Nordic man and the Aryan personality": the peasants represented the backbone of nationalist thought and revival and exemplified the "vital source" of the German people and the Nordic race. For the purpose of diffusing nationalist ideas, schools were given a highly important function, especially the elementary schools: it was expected that a common cultural heritage would "forge" a united nation.

In the 1920s the idea of "colonization as a means for the reform of life" had been the basis for the programs of agrarian reform instigated by R. W. Darré and G. Feder. It was meant, too, to lead to the reorganization of the national body ("popular community"): the land would obviously be taken into public ownership and its use shared in common. At the same time, ideas that were antidemocratic (cult of the Führer), antiurban, antiindustrial, anti-Semitic (the difference between passive and active capital) and anticapitalistic (rejection of land speculation and the ideology of profit) were later expounded in the theories of the Kampfbund für die deutsche Kultur (League for German Culture).

Movements for the Reform of Life and Culture and Nationalistic Movements

During the last two years of the war, nationalistic ideas took possession, to an ever-growing extent, of the thought of the middle class and parties of the Right, who were in any case already disposed to welcome them. For example, in 1917 the journal *Deutschlands Erneuerung* called for a radical renewal of the German people. Only one method could achieve this: the construction of "healthy rural colonies" and the "elimination of dead branches." The program also anticipated that a peasant art, equally healthy, would replace the "deformed" manifestations of the avant-garde (Expressionism). Finally, the large towns, considered the strongholds of Judaism, were put on trial. Racist nationalism became widely followed, especially in the circle or group of Saaleck around Schultze-Naumburg; in this connection I believe there is no need to speak of other theoreticians and other associations (Stahlheim, Werwolf) or journals. After the revolution, Schultze-Naumburg left the Ring and the Arbeitsrat für Kunst and with other like-minded companions, Bonatz, Bestelmeyer, E. Högg and P. Schmitthenner, formed the self-styled "nationaler Block," or national block. In 1927 this group—with the exception of Högg—issued a manifesto of its own, which was essentially a violent attack upon the "Neues Bauen." Later, when a new tax on buildings was imposed—and violently contested by the middle class (owners of houses and lands)—and 50 percent of that tax was assigned to social building, the planning of large residential complexes was un-

dertaken in a modern style. The process of a complete radicalization of racist tendencies became irreversible and, under the influence of H. F. K. Günther and R. W. Darré, Schultze-Naumburg, the Bund für Heimatschutz, and other similar reforming groups for life and culture, it was welcomed by vast sectors of the middle class. Art was thought to be connected with race, and consequently the "blood" was thought indispensable to its form;[5] and history, too, was thought to be determined by the law of race. Meanwhile, a campaign was set in motion against modern art and architecture, judged to be "non-German" and "not bound to the soil of the Fatherland," or, in other words, "racially degenerate." On the basis of the distinction between art that was "in conformity with the race" and art that was "extraneous to the race," the art of the first half of the nineteenth century was reevaluated, since in this art the people still expressed their bond with "Mother Earth." In the second half of the century, however, the mixture of races had determined an irreversible process, whereby individuals were uprooted and art became degenerate. Peasants were then considered to represent the true substance of the German people, so that in the "colonization of the countryside," on the one hand, and in the "purification of the race," on the other, were seen the only two possible ways to rediscover the active Nordic man and the Aryan personality. After 1930 this principle became the slogan for the "national revolution."

The organization that propounded these reactionary, racist and nationalistic ideas was the Kampfbund für deutsche Kultur, which incorporated them into an organic program. But the beginning of an organized cultural work that was already clearly national-socialist[6] coincided with the formation—by A. Rosenberg—of the National-sozialistische Gesellschaft für deutsche Kultur in August 1927. As it specifically stated in its statutes, the task of this society was to summon up "all defenses against the forces now dominant in disintegration" and to "enlighten" the German people on the "connections between race, art, science, and ethical and military values."[7] The league gathered around itself various groups and circles with racist, nationalistic and pan-Germanic views, and set itself the task of "founding a new culture based on a German affinity, which would oppose Marxism, the parliamentary system and modern art and architecture."[8] In 1931 the Kampfbund was transformed into a mass organization with many professional sections: architects and engineers had their own Kampfbund deutscher Architekten und Ingenieure. Beside Rosenberg and Schultze-Naumburg, the principal theoretician, orator and publicist of the league was A. von Senger. According to Senger, it was the "Bolshevist spirit" ("torch of Moscow") that inspired the "Neues Bauen," which he described as a reaction of "underdeveloped" and "racially enfeebled" men.[9] Therefore, the "Neues Bauen" was seen as an attack upon the middle class, since this current threatened the existence of craft work and even the indus-

tries of the middle class (brick making and stone masonry). The "love of Mammon," or large-scale industry and international capitalism, known for scorning human life, was the acknowledged protector of the modern trend in architecture. Behind such slogans was a clear allusion to precise German realities: whereas administrative offices and the sales establishments of the commercial capital and the new commercial pilot sectors, such as the electrotechnical and chemical industries, preferred avant-garde forms, that is, the forms of the "Neues Bauen," in contrast, German heavy industry—in order to create an image of its own industrial might—returned to the monumental architectural forms of tradition. Behind the constructions of popular mass building von Senger saw—mistakenly—the imprint of American capital.

The founding of the Bauhaus was obviously not due directly to the efforts of the Werkbund. But many of the basic objectives of the Werkbund were, in fact, realized in the Bauhaus: a three-year artisan and spiritual apprenticeship before studying the trade, crafts workshop as a teaching model. The controversy that erupted in 1924 around the Weimar Bauhaus shows clearly that the nationalist and bourgeois parties represented in the regional parliament of Thuringia, and, behind the parties, the Thuringian crafts circles (builders' associations), the representatives of the Bund für Heimatschutz and the relative press outlets (*Anhalter-Anzeiger*) were not so concerned about the type of professional training given by the Bauhaus as they were about the aesthetic viewpoint expressed in its works—the new forms of industrialized building production. The argument led to the fall of the government of the Left (SDP) and the transfer of the Bauhaus itself from Weimar to Dessau, where from the very first it met with violent opposition from the parties of the Right. The controversy surrounding the Bauhaus in 1924 marked the beginning of the "local cultural battle," in which there participated, apart from the social strata, groups and associations mentioned, also the universities and some of the communal bureaucracy. From Thuringia the campaign soon spread to other cities, for example, to Stuttgart (Weissenhof Siedlung), Karlsruhe-Dammerstock and Dessau (Törten Siedlung). At that time the Werkbund was synonymous with "Neues Bauen"; the wave of denigration submerged even its own members, who were called "agents of Bolshevism." The Dessau Bauhaus was even stigmatized as a "Communist cell" and the Dessau buildings described as "too cerebral."[10] People often quoted the comparison made by Bonatz between the Weissenhof Siedlung and an outlying district of Jerusalem. The principal objections were that there were no national and historic bonds and no consideration of the site into which the buildings were inserted.[11] The opposition to the Siedlungen was based, on the one hand, on economic reasons (the ruling social and building policy with the protection of tenant's contracts was castigated)

and, on the other hand, on ideological reasons (the "Marxist Siedlungen" lacked "the bond between the occupant and the soil," and their architecture destroyed love for the fatherland, for the nation and for the family). The national socialist critics justly recognized the two aspects of modern architecture, as defined by Schwab; the "upper bourgeois" aspect and the "proletarian" aspect; this is because the architecture was constructed and occupied mainly by these two social classes.

In December 1929 Thuringia elected as Minister of the Interior and of "popular education" a national socialist (W. Frick, who remained in this office until 1931); the Weimar college for engineers was restructured and placed under the directorship of Schultze-Naumburg. The struggle that ensued against the "Marxist depauperization" represented a foretaste of what became the norm after 1933: the frescoes by Oscar Schlemmer were removed from the college, which remained under the control of Schultze-Naumburg until 1940.

Therefore, the conviction held by the lower middle and middle classes that they could serve as an intermediary between capital and labor and so eliminate mass production, at the same time overcoming class divisions through the collective consciousness, was shown to be illusory, and this is confirmed by the history of the Third Reich. The same failure awaited the other hypothesis, that is, the hope that it might be possible to improve living conditions, or even to eliminate the power structure of society, simply by renewing the technique of construction, stylizing form and creating new forms. With regard to the Werkbund of the twenties, one may say, speaking generally, that it lacked depth of thought as applied to politics. At all events, the Werkbund associated itself with other groups of middle-class origin who had an excessive belief in culture, education and teaching, and because of their narrow outlook it underestimated the strength of the economic and social components of society. Its history during the 1920s shows that the Werkbund was not as it was termed the *drudge* of capitalism and it was even more untrue that the new forms could be ascribed to the simple desire to assure greater profitability to industrial production. It is by looking at its history that we can judge what is the only legitimate interpretation to be accorded this group: it was the artistic movement that contributed to developing the new style and to bringing it into architecture.[12] The economic crisis brought complete paralysis to the building sector. The building industry and rental accommodations shared the hope of the various nationalist movements that only a "strong state" could accelerate the economic revival. But the "national revolution" brought to the lower middle and middle classes the exact opposite of what was anticipated from fascism: their economic situation worsened but was compensated for in ideology. All the movements for the "reform of life and culture" were dissolved after 1933.

Notes

1. Parts of the essay are based on: J. Petsch, *Baukunst und Stadtplanung im Dritten Reich, Herleitung, Bestandsaufnahme, Entwicklung, Nachfolge* (Munich, 1976). Documentary sources: specialized architectural journals.

2. The principal causes must be ascribed to two factors: on the one hand, there was an enormous army of unskilled labor, on the other, a market saturation, especially in the sector of residential building, had created unfavorable conditions for the investment of capital. As a result, small and medium firms made up most of the building industry.

3. Cf. H.-U. Wehler, *Das Deutsche Kaiserreich, 1871–1918* (Göttingen, 1975).

4. A disparaging description of the movements for the reform of life can be found in: J. Frecot, J. F. Geist, and D. Kerbs. *Fidus 1868–1948: Zur Ästhetik bürgerlicher Fluchtbewegungen* (Munich, 1972).

5. Cf. P. Schultze-Naumburg, *Kunst und Rasse* (Munich, 1925): H. F. K. Günther, *Rasse und Stil* (Munich, 1926).

6. H. Brenner, *Die Kunstpolitik des Nationalsozialismus* (Reinbek/Hamburg, 1963), p. 8 f. The various nationalist circles are fully described in this volume.

7. Ibid., p. 8.

8. Two principal stylistic currents may be distinguished: for the first, the point of departure remained the architecture of the first years of the nineteenth century, whereas, for the second, it was felt necessary to concentrate efforts toward studying and developing regional traditions.

9. Cf. A. von Senger, *Krisis der Architekfur* (Zurich, 1928), id. *Die Brandfackel Moskaus* (Zurzach, 1931).

10. E. Blunck, "Das Bauhaus in Dessau," in *Deutsche Bauzeitung*. no. 17, 61, year 1927, p. 153 f.

11. Cf. J. Joedicke and C. Plath, *Die Weissenhofsiedlung* (Stuttgart, 1968).

12. Cf. C. Friemert, "Der 'Deutsche Werkbund' als Agentur der Warenästhetik in der Anfangsphase des deutschen imperialismus," in W. F. Haug, ed., *Warenästhetik: Beiträge zur Diskussion, Weiterentwicklung und Vermittlung ihrer Kritik* (Frankfurt, 1975), p. 177 f.

"The November Revolution and the Institutionalization of Expressionism in Berlin" 1988

JOAN WEINSTEIN

After the defeat of Germany in the First World War, Expressionist artists created the Working Council for Art to work for artistic freedom and to end the capitalist art market. After the November Revolution in 1918 and at the beginning of the Weimar Republic, these artists were struggling for official sanction and support, as well as dismantling of the old imperial arts administration. And indeed the new German government did, soon after, sponsor many Expressionist artists. But official recognition and accommodation of Expressionist art by the government and by the German art market were ultimately the downfall of its revolutionary goals; by becoming representative of the government, it lost credibility as a revolutionary art.

The institutionalization of modern art, whether as in German Expressionism or elsewhere, remains a vital area of study in art history. As institutions are created or expanded to house (or monumentalize) the work of contemporary artists, the work that comes afterwards tends inevitably to reflect that new status.

* * *

In late 1918 Germany experienced military defeat, economic collapse, and revolution. These dramatic events brought into the spotlight a number of Expressionist artists who for a short time became active in politics and called themselves revolutionaries. Their names have now become familiar in the history of modern German art: the *Brücke* painters, Max Pechstein and Karl Schmidt-Rottluff, Paul Klee from the *Blaue Reiter*, the young Otto Dix, and the architects Walter Gropius and Bruno Taut. These artists and others formed their own organizations modeled

on those being formed at the same time by revolutionary workers and soldiers in Germany. The names they gave to their organizations were meant to proclaim their revolutionary aspirations: the November Group, the Action Committee of Revolutionary Artists, and the Working Council for Art.[1] They imagined a revolution in which the arts would play a leading role, a revolution that would render a notion like "Expressionism" as a valid criterion of political life. With confidence in their mission, these artists issued excited manifestos that called for complete artistic freedom, an end to the capitalist art market, the dismantling of the old imperial art institutions, and the creation of a new proletarian audience for their art. They assumed that the triumph of the revolution would mean the triumph of their art, disregarding for the moment the complicated history of Expressionism in Germany and the debate among artists and intellectuals over whether it was a constructive or destructive form of art.

A little more than one year later, many of these same Expressionist artists found themselves exhibiting at the annual state salon in Berlin, with the Social Democratic president of the republic, Friedrich Ebert, touring their rooms. For many on the left, Ebert personified the violent suppression of the revolution in Germany. Ebert was led, as one critic put it, "with deferential smiles and friendly bowing before the parade of young, radical, revolutionary art." But, the angry leftist critic continued, "as long as a single member of an artists' group toadies before Fritz Ebert, the authorizer of death sentences...and the personification of bourgeois indolence, it has damned little right to call itself radical or even revolutionary."[2]

This essay traces how Expressionist artists dreamed of reinventing the art world with the November Revolution, abolishing the institutional art world that had excluded them, and wound up instead gradually incorporated into its already existing institutions. This process brought to an end twenty years of conflict between modernist art and the autocratic political structure of the Prussian state. The point here is not to damn Expressionist artists for failing to achieve revolution, something not within their power, but to understand the process whereby their responses to the rapidly changing, seemingly chaotic developments of the revolution were shaped by a socially structured environment of culture. Although the remarks that follow are limited to the broad outlines of an institutional history, it is my contention that this history is essential to understand both the production and reception of Expressionist art during the revolution.

The eventual celebration of Expressionism as an official style in the Weimar Republic did not simply—or inevitably—follow from the establishment of a parliamentary democracy in Germany. Rather, it had its roots in the final years of the war and emerged only after a compli-

cated struggle for the ideological and institutional control of the art world during the November Revolution. The prewar antagonisms between Expressionist art and the art institutions of the Prussian state are well-known to historians today. One supporter of Expressionism called the Prussian academy "that old, fat, perverted institution," adding the opinion that academic art—"the mummy realm of Anton von Werner, Franz von Stuck, and the Siegesallée"—was only an "accumulation of trash."[3] Reciprocally, the Kaiser and institutions connected with the royal household exercised extensive control over cultural affairs and effectively excluded Expressionism from official patronage.[4] These antagonisms were often carried out in a political language, whose hallmarks were xenophobia and fear of the working classes. In the prewar period, Expressionist artists could feel secure in their outsider status, their intention to "demolish insidiously [the bourgeoisie's] comfortable, solemnly elevated view of the world" (as a writer in the first issue of *Der Sturm* put it).[5]

With the war, however, the political debate about Expressionism seems to have ceased, at least temporarily. A kind of *Burgfrieden* took place in the art world, too, as the government and imperial arts administration attempted to gain broad support for the war effort. Artists from the Academy, the Secession, and the Expressionist camp initially supported the war, if not always on the same terms. Members of the Berlin Secession patriotically supported the German position in the journal *Kriegszeit*. Numerous artists of the younger generation volunteered for active duty or duty as medics. Some members of the avant-garde, most notably Franz Marc, welcomed the war—if not as nationalist imperative, then as an apocalyptic solution for cultural crisis. Even the critical writing on Expressionism adjusted to the new political situation. For example, the critic Adolf Behne, a socialist and a leading supporter of modern art, now promoted Expressionism as a new "national" art, defending it against charges that it was international and therefore unpatriotic.[6]

When the German offensive collapsed after 1916, the initial war enthusiasm waned and artists increasingly agonized over their inability to reconcile their ambiguous feelings about the outcome of the war and their art. Karl Schmidt-Rottluff wrote despairingly in 1917: "Either you are a painter and you shit on the whole caboodle or you join in and kiss painting goodbye."[7] Patriotic commitment gave way to detachment, disillusionment, and in a few cases outright opposition. With the awareness of Germany's possible defeat, a new trend became evident in the art community. Art of all kinds was now projected by the artists themselves and by sympathetic critics as an alternative to the war, as a spiritual escape from the misery of the war. Expressionism, too, participated in this general trend and began to achieve its first real success

with a buying public.[8] Its promoters could point to interpretations already before the war that had conspicuously advertised Expressionism as a turning inward from historical reality, as a regeneration in the midst of catastrophe.[9] The "spiritual" element in Expressionism, its speculative nature, had been there from the start, but it was only now, during the crisis in the defeat, that a public dissatisfied with the war suddenly seemed prepared to discover and embrace this rationale for Expressionist art.

It is important also to note that the success of Expressionism was the result not only of an ideological convergence between Expressionist art and a war-weary public, but also of economic conditions. High profits in the armaments industry, few available consumer goods, and tax laws favoring living artists led to a boom in the art market.[10] This incipient success, though, was temporarily delayed when the art market staggered in mid-1918. With Germany's military and economic collapse in November, the economic outlook for artists became even more precarious. They were forcefully reminded once more of their dependence on an art market catering to the wealthy. The Expressionist painter and writer Ludwig Meidner melodramatically summed up the prevailing sentiment when he lamented: "Is our position in society much better and safer than the proletarian's? Aren't we, like beggars, dependent on the whims of the art-collecting bourgeoisie!?"[11] Many artists decided to place their hope in the revolution to radically alter the economics of the art world, to end the isolation of their art as a luxury commodity only for the wealthy, and to bring it instead to the "people" as a new clientele. The revolution further appeared likely to offer artists a kind of workers' control, a freedom to regulate their own affairs, choose their own juries and officials, abolish or radically restructure existing art institutions. A number of these Expressionist artists organized artists' councils, eager to reinvent the art world with the revolution.

There was, however, a major dilemma: how could an art that had found financial success with segments of a war-weary bourgeoisie after 1917, with its emphasis on the individual and his retreat from the world, now reenter that world and appeal to a different, proletarian public? The dilemma may have seemed less daunting because of the promising scenario offered by the rumored triumph of modernist art in revolutionary Russia. Although the news was sketchy, impeded by the blockade, reports of the advancement of artists such as Kandinsky, Tatlin, and Chagall in the new Russian arts administration fired the German artists' imaginations. These developments could only bolster their conviction that a socialist state could provide artists not only with artistic freedom, but with a living independent of the vagaries of a capitalist art market.

For the Expressionist artists' councils the most pressing and overriding question became the fate of the old arts administration. Could their goals be realized within the existing institutional framework, or was it necessary to dismantle the whole apparatus and begin anew? When the Expressionist artists' councils in Berlin issued their first manifestoes in late 1918, their primary target was the old imperial arts administration. Both the Working Council for Art and the November Group demanded either outright abolition or reform of most art institutions, from the royal academies, to state-sponsored exhibitions, to state museums. They were optimistic about the prospects for radical re... rm and quickly took their demands to the *Kultusministerium,* the ministry responsible for cultural affairs.[12] Their first meeting with the arts administration was disillusioning. While waiting behind a folded screen for their own meeting, Walter Gropius, Bruno Taut, and Wilhelm Valentiner from the Working Council for Art listened helplessly as the socialist minister authorized Wilhelm von Bode, the Director General of the Royal Museums, to continue at his post. Bode was viewed with suspicion by the artists' councils. Only months before he had accused supporters of modernist art of consorting with the enemy.[13] In their own subsequent meeting, they came away only with the vague assurance that their program would be put in the files.[14] Expressionist artists were equally discouraged by the ministry's half-hearted efforts to reform the Berlin academy, which, under the leadership of the impressionist Max Liebermann, steadfastly resisted any change towards the goals of modern art.

The events of late 1918 and early January 1919 brought to a close the first phase of the revolution and dampened Expressionist artists' euphoric belief that the revolution would dramatically and instantaneously transform the art world. The second phase of the revolution left no such room for hope; it was one of radicalization, violence, and internal controversy. The bloody street fighting of January and March 1919, the murders of the communist party leaders Karl Liebknecht and Rosa Luxemburg, and the suppression of strikes and street fighting by *Freikorps* troops called out by the Social Democrats forced Expressionist artists to reexamine their vague confidence in the revolution to transform the art world. They now had to ponder several questions. What was the political base for their art? How was the old public for their art to be discounted and a new proletarian audience created? The political struggle for control and containment of the revolution put into doubt the indiscriminate use of a term such as *revolutionary.* Revolution was a word everyone wanted to own, from the competing socialist parties to representatives of industry—all in an attempt to further their own interests. Accrued power was often defended through revolutionary rhet-

oric and retained by counterrevolutionary action. What could it mean, then, to call Expressionism revolutionary?

Convinced that little was to be expected from the current government, Expressionists' opposition to imperial art policies now turned into opposition to those of the Social Democrats. As Adolf Behne, one of the leaders of the Working Council for Art, put it:

> We survey the achievements of our revolution with a feeling of sadness and shame. What has happened in the ten weeks of the revolutionary period? Censorship and the state of siege have been lifted—a foregone conclusion. But otherwise the spirit of the old regime has returned to our people after a few short days of initial enthusiasm. Ideally, they want to set the old machine in motion again, only slightly repainted.[15]

The Working Council for Art in particular tried to devise alternatives to government support. These included attempts to reach a proletarian audience in a series of unusual exhibitions, including the notorious "Exhibition of Unknown Architects," which featured utopian architectural drawings. But these attempts to reach a new audience were fraught with contradictions (not the least of which was that the proletariat could ill afford to buy such art, even had it been so inclined) and foundered on the economic and political realities that the ubiquitous term *revolution* was used to both mask and improve. For its part, the *Kultusministerium,* dominated by the Social Democrats, walked a cautious line between maintenance of the status quo and mild concessions to the left. For instance, when in February 1919 a reform commission at the academy decided that "as little as possible should be reformed,"[16] the ministry pressed it to make concessions, but only in order to "take the wind out of the sails of the young people who represent themselves as oppressed."[17] The commission steadfastly refused, threatening to disband the academy rather than give in to political pressure.[18]

By June a degree of political and economic stabilization returned to Germany. The government elected in Weimar had a familiar look: it was basically a reconstructed coalition of the parties that had been in power in October 1918. Approval by the National Assembly of a new constitution and the signing of the Versailles Treaty were the signposts of this new order. Of importance to the artists' councils, a new government policy toward the arts emerged, one that increasingly sought to include Expressionism, but as part of a broad-based democratic program including all directions in the arts. One of the first signs was the promotion of a new gallery for contemporary art as part of the National Gallery. Before 1918 Expressionist art was barely represented in public museums throughout Germany; the National Gallery did not own a single Expressionist painting. Redress of this exclusion had been among

the high priorities of the Expressionist artists' councils. When the new contemporary wing of the National Gallery opened in August, it included on the upper floors works by almost every major German Expressionist artist, acquired either through new purchases or lent by collectors. For the first time Expressionist art was presented under state auspices.

The purchase of Expressionist paintings by the National Gallery fell far short of fulfilling the radical demands for the complete reorganization of museums under the control of Expressionist artists' councils. The institution of the museum, with its commissions and its conservative director, remained intact. Still, the new policies signaled a willingness to include Expressionism in the arts program of the republic and even gave the new art the aura of an official style. Wilhelm von Bode did not fail to comment on the irony of the situation when he complained that those who wanted to "do away with museums" had now become so prominent in them.[19] At least one commentator believed the purchases were a concession to the Expressionists, a form of cooptation.[20]

The accommodation of Expressionism in 1919 was also fostered by a resurgent art market, which assured Expressionist artists economic opportunity in the new republic. By September a slow but steady improvement was evident in art sales and by early 1920 the conservative journal *Kunst und Künstler* reported:

> Feverish movement reigns on the art market. Works are bought almost sight unseen (...) And since there is no longer a reactionary art, since everyone paints and draws in the modern style, the expressionist who was yesterday still derided becomes overnight an artist with a public and a capitalist. Now it is he who grumbles about the paper money and fears the capital levy...[21]

The sarcastic description of the "capitalist expressionist" was meant to deride the revolutionary claims of Expressionism. The description of the art market, however, was undoubtedly accurate. The coalition government had already signaled its commitment to a capitalist economy and industrialists soon used inflation to rebuild the country's industry—which had as one result a thriving art market. A new clientele had supported Expressionism in the final years of the war, when it was advertised as a spiritual refuge in the midst of catastrophe. It seems this same clientele, mostly members of the newer financial and industrial sectors, was now prepared to accept the revolutionary claims of this art. These members of the enlightened bourgeoisie proved themselves among the most able supporters of the republic—and its revolutionary rhetoric—demonstrating a greater political flexibility than might have been expected in dealing with the revolutionary threat.[22] Most Expressionist artists soon adapted themselves to the new culture of the parlia-

mentary democracy, their artistic freedom of expression and financial opportunities assured.

The ideological debate about Expressionism did not cease with its institutionalization, though. This is observed most strikingly in one of the first tests of the government's new arts program—the annual Berlin Art Exhibition, the first state exhibition in Prussia after the revolution. After complex negotiations, the Ministry of Culture came up with a plan to divide the exhibition space on a separate but equal basis, with one half given over to the conservative Association of Berlin Artists, the other to the combined leadership of the Berlin Secession, the Free Secession, and the November Group. Although the Prussian government claimed for the first time to have unified the entire Berlin art world under one roof, the exhibition was really a series of separate shows, held at the same time in the same place.

When the show opened in July 1919 the reaction was violent and grew in intensity throughout its duration. Critics were quick to point out the charade of the exhibition, acknowledging that there was no unity in the Berlin art world. The most vehement remarks were reserved for the unjuried rooms of the November Group. One prominent critic likened them to a "lunatic asylum" and called the young artists "malingerers who reproduce traits of strange madness with cold method."[23] Even sympathetic critics admitted that the works were for the most part derivative, the efforts of a second generation of Expressionist "fellow-travellers." Whatever the artistic merits of the works, the debate did not remain on the question of their originality or skill. By September the criticism changed to a discussion of political persuasion, taking on an even more aggressive and hostile tone. For example, the critic for the conservative *Kunstchronik und Kunstmarkt* wrote: "One stands as if before a fate and asks oneself if it had to come to this, if our time is condemned to destroy the forms of the old art, just as the Bolsheviks in Russia smash the forms of social life...."[24]

Not so subtly, the critic equated the shattering of old forms in art with the reputed violence of the Bolsheviks in Russia. He thereby seemed to confirm the revolutionary nature of Expressionism despite its acceptance by the state and the buying public. Verbal assaults like these now transpired not only in the press, but at the exhibition itself. As reported by the Berlin newspapers, a representative of the Anti-Bolshevist League appeared regularly in the November Group rooms protesting against "the art that...dishonours (the) fatherland" and warning that the "nihilism that topples everything previously established in art" was responsible for the political upheaval of the revolution.[25] Conversely, the resident critic for the Social Democratic newspaper *Vorwärts* defensively maintained in the face of these attacks the original claims of the November Group and Working Council for Art to mass accessibil-

ity, declaring that Expressionism was destined to become "an art for the great masses." Only the lack of an adequate "cultural level" among the masses, he wrote, prevented Expressionism from being a "true people's art"—a problem that would be remedied under socialism.[26]

The verbal assaults at the exhibition soon escalated into physical ones. At least one sculpture was damaged and the November Group commission announced that it could no longer guarantee the safety of the exhibited works. *Kunstchronik und Kunstmarkt* commented on this turn of events:

> ...the whole affair is played over again into the political sphere. One speaks of agents of counter-revolutionary groups who incite the public through adept agitation. (...) The attempt is made on the one side to use art as a means of political struggle, on the other to exploit the revolution-ary boom in order tendentiously to bring the latest manifestations in the cultural realm into contact with the party groups that stand furthest to the left—as was already successfully attempted in Russia.[27]

The divergent critical reaction to the exhibition represented the contra-dictory claims made about Expressionism. Denunciations by the political right still assumed not only the revolutionary nature of Expressionism, but its ties with proletarian dictatorship. Such attacks allowed Expres-sionist artists to go on believing for a time that their art was revolution-ary and helped them to dismiss the apparent contradiction of a revolutionary art increasingly embraced by the bourgeoisie (no matter how enlightened), which had already taken up the cause of Expression-ism in 1917 as part of an escapist wartime culture. On the other hand, Expressionism had reached no mass audience, nor had it been accepted by the extreme left. The contradiction of claiming revolutionary status for their art while increasingly enjoying the benefits of an anti-revolutionary government and economy was not lost on some critics of Expressionism, including the Dadaists.

Expressionism, in a sense, had proven in retrospect both too polit-ical and not political enough. Under these circumstances, the new social democratic art policies could be used both to buttress the party's revo-lutionary rhetoric—in reality, mere narrative clichés for resolving con-flict—but also by its critics to prove its antirevolutionary stance. Expressionism seemed perfectly suited to represent the greatest cultural achievement of the new government policy, the illusion of successful revolution.

The celebration of Expressionism as an official style had about it a somewhat funereal aspect. Many critics on the left became alarmed at an Expressionist art supported by (and supporting) the republic and saw it as a going hand in glove with the republic's increasing political

regression. By 1920 many critics proclaimed the death of Expressionism. What is meant by this is not that Expressionism disappeared, not that its practitioners suddenly abandoned it or its new patrons deserted it, but that its fateful history during the revolution, its institutionalization, had destroyed confidence in its ability to serve the avant-garde notion of art in the forefront of revolutionary politics.

Notes

* This essay is part of a larger study on art and the November Revolution in Germany published under the title *The End of Expressionism. Art and the November Revolution in Germany* (Chicago: The University of Chicago Press, 1989). It was delivered as a paper in a slightly different form at the 1988 annual meeting of the College Art Association. All translations from the German are by the author unless otherwise noted. My thanks to Elizabeth Johns and Aaron Sheon for reading a draft of this essay.

1. The term *Expressionist* was used by critics to describe not only painting and graphics, but also the work of the architect-members of the Working Council for Art, who produced Expressionist- and Cubist-inspired utopian architectural drawings in 1918–19.

2. Franz Schulz, "Kunst, Bürger, Staat," *Das Forum* 4, no. 9 (June 1920), 656.

3. Hermann von Wedderkop, "Revolution in der Kunst," *Ostern 1919,* catalogue of the Alfred Flechtheim Gallery (Düsseldorf, 1919), 48.

4. See: Peter Paret, *The Berlin Secession* (Cambridge, Belknap Press of Harvard University Press, 1980).

5. Rudolf Kurtz, "Programmatisches," *Der Sturm* 1, no. 1 (1910), 2.

6. Adolf Behne, "National-antinational," *Zeit-Echo* 1, no. 18 (1915–16), 273; "Organisation, Deutschtum und Kunst," *Zeit-Echo* 1, nos. 23–24 (1915–16), 361–364.

7. Quoted in Theda Shapiro, *Painters and Politics* (New York, Elsevier 1976), p. 154.

8. For a more detailed account of the economic success of Expressionism during the war see: O. K. Werckmeister, "Klee im Ersten Weltkrieg," in *Versuche über Paul Klee* (Frankfurt am Main, Syndikat 1981), pp. 86–87.

9. See, for instance, the influential text by Wilhelm Worringer, *Abstraktion und Einfühlung* (Munich, 1908).

10. Werckmeister, "Klee im Ersten Weltkrieg," p. 85.

11. Ludwig Meidner, "An alle Künstler, Dichter, Musiker," *An alle Künstler!* (Berlin, 1919), p. 8.

12. Like all other Prussian ministries in November 1918, the *Kultusministerium* was presided over by one member of the Social Democratic Party (SPD) and one member of the further left Independent Social Democratic Party (USPD). The USPD member left the ministry in January 1919 when his party resigned en bloc from the provisional government.

13. See *Münchner Neueste Nachrichten* 71 (November 25, 1918).

14. An account of the meeting appears in Hermann Schmitz, *Revolution der Gesinnung!: Preussische Kulturpolitik und Volksgemeinschaft seit dem 9. November 1918* (Neubabelsberg, 1931), pp. 50–51.

15. Adolf Behne, "Unsere moralische Krise," *Sozialistische Monatshefte* (January 20, 1919), quoted in Iain Boyd Whyte, *Bruno Taut and the Architecture of Activism* (Cambridge, Cambridge University Press, 1982), p. 115.

16. Sitzung der Kommission für Reformvorschläge der Akadamie, Berlin, February 3, 1919, Akademie der Künste, Berlin, Registratur 3, #693a, "Reform."

17. *Ibid.*, March 26, 1919.

18. *Ibid.*, April 2, 1919.

19. Wilhelm von Bode, "Die 'Not der Geistigen Arbeiter'," *Kunst und Künstler* 18, no. 7 (April 1, 1920), p. 197.

20. Otto Grautoff, *Die neue Kunst* (Berlin, 1921), p. 133.

21. "Ausverkauf," *Kunst und Künstler* 18, no. 5 (February 1, 1920), 191.

22. Among the most prominent supporters of Expressionist art were patrons such as Walter Rathenau of the AEG and the Stuttgart industrialist Robert Bosch, who held reformist social and political views already during the war.

23. Fritz Stahl, "Kunstausstellung Berlin 1919," *Berliner Tageblatt* 48 (July 24, 1919).

24. Curt Glaser, "Kunstausstellung Berlin 1919," *Kunstchronik und Kunstmarkt* 30, no. 45 (September 5, 1919), 962.

25. "Bildstürmer im Glaspalast," *Berliner Zeitung am Mittag* (September 5, 1919).

26. John Schikowski, "Die Expressionisten im Landesausstellungsgebaude," *Vorwärts* 36, no. 465 (September 11, 1919).

27. "Notizen," *Kunstchronik und Kunstmarkt* 30, no. 47 (September 19, 1919), 1002.

"Beyond Communism" 1920
"Portrait of Mussolini" 1929

FILIPPO MARINETTI

Written at a time when the Futurist movement had been essentially integrated into the Italian Fascist government, Marinetti criticizes Communism as a leveling of individuality and creativity; he affirms patriotism and heroism as the great motivators of human progress. Communist glorification of the proletariat is attacked as idealistic and he reaffirms art which celebrates anarchic individuality and is displayed in public festivals of art. Mussolini is portrayed as an exemplification of Futurist ideals.

The image of the modern artist as the rugged individual speaking for creative freedom can be very problematical when it becomes linked to political events. In the case of Italian politics specifically, there was a shift among some socialists during the First World War toward militarist interventionism that helped fuel what later became the Fascist movement. Mussolini himself had been an anarchist socialist of sorts. And indeed, certain Italian artists swung toward Fascist interventionism in much the same way, particularly during the attempted invasion of Trieste, along the Dalmation coast, in 1919. As an aestheticized version of anarchism blended into the political rhetoric of Fascism, Futurist ideas were used officially by the Fascist state in documents and government art shows.

* * *

We Italian Futurists have amputated all the ideologies and everywhere imposed our new conception of life, our formulas for spiritual health, our aesthetic and social dynamism, the sincere expression of our creative and revolutionary Italian temperaments.

After having struggled for ten years to rejuvenate Italy, after having dismantled the ultrapasséist Austro-Hungarian Empire at Vittorio Veneto, we were put in jail, accused of criminal assault on the security of the state, in reality of the guilt of being Italian Futurists.

We are more inflamed than ever, tireless and rich in ideas. We have been prodigal of ideas and will continue to be so. We are therefore in no mood to take directions from anyone, nor, as creative Italians, to copy the Russian Lenin, disciple of the German Marx.

Humanity is marching toward anarchic individualism, the dream and vocation of every powerful nature. Communism, on the other hand, is an old mediocritist formula, currently being refurbished by war-weariness and fear and transmuted into an intellectual fashion.

Communism is the exasperation of the bureaucratic cancer that has always wasted humanity. A German cancer, a product of the characteristic German preparationism. Every pedantic preparation is anti-human and wearies fortune. History, life, and the earth belong to the improvisers. We hate military barracks as much as we hate Communist barracks. The anarchist genius derides and bursts the Communist prison.

For us, the fatherland represents the greatest expansion of individual generosity, overflowing in every direction on all similar human beings who sympathize or are sympathetic. It represents the broadest concrete solidarity of spiritual, agricultural, fluvial, commercial, and industrial interests tied together by a single geographical configuration, by the same mixture of climates and the same coloration of horizons.

In its circular expansion, the heart of man bursts the little suffocating family circle and finally reaches the extreme limits of the fatherland, where it feels the heartbeats of its fellow nationals as if they were the outermost nerves of its body. The idea of the fatherland cancels the idea of the family. The idea of the fatherland is generous, heroic, dynamic, Futurist, while the idea of the family is stingy, fearful, static, conservative, passéist. For the first time a strong idea of *patria* springs today from our Futurist conception. Up to now it has been a confused mishmash of small-townishness, Greco-Roman rhetoric, commemorative rhetoric, unconscious heroic instinct, praise for dead heroes, distrust of the living, and fear of war.

But Futurist patriotism is an eager passion, for the becoming-progress-revolution of the race.

As the greatest affective force of the individual, Futurist patriotism, while remaining disinterested, becomes the most favorable atmosphere for the continuity and development of the race.

The affective circle of our Italian heart expands and embraces the fatherland, that is, the greatest maneuverable mass of ideals, interests, and private and common needs fraternally linked together.

The fatherland is the greatest extension of the individual, or better: the largest individual capable of living at length, of directing, mastering, and defending every part of its body.

The fatherland is the psychic and geographical awareness of the power for individual betterment.

You cannot abolish the idea of the fatherland unless you take refuge in an absentist egotism. For example, to say: I'm not Italian, I'm a citizen of the world, is equal to saying: Damn Italy, Europe, Humanity, I'll think of myself.

The concept of the fatherland is as indestructible as the concept of party.

The fatherland is nothing but a vast party.

To deny the fatherland is the same as to isolate, castrate, shrink, denigrate, or kill yourself.

The workers who today are marching and waving red banners demonstrate after four years of victorious war an obscure need of their own to wage a little heroic and glorious war.

It's absurd to sabotage our victory with the cry "Long live Lenin, down with war," because Lenin, after having pushed the Russians into renouncing one war, forced another war on them against Kolchak, Denikin, and the Poles.

Russian Bolshevism thereby involuntarily creates Russian patriotism, which is born of the need for a defensive war.

You cannot escape these two idea-feelings: *patriotism,* or the active development of the individual and race, and *heroism,* or the synthetic need to transcend human powers, the ascensional force of the race.

All those who are tired of the stormy-dynamic variety of life dream of the fixed, restful uniformity promised by Communism. They want a life without surprises, the earth as smooth as a billiard ball.

But the pressures of space have not yet leveled the mountains of the earth, and the life that is Art is made up (like every work of art) of points and contrasts.

Human progress, whose essence is increasing velocities, like every velocity admits obstacles to overthrow, that is, revolutionary wars.

The life of insects demonstrates that everything comes down to reproduction at any cost and to purposeless destruction.

Humanity vainly dreams of escaping these two laws that alternately excite and exhaust it. Humanity dreams of stabilizing peace by means of a single type of world man, who should then be immediately castrated lest his aggressive virility declare new wars.

A single human type should live on a perfectly smooth earth. Every mountain defies every Napoleon and Lenin. Every leaf curses the wind's warlike will....

Communism may be realized in cemeteries. But, considering that many people are buried alive, that a man's total death cannot be guaranteed, that sensibilities survive to die later, cemeteries doubtless contain furious gatherings, rebels in jail, and ambitions that want to arise. There will be many attempts at Communism, counterrevolutions that wage war and revolutions that defend themselves with war.

Relative peace can be nothing but the exhaustion of the final war or the final revolution. Perhaps absolute peace will reign when the human race disappears. If I were a Communist, I would concern myself with the next war between pederasts and Lesbians, who will then unite against normal men.

I would begin propagandizing against the coming interplanetary war.

The more leveling revolutionaries in Russia defend their power against the attacks of less leveling revolutionaries who would like a fresh inequality.

Above all, Bolshevism was a violent, vindictive antidote to czarism.

Now it is belligerently defended by those social doctors who are changing themselves into masters of a sick people....

In every country, particularly in Italy, the distinction between proletariat and bourgeoisie is false. An entirely soiled and moribund bourgeoisie does not exist, nor an entirely sane and vigorous proletariat. Rich and poor exist; poor from bad luck, illness, incapacity, honesty; rich from fraud, cleverness, avarice, ability; exploiters and exploited; stupid and intelligent; false and sincere; so-called rich bourgeois who work much more than the workers; workers who work as little as possible; slow and fast; conquerors and conquered.

"Soiled and moribund bourgeoisie" is an absurd description of that great mass of young, intelligent, and hard-working lower middle class; notaries, lawyers, etc., all sons of the people, all absorbed in working furiously to do better than their fathers.

All of them fought the war as lieutenants and captains, and, tired as they are today, they are ready to take up their lives again with heroism.

They are not intellectuals, but workers endowed with intelligence, foresight, the spirit of will and sacrifice. They constitute the better part of our race. The war was fought by these energetic young men always in command of worker and peasant infantry.

The peasants and workers who fought the war, not having acquired any national awareness, could never have won without the example and intelligence of those *piccoli borghesi,* the heroic lieutenants. It is more-

over unquestionable that attempts at Communism are and will always be led by the young, willful, and ambitious lower middle class.

On the other hand it is absurd to characterize all workers with the word *proletariat,* promising equal glory and dictatorship to the peasant infantry who are now resuming their work on the land without tiredness, and to the factory workers who claim to be exhausted.

We must destroy passéism, cowardice, quietism, conservative traditionalism, materialist egotism, misogyny, the fear of responsibility, and plagiarist provincialism.

It is provincial plagiarism to cry: *Long Live Lenin; Down with Italy; Long Live the Russian Revolution!* Cry instead: *Long Live the Italy of Tomorrow! Long Live the Italian Revolution! Long Live Italian Futurism!*

The Russian Revolution has its *raison d'être* in Russia and can only be judged by the Russians. It cannot be imported into Italy.

Innumerable differences separate the Russian from the Italian people, beyond the typical one separating a conquered from a conquering people.

Their needs are different and opposite.

A conquered people feels its patriotism dying within it, turns itself inside out with a revolution, or copies the revolution of a neighboring people. A conquering people like ours wants to make its own revolution, just as the pilot of an airplane throws ballast overboard in order to climb higher.

Let's not forget that the Italian people, notably bristling with sharp individualisms, is the most anti-Communist and dreams of individualist anarchy.

Anti-Semitism does not exist in Italy. Therefore we have no Jews to redeem, validate, or follow.

The Italian people can be compared to an excellent wrestler who wants to wrestle with no special training and is unequipped with the means to train. Circumstances force it to win or to disappear. The Italian people has gloriously won. But the effort was too much for its muscles, so now, panting, exhausted, almost unable to enjoy its great victory, it curses us, its trainers, and opens its arms to those who counsel it not to fight.

Between these partisans of quiet who want to keep our people down and we who want to cure and raise it up again at any cost, a struggle has broken out that disgracefully continues over the broken body of the very wrestler himself.

The huge mess of difficulties, stumbling blocks, sufferings that every war always leaves behind, the exasperation of all demobilized men drowning in the immense bog of bureaucracy, the belated energetic

taxation of war profits, all this is crowned by the still-unsolved Adriatic question, the still-unsettled Brenner, etc., etc.

We were governed by an incurable neutralist, who did everything he could to diminish the moral force of our victory.

This government favored the Socialists who, waving the Communist banner of a people conquered like the Russians, took control in the elections of the tired and discontented but victorious Italians.

It is not a matter of a struggle between bourgeoisie and proletariat, but a struggle between those who, like us, have a right to make the Italian revolution and those who should submit to its conception and realization.

I know the Russian people. Six months before the universal conflagration I was invited by the Society for Great Lectures to give eight lectures in Moscow and Saint Petersburg on Futurism. The triumphant ideological repercussion of those lectures and my personal success as a Futurist orator in Russia have remained legendary. I bring this up so that the complete objective fairness of my judgment of the Russian Futurists will be plain. I am delighted to learn that the Russian Futurists are all Bolsheviks and that for a while Futurist art was the official Russian art. On May Day of last year the Russian cities were decorated with Futurist paintings.

Lenin's trains were decorated on the outside with colored dynamic forms very like those of Boccioni, Balla, and Russolo. This does honor to Lenin and cheers us like one of our own victories. All the Futurisms of the world are the children of Italian Futurism, created by us in Milan twelve years ago. All Futurist movements are nevertheless autonomous. Every people had, or still has, its passéism to overthrow. We are not Bolsheviks because we have our own revolution to make....

We want to free Italy from the Papacy, the Monarchy, the Senate, marriage, Parliament. We want a technical government without Parliament, vivified by a council or exciter [*eccitatorio*] of very young men. We want to abolish standing armies, courts, police, and prisons, so that our race of gifted men may be able to develop the greatest number of free, strong, hard-working, innovating, swift men.

All that, in the great affectionate solidarity of our race on our peninsula within the firm circle of boundaries conquered and deserved by our great victory.

We are not only more revolutionary than you, Socialist officials, but we are beyond your revolution.

To your immense system of leveled and intercommunicating stomachs, to your tedious national refectory, we oppose our marvelous anar-

chic paradise of absolute freedom, art, talent, progress, heroism, fantasy, enthusiasm, gaiety, variety, novelty, speed, record-setting....

Our optimism is great.

The Italian blood shed at Tripoli was better than that shed at Abba Garima. That shed on the Carso, better; that shed on the Piave and at Vittorio Veneto, better.

By means of the schools of physical courage that we propose, we want to increase this vigor of the Italian blood, predisposing it for every audacity and an ever-greater creative artistic capacity, to invent and enjoy spiritually.

One must cure all cowardices and all languors and develop the spiritual elegance of the race, so that the best thing to be found in a tumultuous crowd is the sum of its spiritual elegances: heroic, and generous.

One must increase human capacity to live the ideal life of lines, forms, colors, rhythms, sounds, and noises combined by genius.

If they could relieve the hunger of every stomach, there would always be those who can overcome their lust for refined, privileged dinners.

One must stimulate spiritual hunger and satiate it with a great, joyous, astonishing art.

Art is revolution, improvisation, impetus, enthusiasm, record-setting, elasticity, elegance, generosity, superabundance of goodness, drowning in the Absolute, struggle against every hindrance, an aerial dance on the burning summits of passion, destruction of ruins in the face of holy speed, enclosures to open, hunger and thirst for the sky...joyous airplanes gluttonous for infinity....

There are shadowy, flaccid human masses, blind and without light or hope or willpower.

We will tow them after us.

There are souls who struggle without generosity to win a pedestal, a halo, or a position.

These base souls we will convert to a higher spiritual elegance.

Everyone must be given the will to think, create, waken, renovate, and to destroy in themselves the will to submit, conserve, copy.

When the last religions are in their death throes, Art should be the ideal nutriment that will console and reanimate the most restless races, unsatisfied and deluded by the successive collapse of so many unsatisfying ideal banquets.

Only the inebriating alcohol of Art can finally take the place of and eliminate the tiresome, vulgar, and sanguinary alcohol of the proletariat's Sunday taverns.

Thus, in my tragicomedy *Re Baldoria* [*King Riot*], the artistic innovative dynamism of the Poet-Idiot ridiculed by the mob fuses with the insurrectional dynamism of the libertarian Famone [Big Hunger], to propose to humanity the only solution of the universal problem: Art and the artists to power.

Yes! Power to the artists! The vast proletariat of gifted men will govern.

The most sacrificed, the worthiest of the proletariats. Everyone is tired and disillusioned. The artist does not give in. Soon his genius will explode immense roses of exhilarating artistic power over Italy and the world, purifying and pacifying them.

The proletariat of gifted men in power will create the theater free to all and the great Futurist Aero-Theater. Music will reign over the world. Every town and city square will have its great instrumental and vocal orchestra. So there will be, everywhere, fountains of harmony streaming day and night from musical genius and blooming in the sky, to color, gentle, reinvigorate, and refresh the dark, hard, banal, convulsive rhythm of daily life. Instead of nocturnal work, we will have nocturnal art. Squads of musicians will alternate, to centuple the splendor of the days and the suavity of the nights.

The proletariat of gifted men will alone be able to undertake the wise, gradual, worldwide sale of our artistic patrimony, according to a law conceived by us nine years ago. This small spiritual seed will implant admiration for us in the crudest people of the world.

Sold to the world, our museums will become a dynamic overseas advertisement for the Italian genius.

The proletariat of gifted men, in cooperation with the growth of mechanized industrialism, will arrive at that maximum of salary and that minimum of manual labor which, without lessening production, will be able to give every intelligent person the freedom to think, create, and enjoy the arts.

In every city will be built a Palace or House of Genius for Free Exhibitions of the Creative Intellect.

1. For a month a work of painting, sculpture, any plastic art, architectural drawing, machine designs, or inventor's plans will be shown.
2. A musical work, large or small, orchestral or pianistic or whatever, will be played.
3. Poems, prose works, scientific writings, of every kind, form, or length, will be read, expounded, declaimed.
4. No jury trial or entrance fee will be required for the reading or display of works of any kind or apparent value, no matter how superficially absurd, cretinous, insane, or immoral they seem to be.

The Futurist revolution that will bring the artists to power promises no earthly paradises. It will certainly be unable to suppress the human torment that is the ascensional power of the race. The artists, tireless airmen of this feverish travail, will succeed in reducing suffering.

They will solve the problem of well-being in the only way it can be solved: spiritually.

Art must be an alcohol, not a balm. Not an alcohol that gives forgetfulness, but an alcohol of exalting optimism to deify the young, to centuple maturity and refresh old age.

This intellectual art-alcohol must be extended to everyone. Thus will we multiply the artist-creators. We will have a race almost entirely composed of artists. In Italy we will have a million intuitive diviners, eager to solve the problem of collective human happiness. Such a formidable assault cannot help being victorious. We will solve the social problem artistically.

Meanwhile we suggest the expansion of our people's faculty of dreaming, to educate it in a completely practical direction.

The satisfaction of any need is a pleasure. Every pleasure has a limit.

Dreams begin at the limit of pleasures. We must control the dream and prevent it from becoming nostalgia for the infinite or hatred for the finite. The dream should envelop, bathe, perfect, and idealize pleasure.

Every brain should have its palette and its musical instrument for coloring and lyrically accompanying every small act of life, even the humblest.

The common life is too heavy, austere, monotonous, materialistic, badly ventilated, and, if not strangled, at least clogged up.

As we await the grandiose realization of our Futurist Aero-Theater, we propose a vast program of daily free concerts in every quarter of the city, cinema theaters, reading rooms, absolutely free books and magazines. We will develop the spiritual life of the people and centuple its faculty of dreams.

Thanks to us, the time will come when life will no longer be a simple matter of bread and labor, nor a life of idleness either, but *a work of art*.

Every man will live his best possible novel. The most gifted spirits will live their best possible poem. There will be no contests of rapacity or prestige. Men will compete in lyric inspiration, originality, musical elegance, surprise, gaiety, spiritual elasticity.

We will have no earthly paradise, but the economic inferno will be lightened and pacified by innumerable festivals of Art.

* * *

With Mussolini I have lived tragic, certainly revealing days. I can limn his typical and exceptional figure.

Mussolini has an exuberant, overwhelming, swift temperament. He is no ideologue. Were he an ideologue he would be held back by ideas that are often slow, or by books that are always dead. Instead he is free, free as the wind.

He was a Socialist and internationalist, but only in theory. Revolutionary yes, but pacifist never. He necessarily had to end up obeying his own kind of patriotism, which I call physiological.

Physiological patriotism, because physically he is built *all'italiana,* designed by inspired and brutal hands, forged, carved to the model of the mighty rocks of our peninsula.

Square crushing jaws. Scornful jutting lips that spit with defiance and swagger on everything slow, pedantic, and finicking. Massive rocklike head, but the ultradynamic eyes dart with the speed of automobiles racing on the Lombard plains. To right and left flashes the gleaming cornea of a wolf.

The round felt cap pulled down over the intense black of the eyes like the round black clouds that hover over the intense black of Apennine ravines. And when the cap is removed, the baldness of a Verlaine, a D'Annunzio, a Marinetti shines forth like an electric lamp.

His coat collar always turned up from an instinctive need to disguise the violent *romagnolo* words hatching their plots in his mouth.

His right hand in his coat pocket grasps his stick like a saber straight along the muscles of his arm.

Bent over his desk on large elbows, his arms as alert as levers, he threatens to leap across his papers at any pest or enemy. A swing of the agile torso from right to left and from left to right, to brush off trivial things. Rising to speak, he bends forward his masterful head, like a squared-off projectile, a package full of good gunpowder, the cubic will of the State.

But he lowers it in conclusion, ready to smash the question head on or, better, to gore it like a bull. Futurist eloquence, well masticated by teeth of steel, plastically sculpted by his intelligent hand that shaves off the useless clay of hostile opinions. From time to time, the great gesture-fist-image-conviction forcing a passage through a tangle of objections.

His will splits the crowd like a swift antisubmarine boat, an exploding torpedo. Rash but sure, because his elastic good sense has accurately judged the distance. Without cruelty, because his vibrant fresh lyric childlike sensibility laughs. I remember how he smiled, like a happy infant, as he counted off twenty shots from his enormous revolver into the policemen's kiosk on the Via Paolo da Cannobio. I remember how lyrically he sought the beautiful patriotic roses amid the

barbed wire and sportively caressed the Frisian horses that cluttered the little yard of the *Popolo d'Italia* when it was raided in 1919.

Lyric child armed with lightning intuition, Mussolini was speaking to foreign representatives and journalists, with no false cultural modesty, as follows: "We are a young people who want and ought to create and refuse to be a syndicate of hotel-keepers and museum guards. Our artistic past is admirable. But as for me, I couldn't have been inside a museum more than twice."

For which reason we Futurists, prophets and preparers of the great Italy of today, are happy to salute in the forty-year-old President of the Council of Ministers a marvelous Futurist temperament.

"Guns" 1919

WYNDHAM LEWIS

Artist and critic Wyndham Lewis discusses his one-person show, "Guns," held at the Goupil Gallery, London in February 1919. While acknowledging the "experiments in art" which took place before the First World War, Lewis in his exhibition wishes only to give a personal interpretation of his own war experience, in the manner of Goya rather than Ucello—with passion rather than dispassion.

As the editor of the Vorticist journal *Blast,* as novelist, political activist, and art ideologue, Lewis was central to the direction that modern art took in poetry and painting in England immediately after the First World War. Critic and literary historian Hugh Kenner writes about that moment at great length in his study *The Pound Era* (1971), particularly the Vorticist movement, led by Lewis and Ezra Pound:

> The (English) Vorticists disowned Futurism because it denied tradition, and were wary of Cubism because it seemed indifferent to personality.
>
> To sort out these interfused meanings: Vorticism denoted first of all the Great *London* Vortex. The Future has no locale, an Image or a Cube may turn up in anyone's pocket, but any Vortex is somewhere on the map. And this was the English, not the French or the Russian, version of abstract art. Behind Parisian Cubism one may see cafe tables, behind Italian Futurism a horde of museum-keepers bedazzled by zip; behind London Vorticism, English ships and London buildings, and the intent detached passion of the countrymen of Charles Babbage and Lord Kelvin.[1]

Kenner goes on to say:

> Nearer to the end of the century than to those times, we think that imagined world of theirs old hat: a strange illusion since it was never colonized. A landing party or two set down, no more. Then the supply ships

were scuttled, the effort faltered, some pilots were killed, others devoted long lives to catechizing a bitter lesson, each in an isolation from the others that 1914 could not have foreseen. Have we studied the manifestoes too often, and the flight plans that were never used? Or are we dulled by loudspeakers, or have we lost the capacity to participate in a hope? 'The twentieth century's early modernism,' we yawn respectfully or indifferently. There have been so many modernisms. *That* period, we feel sure, played itself out. But it never played; its energies separated, some were cancelled by lead, its synergies faded amid the roar of field guns. What we feel so used to in retrospect, nearly convinced that we were *there* and found it meager, is like the memory of a TV program we cannot be bothered to interrogate.[2]

* * *

Foreword to the Catalogue of Lewis's One-Man Show 'Guns,' Held at the Goupil Gallery, London, in February 1919.

The public, surprised at finding eyes and noses in this exhibition, will begin by the reflection that the artist has conceded Nature, and abandoned those vexing diagrams by which he puzzled and annoyed. The case is really not quite that. All that has happened is that in these things the artist has set himself a different task. A Tchekhov story, or the truth of a drawing by Rembrandt, is a highly respectable thing, and in the highest degree worth doing. I never associated myself to the jejune folly that would tell you one week that a Polynesian totem was the only formula by which the mind of Man—the Modern Man, Heaven help him!—might be expressed: the next, that only by some compromise between Ingres and a Chinaman the golden rule of self-expression might be found. My written work is hardly, after all, a monument of abstraction! 'Abstract art,' expressionism, cubism, or what not is a fanatic, if you will, but a perfectly sincere insistence on the fundamentals of design or colour. The multitudinous formulae that present themselves to the artist and stimulate his curiosity or challenge his sense of adventure are investigated, combined, new formulae evolved. At the present day the Greco-Roman, Renaissance tradition, equally with the naturalism of the nineteenth century in France, or of the flat facilities that flourish by the Chinese sea, are not a fetish or a thing exclusively imbibed or believed. The Artist 'takes what he will,' like the gentleman in the Purple Mask. As a logical development of much of the solidest art in this very various world there is nothing so devilish or mad in any of the experiments in art that prevailed in the years preceding the War.

That much said, and turning to this exhibition: there is very little technically abstruse in it; except in so far as it is always a source of astonishment to the public that an artist should not attempt to transcribe Nature literally, without comment, without philosophy, without vision.

I have attempted here only one thing: that is in a direct, ready formula to give an interpretation of what I took part in in France. I set out to do a series dealing with the Gunner's life from his arrival in the Depot to his life in the Line. Some episodes or groupings may, for the physical interest I took in them, or in their arrangement, somewhat impair the scheme, looked at from the standpoint of the illustrator, and I have not yet got my series.

The War has, so far, been reflected in art with the greatest profusion. But the same can be said of life at any time; and we are not much the wiser. Whatever we may think about that, it is certain that the philosophy of the War, all the serious interpretation of it, has yet to be done. That could not, for a hundred reasons, be accomplished during the War. This is in no way meant to disparage the good work relating to the War, in painting, that has been done so far. But all the War journalism, in painting and writing, will cease with the punctuality and *netteté* of a pistol shot when the war-curtain goes down. It will then be the turn of those with experience of the subject, the inclination, the mood, to make the true record. Truth has no place in action.

This show, then, pretends nothing, in extent: I make only the claim for it in kind that it attempts to give a personal and immediate expression of a tragic event. Experimentation is waived: I have tried to do with the pencil and brush what story-tellers like Tchekhov or Stendhal did in their books.

It may be useful to consider War as subject-matter, its possibilities and appeals to the artist. Since war-art has been discussed as a result of the universal conditions of war prevailing and since artists, such as were not in the Army, have turned their subject-matter from the Academy rosebud into the khaki brave; or those in the outer fashion, from the cubed cockney into the cubed Tommy; ever since the art-critic, he also, has been forced to drag his eye and pen away from the Nymph and Pretty Lady and fix them on a muddy fight; what artist's name has been most frequently heard?

Uccello: that is the name we have most frequently heard. Now, in an automatic way people began to accept that name, and the picture that hangs in the National Gallery above that name, as typifying what the artist can do with War. Detaille, Meissonier were banal illustrators; Verestchagin was a war artist primarily; Uccello was the only great master, in a handy place, who could give us an example of war as subject-matter.

Uccello's battle-piece is a magnificent still life, a pageant of armours, cloths, etc., the trappings and wardrobe of War, but in the lines and spirit of it, as peaceable and bland as any tapestry representing a civic banquet could be. It does not borrow from the *fact* of War any emotion, any disturbing or dislocating violence, terror or compassion— any of the psychology that is proper to the events of War. A Japanese warrior, with his ferocious mask, is more frigid than the classic masks of Mantegna's despairing women. Uccello's battle-piece is a perfectly placid pageantry. It was easier, no doubt, with so much obvious splendour at that period to retain this aloofness. But in any case, the principal thing is that this is a purely inhuman picture, in the sense that the artist's attitude was that of the god for whom blood and death mean no more than bird's plumage and the scintillations of steel.

Another great artist has given us a rich and magnificent work dealing with war from a very different angle. Goya's *Desastres de la Guerra,* a series of etchings done in his old age, is an alternately sneering, blazing, always furious satire directed against Fate, against the French, against every folly that culminates in this jagged horror. This war-art is as passionate as Uccello's is cold. Both are equally great as painting.

You know Van Gogh's scene in a prison yard? Then you know how he would treat war. You know Velasquez' *Surrender of Breda?* That is his war.

It is clear, then, that an artist of a certain type would approach any disturbance or calamity with a child-like and unruffled curiosity and proceed to arrange Nissen huts, shell-bursts, elephants, commanding officers, aeroplanes, in patterns, just as he would proceed with flowers in a vase, or more delectable and peaceful objects. Another comes at pictorial expression with one or other of the attendant genii of passion at his elbow, exciting him to make his work a 'work of action'; the Man of Action having his counterpart in the works of the mind.

Such general remarks may help in the reading of these pictures.

Notes

1. Hugh Kenner, *The Pound Era* (Berkeley: University of Calif. Press, 1971), p. 238.
2. Ibid., p. 246.

"The Men Who Paint Hell" 1919

WYNDHAM LEWIS

In a February 10, 1919 article for the *London Daily Express*, Lewis discusses different approaches to artists who wish to communicate the "barbaric nightmare" which is war, from pageantry to personal observation of human beings immersed in the monotony of trench warfare. The impact of this war on world culture cannot be overestimated, in literature, social theory, the visual arts. It became the fracture that reconstituted art discourse, so that much of our understanding of modern art today is conditioned by how the prewar era was remembered in the 1920s, both the nihilism and utopianism of the world that was left after the Great War.

* * *

From the Daily Express, No. 5,877, 10 Feb. 1919, p. 4. Printed with the following editorial note: "(Mr Wyndham Lewis is an artist without category. He declines to call himself an impressionist or a cubist. His exhibition 'Guns', at the Goupil Gallery, is exciting much criticism.)" The first of the two exhibitions referred to in the first paragraph was the Canadian War Memorials Exhibition, 1919, and the second was held in 1920 at the Imperial War Museum.

A new subject-matter has been found for art. That subject-matter is not war, which is as old as the chase or love; but modern war. We have had a series of exhibitions of war-art, drawings and paintings of soldiers, trench landscapes, pictures of the singular technical fauna of the air, battalion scenes and battery scenes; culminating in the present exhibition at the Royal Academy of war pictures for Canada. This is to be followed in a few months, I believe, by a similar Government exhibition

of pictures destined to remain in this country in some public gallery. So there has been much discussion on the resources of this new subject for pictures and its appeal to artists.

As a theme for pictorial art, war differs from most others in that it is spasmodic and ephemeral. Today it is much more ephemeral than at any former period, but also much more intense. The French Impressionists of the last century took the life of the city for the subject of their pictures—café scenes, bars of music halls, a family at dinner, the eternal child-like awakening of a woman, or her equally eternal but less child-like going to bed, prayerless and bedizened, in some Paris room. British Royal Academicians portray principally episodes from the school history books and interminable stiff portraits. All the subjects persist, and are year in, year out, ready to the hand, either as studio property or daily life.

The eight-mile-wide belt of desert across France will be a green, methodic countryside in five years' time. The harsh dream that the soldier has dreamed—the barbaric nightmare—will be effaced by some sort of a cosy sun tinting the edges of decorous lives. At Austerlitz the trees waved pleasantly all through the carnage with Schilleresque oscillations; the earth at Eylau could not have had many wounds to show. At a few miles' distance Salamis might have been mistaken for a stunt-regatta.

Ypres and Vimy, on the other hand, were deliberately invented scenes, daily improved on and worked at by up-to-date machines, to stage war. There is, or was, no trace in one of the valleys before Ypres except of this agency.

The artist will approach this territory and this life in one of two ways—either as the artist visiting a picturesque spot and selecting quaint bits and views of dilapidated survivals of a dead life—or as the artist who takes his subject-matter from the life around him.

Daumier would have painted soldiers with the same relish with which he painted women washing their clothes in the Seine, gatherings of rough people in the street, or what not. Degas, Delacroix, Van Gogh, are other names that suggest themselves. Delacroix would have painted the human subject of the war with his French, theatrical, fury—*furia francese*—Van Gogh with the delicate compassion with which he imbued everything that he touched. The Japanese formularized war into staring masks of hatred and the elegancies and energies of extravagant sword-play.

The wars of the Middle Ages partook of the pageantry of a Lord Mayor's Show—so that Uccello (whose painting in the National Gallery is rightly regarded, as art, as the greatest war painting accessible to the English public) could show you a scene of carnage with a super-calm pulse, and without the faintest indication that his fantasy had been

troubled by the noises or horrors of battle. The armour, plumes, the decorative spears make up as suavely composed a picture as though the subject were a civic banquet. Nothing of the sombre strain, the hopeless monotony of war as we have it today, can be found in that placid and pleasant canvas.

It is clear that modern war, as a subject-matter, is accessible only to a certain type of creative artist. The man who painted Hell with such ability at Orvieto would have been the man to commission to make you a monument of the "Over There" of the popular song.

"Revolutionary Art, Mass Art and the Specific Form of the Class Struggle" 1929

CESAR VALLEJO

Cesar Vallejo (1892–1938) was born in Peru but moved to Paris in 1921. In 1928, he founded the Peruvean Socialist Party (in exile), and joined the Communist Party in early 1931 in Madrid. Vallejo argues that the revolutionary artist should communicate to a mass audience and stay in close touch with the revolutionary struggles of the international working class. Art becomes a species of (enlightened) political propaganda.

This document appeared at the beginning of a decade of intense political debate among modern artists. With political repression in Germany and the Soviet Union in the mid-1930s, and the crisis of the Spanish Civil War, severe shifts in the debates over modern art became necessary in order to redefine problems in terms of coming global conflict against Nazism and Fascism.

* * *

1. In the present social period—owing to the acuteness, the violence and the profundity evident in the class struggle—the inherent revolutionary spirit of the artist cannot avoid having social, political and economic problems as the thematic essence of his works. Today these problems are posed throughout the entire world so fully and with such bitter anger that they irresistibly penetrate and encroach upon the life and the consciousness of the most solitary of recluses. The sensibility of the artist, perceptive and sensitive by its own definition, cannot avoid

them. It is not in our hands to keep from taking part, on one side or the other, in the conflict. Therefore to say "art" and, what is more, "revolutionary art," is equivalent to saying class art, art of class struggle. The revolutionary artist in art implicates the revolutionary artist in politics.

2. Where is one to find the revolutionary front in today's class struggle? Which social class embodies the movement, the idea and the revolutionary force of history? I assume no one would dare consider him or herself as being on the capitalist front, in the bourgeois class. The social revolution is being seeded with the blood and battles of the proletarian class, and the front which embodies that class is none other than that of the Bolsheviks, vanguard of the working masses. In this struggle the place of the revolutionary artist is, therefore, in the ranks of the proletariat, the Bolshevik ranks, among the laboring masses.

3. This being revolutionary art, specifically in terms of class struggle and mass art, what should be the point of departure, the form and content, the social goals of the artwork?

a. The strategic and tactical positions which, in the course of class struggle, the international working class adopts in accord with the critical twists and turns imposed by momentary circumstances, must constitute the point of departure for the revolutionary artwork. In other words: the work of art must always be grounded in the most recent incident of the struggle and must start out from the day-to-day necessities and interests of this struggle. Hence the artist and writer must follow closely the directives and guidelines of the Communist Party, and is to keep up, hour by hour, with events.

b. The form of revolutionary art must be as direct, simple and spare as possible. An implacable realism. Minimum elaboration. The shortest road to the heart, at point-blank range. Art of the foreground. Phobia of halftones and shades of meaning. Everything in the rough—angles and no curves, yet heavy, barbarous, brutal, as in the trenches.

c. The content of the artwork must be a content of the masses. The stifled aspirations, the turbulence, the common fury, the frailties and the driving thrusts, the lights and shadows of class consciousness, the back-and-forth swaying of individuals within the multitudes, the frustrated potential and the heroism, the triumphs and the vigils, the ups and downs, the experiences and lessons of every working day—in short, all the shapes, gaps, flaws, hits and misses of the masses in their

revolutionary struggles. To this end, it is necessary to create and develop throughout the proletarian ranks a vast network of organizations and contacts involving revolutionary art—such as, among others, the factory and farm correspondents, the workers' control within the national sections of the U.I.R.E., and in the organs of the press and the revolutionary publishing houses, the peasants' and workers' reading circles, the "Blue Shirts" theatre group, the critiques of the masses, the workers' clubs, the fairs for proletarian and peasant artisans, the roving academies, the artists' and writers' brigades in workers' organizations, in the trenches of the civil wars, etc. etc.

d. The concrete and immediate ends of revolutionary art will vary according to the changing needs of the moment. One must bear in mind that the audience for this art is multiple: the masses who still are not yet radicalized and who fall into line in the ranks of Fascism or Anarcho-Syndicalism or even the parties of the bourgeois left; the masses without class consciousness, the masses already radicalized and Bolshevik; and, lastly, the petty bourgeoisie and the bourgeoisie itself. In this field of action one has to employ tactics which are shrewd, skillful, sharp and flexible, since the practical objective of the artistic or literary work depends on the means used with regard to each audience, and on the needs of the moment. For instance, in dealing with the bourgeoisie in general, the revolutionary end is realized either by attacking it to the death or by winning it over. The "fellow-travelers"—of whom Romain Rolland speaks—cannot be aroused or won over except on grounds that are straightforward and cordial. And we know already what a great service these liberal or sympathetic artists and intellectuals bring to the revolutionary movement, when, as in many cases, they have not completed being radicalized or even proletarianized. And lastly, we know that the majority of the members belonging to the "International Union of Revolutionary Writers" are presently "fellow-travelers."

"Functionalism" 1936

KATARZYNA KOBRO

"Modern Art in Poland" 1934

WLADYSLAW STRZEMINSKI

Polish painter and sculptor Katarzyna Kobro defines functionalism as a counterpart to the scientific organization of work. A functional work of art is directly connected with everyday life by undertaking research into the purposeful organization of shapes and their influence upon consumers. Artists work with architects, designers, and "psychological engineers" to reconstruct human life.

Kobro was a painter, sculptor, and architectural designer. With her husband, Wladyslaw Strzeminski, she returned from Russia to her Polish homeland in 1923. Strzeminski, the guiding force in the Polish Constructivist movement, had taught for a few years at Unovis and been deeply influenced by Kasimir Malevich.

Malevich was of Polish extraction and visited Poland regularly in the 1920s. Until 1918, much of Poland had been part of the old Russian empire, and despite a short war with the Bolsheviks in 1920 and great tension between the two nations during that decade, many in the Soviet avant-garde worked closely with their counterparts in Poland.

There were also strong ties between Poland and western Europe. Many Polish intellectuals and artists had been educated in Germany before the First World War. A leading Polish journal, whose title translates roughly as *Railway Switch,* served very much as switching point for German culture in Poland.

So we should read this document not as a reflection of Russian or German influence, but rather as another link in what amounted to a transcontinental correspondence, from Paris, Holland, and Germany to Poland and the Soviet Union. In many ways, the memory of this international Constructivist style of the 1920s became the foundation for the international style in architecture and design after World War II.

* * *

I. Functionalism is not one of the directions of art for art's sake. The aim of functionalism is to affect the pattern of common life by artistic forms according to the principles of scientific organization of labour; i.e. an attaining of the maximally useful effect at the minimum of expenditure of efforts and resources.

The task of functionalism is to find such a set of artistic forms that would work towards utilitarian ends in the most economic way. Functionalism looks for the shortest way of producing an artistic emotion, and it considers utilitarian endeavours that bring about an orderly organization as the discharge of such emotion.

Starting from the assumptions of a planned utilitarianism—functionalism, however, defies all sorts of cynical disillusionment, the laissez-faire doctrine as applied to life, vitalism etc. These intellectual directions, so typical for the present dismal epoch of crisis, actually strive to discredit systematically the progress of human mind.

On artistic grounds, functionalism opposes all the attempts at ornamentation, beautifying, contemplation in art, "spirited" sensing of impressions. The test of an artistic value is its utilitarian effect, broadening the productive scale of opportunities in life. Accordingly, the main principles of functionalism are: (1) utilitarianism; (2) economy; (3) planning. The method of functionalism is the subjugating of each activity to the general objective and utilitarian content. Thus, functionalism encompasses: (1) the field of direct organization of life by correcting the current utilitarian production (architecture in the sense of organization of individual and collective motion; printing etc.); (2) organization of psychical life towards planned utilitarianism and of purposeful activity towards the emergent phenomena*).

Nonfunctional art produces beautiful paintings, sculptures, architecture. Those works of art do not unite with life into an organic whole, because the life in which we have been and still are living has been directed to drain out maximum profits and to produce welfare for individuals. Those aims, called "practical" but actually antisocial, have neglected both the human needs** and the necessity continually to supplement the store of energy of a man, exhausted by the struggle for

*Our psyche is too entangled and complex. Its bewildered state is to a large extent due to the chaos and disorganization prevailing around us. A society molded by the contradiction of struggling forces produces, as its correlate, a psyche which is not integrated and incompatible in its particular expressions. An organization of society on the principle of the functional fulfillment of needs will liberate us from this state of "overrefined trembling."

**"We are still always similar to an Indian who has come to a town with all his money and buys everything he can see. We do not properly appreciate, how great a part of labor and raw materials in industry is used to supply the world with naughts and toys which are produced only to be sold and bought only to be had; that render no service to the world, and in the end become trash, as they had been mere waste at the outset" (Henry Ford, *My Life and Work*).

survival. The result of such practical "sobriety" is a desire to withdraw from life and to seek for a recompense in art which has nothing to do with the somber reality. The withdrawal of art from serving the productive needs of life causes the necessity for it to be elevated into the world of unearthly, Platonic beauty. Thus art, instead of being the organizing factor in life, becomes a factory of illusions and dreams. Remarkably, the contemporary crisis finds its reflection in the bodiless, floating apparitions and colourful mists on the paintings by kapists (a Polish group of postimpressionist painters. A deterioration of architecture, which used to be a domain of cooperation between artists and architects, caused the peculiar phenomenon of "sublimation" of painting and of its flight to the colourful land of impressionist illusions. In industry, we observe, on one hand, a moving away from the pursuit of integral constructive solutions of forms of the produced objects, with at the same time a flourish of all kinds of ornamental showiness, reminiscent of the Modernist epoch. Instead of being one of the methods of construing life, art becomes a narcotic anaesthetic against its imperfections. This is also what is underlying the flourish in art of the biological line in surrealism, with its emotive-dreamlike experiencing of pictures subduing the constructive-managerial approach. The entangled, freakish line in surrealist art reflects all vibrations of an inspired artist, but it finds its justification in himself only—in his biology and physiology. The profound emotionality of surrealist paintings is an expression of the yearning of a desperately struggling individual, withdrawn from any direct productive functions. In this sense, surrealism is a counterpart—on a higher level, of course—of the colourful "more sublime" dreams of the kapists.

II. The main laws of the scientific organization of work are:

1. the law of the division of labour;
2. the law of concentration;
3. the law of harmony.

K. Adamiecki wrote in "The Science of Organization": "A careful observation proves that the whole living nature including the human organism is governed by these laws and that due to this fact it attains the highest economy in its vital processes. Also man has been making unconscious use of these laws in his communal life since the very beginning of his existence." Exactly the same laws find their application in functionalism. However, when translated into the language of artistic form, these principles are somewhat modified in their formulation.

Every human activity embodies several moments. Each activity has, as its counterpart, a certain set of plastic shapes which control the

activity. The shortest way towards a productive outcome is a straight line. Therefore the way of transition from one activity to another is a straight line and the geometrical shape appropriate for it. The law of the division of labour finds its counterpart in the geometrization of form.

Every human activity yields the highest productive turnout, if it is distinct from the others and reduced so as to allow an inferring of its peculiar remarkable elements, distinguishing it from the other activities. The more strictly is such a selection of the distinctive features made, the greater is the productive outcome. The law of concentration of the moments of work finds its counterpart in the principle of formal contrast.

The particular sets of activities ought to pass into each other in an orderly manner. Such accordance, the fluidity of the transition depends on an invention of an appropriate method of coordination of those sets. Too much growth of one of them brings about a tightened condition and an obstruction in the passage to another. There should exist a law governing the process of transition from one set of shapes, directing the motions into another. Such a law is provided by apprehending the form into the calculated spatio-temporal rhythm controlling the sizes of the particular shapes. Such spatio-temporal rhythm is the plastic correlate of the law of harmony of the particular sections.

III. If we cast a glance at the evolution of art towards functionalism, cubism can be seen as the starting point. A cubistic composition is a wrestling of forces expressed by the line, opposed against each other, closing up into a system of dynamic balance. Contrasts of dimensions and directions produce a strong tension of form. The particular qualities of the texture juxtaposed with lines produce the conflicts of themes and patterns of plastic contrasts. Cubism is a striving towards a functionalization of life shred by the contradictions of the struggling forces; it is a conscious opposition against the chaos of life at the most awful crossroads of the epoch. Suprematism has introduced a further search for the greater cooperation of shapes: a suprematist work of art offers the emotions of a planned and integral system. Such a system arises as a result of an interaction of the motion of the particular shapes. The emotions of a plan: construction and organization became for the first time the sole emotions in a work of art. In fact, the dynamic character of suprematism made a utilitarian realization of its forms impossible, but the emotion of a plan has ever since become the main emotion in artistic pursuits. Such a plan must, in its turn, be extended to cover the problem of transition of the particular aggregates of form into each other. Nothing valuable can arise all by itself, without being dependent on something precedent. Strefism (a theory of art by Leon

Chwistek; from "strefa"—"a zone") arose as an endeavour to bring order into a picture by placing similar shapes together in aggregates appearing once only, and by making each of them to pass another in due sequence. However, the fitting of the aggregates was purely mechanical, not resulting from any common connection of shapes. It was apparently a display of the pursuit to build up the whole around a single axis. On this axis the aggregates of form were strung, which, however, lacked a uniform common resonance, the rhythm of creative participation in life. Therefore strefism remained a phenomenon of painting only, without producing any further effect on the level of life. The only productive idea contributed by strefism was the method of architectural designing as dependent on the sequence of life activities. In this manner, a chart of an architectural interior could become a function of the sequence of life activities.

Neoplasticism offers the most advanced simplification of form reduced to geometry. The variety of shapes is brought down to the horizontal and vertical in the plane of a picture and to the three mutually perpendicular directions in sculpture and architecture. Neoplasticism realizes to the utmost degree the principle of economy. As a foundation of all composition it offers a clear and irrevocable proportion, instead of a varied and accidental play of shapes. A neoplastic picture, considered as a plan of an organization of motions, renders the highest concentration of perpendicular contrasted movements, proceeding along the shortest lines of action. Instead of a variety of liberal motions, there is only a single one, the shortest of all. Neoplasticism arranges motions by a standard, along the shortest lines of action. It is a plan which principally excludes any license.

A harmonious transition of one action into another requires that all these activities be subject to a common numerical formula defining the dimension of each of them. This common formula, underlying every shape, connects the particular activities into one common spatio-temporal rhythm, determining in advance the harmonious character of the transition of one aggregate into another.

IV. The development of the plastic form has grown beyond the stage of a picture as the sole field on which artistic ideas are embodied. At the early phase, the plastic form had to seek support for itself in nature— hence the naturalistic character of the passed plastic arts. An artist strove to reproduce nature and to add a certain plastic value to it: to draw particularly harmonious lines, to bring forth a play of colours and shades more beautiful than in nature, etc. As the plastic form has been developing, such deformations become ever more frequent and conscious. The plastic form has become self-sufficient. There is a flourish of easel painting—compositions that owe their beauty to the juxtaposi-

tion of purely plastic elements, rather than to the imitation of nature. A further insight into the laws guiding the elements of plastics work has revealed that every plastic form is at the same time a norm of the organization of the human psyche and activities. The set of such norms embodies the potential methods of utilitarian endeavours.

As long as we remain within the limits of a picture as the only kind of a work of art that is deserving of an artist, we shall never grasp the essence of functionalism. A work of art cannot be more or less "functional." It can be simply a field of a plastic experiment, offering more or less useful solutions of form for a utilitarian realization of functionalism.

The scientific organization of work traces the particular moments and sets of productive processes. Its objective is to increase the efficiency of production. Functionalism searches for the particular moments in the course of everyday life. Its objective is such a simplification and sequence of them, in order to arrive at a whole that facilitates life. Any sequence of moments of life has juxtaposed to it a corresponding sequence of utilitarian objects properly arranged. At the same time, functionalism permeates its shapes with the emotions of planning and of purposeful organization. While the methods of functionalism and of the scientific organization of work are similar, there is a difference as to the scopes covered by both. The scientific organization of work regulates the productive process and its effect or output. The task of functionalism is to study the working of utilitarian shapes upon a consumer, taking as the starting point the maximum economy of his psychical energy as he makes use the objects that are around him in his daily life.

By 1870 the current task of art was to master light. Impressionism did it, by studying the distribution of light to the several elements of colour. Out of those discoveries the harmony of colours in impressionist paintings was built. However, for these purposes the range of artistic knowledge alone was not enough. A collaboration of artists and physicists was necessary. Owing to it, impressionism succeeded in creating its epoch-making work. Now, we can see how false the legend is, widespread by the epigones of impressionism, about an artist who is deaf and blind to the events of life around him, or that everything that happens in life is "prose," unworthy of a true artist.

By 1918, the current task was to master artistically the technology of reinforced concrete. This was done by cubism and the constructivist directions deriving from it. In this purpose, the plastic arts had to establish a mutual exchange of achievements with building and with the technology of building materials. As a result, houses of iron, glass and concrete have been built, full of light and sincerity of the revealed beauty of materials.

At present, the task is a reconstruction of cities: an organization of the totality of urban life.

Functionalism is a result of a summing up of the potential opportunities inherent in several fields of contemporary culture. A visible justification of functionalism will be an epoch of building, originating in the proper use of the productive forces of contemporary industry, art and psychological engineering, and directed to the planned fulfillment of human needs. Such a justification of functionalism is the sum of opportunities inherent in the epoch.

Wladyslaw Strzeminski
Modern Art in Poland

The evolution to which art has been subject and the complete change of artistic and artistic-social standards imply the following consequences:

1. A break with reproductive, literary and contemplative art.
2. A break with the conception of art as luxury and of ornamenting the forms which an artist receives readymade.
3. Art ought to become a formal organization of the course of everyday events. This implies a relationship between art and the scientific organization of work and leisure, as well as its grounding in modern technology, psychophysiology and bio-mechanics.
4. The field of artistic activity is the production of form in the sphere of social utility.
5. A condition of the development of art is an experiment and a collective control of its results. The aim of an experiment is a disinterested search for the highest perfection of form.
6. The ultimate confirmation of the value of an artistic experiment is its utility in production, attained with the means of contemporary industrial technology.
7. An industrial realization of an artistic experiment is possible only on the condition of the appropriately deep understanding of its consequences.
8. An experiment that has achieved new plastic values need not imply the possibility of its immediate realization. The present state, a result of the functions which art attempts to perform for society and the character of forms employed by it, is still linked with the ground of the dissolving forms of natural and handicraft economy. Both its top achievements—easel painting and applied art—have maintained themselves in the contemporary reality only by the law of inertia, but they are alien to it and they have their origin in a different economic background.

Those who are immune to artistic sensibility will be persuaded by the most eloquent factor: calculation and economic justification.

"Virility and Domination in Early Twentieth Century Vanguard Painting" 1973

CAROL DUNCAN

Carol Duncan examines the sexist implications in Expressionist and Cubist paintings of the early twentieth century. Statements by male artists and critics about "artistic experimentation" and personal liberation masked very traditional views toward women and patriarchal authority, and reinforced the sexist policies of bourgeois art collectors.

This article has become a classic in feminist art criticism from the early 1970s, an early reading in an ongoing process. Since then, the field has expanded considerably, with more contemporary women artists receiving critical attention. And yet, the questions suggested here are still quite relevant: (1) the male perception of women as object in modern art; (2) women's experience directly in the gallery art world; and (3) the pathology of patriarchy as a modern aesthetics. In any revised history of modern art, the influence of the woman's movement from 1972 onward should be included, as a modernization within the arts at large, even as a second visitation of modernism itself. Ironically enough, articles from the woman's movement often resemble, in their enthusiasm and lucidity, manifestoes written on behalf of modern art from 1905 to 1930. Both engage in an ideological conflict against late Victorian repression and very often envision the artist as a social activist.

* * *

In the decade before World War I, a number of European artists began painting pictures with a similar and distinctive content. In both imagery and style, these paintings forcefully assert the virile, vigorous and uninhibited sexual appetite of the artist. I am referring to the hundreds of pictures of nudes and women produced by the Fauves, Cubists, German Expressionists and other vanguard artists. As we shall see, these

paintings often portray women as powerless, sexually subjugated beings. By portraying them thus, the artist makes visible his own claim as a sexually dominating presence, even if he himself does not appear in the picture.

This concern with virility—the need to assert it in one's art—is hardly unique to artists of this period. Much of what I am going to say here is equally relevant to later twentieth-century as well as some nineteenth-century art.[1] But the assertion of virility and sexual domination appears with such force and frequency in the decade before World War I, and colors the work of so many different artists, that we must look there first to understand it. It is also relevant to ask whether these artists sought or achieved such relationships in reality, whether their lives contradict or accord with the claims of their art. But that is not the question I am asking here. My concern is with the nature and implications of those claims as they appear in the art and as they entered the mythology of vanguard culture. In this I am treating the artists in question not as unique individuals, but as men whose inner needs and desires were rooted in a shared historical experience—even if the language in which they expressed themselves was understood by only a handful of their contemporaries.

The material I explore inevitably touches on a larger issue—the role of avant-garde culture in our society. Avant-garde art has become the official art of our time. It occupies this place because, like any official art, it is ideologically useful. But to be so used, its meaning must be constantly and carefully mediated. That task is the specialty of art historians, who explain, defend and promote its value. The exhibitions, courses, articles, films and books produced by art historians not only keep vanguard art in view, they also limit and construct our experience of it.

In ever new ways, art history consistently stresses certain of its qualities. One idea in particular is always emphasized: that avant-garde art consists of so many moments of individual artistic freedom, a freedom evidenced in the artist's capacity for innovation. Accounts of modern art history are often exclusively, even obsessively, concerned with documenting and explicating evidence of innovation—the formal inventiveness of this or that work, the uniqueness of its iconography, its distinctive use of symbols or unconventional materials. The presence of innovation makes a work ideologically useful because it demonstrates the artist's individual freedom as an artist; and *that* freedom implies and comes to stand for human freedom in general. By celebrating artistic freedom, our cultural institutions "prove" that ours is a society in which all freedom is cherished and protected, since, in our society, all freedom is conceived as individual freedom. Thus vanguard paintings, as celebrated instances of freedom, function as icons of individualism, objects

that silently turn the abstractions of liberal ideology into visible and concrete experience.

Early vanguard paintings, including many of the works I shall discuss, are especially revered as icons of this kind. According to all accounts, the decade before World War I was the heroic age of avant-garde art. In that period, the "old masters" of modernism—Picasso, Matisse, the Expressionists—created a new language and a new set of possibilities that became the foundation for all that is vital in later twentieth-century art. Accordingly, art history regards these first examples of vanguardism as preeminent emblems of freedom.

The essay that follows looks critically at this myth of the avant garde. In examining early vanguard painting, I shall be looking not for evidence of innovation (although there is plenty of that), but rather for what these works say about the social relations between the sexes. Once we raise this question—and it is a question that takes us outside the constructs of official art history—a most striking aspect of the avant garde immediately becomes visible: however innovative, the art produced by many of its early heroes hardly preaches freedom, at least not the universal human freedom it has come to symbolize. Nor are the values projected there necessarily "ours," let alone our highest. The paintings I shall look at speak not of universal aspirations but of the fantasies and fears of middle-class men living in a changing world. Because we are heirs to that world, because we still live its troubled social relations, the task of looking critically, not only at vanguard art but also at the mechanisms that mystify it, remains urgent.

Already in the late nineteenth century, European high culture was disposed to regard the male-female relationship as the central problem of human existence. The art and literature of the time is marked by an extraordinary preoccupation with the character of love and the nature of sexual desire. But while a progressive literature and theater gave expression to feminist voices, vanguard painting continued to be largely a male preserve. In Symbolist art, men alone proclaimed their deepest desires, thoughts and fears about the opposite sex. In the painting of Moreau, Gauguin, Munch and other end-of-the-century artists, the human predicament—what for Ibsen was a man-woman problem—was defined exclusively as a male predicament, the woman problem. As such, it was for men alone to resolve, transcend or cope with. Already there was an understanding that serious and profound art—and not simply erotic art—is likely to be about what men think of women.

Symbolist artists usually portrayed not women but one or two universal types of woman.[2] These types are often lethal to man. They are always more driven by instincts and closer to nature than man, more subject to its mysterious forces. They are often possessed by dark or

enigmatic souls. They usually act out one or another archetypal myth—Eve, Salome, the Sphinx, the Madonna.

Young artists in the next avant-garde generation—those maturing around 1905—began rejecting these archetypes just as they dropped the muted colors, the langorous rhythms and the self-searching artist-types that Symbolism implied. The Symbolist artist, as he appears through his art, was a creature of dreams and barely perceptible intuitions, a refined, hypersensitive receiver of tiny sensations and cosmic vibrations. The new vanguardists, especially the Fauves and the Brücke, were youth and health cultists who liked noisy colors and wanted to paint their direct experience of mountains, flags, sunshine and naked girls. Above all, they wanted their art to communicate the immediacy of their own vivid feelings and sensations before the things of this world. In almost every detail, their images of nudes sharply contrast to the virgins and vampires of the 1890s. Yet these younger artists shared certain assumptions with the previous generation. They, too, believed that authentic art speaks of the central problems of existence, and they, too, defined Life in terms of a male situation—specifically the situation of the middle-class male struggling against the strictures of modern, bourgeois society.

Kirchner was the leader and most renowned member of the original Brücke, the group of young German artists who worked and exhibited together in Dresden and then Berlin between 1905 and 1913. His *Girl Under a Japanese Umbrella* (ca. 1909) asserts the artistic and sexual ideals of this generation with characteristic boldness. The artist seems to attack his subject, a naked woman, with barely controlled energy. His painterly gestures are large, spontaneous, sometimes vehement, and his colors intense, raw and strident. These features proclaim his unhesitant and uninhibited response to sexual and sensual experience. Leaning directly over his model, the artist fastens his attention mainly to her head, breasts and buttocks, the latter violently twisted toward him. The garish tints of the face, suggesting both primitive body paint and modern cosmetics, are repeated and magnified in the colorful burst of the exotic Japanese umbrella. Above the model is another Brücke painting, or perhaps a primitive or Oriental work, in which crude shapes dance on a jungle-green ground.

Van Dongen's *Reclining Nude* (1905–06), a Fauve work, is similar in content. Here, too, the artist reduces a woman to so much animal flesh, a headless body whose extremities trail off into ill-defined hands and feet. And here, too, the image reflects the no-nonsense sexuality of the artist. The artist's eye is a hyper-male lens that ruthlessly filters out everything irrelevant to the most basic genital urge. A lustful brush swiftly shapes the volume of a thigh, the mass of the belly, the fall of a breast.

Such images are almost exact inversions of the *femmes fatales* of the previous generation. Those vampires of the 1890s loom up over their male victims or viewers, fixing them with hypnotic stares. In Munch's paintings and prints, females engulf males with their steaming robes and hair. The male, whether depicted or simply understood as the viewer-artist, is passive, helpless or fearful before this irresistibly seductive force which threatens to absorb his very will. Now, in these nudes by Kirchner and Van Dongen, the artist reverses the relationship and stands above the supine woman. Reduced to flesh, she is sprawled powerlessly before him, her body contorted according to the dictates of his erotic will. Instead of the consuming *femme fatale,* one sees an obedient animal. The artist, in asserting his own sexual will, has annihilated all that is human in his opponent. In doing so, he also limits his own possibilities. Like conquered animals, these women seem incapable of recognizing in him anything beyond a sexually demanding and controlling presence. The assertion of that presence—the assertion of the artist's sexual domination—is in large part what these paintings are about.

In the new century, even Munch felt the need to see himself thus reflected. His *Reclining Nude,* a watercolor of 1905, is a remarkable reversal of his earlier *femmes fatales.* Both literally and symbolically, Munch has laid low those powerful spirits along with the anxieties they created in him. This nude, her head buried in her arms, lies at his disposal, while he explores and translates into free, unrestrained touches the impact of thighs, belly and breasts on his senses and feelings.

Most images of female nudity imply the presence (in the artist and/or the viewer) of a male sexual appetite. What distinguishes these pictures and others in this period from most previous nudes is the compulsion with which women are reduced to objects of pure flesh, and the lengths to which the artist goes in denying their humanity. Not all nudes from this decade are as brutal as Van Dongen's, but the same dehumanizing approach is affirmed again and again. Nudes by Braque, Manguin, Puy and other Fauves are among scores of such images. They also occur in the work of such artists as Jules Pascin, the Belgian Realist Rik Wouters and the Swiss Félix Vallotton (*The Sleep,* 1908). *Nude in a Hammock* (1912), by Othon Friesz, is a Cubistic version of this same basic type of sleeping or faceless nude. So is Picasso's more formalistically radical *Woman in an Armchair* (1913), where all the wit and virtuoso manipulation of form are lavished only upon the body, its literally hanging breasts, the suggestive folds of its underwear, etc. Indeed, Picasso's Cubist paintings maintain the same distinction between men and women as other artists of this decade did—only more relentlessly; many of these other artists painted portraits of women as

authentic people in addition to nudes. Max Kozloff observed the striking difference between Picasso's depictions of men and women in the Cubist period:

> The import of *Girl With a Mandolin* perhaps becomes clearer if it is compared with such contemporary male subjects as Picasso's *Portrait of Ambroise Vollard.* The artist hardly ever creates the image of a woman as portrait during this period. He reserved the mode almost entirely for men....In other words, a woman can be typed, shown as a nude body or abstracted almost out of recognition, as in *Ma Jolie,* where the gender of the subject plays hardly any role, but she is not accorded the particularity and, it should be added, the dignity of one-to-one, formalized contact furnished by a portrait. More significant is the fact that Vollard is presented as an individual of phenomenal power and massive, ennobled presence, while the female type often gangles like a simian, is cantilevered uncomfortably in space, or is given bowed appendages.[3]

The artistic output of the Brücke abounded in images of powerless women. In Heckel's *Nude on a Sofa* (1909) and his *Crystal Day* (1913), women exist only in reference to—or rather, as witnesses to—the artist's frank sexual interests. In one, the woman is sprawled in a disheveled setting; in the other, she is knee-deep in water—in the passive, arms-up, exhibitionist pose that occurs so frequently in the art of this period. The nude in *Crystal Day* is literally without features (although her nipples are meticulously detailed), while the figure in the other work covers her face, a combination of bodily self-offering and spiritual self-defacement that characterizes these male assertions of sexual power. In Kirchner's *Tower Room, Self-Portrait with Erna* (1913), another faceless nude stands obediently before the artist, whose intense desire may be read in the erect and flaming object before him. In a less strident voice, Manguin's *Nude* (1905) makes the same point. In the mirror behind the bed, the nude is visible a second time, and now one sees the tall, commanding figure of the artist standing above her.

The artists of this decade were obsessed with such confrontations. In a curious woodcut, published as *The Brothel* (ca. 1906), the French Fauve Vlaminck played with the tension inherent in that confrontation. What activates the three women in this print is not clear, but the central nude raises her arms in ambiguous gesture, suggesting both protest and self-defense. In either case, the movement is well contained in the upper portion of the print and does not prevent the artist from freely seizing the proffered, voluptuous body. Evidently, he has enjoyed the struggle and purposely leaves traces of it in the final image.

Matisse's painting of these years revolves around this kind of contest almost exclusively, exploring its tensions and seeking its resolution. Rarely does he indulge in the open, sexual boasting of these other

artists. Matisse is more *galant,* more bourgeois. A look, an expression, a hint of personality often mitigate the insistent fact of passive, available flesh. In the nice, funny face of *The Gypsy* (1905–06), one senses some human involvement on the part of the artist, even as he bent the lines of the model's face to rhyme with the shape of her breasts. Matisse is also more willing to admit his own intimidation before the nude. In *Carmelina* (1903), a powerfully built model coolly stares him down—or, rather, into—a small corner of the mirror behind her. The image in that mirror, the little Matisse beneath the awesome Carmelina, makes none of the overt sexual claims of Manguin's *Nude* or Kirchner's *Tower Room.* But the artful Matisse has more subtle weapons. From his corner of the mirror, he blazes forth in brilliant red—the only red in this somber composition—fully alert and at the controls. The artist, if not the man, masters the situation—and also Carmelina, whose dominant role as a *femme fatale* is reversed by the mirror image. Nor is the assertion of virility direct and open in other paintings by Matisse, where the models sleep or lack faces. Extreme reductions and distortions of form and color, all highly deliberated, self-evident "aesthetic" choices, transpose the sexual conflict onto the "higher" plane of art. Again, the assertion of virility becomes sublimated, metamorphosed into a demonstration of artistic control, and all evidence of aggression is obliterated. As he wrote in "Notes of a Painter" (1908), "I try to put serenity into my pictures...."[4]

The vogue for virility in early twentieth-century art is but one aspect of a total social, cultural and economic situation that women artists had to overcome. It was, however, a particularly pernicious aspect. As an ethos communicated in a hundred insidious ways, but never overtly, it effectively alienated women from the collective, mutu-ally supportive endeavor that was the avant garde. (Gertrude Stein, independently wealthy and, as a lesbian, sexually unavailable to men, is the grand exception.) Like most of their male counterparts, women artists came primarily from the middle classes. It is hardly conceivable that they would flaunt a desire for purely physical sex, even in private and even if they were capable of thinking it. To do so would result in social suicide and would require breaking deeply internalized taboos. In any case, it was not sexuality per se that was valued, but male sexuality. The problem for women—and the main thrust of women's emancipa-tion—was not to invert the existing social-sexual order, not to replace it with the domination of women; the new woman was struggling for her own autonomy as a psychological, social and political being. Her problem was also the woman problem. Her task was also to master her own image.

Accordingly, the German artist Paula Modersohn-Becker con-fronted female nudity—her own—in a *Self-Portrait* of 1906. Fashioned out of the same Post-Impressionist heritage as Brücke art and Fauvism,

this picture is startling to see next to the defaced beings her fellow artists so often devised. Above the naked female flesh are the detailed features of a powerful and determined human being. Rare is the image of a naked woman whose head so outweighs her body. Rare, that is, in male art. Suzanne Valadon, Sonia Delaunay-Terk and other women of this period often painted fully human female beings, young and old, naked and clothed. Among male artists, only Manet in the *Olympia* comes close. But there the image-viewer relationship is socially specified. Olympia is literally flesh for sale, and in that context, her self-assertiveness appears willful and brash—a contradiction to the usual modesty of the nude. As a comment on bourgeois male-female relationships, the *Olympia* is both subversive and antisexist; it is, however, consciously posed as male experience and aimed, with deadly accuracy, at the smug and sexist male bourgeoisie. Modersohn-Becker, on the other hand, is addressing herself, not as commodity and not even as an artist but as a woman. Her effort is to resolve the contradiction Manet so brilliantly posed, to put herself back together as a fully conscious and fully sexual human being. To attempt this, with grace and strength to boot, speaks of profound humanism and conviction, even while the generalized treatment of the body and its constrained, hesitant gestures admit the difficulty.

Earlier, I suggested that the powerless, defaced nude of the twentieth century is an inversion of the Symbolist *femme fatale*. Beneath this apparent opposition, however, is the same supporting structure of thought.[5] In the new imagery, woman is still treated as a universal type, and this type, like the Sphinxes and Eves of the previous generation, is depicted as a being essentially different from man. In the eyes of both generations of artists, woman's mode of existence—her relationship to nature and to culture—is categorically different from man's. More dominated by the processes of human reproduction than men, and, by situation, more involved in nurturing tasks, she appears to be more *of nature* than man, less in opposition to it both physically and mentally. As the anthropologist Sherry Ortner has argued, men see themselves more closely identified with culture, "the means by which humanity transcends the givens of natural existence, bends them to its purposes, controls them in its interests." Man/culture tends to be one term in a dichotomy of which woman/nature is the other: "Even if woman is not equated with nature, she is still seen as representing a lower order of being, less transcendental of nature than men."[6]

However different from the Symbolists, these younger artists continued to regard confrontations with women as real or symbolic confrontations with nature. Not surprisingly, the nude-in-nature theme, so important to nineteenth-century artists, continued to haunt them. And like the older artists, they, too, imagined women as more at home there

than men. Placid, naked women appear as natural features of the landscape in such works as Heckel's *Crystal Day,* Friesz's *Nude in a Hammock* and numerous bathers by Vlaminck, Derain, Mueller, Pechstein and other artists. The bacchante or the possessed, frenzied dancer is the active variant of the bather and frequently appears in the art of this period. Nolde's *Dancers with Candles* (1912) and Derain's *The Dance* (ca. 1905) equally represent women as a race apart from men, controlled by nature rather than in control of it.

Myths cultivated by artists would seem to contradict this dichotomy. Since the nineteenth century, it was fashionable for male artists to claim a unique capacity to respond to the realm of nature. But while they claimed for themselves a special intuition or imagination, a "feminine principle," as they often called it, they could not recognize in women a "masculine principle." The pictures of women produced in this epoch affirm this difference as much as Symbolist art. Women are depicted with none of the sense of self, none of the transcendent, spiritual autonomy that the men themselves experienced (and that Modersohn-Becker so insisted upon). The headless, faceless nudes, the dreamy looks of Gauguin's girls, the glaring mask of Kirchner's *Girl Under a Japanese Umbrella,* the somnambulism of the *femmes fatales*—all of these equally deny the presence of a human consciousness that knows itself as separate from and opposed to the natural and biological world.

The dichotomy that identifies women with nature and men with culture is one of the most ancient ideas ever devised by men and appears with greater or lesser strength in virtually all cultures. However, beginning in the eighteenth century, Western bourgeois culture increasingly recognized the real and important role of women in domestic, economic and social life. While the basic sexual dichotomy was maintained and people still insisted on the difference between male and female spheres, women's greater participation in culture was acknowledged. In the nineteenth century the bourgeoisie educated their daughters more than ever before, depended on their social and economic cooperation and valued their human companionship.

What is striking—and for modern Western culture unusual—about so many nineteenth- and twentieth-century vanguard nudes is the absoluteness with which women were pushed back to the extremity of the nature side of the dichotomy, and the insistence with which they were ranked in total opposition to all that is civilized and human. In this light, the attachment of vanguard artists to classical and biblical themes and their quest for folk and ethnographic material takes on special meaning. These ancient and primitive cultural materials enabled them to reassert the woman/nature–man/culture dichotomy in its harshest forms. In Eve, Salome, the Orpheus myth and the primitive dancer, they found Woman as they wanted to see her—an alien, amoral creature of passion and

instinct, an antagonist to rather than a builder of human culture. The vanguard protested modern bourgeois male-female relationships; but that protest, as it was expressed in these themes, must be recognized as culturally regressive and historically reactionary. The point needs to be emphasized only because we are told so often that vanguard tradition embodies our most progressive, liberal ideals.

The two generations of artists also shared a deep ambivalence toward the realm of woman/nature. The Symbolists were at once attracted to and repelled by its claims on them. Munch's art of the nineties is in large part a protest against this male predicament. From his island of consciousness, he surveys the surrounding world of woman/nature with both dread and desire. In paintings by Gauguin, Hodler and Klimt (especially his "Life and Death" series), woman's closeness to nature, her effortless biological cooperation with it, is enviable and inviting. She beckons one to enter a poetic, non-rational mode of experience—that side of life that advanced bourgeois civilization suppresses. Yet, while the realm of woman is valued, it is valued *as* an alien experience. The artist contemplates it, but prefers to remain outside, with all the consciousness of the outside world. For to enter it fully means not only loss of social identity, but also loss of autonomy and of the power to control one's world.

The same ambivalence marks the twentieth-century work I have been discussing, especially the many paintings of nudes in nature. In these images, too, the realm of woman/nature invites the male to escape rationalized experience and to know the world through his senses, instincts or imagination. Yet here, too, while the painter contemplates his own excited feelings, he hesitates to enter that woman/nature realm of unconscious flesh, to imagine himself *there*. He prefers to know his instincts through the objects of his desire. Rarely do these artists depict naked men in nature. When they do, they are almost never inactive. To be sure, there are some naked, idle males in Kirchner's bathing scenes, but they are clearly uncomfortable and self-conscious-looking. More commonly, figures of men in nature are clothed, both literally and metaphorically, with social identities and cultural projects. They are shepherds, hunters, artists. Even in Fauve or Brücke bathing scenes where naked males appear, they are modern men going swimming. Unlike the female bather, they actively engage in culturally defined recreation, located in historical time and space. Nowhere do these men enter nature—and leave culture—on the same terms as women. Now as in the 1890s, to enter that world naked and inactive is to sink into a state of female powerlessness and anonymity.

Matisse's *Joy of Life* (*Bonheur de vivre*) of 1905–06 seems to be an exception. In this sun-drenched fantasy, all the figures relate to nature, to each other and to their own bodies in harmony and freedom. No one

bends to a force outside oneself. Yet, even in this Arcadia, Matisse hesitates to admit men. Except for the shepherd, all the figures with visible sexual characteristics are women. Maleness is suggested rather than explicitly stated. Nor is the woman/nature–man/culture dichotomy absent: culturally defined activities (music-making and animal husbandry) are male endeavors, while women simply exist as sensual beings or abandon themselves to spontaneous and artless self-expression.

No painting of this decade better articulates the male-female dichotomy and the ambivalence men experience before it than Picasso's *Demoiselles d'Avignon* of 1905–06. What is so remarkable about this work is the way it manifests the structural foundation underlying both the *femme fatale* and the new, primitive woman. Picasso did not merely combine these into one horrible image; he dredged up from his psyche the terrifying and fascinating beast that gave birth to both of them. The *Demoiselles* prismatically mirrors her many opposing faces: whore and deity, decadent and savage, tempting and repelling, awesome and obscene, looming and crouching, masked and naked, threatening and powerless. In that jungle-brothel is womankind in all her past and present metamorphoses, concealing and revealing herself before the male. With sham and real reverence, Picasso presents her in the form of a desecrated icon already slashed and torn to bits.

If the *Demoiselles* is haunted by the nudes of Ingres, Delacroix, Cézanne and others,[7] it is because they, too, proceed from this Goddess-beast and because Picasso used them as beacons by which to excavate its root form. The quotations from ancient and non-Western art serve the same purpose. The *Demoiselles* pursues and recapitulates the Western European history of the woman/nature phantom back to her historical and primal sisters in Egypt, ancient Europe and Africa in order to reveal their oneness. Only in primitive art is woman as sub- and super-human as this.[8] Many later works by Picasso, Miró or de Kooning would recall this primal mother-whore. But no other modern work reveals more of the rock foundation of sexist antihumanism or goes further and deeper to justify and celebrate the domination of woman by man.

Although few of Picasso's vanguard contemporaries could bear the full impact of the *Demoiselles* (Picasso himself would never again go quite as far), they upheld its essential meaning. They, too, advocated the otherness of woman, and asserted with all their artistic might the old idea that culture in its highest sense is an inherently male endeavor. Moreover, with Picasso, they perpetuated it in a distinctly modern form, refining and distilling it to a pure essence: from this decade dates the notion that the wellsprings of authentic art are fed by the streams of male libidinous energy. Certainly artists and critics did not consciously expound this idea. But there was no need to argue an assumption so deeply felt, so little questioned and so frequently demonstrated in art. I

refer not merely to the assumption that erotic art is oriented to the male sexual appetite, but to the expectation that significant and vital content in *all* art presupposes the presence of male erotic energy.

The nudes of the period announce it with the most directness; but landscapes and other subjects might confirm it as well, especially when the artist invokes aggressive and bold feeling, when he "seizes" his subject with decisiveness, or demonstrates other supposedly masculine qualities. Vlaminck, although primarily a landscape painter, could still identify his paintbrush with his penis: "I try to paint with my heart and my loins, not bothering with style."[9] But the celebration of male sexual drives was more forcefully expressed in images of women. More than any other theme, the nude could demonstrate that art originates in and is sustained by male erotic energy. This is why so many "seminal" works of the period are nudes. When an artist had some new or major artistic statement to make, when he wanted to authenticate to himself or others his identity as an artist, or when he wanted to get back to "basics," he turned to the nude. The presence of small nude figures in so many landscapes and studio interiors—settings that might seem sufficient in themselves for a painting—also attests to the primal erotic motive of the artist's creative urge.

Kirchner's *Naked Girl Behind a Curtain* (dated 1907) makes just this connection with its juxtaposition of a nude, a work of primitive art and what appears to be a modern Brücke painting. The *Demoiselles,* with its many references to art of varied cultures, states the thesis with even more documentation. And, from the civilized walls of Matisse's *Red Studio* (1911) comes the same idea, now softly whispered. There, eight of the eleven recognizable art objects represent female nudes. These literally surround another canvas, *The Young Sailor* (1906), as tough and "male" a character as Matisse ever painted. Next to the *Sailor* and forming the vertical axis of the painting is a tall, phallic grandfather clock. The same configuration—a macho male surrounded by a group of nude women—also appears in the preparatory drawings for the *Demoiselles,* where a fully clothed sailor is encircled by a group of posing and posturing nudes. Picasso eventually deleted him but retained his red drinking vessel (on the foreground table) and made its erect spout a pivotal point in the composition.[10] Another phallocentric composition is Kirchner's much-reproduced *Self-Portrait with Model* (1907). In the center, Kirchner himself brandishes a large, thick, red-tipped paintbrush at groin level, while behind him cringes a girl wearing only lingerie.

That such content—the linking of art and male sexuality—should appear in painting at precisely the moment when Freud was developing its theoretical and scientific base indicates not the source of these ideas but the common ground from which both artist and scientist sprang. By

justifying scientifically the source of creativity in male sexuality,[11] Freud acted in concert with young, avant-garde artists, giving new ideological shape and force to traditional sexist biases. The reason for this cross-cultural cooperation is not difficult to find. The same era that produced Freud, Picasso and D. H. Lawrence—the era that took Nietzsche's superman to heart—was also defending itself from the first significant feminist challenge in history (the suffragist movement was then at its height). Never before had technological and social conditions been so favorable to the idea of extending democratic and liberal-humanistic ideals to women. Never before were so many women and men declaring the female sex to be the human equals of men, culturally, politically and individually. The intensified and often desperate reassertions of male cultural supremacy that permeate so much early twentieth-century culture, as illustrated in the vanguard's cult of the penis, are both responses to and attempts to deny the new possibilities history was unfolding. They were born in the midst of this critical moment of male-female history, and as such, gave voice to one of the most reactionary phases in the history of modern sexism.

Certainly the sexist reaction was not the only force shaping art in the early twentieth century. But without acknowledging its presence and the still uncharted shock waves that feminism sent through the feelings and imaginations of men and women, these paintings lose much of their urgency and meaning. Moreover, those other historical and cultural forces affecting art, the ones we already know something about—industrialization, anarchism, the legacy of past art, the quest for freer and more self-expressive forms, primitivism, the dynamics of avant-garde art-politics itself, and so on—our understanding of these must inevitably be qualified as we learn more about their relationship to feminism and the sexist reaction.

Indeed, these more familiar issues often become rationalizations for the presence of sexism in art. In the literature of twentieth-century art, the sexist bias, itself unmentionable, is covered up and silently approved by the insistence on these other meanings. Our view of it is blocked by innocent-sounding generalizations about an artist's formal courageousness, his creative prowess or his progressive, humanistic values. But while we are told about the universal, genderless aspirations of art, a deeper level of consciousness, fed directly by the powerful images themselves, comprehends that this "general" truth arises from male experience alone. We are also taught to keep such suspicions suppressed, thus preserving the illusion that the "real" meanings of art are universal, beyond the interests of any one class or sex. In this way we have been schooled to cherish vanguardism as the embodiment of "our" most progressive values.

Our understanding of the social meanings of the art I have been considering—what these artists imply about society and their relationship to it—especially needs reevaluation. Much avant-garde painting of the early twentieth century is seen as a continuation of the nineteenth-century traditions of Romantic and Realist protest. Most of the artists whose names appear here were indeed heirs to this tradition and its central theme of liberation. Like others before them, they wished for a world in which man might live, think and feel, not according to the dictates of rationalized, capitalist society, but according to his own needs as an emotionally and sensually free human being.

The Fauves and the Brücke artists especially associated themselves with the cause of liberation, although in different national contexts. The French artistic bohemia in which the Fauves matured enjoyed a long tradition of sympathy and identification with vanguard politics.[12] In the first decade of the century, the anarchist ideas that so many Neo-Impressionists had rallied to in the previous generation were still nurtured. (Picasso, too, moved in anarchist circles in Barcelona before he settled in Paris.) The heyday of the artist bomb-thrower was over, but the art-ideology of the avant garde still interpreted flamboyant, unconventional styles of art and behavior as expressions of anarchist sentiments. The young Fauves understood this, and most of them enjoyed (at least for a time) being publicized as wild anarchists out to tear down the establishment. Germany, on the other hand, more recently organized as a modern, bourgeois state, had only begun to see artist-activists; traditionally, dissident German artists and intellectuals withdrew from society and sought solace in transcendental philosophies. In accord with this tradition, Brücke artists were programatically more hostile to cities than the Fauves, and more fervent nature-lovers.[13] They were also more organized and cohesive as a group. In a Dresden shop, they established a communal studio where they worked and lived together in what we would call today an alternative lifestyle. Yet, however distinct from the Fauves, they embraced many of the same ideals. At the outset, they announced their opposition to the rationalism and authoritarianism of modern industrial life. The banner they waved was for free, individual self-expression and the rehabilitation of the flesh.

The two groups shared both an optimism about the future of society and the conviction that art and artists had a role to play in the creation of a new and freer world. For them, as for so many of their vanguard contemporaries and successors, the mission of art was liberation—individual, not political. Liberal idealists at heart, they believed that artists could effect change simply by existing as individual authentic artists. In their eyes, to exercise and express one's unfettered instinctual powers was to strike a blow against, to subvert, the established order. The idea

was to awaken, liberate and unleash in others creative-instinctual desires by holding up visions of reality born of liberated consciousness. That only an educated, leisured and relatively nonoppressed few were prepared to respond to their necessarily unconventional and avant-garde language was generally ignored.

The artist, then, exemplified the liberated individual *par excellence,* and the content of his art defined the nature of liberated experience itself. Such ideas were already present in the nineteenth century, but in that decade before World War I, young European painters took to them with new energy and excitement. More than anything else, the art of this decade depicts and glorifies what is unique in the life of the artist—his studio, his vanguard friends, his special perceptions of nature, the streets he walked, the cafés he frequented. Collectively, early vanguard art defines a new artist type: the earthy but poetic male, whose life is organized around his instinctual needs. Although he owes much to the nineteenth century, he is more consciously anti-intellectual—more hostile to reason and theory—and more aggressive than any of his predecessors. The new artist not only paints with heart and loins, he seizes the world with them and wrenches it out of shape. And he not only experiences his instinctual nature with more intensity than those trapped in the conventional guilt-ridden world; his bohemian life offers him more opportunities to gratify his purely physical needs.

According to the paintings of the period, sexually cooperative women are everywhere available in the artist's environment, especially in his studio. Although they were sometimes depicted as professional models posing for their hourly wage, they usually appear as personal possessions of the artist, part of his specific studio and objects of his particular gratification. Indeed, pictures of studios, the *inner sanctum* of the art world, reinforce more than any other genre the *social* expectation that "the artist" is categorically a male who is more consciously in touch with his libido than other men and satisfies its purely physical demands more frequently. The nudes of Van Dongen, Kirchner and Modigliani often read as blatant pre- or postcoital personal experiences, and, according to much Brücke art, that communal studio in Dresden was overrun by naked, idle girls.

However selective these views of bohemia are, some social reality filters in—enough to identify the nameless, faceless women who congregate there in such numbers and offer their bodies with such total submission. Their social identity is precisely their availability as sex objects. We see them through the eyes of the artist, and the artist, despite his unconventional means, looked at them with the same eyes and the same class prejudices as other bourgeois men. Whatever the class situation of the actual models, they appear in these pictures as lower-class women who live off their bodies. Unlike generalized, classi-

cal nudes, they recline in the specified studio of the artist and take off contemporary—and often shabby—clothes. The audience of that time would instantly recognize in them the whole population of tarty, interchangeable and *socially* faceless women who are produced in quantity in modern, industrialized societies: mistresses of poor artists drawn from the hand-to-mouth street world of bohemia, whores, models (usually semiprofessional whores), and an assortment of low-life entertainers and bar-flies. Whatever their dubious callings, they are not presented as respectable middle-class women. Indeed, by emphasizing their lower-class identity, by celebrating them as mere sexual objects, these artists forcefully reject the modesty and sexual inhibitedness of middle-class women as well as the social demands their position entitles them to make. Thus the "liberated" artist defined his liberation by stressing the social plight of his models and his own willingness to exploit them sexually.

For, despite the antibourgeois stance of these artists and their quest for a liberated vision, they rarely saw the social oppression before them, particularly that yoke which the bourgeoisie imposed upon womankind at large and on poor women in particular. The women that Toulouse-Lautrec painted and sketched were surely no better off socially than the women in these pictures. But where he could look through class differences and sordid situations, and still see sympathetic human beings, these young men usually saw only sexually available objects. Usually but not always. Two paintings of the same cabaret dancer, painted by Derain and Vlaminck on the same day, make a significant contrast. The woman in Derain's work, *Woman in Chemise* (1906), looks uncomfortable and unsure of herself before the gaze of the artist. Her awkward, bony body is self-consciously drawn together, and a red, ungainly hand, exaggerated by the artist, hovers nervously at her side. The artist's social superiority and the model's shabbiness are acknowledged, but not enjoyed or celebrated. Despite her dyed hair and make-up, the woman is seen as an authentic subjective presence who commands serious attention, unbeautiful but human. In Vlaminck's *Dancer at the "Rat Mort"* (1906), the same woman in the same pose is a brassy, inviting tart, a mascara-eyed sexual challenge. Set against a pointillist burst of color—those dots that were so beloved by the previous generation of anarchists—she is all black stockings, red hair, white flesh and a cool, come-on look. Vlaminck, the avowed anarchist, is as thrilled by her tawdry allure as any bourgeois out for an evening of low life.

The socially radical claims of a Vlaminck, a Van Dongen or a Kirchner are thus contradicted. According to their paintings, the liberation of the artist means the domination of others; his freedom requires their unfreedom. Far from contesting the established social order, the male-female relationship that these paintings imply—the drastic reduc-

tion of women to objects of specialized male interests—embodies on a sexual level the basic class relationships of capitalist society. In fact, such images are splendid metaphors for what the wealthy collectors who eventually acquired them did to those beneath them in the social as well as the sexual hierarchy.

However, if the artist is willing to regard women as merely a means to his own ends, if he exploits them to achieve his boast of virility, he in his turn must merchandise and sell himself, or an illusion of himself and his intimate life, on the open avant-garde market. He must promote (or get dealers and critic friends to promote) the value of his special credo, the authenticity of his special vision, and—most importantly—the genuineness of his antibourgeois antagonism. Ultimately, he must be dependent on and serve the pleasure of the very bourgeois world (or enlightened segments of it) that his art and life appear to contest.[14] Here he lives a moral-social contradiction that is the corollary to his psychological dilemma before the sphere of woman/nature. The artist wants to but cannot escape the real world of rationalized bourgeois society. He is as tied to it economically as he is bound within its cultural and psychological constructs.

The enlightened art collector who purchased these works, then as now, entered a complex relationship with both the object he purchased and the artist who made it. On the most obvious level, he acquired ownership of a unique and—if he had taste—valuable and even beautiful object. He also probably enjoyed giving support and encouragement to the artist, whose idealism he might genuinely admire. At the same time, he purchased a special service from the artist, one that is peculiarly modern. In the sixteenth, seventeenth and eighteenth centuries, the wealthy patron often owned outright both the object he purchased and its erotic content. Frequently he specified its subject and even designated its model, whose services he might also own. The work bore witness not to the artist's sexual fantasies or libertine lifestyle (the artist could hardly afford such luxuries), but to the patron's. The erotic works commissioned by famous eighteenth-century courtesans were equally addressed to their male benefactors. In these twentieth-century images of nudes, however, the willfully assertive presence of the artist stands between the patron and the erotic situation represented. It is clearly the artist's life situation that is depicted; it is for him that these women disrobe and recline. And the image itself, rendered in a deliberately individual and spontaneous style, is saturated with the artist's unique personality. The collector, in fact, is acquiring or sharing another man's sexual-aesthetic experience. His relationship to the nude is mediated by another man's virility, much to the benefit of his own sense of sexual identity and superiority. For these nudes are not merely high-culture versions of pornography or popular erotica. Often distorted and bestial,

they are not always very erotic, and they may appeal to homosexual males as much as to heterosexuals. They are more about power than pleasure.

The relationship between the collector and the artist may be read in the monographs that art historians and connoisseurs so often write about painters of nudes. These usually praise the artist's frank eroticism, his forthright honesty and his healthy, down-to-earth sensuality. Often there are allusions to his correspondingly free sex life. The better writers give close and detailed analyses of individual works, reliving the artist's experience before the nude. At some point, higher, more significant meanings are invoked, things about the human condition, freedom, art and creativity—or, if the writer is a formalist, about the artist's coloristic advances, his stylistic precocity or his technical innovations. It is the moment of rationalization, the moment to back away and put abstractions between oneself and the real content of the paintings.

The collector could enjoy the same closeness to and the same distance from that content. What ensues in that collapsing and expanding space is a symbolic transference of male sexual mana from bohemian to bourgeois and also from lower to upper classes. The process began with the artist, who adopted or cultivated the aggressive, presumably unsocialized sexual stance of the sailor or laborer. The content of his art—his choice of nameless, lower-class women and his purely physical approach to them—established the illusion of his non-bourgeois sexual character. In acquiring or admiring such images, the respectable bourgeois identifies himself with this stance. Consciously or unconsciously, he affirms to himself and others the naked fact of male domination and sees that fact sanctified in the ritual of high culture. Without risking the dangers that such behavior on his own part would bring, he can appropriate the artist's experience and still live peacefully at home. For he cannot afford, and probably does not want, to treat his wife as an object. He needs and values her social cooperation and emotional presence, and to have these, he must respect her body and soul.

What the painting on the wall meant to that wife can only be imagined. A Van Dongen or a Kirchner was scandalous stuff, and few matrons were prepared to accept such works on their aesthetic merits. But no doubt there were women who, proud of their modernity, could value them as emblems of their own progressive attitudes and daring lack of prudery. Finally, we can speculate that some women, frightened by suffragist and emancipation movements, needed to reaffirm—not contest—their situation. The nude on the wall, however uncomfortable it may have been in some respects, could be reassuring to the wife as well as the husband. Although it condoned libertinism, it also drew a veil over the deeper question of emancipation and the frightening thought of freedom.

Notes

1. See my "Esthetics of Power," *Heresies,* 1 (1977), pp. 46–50.

2. For the iconography of late nineteenth-century painting, I consulted A. Comini, "Vampires, Virgins and Voyeurs in Imperial Vienna," in *Woman as Sex Object,* ed. L. Nochlin, New York, 1972, pp. 206–21; M. Kingsbury, "The Femme Fatale and Her Sisters," in *ibid.,* pp. 182–205; R. A. Heller, "The Iconography of Edvard Munch's *Sphinx,*" *Artforum,* January 1970, pp. 56–62; and W. Anderson, *Gauguin's Paradise Lost,* New York, 1971.

3. M. Kozloff, *Cubism and Futurism,* New York, 1973, p. 91.

4. Matisse, in H. Chipp, *Theories of Modern Art,* Berkeley, Los Angeles, London, 1970, pp. 132–33.

5. S. Ortner, "Is Female to Male as Nature Is to Culture?" *Feminist Studies,* Fall 1972, pp. 5–31.

6. *Ibid.,* p. 10.

7. R. Rosenblum, "The 'Demoiselles d'Avignon' Revisited," *Art News,* April 1973, pp. 45–48.

8. The crouching woman at the lower right, especially as Picasso rendered her in preparatory studies, is a familiar figure in primitive and archaic art. See Douglas Fraser, "The Heraldic Woman: A Study in Diffusion," *The Many Faces of Primitive Art,* ed. D. Fraser, Englewood Cliffs, N.J., 1966, pp. 36–99. Anyone familiar with these symmetrical, knees-up, legs-spread figures can have little doubt that Picasso's woman was inspired by one of them. Grotesque deities with complex meanings, they are often in the act of childbirth, and in primitive villages they frequently occupied the place above the door to the men's lodge, the center of culture and power. Often, they were meant to frighten enemies and were considered dangerous to look at. They surely functioned ideologically, reinforcing views of women as the "other." Picasso intuitively grasped their meaning.

9. Vlaminck, in Chipp, *Theories,* p. 144.

10. Leo Steinberg discusses the phallic meaning of this object in "The Philosophical Brothel, Part I," *Art News,* September 1972, pp. 25–26. The juxtaposition of the phallus and the squatting nude especially recalls the self-displaying figures Fraser studies (see note 8), since they were sometimes flanked by phalli.

11. Philip Rieff, *Freud: The Mind of the Moralist,* New York, 1959, Ch. 5.

12. F. Nora, "The Neo-Impressionist Avant-garde," in *Avant-garde Art,* New York, 1968, pp. 53–63; and E. Oppler, *Fauvism Re-examined,* New York and London, 1976, pp. 183–95.

13. B. Myers, *The German Expressionists,* New York, 1957; and C. S. Kessler, "Sun Worship and Anxiety: Nature, Nakedness and Nihilism in German Expressionist Painting," *Magazine of Art,* November 1952, pp. 304–12.

14. R. Poggioli, "The Artist in the Modern World," in M. Albrecht, J. Barnett, and M. Griff, eds., *The Sociology of Art and Literature: A Reader,* New York, 1970, pp. 669–86.

"Femininity and Feminism" 1981

ROZSIKA PARKER AND GRISELDA POLLOCK

Rozsika Parker and Griselda Pollock examine different ways in which female Surrealist artists addressed issues of sexual difference, female archetypes and male mythologies. Part of a larger historical study, this essay shows how the interest of Surrealists in "the feminine," and in "convulsive" fantasy imagery encouraged female artists to subvert traditional stereotypes while trying to break out of their traditional "containment" by patriarchal culture.

Victorianism in Europe and America receded very slowly in our century. Restrictions upon women continued throughout the era of modern art practice, including exclusion by male artists and by art dealers. Therefore, the issue of "the feminine" in modern art is not automatically equated with feminism itself, but rather with the roles women played (for men) as exotic subject and segregated artists.

* * *

Throughout this book we have been mapping the positions of women in art by analysing the structures which determine and sustain the differences of power and privilege for men and women in art. These structures not only include conditions of production but, as importantly, conditions of reception. Our point of departure was the need to understand and explain contradictions. The contradictions exist between, on the one hand, current art history's silence on or stereotyping of women's art past and present and, on the other, the vast number of women artists who practise. This situation illustrates a particular brand of twentieth-century patriarchal attitude. Equal opportunities are apparently avail-

able but they are effectively contradicted by disguised but profound levels of constraint, containment and oppression.

Any female art student finds herself in an historically determined situation within which the operation of ideology is deeply rooted but frustratingly elusive. The individual female artist alone in her studio or in a traditional art school can achieve only a partial breakthrough. Besides, the situation demands a great deal more than token acceptance of a few women by an establishment which upholds not only the traditional views and limited definitions of art but which also embodies those very values for which the containment and repression of women is structurally necessary.

In "The Women Artists' Movement—What Next," a thoughtful essay on the situation of current American feminist artists, whose consistent campaigning has raised the proportions of women exhibited in major national institutions, Lucy Lippard has rightly questioned the value of the single-minded pursuit of limited recognition by the establishment. The higher quotas are still quotas. They may become merely new barriers to further change:

> The great danger of the current situation in America...is that the barrier will be accepted, that women artists will be content with a "piece" of the pie, so long dominated by men, satisfied with the new found luxury of greater representation in museums and galleries (though not yet in teaching jobs and art history books) rather than continuing to explore the alternatives. These alternatives will, hopefully, change more than mere percentages, more than the superficial aspect of the way art is seen, bought, sold and used in our culture.[1]

Lippard anticipates that if art by women is absorbed into the establishment in this partial way we shall find ourselves within a decade right back where we started, with a few more women's names known in the art world, but with the same system intact and a whole new group of women wondering why they are still left out. Her timely doubts about the direction of the women artists' fight for recognition echo our questions about the feminist art historians' strategies with regard to the women artists of the past.

Lippard's comments raise a pertinent question. Should women artists' energies be directed towards gaining access to the art establishment, demanding full and equal participation in its evident benefits, exhibition, critical recognition, status—a living? Or, instead, should their efforts be channelled into their independent and alternative sys-

tems of galleries, exhibitions, educational programmes? These are not in fact oppositions, but differing strategies. Tactically women's collective efforts to provide their own supportive networks are immensely important and they have effectively opened up new spaces and extended the possibilities of work for many women. However there is a real danger of remaining on the margins, occupying the separate sphere established for women's practice in the nineteenth century, at best annexed to mainstream cultural production.

Both interventions in the existing establishment and alternative institutions to those which dominate artistic practice are necessary. They are however but one aspect of the problem. In discussing women artists' relations to eighteenth-century art institutions such as the academies we noted the existence of women's studios and alternative networks. Equally there was evidence of tokenist policies of limited and belated admission of some women to these official bodies. But women's exclusion from the academies did not only mean reduced access to exhibition, professional status and recognition. It signified their exclusion from power to participate in and determine differently the production of the languages of art, the meanings, ideologies and views of the world and social relations of the dominant culture. Women artists did of course produce their own variant or different meanings through their work, challenge or disrupt the ways women were represented. But such interventions as have been made could be dismissed, ignored, redefined and eventually obliterated because the power to determine what is "high," "great" or "historically significant" art remained in the hands of male-dominated institutions. In the later nineteenth century we pointed to the special significance for women of the conjuncture in avant-garde practices, when institutional *and* representational practices were jointly questioned and restructured. Avant-garde practices in the twentieth century have themselves presented challenges to traditional notions of art, the artist and codes of representation, though in many cases their impact has been safely absorbed and diverted to become the new establishment. Admittedly, women's participation in these avant-garde practices is still conditioned by their position as women. This is obvious in the way men within such movements view their female colleagues and how critics respond in stereotypical ways to the work women produce. However some of these movements in twentieth-century art have a particular relevance for feminist theory and practice.

In the previous section we discussed the difficulties and pitfalls for women artists who have had to work within codes of representation dominated and controlled by men. Modernistic movements within the

twentieth century, for instance, abstraction, "conceptual art," "assemblage of found objects," have broken with figurative representation and traditional fine art media. There has been some challenge to the Romantic notion of the artist both by those who stress the impersonality of the work of art or see the individual as mere medium and by those who make use of chance, automatism and encourage spectator involvement. The classical separation of artist, product (the expression of artist) and public has been undermined, while the activity of art itself, the processes of making, the manner in which meanings are produced in a process that includes spectator or receiver as much as maker have all been examined.

But despite new signifying practices and the different relation of the spectator to the work of art, the critic has assumed an unprecedented importance, reconsidering and assessing the significance of the art produced while elaborating the theories and premises upon which modern art is based. The critic of modern art is a central element in twentieth-century art practice, one who conditions the reception of works of art. It is through the discourse of critics, however, that ideology operates to protect the dominant system and stamp the work that women produce, even within radical art practices, with its stereotypes and values.

Our purpose in this book has not been to ascertain a female, feminine or even feminist essence in art or to expose a long-hidden, alternative female culture, gratifying as that might be to our sense of self. It plainly cannot exist isolated like some deep frozen essence in the freezer of male culture. Rather we are concerned to discover the relationships between women artists and the institutions of art and ideology throughout historical shifts and changes.

The heterogeneous activities of women in the twentieth century convincingly dismiss any notion of a homogeneous woman's art. Instead we are confronted with the very many different ways women have intervened in avant-garde practice. But it is those practices or movements which have, however obliquely, touched on the issues of sexual difference that we will consider.

In order to bring out those points that relate specifically to a feminist analysis, we will look in detail at a few works by individual women within selected modernist movements. These works and artists are not special examples whose reputations we wish to establish. We have chosen already well-known artists precisely because their works have already been discussed extensively by critics and this enables us to set their work in the context of its reception by critics.

There are many reasons to take a look at one of the most important twentieth-century movements, Surrealism, the most obvious being that a large number of women became involved; some of the better known are Dorothea Tanning (b. 1910), Meret Oppenheim (1913–1985), Leonor Fini (b. 1908), Remedios Varo (1913–63), Leonora Carrington (b. 1917) and Toyen (b. 1902). Their contribution to Surrealism has, however, been masked by male attitudes. Fellow Surrealists or modern historians either ignore them altogether, or, like Marcel Jean who, in *History of Surrealist Painting* (1960), chivalrously discusses Carrington for her Surrealist cooking, notes the Surrealist women's eccentric fashion sense, delights in Oppenheim's charming Surrealist jewellery or appraises Leonor Fini for her elegant, chic style and dab hand at furniture decoration.

But Surrealism has importance for our purposes beyond the fact of the presence of women in the movement. Surrealist manifestos were produced in the wake of the First World War and movements in art such as Dadaism, which reacted against the bourgeoisie and the system that had taken Europe into war. The Surrealists declared their opposition to prevailing notions of art and the perverted values of their society, its repressions, its notion of common sense and rational order. In the 1930s some members of the movement explicitly allied themselves to revolutionary political movements. Others were particularly interested in promoting quite new definitions of art and a different role for the artist. Lucy Lippard described one of their aims in her introduction to *Surrealists on Art* (1970): "Surrealism intended to initiate a new humanism, in which talent did not exist, in which there were no artists and non-artists, but a broad new consciousness that would sweep the old concept of art along with it."[2]

Their interest in psychoanalysis, whether they fully understood it or merely found it useful, represented a desire to attack the symbolic order of their culture, to liberate fantasy, repressed or censored material, to enlarge their experience and their concept of mankind. What they reacted against was defined by André Breton as all that was masculine and what they sought was symbolized by all that was attributed to femininity:

> The time should come to assert the ideas of woman at the expense of those of man the bankruptcy of which is today so tumultuously complete. Specifically it rests with artists, even if it is only in protest against this scandalous state of affairs, to ensure the supreme victory of all which derives from a feminine system in the world in opposition to the masculine

system, to base the foundations exclusively on the faculties of women, to exalt, or better still, to appropriate and make jealously one's own all which distinguishes woman from man with regard to modes of appreciation and volition....Yes it is always the lost woman who sings in man's imagination but who—after what trials for them both!—should be also woman regained. And first she must regain herself, learn to know herself, through those hells which, without his more than doubtful aid, man's attitude in general sets up around her.[3]

Although the Surrealists identified masculinity and patriarchy as the repressive order, they intended to subvert it by appropriating the feminine. That which was defined as "other" was to be taken over by men to fulfil their desire for their total humanity; women it is presumed could not conversely desire to appropriate all that was disparaged as masculine to complete themselves.

Many of the Surrealist notions of the feminine and their fascination with Woman are no more than idealist or essentialist notions of the difference between the sexes and ultimately work to endorse traditional definitions of Woman as Nature, Woman as silent enigma, Woman as Sphinx, Woman as child. Nonetheless they were directly concerned, however mystifyingly, with altering existing definitions of sexual difference. Their notion of the primary androgyne, a composite of masculine and feminine, can be read not just for its overt humanist content but as an unconscious desire to revert to that state which Freud perceived in the pre-oedipal child (the "little man"), namely the bisexuality, the not yet fixed gender identity, of the human infant, prior to its positioning in patriarchal culture as definitively masculine or feminine subjects.

The implications of this attempt to break open the order of our culture, the pursuit of an androgynous ideal or the exploration of fantasy, castration anxiety and sexual difference by so many Surrealist male artists was crucial for women of that circle. The cult of the feminine as opposed to the celebration of machismo sexuality in art, the notion of artist as medium rather than domineering, ordering force, the search for hidden, mysterious meanings by a variety of techniques all opened the way for women's participation in the movement.

Leonor Fini (b. 1908) arrived in Paris in the 1930s and although she was never a member of the group, she took part in Surrealist exhibitions and became friendly with Max Ernst, Paul Eluard and Leonora Carrington. Her work is decidedly about Woman, in many mythic guises, as alchemist, goddess, priestess, seamstress, spinner and sphinx, often with her own features. Invocations of old myths and female

archetypes from pagan religions celebrate woman as creator, as powerful. But none the less they fall back into traditional definitions of woman, silent or silenced, mysterious, chthonic, enigmatic. Yet the way in which Fini combines her images of woman with her own image, woman as alchemist with woman as artist in the rituals of art, can be seen as an attempt to appropriate to woman exactly the divine force—access to another level of experience—that has been the sacred and exclusive attribute of "the great male artist."

In her repeated use of the sphinx, for example, *The Little Guardian Sphinx* of 1948, originally in Egyptian culture a male creature but in Greek mythology a symbol of woman, half-human and half-beast, Fini offers an image of woman as seen by patriarchal society, mythological, intermediate between spheres of nature and humanity, brooding, mysterious and eternally silent. The sphinx exerts an endless fascination, a symbol of an unknown; as Laura Mulvey and Peter Wollen suggested in their film *Riddles of the Sphinx* (1977), it is the symbol of the feminine as the unconscious.

Later works by Fini in the 1960s address the issues of sexual difference more directly, with cooler colours, a more stark, linear style, clinical at times, the protagonists always silent. In *Capital Punishment* (1969) she deals with castration. A female figure kneels beside a block. Behind her stands a young girl, unseeing, her eyes covered by a large sunhat, in her hand a kitchen knife. Both look at a seated figure whose legs are open and whose pubic hair is marked by a bright red stain. The painting has suggested to some a reference to castration, especially because of the goose held by the girl under the menace of her knife. Of her *Fait Accompli (The Deed Accomplished)* of 1967 Fini has written:

> In a café full of girls the outline of a man is drawn on the ground in the same way that the police mark the position of a dead body....It is in this outline that the witch rebels against all the social opacity of men. That is to say; the deceit, the conventionality, the sordidness—this is everything which the girls cannot tolerate.[4]

By exposing the terrible cost to women of the patriarchal system, Fini desires to eradicate sex distinctions. But she uses sex distinction in her own work; she employs reversals. Her paintings are often based on series of oppositions: verticals and horizontals, sleep and consciousness, black and white. In *Chthonian Deity Watching a Young Man Asleep* of 1947 she took up a theme popular in rococo and Romantic art and epitomized by *The Sleep of Endymion* (1791) by Girodet (1767–1824).

The sensuality of the sleeping boy gently caressed by the embrace of the light of the moon goddess Selene in Girodet's work is replaced by a more sinister Goya-esque atmosphere. An angular young man lies asleep, legs sprawled, his genitals protected and disguised by a soft drapery, typical of the traditional effacement of female sexuality in images of the female nude. The shadows of his imminent beard place him on the verge of manhood. He is watched by a black sphinx, adorned with Minoan jewels and ostrich plumes. The gaze of the sphinx is not subordinated to the viewer's gaze but dominates; her awareness and upright alertness signifies power over the supine male. Although many of its possible meanings are obscured by arcane references and private symbolism, it actively refers to and works over traditional representations. Once again woman's menace to the male order is represented through mythological figures, taking up perhaps Freud's insights in his reading of myths and legends such as the story of Medusa's head and, of course, in the drama of Oedipus. By structural use of verticals and horizontals, by use of colour, the black sphinx contrasting with the pale male, the power of woman, the watcher, but also the fantastic creature, is represented. She also sets up oppositions between aspects of femininity, as in *The White Train* of 1966, which Linda Nochlin has pointed out is a reworking of a Victorian painting, *The Travelling Companions* of 1859 by Augustus Egg (1816–63). At one level Fini appears to be exposing what lies beneath the surface of Old Master paintings, the sexuality of women hidden beneath layers of Victorian drapery; but at the same time she uses the sleeping/waking dichotomy, though to different effect.

In Egg's painting two passive, identical young women are travelling in a carriage. One reads and the other sleeps, with her bodice just perceptibly unbuttoned, while their silk petticoats billow in vaguely suggestive shapes. Fini makes the repressed Victorian sexuality overt. She uses the train imagery in several paintings, and twins, or doubles, appear again and again in her work. In *The White Train* they seem to be reflecting the Surrealists' concern with the resolution of opposites, conscious and unconscious, sleeping and waking, life and death, socially admissible and inadmissible behaviour, masculine and feminine. Fini once said, "I am in favour of a world where the sexes are not differentiated, or little differentiated." The male Surrealists tended to seek androgyny by appropriating what they saw as the feminine; Fini, on the other hand, appears to be demanding a fuller "humanity" for women, not necessarily based only on the acquisition of supposedly "masculine" qualities. She challenges Egg's one-dimensional view of women by differentiating the travelling companions. Describing the painting she said

one woman was "like a beautiful cow, very white and somnolent, while the other much more alive, much more alert, pulls the curtain. She doesn't know what she will do next, whether she will kill the other or make love to her."[5]

Fini's images are strange and difficult to understand because of the mixture of esoteric symbolism and clearly delineated representational forms. But her work betrays certain important tendencies predicated on but differing in effect from the tenets of Surrealism. Behind the valorization of women as alchemist or priestess lie other levels of meaning which are revealed in her chosen forms and images and through references to mythology or which are embedded in the structural oppositions of the compositions. These works deal with woman and the structure of sexual difference but inevitably woman is seen as enigmatic, ambiguous. These are not, therefore, simply "positive" images celebrating women's power or an alternative female culture but pointers to the unknown quantity that is woman, distantly present in our culture through myths, fantasies, a menace of the repressed. What is present in Fini's work, however, is the discourse of the female artist, working over traditional representations, shifting their meanings, exposing the fears, the limiting divisions of masculinity and femininity.

To shift meanings and to break open common sense were two of the goals of Surrealism, especially apparent in those activities that displaced the traditional notions of the artist and the art object, offering a larger space to the spectator. Certain works known as "Surrealist objects" abandoned conventional media, oil and canvas, and reworked objects from the environment. Meret Oppenheim's (1913–1985) famous *Déjeuner en fourrure (Fur Tea Cup)* of 1936 brings together two banal forms, a cup and saucer and pieces of fur. But their juxtaposition gives rise to powerful effects that cannot be related individually to any one of the component elements. There is the shock of the unexpected, the dislocation of elements from their roles in daily life, the transformation of objects by being placed in an unusual context, not only a teacup and piece of fur in an art exhibition, but fur in the kitchen, luxury on the surface of the commonplace. The juxtaposition is full of condensed meanings, but to take the Freudian terminology further, it suggests another aspect of unconscious processes, displacement. Has not some of the shock of the object a vague, discomforting sexual undertone? With whom are fur coats and tea cups associated? And in a larger, symbolic sense, vessels, nourishment and hair introduce another level of female sexual reference. One can ultimately only ask questions because the use of juxtaposition and found objects in this way liberates many meanings.

Displaced and condensed, intimations of female sexual difference occur in the signifying practice, the materials and methods used and the space opened up to the spectator to bring his/her readings to the object have all been brought together by Oppenheim.

Oppenheim not only exploited the possibilities of strange juxtapositions of objects in her search to produce novel experiences of and through art, she organized events, for instance *The Banquet* in 1959 in which she disturbingly played upon notions of woman as nourishment by placing a nude woman as the centre-piece of the banquet. Oppenheim's conception of novel definitions of men and women's roles was both in line with general Surrealist theories and distinct. She shared the tendency to assume that there was an "essence" of woman beneath or beyond the socially ordained roles and current definitions, and like other women in the movement she drew upon fertility archetypes and mythologies.

However, whereas Breton in *Arcane 17* discussed the value of femininity in terms of men appropriating the special qualities associated with women, Oppenheim demands that women reclaim their "masculinity." The following comment was written in 1975 and, judging from the notions of projected and introjected masculinity and femininity, bears the stamp of Jungian thought (Oppenheim entered Jungian analysis in 1944):

> I believe that men, since creating patriarchy, that is since the devaluation of the female, projected the femininity inherent in themselves, which is regarded as being inferior, onto woman. This means for the women that they have to live their own femininity plus the femininity projected onto them by the males. They are therefore females squared. They are not allowed to live their masculinity. The same applies vice versa for the male.[6]

Women have participated in many of the twentieth-century movements, but Surrealism, not only as a movement but as an approach which has continued to exert influence on other avant-garde practices, is particularly relevant to feminist studies because it was a conscious attempt to fight repression by introducing fantasy and the dream into the discourse of art. But many Surrealists remained within a figurative style of representation which only partially broke with traditional meanings and connotations. Certain forms of abstraction—for instance American Abstract Expression in the 1940s and 1950s—which were touched by Surrealist practices and concerns with unconscious processes, rather

than with their styles of representation, offered a different kind of space and potential for women's intervention and transformation of art language....

In *Old Mistresses: Women, Art and Ideology* we have argued that women's art has occupied a strategic though contradictory position in the history of art, always present, always diverse, but represented in art history as always absent or forever the same. A closer analysis of the implications of the ways in which art by women has been discussed and repeatedly belittled suggested an important link between the representation of women's art and the creation of the dominant assumptions about art and the artist.

We have to reject the simple notions that women's art has been ignored, neglected or mistreated by art history, and seriously question the belief that women need to struggle to gain entry into and recognition from the existing male-dominated field of art. Far from failing to measure up to supposedly "objective" standards of achievement in art, so unproblematically attained by men by virtue of their sex, we discover that art by women has been made to play a major role in the creation and reproduction of those very standards. This represents a fundamental rereading of the history of women artists and the historical significance of women's art. The focus shifts from the peripheries to the centre—that centre is the historical development of the definitions of art and identities of the artist as the exclusive prerogatives of masculinity.

We can now recognize the reasons for and political importance of the persistent feminine stereotype within the structure of art history's ideological practices. In this stereotype women are presented negatively, as lacking creativity, with nothing significant to contribute, and as having had no influence on the course of art. Paradoxically, to negate them women have to be acknowledged; they are mentioned in order to be categorized, set apart and marginalized. We have focused therefore on art history, its words, its categories, its values, its discourses as ideology. By breaking open the feminine stereotype within art history to expose it not as the product of female gender but of the masculine discourses of art history, we have shown it to be one of the major elements in the construction of the hegemony of men in cultural practice, in art.

Trying to establish the relationship between women's history in art and the history of ideologies in art has led us to question some of the current interpretations of women's art history. Both nineteenth- and twentieth-century women writers claim that women artists have made a slow but steady progress into art from the few individual celebrities

like Anguissola in the sixteenth century to the more numerous but not yet fully integrated professionals of more recent times. We have observed, however, a more varying history in which at different periods the factors of sex, class and dominant forces in art, together with the changing identity of the artist, have produced distinct and differing possibilities for women's practice. Women artists have negotiated their situations within these changing circumstances to produce art which at times conforms to and at other times is in conflict with current ideologies in art making. However in the last two centuries, with the consolidation of bourgeois society and its rigid enforcement of women's economic and social position, manifested in the elaboration of women's "natural femininity" and divinely ordained domesticity, women artists have been subjected to a more complex process of constraints. The antithesis of artist and "Woman" have become more profound and entrenched.

Our book is not a conclusive nor an exhaustive study of this history. There are many gaps and generalizations. We have tried to construct a conceptual framework for the analysis of women, art and ideology. We attempt to provide ways of connecting the specific histories of women throughout the history of art with the ideologies and structures that have shaped both their practice and its place in art historical accounts of the art of the past. This helps us understand some of the paradoxes and contradictions in the present situation of women and art, for instance the growing numbers of women artists, and the disproportionately few who are ever fully recognized; the 50 percent female intake into art schools, and the absence of women in major teaching posts in art education; the language of the critics with the redeployment of the feminine stereotype in almost every reference to a woman artist published in the art press. Women's practice in art has never been absolutely forbidden, discouraged or refused, but rather contained and limited to its function as the means by which masculinity gains and sustains its supremacy in the important sphere of cultural production.

The mapping out of a new framework and our revisions are relevant to both feminist historians and artists. We must understand the historical process and practices that have determined the current situation of women artists if we are to confront the role of cultural production and representations in the systems of sexual domination and power.

Notes

1. L. Lippard, *From the Centre,* New York: E. P. Dutton, 1976, p. 14.
2. Lucy Lippard, *Surrealists on Art,* Englewood Cliffs: Prentice-Hall, 1970, p. 4.

3. André Breton, *Arcane 17,* 1945, p. 89.
4. Constantin Jelenski, *Leonor Fini,* New York: Olympia Press, 1968, pp. 14–15.
5. Jelenski, 1968, p. 37.
6. Cited in *Künstlerinnen International 1877–1977,* p. 78.

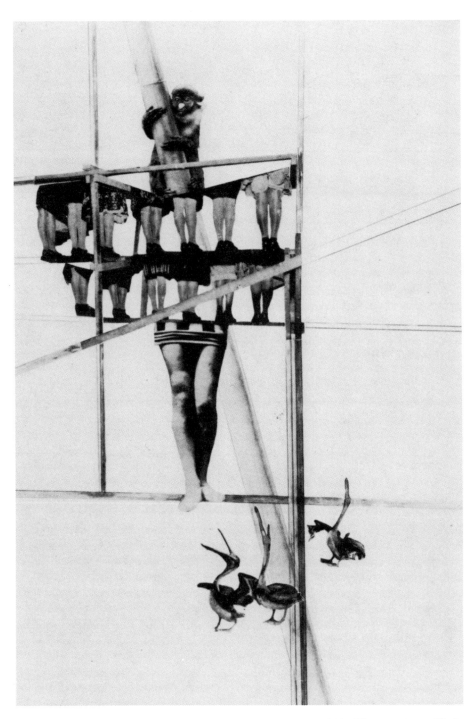

Structure of the World, 1927 by Laszlo Moholy-Nagy (1895-1946). Photomontage, Photo International Museum of Photography at George Eastman House, Rochester.

PART THREE

Modern Art and Mass Culture

A movie short is shown at a theater in 1900, a one-reeler by Lumière about workers in a factory. We look over the audience and find a mix of workers and middle class sitting together. This setting is symptomatic of a world to come, of something that will change the direction of art and civilization in cities. But in 1900, it was still something of an oddity. Mass culture in modern cities still operated very much as a duality: there was worker entertainment and middle-class entertainment. This duality is the key to understanding how modernism operated in mass markets from 1900 to 1940. And these markets did not exist in this configuration until about 1900.

Emergence of Working-class Culture in Cities

Prior to 1800, working-class mass culture was synonymous with rural folklore and not associated with city life at all.

By 1840, much of the folk tradition had been destroyed, while proletarian entertainments in cities were still very rudimentary or derivative, particularly of middle-class Romantic literature.

After 1860, this changed. As real wages and leisure time improved marginally for workers in cities, new markets emerged, large enough to rival middle-class culture.

By 1900, the two systems of mass culture coexisted in a way rarely seen before or after. Many additions to popular entertainment could be seen as one crossed the city, district by district. On corners in Paris, London, or New York where subway stations opened, new shops clustered. As trolley routes continued to push out in Los Angeles, tourist

attractions developed along the stops, from art shows to botanical events, from ostrich farms to private zoos.

In working-class neighborhoods, the number of music halls and entertainment arcades increased steadily, from the cheap burlesques to the ten-fifteen vaudevilles, and finally to the fancier vaudevilles.

Publishing grew considerably in all quarters. It still remains astonishing to discover how many streets in the United States once lined with bookstores now are lined with Seven-Elevens and Burger Kings. In the last third of the nineteenth century, pulp literature spread laterally across the land, in Europe and America: from the Bibliothèque Rose, published by Hachette in Paris, to the Beadle dime novels in America. Daily newspapers, illustrated magazines, and railway novels for sale at train stations (forerunners of the paperback book) had all increased their circulation remarkably, as had book stalls and lending libraries. Some of these books and magazines clearly were intended to reach both the "working-class reader" and the middle class, and these crossover markets boomed. Books strictly for a middle-class reader kept their distance and represented a narrower market (with modern literature at one progressive end).

Increasingly, a dual urban or dialectical culture was apparent, even in entertainment. It is this duality that helped support the avant-garde; however, it also could be ideologically suffocating. It is a duality characteristic of the late Victorian and Edwardian Ages in England when the "two" Englands were both paying hard cash for their leisure, occasionally stiffening the resolve of the middle class to stay clear of the invaders. Some sea resorts lost their exclusive clientele as workers began to be accepted on weekend excursions. It was the age of Coney Island, of new institutions for racing and gambling, of shooting galleries, penny museums, and freak shows. And it was an age of exclusive clubs, blue books, and extremely lavish restaurants for the well dressed, where the two worlds still mixed, despite the restrictions.

The distinctions between one mass culture and the other were actually more rigid for a time than they had been earlier, perhaps because the middle class no longer held as firm a cultural monopoly in cities.

In the districts where the middle class enjoyed their leisure, the world of mass culture seemed staid; yet it was also suggestive of the high spectacle that came later. Middle-class popular entertainment achieved a monumentality that would have been impossible only fifty years before. Massive new symphony halls, opera houses, museums, and theaters for high melodrama had been built, often from public funds. The number of stores on shopping boulevards had also grown into long pedestrian promenades, wonders of the industrial world.

The Growth of Communications Industries

From 1910, this duality changed as the split between the classes became considerably less evident. The middle class watched movies, listened to radio, went to the Ziegfield Follies, to baseball games, and so on. With the growth of communications industries and the automobile culture, the mutual isolation between middle-class and working-class entertainment rapidly began to disappear. As boundaries faded, a broader, more omnipotent mass culture became ever more central to fine arts production.

We do not yet see a consumer world like our own, but the process is already evident. The international communications corporations come later, but the first large theater chains emerged, the first large movie studios, and the first advertising agencies. To market the new consumer products and services in print, advertising lineage was added steadily to magazines and newspapers. Advertising was an important element in pushing economic modernization. Social historian Roland Marchand writes:

> An economy organized for efficient production through economies of scale, rationalization of the working place, functional specialization, and a rapid and integrated flow of materials and communications also needed a high "velocity of flow" in the purchase of goods by consumers. Ad creators were becoming the highly specialized facilitators of that process.[1]

Nearly all of the glamour industries of the era—automobiles, radio, chemicals, movies, drugs, and electrical refrigeration—advertised directly to the consumer.[2] We see the first nationwide trademark campaigns as early as 1907 (for Sunkist oranges), with far more simplified graphics, including more logos. The abstraction of consumer product onto a flat surface had begun, as well as the industrialization of consumer marketing—from Sears catalogues to design shows and world's fairs, a tradition continuing from the mid-nineteenth century.

What is Modernist in Mass Culture?

Already, mass culture presented a world out of scale—fantasy narratives transformed into huge theaters and window displays. Some of these narratives pointed toward what would come in cinema—the dislocation of time and space, very much like in film montage. In middle-class theatrical melodramas, dissolves and split-screen effects were presented "live" on stage, a simultaneity not unlike Futurist paintings. In the Sunday *New York Herald,* in the comic strip "Little Nemo in Slumberland" (1905), Winsor McCay designed a kingdom of ice that fractured

across the page into simultaneous space, very much like a modernist installation.

Mass cultural objects were not only divided into middle-class and proletarian markets, but they also were split in two aesthetically. Two extremes in perception often coexisted in the same object. For example, the imaginary ice kingdom in McCay's comic strip could be viewed as a dematerialized object, an abstraction of the material world, whether in print or in its ghostly electronic, cinematic glamour. The skating rink, surrounded by murals about kingdoms of ice, could also be seen as simulated fantasy. The objects or services for sale could look amazingly solid, as solid as an automated machine, or an amusement park ride, while submerged in what today is called "hyper-reality."

Fantasy itself was being industrialized. In America, with each decade after 1900, advertising, film techniques, popular photography, theater chains, chain stores, and electronic entertainment claimed larger consumer audiences, transforming a rural civilization into both an industrial and a simulated one based on glamour, not landscape; the post card was converted into a city, rather than the other way around. Science fiction merely catalogued what popular perceptions were becoming.

For modern artists, these invading objects were invested with sardonic meaning in collages, Dada objects, and Surrealist imagery. In particular, modernists of the 1920s exploited the many new forms of entertainment that had emerged out of working-class leisure industries since 1870: vaudeville, cinema, larger circuses, penny arcades, penny museums of popular oddities, resort parks like those in Coney Island, sports events (baseball, boxing), the Sunday funnies, pocket items like flip books and photo post cards, new cabaret music, ragtime and jazz, and dance halls.

By the 1920s, the sum of these activities seemed to represent a liberation, a modern art from Chaplin to dancer Josephine Baker, from movie theaters to the poster. To many progressive artists, mass cultural forms were metonyms for the modern whether it be a skyscraper, the Eiffel Tower, a detective novel, a comic strip, or, as city planning, what El Lissitzky called "the Americanization of Europe." Indeed, America itself had already become synonymous with mass cultural modernism, a world given over to consumer planning and industrial civilization. America also was seen as the threat of a hazardous future invading the Old World. In the early 1940s, German critics Adorno and Horkheimer complained about the standardization of mass culture, a civilization based exclusively on marketing and mass hypnosis, with America as the paradigm, and Nazi Germany as one terrifying example. Arguments for and against mass cultural modernism were common among critics from the 1920s on. The range of debate was very fertile, as the crisis of

consumerized art production began to be felt ever more clearly. As modern art increasingly lost its outsider status, its "transgression and indictment" were thought to be neutralized.

But this critical theory would be a volume in itself, beyond the spectrum of this book. For our purposes, we need to simplify target issues, limit our review to a few, key anecdotal examples, and stay inside the world of the modern city.

Chaplin's Face

The movie industry came of age in the second decade of the century and presented conundrums of all sorts to modern artists. By 1920, the single most recognizable face in the world was Charlie Chaplin, who was heralded probably more than any movie star before or since. We narrow to three modern artists studying Chaplin movies in the years immediately after the First World War: Kafka, Brecht, and Leger. How do they receive Chaplin as a modernist?

All three artists were very interested in how cinema redefined the role of the audience, how it altered narrative time and created a simultaneity of space. Kafka found these changes distressing and tried to avoid them in his work. Brecht and Leger found them fascinating, and used them directly.

Kafka was shown stills of Chaplin's face, and looked long and seriously at the stills...then said:

> That's a very energetic, work-obsessed man. There burns in his eyes the flame of despair at the unchangeable condition of the oppressed, yet he does not capitulate to it. Like every genuine comedian, he has the bite of a beast of prey, and he uses it to attack the world. He does it in his own unique way. Despite the white face and the black eyebrows, he's not a sentimental Pierrot, nor is he some snarling critic. Chaplin is a technician. He's the man of a machine world, in which most of his fellow men no longer command the requisite emotional and mental equipment to make the life allotted to them really their own. They do not have the imagination. As a dental technician makes false teeth, so he manufactures aids to the imagination. That's what his films are. That's what films in general are.[3]

When asked to join friends to see a Chaplin film, Kafka demurs: "Thank you, no. I would rather not. Jokes are far too serious a matter for me. I could quite easily stand there like a completely painted clown."[4]

Kafka also said, at another point:

> The cinema disturbs one's vision. The speed of the movements and the rapid change of images force men to look continually from one to another.

Sight does not master the pictures, it is the pictures which masters one's sight. They flood one's consciousness. The cinema involves putting the eye into uniform, when before it was naked.[5]

His friend finds these indictments of cinema disturbing. Kafka agrees: "Films are iron shutters." But a few days later, he adds: "Real life is only a reflection of the dreams of poets. The strings of the lyre of modern poets are endless strips of celluloid."[6]

In contrast, we sit beside the young Berthold Brecht in 1921 as he tries to write screenplays, then finally decides that he cannot "make sausages." A Chaplin one-reeler haunts him (*Face on the Bar-Room Floor*). The simplicity of movement is astonishing in this slapstick about an artist's memory of a woman he lost. In the final twist, the drunkard dies over her portrait. After watching this film, Brecht wrote in his diary:

> Chaplin's face is always impassive, as though waxed over, a single expressive twitch rips it apart, very simple, strong, worried. A pallid clown's face complete with thick moustache, long artist's hair and a clown's tricks: he messes up his coat, sits on his pallette, gives an agonized lurch, tackles a portrait by—of all things—elaborating the backside. But nothing could be more profoundly moving, it's unadulterated art. Children and grownups laugh at the poor man, and he knows it: this nonstop laughter in the auditorium is an integral part of the film, which is itself deadly earnest and of a quite alarming objectivity and sadness. The film owes (part of) its effectiveness to the brutality of its audience.[7]

Soon after this diary entry, Brecht begins increasingly to experiment with agit-prop and Expressionist theater. However, his fascination with the way cinema affects its audience continues to inform his work. Movies pacify the audience, but also turn the audience into a ferocious community all its own.

In 1923, when painter Fernand Leger made the experimental film *Ballet Mechanique,* he included segments from a movie he had started earlier on Chaplin. Art historian Judi Freeman writes:

> The painter was a passionate fan of the work of Charles Chaplin, having been first introduced to Chaplin's films during the First World War by the poet Guillaume Apollinaire. Leger was fascinated by Chaplin's control over his audience and, by extension, the potential of cinema to affect and manipulate audience response. He illustrated an edition of Ivan Goll's book *Die Chaplinade* (1920) and shortly thereafter began work on a scenario for an animated film, *Charlot Cubiste* (Charlot was the French nickname for Chaplin). Leger's scenario was extremely detailed, chronicling every moment in a day in the life in Paris of Charlot, who was constructed as a marionette in relief. At least five lengthy drafts of the scenario were penned by Leger; however, the film appears never to have

been made, probably due to the lack of financial backing. "Leger made use of the marionette and the idea of a disintegrating/reconstituting Charlot at the beginning and end of *Ballet Mechanique.*"[8]

Chaplin became Leger's emblem for the machine man and for the rhythm of the machine environment. Leger saw film faces as industrial logos, both in his painting and in the film *Ballet Mechanique.*

Shopping Arcades

By the 1920s in Europe and the United States, the middle-class consumer world of the nineteenth century had begun to decay in many urban centers. Business was shifting. Downtown areas were beginning to totter. One modernity was overcoming another quite literally, street by street. Surrealists Louis Aragon and André Breton were particularly fascinated by the anxious world of small shops in Paris. It offered a dreamlike journey similar to the hyper-realist or Surrealist experience.

The shopping world translates directly into a literary collage in Aragon's novel *Paysan de Paris* (1927). The narrator wanders through a glassed-over shopping arcade that is about to be torn down (Passage de l'Opera). It had been built almost a century before, was once a monument to genteel browsing and shopping, then had slowly been absorbed into working-class consumer life, and now was an open wound about to be surgically removed. The struggles of the shopkeepers inside the arcade, beneath the industrially filtered light of the glass enclosure, create an uneasy stillness (business fading, along with the sunlight streaking through the dirty glass), like a Balzac novel disintegrating inside the emergent consumer world of the twentieth century, in a city not altogether recovered from the shocks of the First World War. Here are a few paragraphs:

On the light inside the shopping arcade:

> A glaucous gleam, seemingly filtered through deep water, with the special quality of pale brilliance of a leg suddenly revealed under a lifted skirt. The great American passion for city planning, imported into Paris by a prefect of police during the Second Empire and now being applied to the task of redrawing the map of our capital in straight lines, will soon spell the doom of these human aquariums. Although the life that originally quickened them has drained away, they deserve, nevertheless, to be regarded as the secret repositories of several modern myths; it is only today, when the pickaxe menaces them, that they have at last become the true sanctuaries of a cult of the ephemeral, the ghostly landscape of damnable pleasures and professions. Places that were incomprehensible yesterday, and that tomorrow will never know.[9]

On consumer industrial modernism, and the spirit of browsing in shops:

> At freedom in the shop, huge and thoroughly modern wild animals lay in wait for *homo's* female, already the prey of small iron tongs: the mechanical dryer with its serpentine neck, the ultraviolet ray tube with its gentle eyes, the summer-breathed fumigator, all the crafty instruments already to snap their jaws, all the steel slaves who one fine day will rebel. As for the simulacra on display in the shop window, I will say no more about these waxworks that fashion has stripped of their clothes, digging cruel thumbprints into their flesh in the process.[10]

On the services inside the shopping arcade:

> Shoeshine parlours breathe the very spirit of modernism: what decorative splendour invests the tins of polish, despite their Americanism and lack of ingenuity shown in displaying them...One may equally regret that in a civilization such as ours the shoeblacks have registered technical advances over their predecessors of the romantic era. They have tended hitherto to demonstrate their inventiveness mainly in the interior decoration of their shops. The great discovery in this field has been that of elevated armchairs...If savants made a practice of having their shoes polished, what magnificent machines, what grandiose conceptions of the universe would emerge from between the arms of the shoeblacks' chairs.[11]

Comparing the mood of browsing in the arcade with Surrealist art practice:

> And how easy it is, amid this enviable peace, to start daydreaming. Reverie imposes its presence, unaided. Here, surrealism resumes all its rights. They give you a glass inkwell with a champagne cork for a stopper, and you are away! Images flutter down like confetti. Images, images everywhere. On the ceiling. In the armchairs' wickerwork. In the glasses' drinking straws. In the telephone switchboards. In the sparkling air. In the iron lanterns which light the room. Snow down, images, it is Christmas. Snow down upon the barrels and upon credulous hearts. Snow onto people's hair and onto their hands.[12]

Materiality vanished in the arcade, but in the displays, fantasy was laid like bricks into real space. The decomposed and yet extremely solid object (another sort of simultaneity) was a feature of both mass cultural modernism and of Surrealism. This was observed very precisely by Aragon as well as by Breton in his novel *Nadja:* "Beauty is like a train that ceaselessly roars out of the Gare de Lyon and which I know will never leave, which has not left...Beauty, neither static nor dynamic...Beauty will be CONVULSIVE or will not be at all."[13] Consider

Breton's famous commentary in terms of mass culture: beauty is both convulsive and nothing at all but a radio message, a "message transmitted on a wave length of 625 meters," a ghostly tether. Mass culture suggests a highly problematical object in a dreamlike space, where gravity and substance can be turned upside down, all to turn a profit.

Walter Benjamin called this quality in Surrealism profane illumination.

> Breton and Nadja are the lovers who convert everything that we have experienced on mournful railway journeys (railways are beginning to age), on Godforsaken Sunday afternoons in the proletarian quarters of the great cities, in the first glance through the rain-blurred window of a new apartment, into revolutionary experience, if not action. They bring the immense forces of "atmosphere" concealed in these things to the point of explosion. What form do you suppose a life would take that was determined at a decisive moment precisely by the street song last on everyone's lips?[14]

Benjamin goes on to say: "At the center of this world of things stands the most dreamed-of of their objects, the city of Paris itself...No face is surrealistic in the same degree as the true face of a city. No picture by de Chirico or Max Ernst can match the sharp elevations of the city's inner strongholds..."[15]

Of these strongholds, Benjamin found the aging shopping arcades deeply compelling. They were faded heralds from an earlier modernism of Baudelaire and Manet. In a proposal for a book on the arcades, he links the Parisian arcades to the modernist imagery of steel architecture in the nineteenth century and to the "panoramic" world of "commodity fetishism" in Paris during the Second Empire (1852–71). In effect, these arcades become for Benjamin very much a cradle of modernism. They reveal sources for abstraction and disjunction in the world of browsing. In their benevolent isolation, they suggest both political and consumerist utopias, how such utopias are imagined and then simulated under glass. To Benjamin, mass cultural modernism and fine arts modernism emerge out of virtually the same roots from the early nineteenth century on.

Expanding the Field to Include Masters from Mass Culture

Choosing the masters of mass culture has proven to be a very tricky issue, varying from one museum show to another. Industrial design, packaging, cell animation, fashion design, any number of crafts in film and television all have received recognition in major shows over the years, bringing new names into the canon of "modernism" from Raymond Loewy, Norman Bel Geddes and Henry Dreyfuss (product design) to Ernie Kovacs (television).

From a social-historical point of view, however, the problem is how to discuss mass culture within the modern city. One fact is indisputable: mass culture is a vital partner in what we call modern art. We need not argue the differences here. For our purposes, mass culture is neither deeper nor shallower, but simply a different market than the fine arts. It functions through a different system of censorship and approval, whether in auto design, graphic design, or set design (for movies). Aesthetics and marketing are lumped together, which is not to say that they are synonymous. What areas of modern art are problematical in terms of marketing? How should we consider what the artists themselves have faced for a century now, the problem of being avant-garde entrepreneurs? For example, a great many essays have been written on how modern art assimilated features from mass culture. In one essay by Thomas Crow, he argues that Cubist collage and montage techniques were striking attempts to integrate high and low culture, to mix together the realm of high art with that of the mass culture of newspapers and magazines. Unlike Berlin Dada, which collapsed art into a kind of politics, "the cubist precedent was, in contrast, an effort to fend off that outcome, to articulate and defend a protected aesthetic space."[16]

According to Crow, Cubism, like the avant-garde subcultures which preceded it, was assimilated into mass culture.

> The Cubist vision of sensory flux and isolation in the city became in Art Deco a portable vocabulary for a whole modern "look" in fashion and design. Cubism's geometricization of organic form and its rendering of three-dimensional illusion into animated patterns of over-lapping planes were a principal means by which modernist architecture and interior design were transformed into a refined and precious high style. Advertised as such, now through the powerful medium of film costume and set decoration—the "white telephone" school of cinema—the Art-Deco stamp was put on the whole range of twenties and Depression-era commodities: office buildings, fabric, home appliances, furniture, crockery. The Art-Deco style was also easily drawn into the imagery of the mechanized body characteristic of protofascist and fascist utopianism.[17]

In the United States, the ideals of Gropius, Moholy-Nagy, and Le Corbusier for "the total infiltration of good design as a means of rejuvenating culture" succeeded completely as capitalism appropriated modern art to increase the power of the corporation. As a result, fine art became a mediator between the avant-garde and three publics: "(1) Its immediate initiated clientele; (2) the much larger middle-class public for validated high culture with which it is in fairly constant negotiation; and (3) those publics excluded from or indifferent to high culture..."[18]

Art which began the twentieth century drawing on the Van Gogh myth of the misunderstood outsider who finally kills himself in despair,

finds itself by the end of the century completely accepted as a commodity, an investment, and as an important influence on design, embraced by the corporate powers it at once disdains and wishes to influence. As Herbert Marcuse said, "Artistic alienation succumbs, together with other modes of negation, to the process of technological rationality."[19]

Another example of the overlap of art and mass culture is architecture. Among all of the creative disciplines, architecture most consciously straddles the line between art and design, between modern art and mass culture. In 1923, Le Corbusier wrote an essay entitled "Art or Revolution," in which he argued that architecture, through its rationalization of the built environment, could reshape mass housing and urban life. "Industry has created its tools. Business has modified its habits and customs. Construction has found new means. Architecture finds itself confronted with new laws."[20]

For Le Corbusier, the question of style was secondary. The primary question was whether there was sufficient determination to use the new tools intelligently. As Mies van der Rohe argued in 1938, "The long path from material through function to creative work has only a single goal: to create order out of the desperate confusion of our time."[21]

An area of debate is the problem of precedence: Which came first, the mass cultural version of modernism or the fine arts version? Well, suppose they both came first—two different eggs. Each developed on its own, relatively separate from the other. A parallel model seems easiest to work with, though modern artists were very interested in mass culture, and in fact often become popular heroes themselves.

Mass cultural modernism parallels modern art, covering essentially the same years, 1912 to about 1940. Instead of the *Demoiselles D'Avignon* (1907), we might start with the first gas station in 1912, or the history of poster art, the first nationally advertised product, or the first major feature-length movie. As in other sections, we do not go far beyond the Second World War, although if we followed all the circuits and networks, we could wind up finally with the computer as the ultimate expression of abstraction. This computer would perhaps be on display at a franchise store, industrially designed throughout, inside a modernist shopping center, near a modernist freeway, with modernist pollution descending on rush hour. We decided instead to keep the industrial city—before World War II—as our principal enclosure, and abide by the limitations, leaving for the most part the syndication and franchising of modern art for another book.

Notes

1. Roland Marchand, *Advertising the American Dream* (Berkeley: University of California Press, 1985), p. 2.

2. Ibid., p. 416.

3. Gustav Janouch, *Conversations With Kafka*, translated by Gorony Rees (New York: Andre Deutsch, 1968), pp. 158–159.

4. Ibid., pp. 158–159.

5. Ibid., pp. 158–159.

6. Ibid., pp. 158–159.

7. Berthold Brecht, *Diaries*, edited by Herta Ramthun, translated by John Willett (New York: St. Martin's Press, 1979), p. 141. Entry is dated October 29, 1921.

8. Judi Freeman, "Bridging Purism and Surrealism: The Origins and Production of Fernand Leger's Ballet Mechanique," (*Dada/Surrealism,* 1987), pp. 35, 36.

9. Louis Aragon, *Paris Peasant,* first published in 1926, translated by Simon Watson Taylor (London: Jonathan Cape, 1971), pp. 28–29.

10. Ibid., p. 54.

11. Ibid., pp. 82–83.

12. Ibid., p. 94.

13. André Breton, *Nadja,* first published in 1928, translated by Richard Howard (New York: Grove Press, 1960), p. 112.

14. Walter Benjamin, "Surrealism: The Last Snapshot of the European Intelligensia," reprinted in Peter Demetz, ed., and Edmund Jephcott, translator, *Reflections* (New York: Harcourt, Brace, Jovanovich, 1978), pp. 182, 183.

16. Thomas Crow, "Modernism and Mass Culture," reprinted in Buchloh, Guilbaut, Solkin, eds., *Modernism and Modernity* (Halifax, Canada: Press of the Nova Scotia College of Art and Design, 1983), p. 250.

17. Ibid., p. 254.

18. Ibid., p. 254.

19. Herbert Marcuse, *One Dimensional Man* (Boston, Massuchusetts, Beacon Press, 1964), p. 65. Reprinted in this volume, p. 381.

20. Le Corbusier, "Architecture or Revolution," reprinted in Le Corbusier, *Towards a New Architecture,* first published in 1923, English translation 1927 (New York: Praeger Publishers, 1960), p. 263.

21. Mies van der Rohe, "Inaugural Address of Director of Architecture at Armour Institute of Technology," 1938, reprinted in Philip Johnson, *Mies van der Rohe* (New York: The Museum of Modern Art, 1947), p. 199.

"The Significance of Colour for Interior and Exterior Architecture" 1923

THEO VAN DOESBURG

Theo van Doesburg discusses the difference between paint, which covers interior surfaces, and color, which reveals the proportions of a space, making an interior visually articulate and unified. In a technological age, the new function of painters is to help architects and engineers visualize spatial relationships of proportion, scale, and direction.

From 1917 until his death in 1931, van Doesburg led de Stijl, a modern art movement that began in Holland, but migrated to Germany and then to Paris. While various artists and architects joined and then left, van Doesburg, both a painter and critic, remained a committed member. As much as any movement in that period, de Stijl tried to establish a unified language for modern art, an internationalist code for abstraction to be applied, they hoped, not only to painting but also to sculpture, architecture, and even to cinema.

Today van Doesburg's optimism may seem rather naive. He tried to strike an ideological balance between Futurist dynamism and the work of Schwitters, El Lissitzky, Mondrian, German Constructivists, and Dadaists. He felt that the nihilism of the Dadaist could be translated more affirmatively; that Mondrian's spiritualism could be allied to industrial planning; that Constructivism did not mark the end of studio art.

His writings might be compared to that of an eighteenth-century *philosophe,* to the more mechanistic wing of Enlightenment, striving for method whatever the contradictions in order to perfect the human environment. From 1922 on, he often wrote about integrating architecture with painting; "by including all the arts in their most elementary appearance, the new architecture manifests its very essence."[1] This confidence in the industrial setting was not necessarily shared as enthusiastically by other members of de Stijl, for example, by Mondrian.

Van Doesburg's optimism aside, there remained the problem of locating the intimate and the confessional in terms of the industrial city. This problem has grown since the 1920s, now that the industrial city seems to have been replaced by even more abstract versions of urban life, by electronic fantasy-scapes and TV communities. One wonders what van Doesburg (or Mondrian, or El Lissitzky) might have said about Disneyland as the primary architectural model for city planning in the late twentieth century.

Another continuing problem is evident in this document: The master system van Doesburg represented (western European Constructivism applied to painting) seemed to integrate two conflicting ideological camps in modern art: formalism and social modernity. Essentially the same camps can be located in art criticism after 1968.

* * *

I. Colour is of extreme importance to the new architecture. It represents an intrinsic part of the material of expression. Colour renders *visible* the spatial effect for which the architect strives. It is in this way that colour makes architecture *complete* and becomes intrinsic to it. Until now colour remained an element of secondary importance. This should cause no surprise since the boxes we live in, which are badly built and knitted together, do not result from a visualization of space. Only when building is transformed into architecture once more, that is to say a monumental synthesis of space, form and colour, will it acquire the significance to which it has a right. It must be admitted that, with few exceptions, until now satisfactory results have not been obtained. Nor should this be a matter for surprise, since a good result can be expected only from the consistent application of colour in interior and exterior architecture. Many a misunderstanding or mistake has resulted when painter and architect did not sufficiently respect one another's field. On the one hand, architects restricted painters; on the other hand they presented them with *too much* freedom. A compromise resulted from the former type of relationship, while painting, which retained a separate function, dominated in the latter (as happened, for example, with Taut and Oskar Fischer in Magdeburg). In both cases, colour led to the destruction of architecture.

The problem of colour's role in architecture is too important to be determined summarily, as is usually done only when the building is finished. A builder's estimate generally does not include the expense of painting, although the results which architects produce are more often than not detrimental rather than beneficial to the solution of the problem of colour. Painting doors or window-frames blue or yellow does not

differ essentially from applying paint to timberwork in order to protect
it from humidity, which is what house-painters did in the past.

II. Paint and colour are two different things. Paint is a means,
colour an end. One can cover a whole interior or façade with blue, yellow,
green, violet or red paint without achieving true colour, no matter how
multi-coloured the whole may be. Just as the knitting together of spaces
in which to live does not connote architecture, so the unlimited applica-
tion of "bright" colours does not provide a solution to the problem of
colour.

As always, we are concerned here with balance. Playing with forms,
which has become a slogan, is of no use here. Only practice can help.

When starting with the latter we must imagine a completely col-
ourless, neutral, that is to say a grey interior. A limitation of space by
means of six neutral, grey planes. This neutral space is not *active,* it
does not reveal its proportions and the less so the more a free entrance
of light avoids opposition with shadowy corners. Such inactive space
comprises a *void.* If one places in this interior furniture which uses a
neutral, grey material, the result will prove negative or passive. (This
contradiction in terms is intentional.) It is impossible to orientate one-
self in this interior, to judge the distance between wall and furniture.
Everything fuses together. Neither space, nor natural objects can be
ascertained according to their mutual relationships. *It comprises a vis-
ually inarticulate interior.*

I have chosen this negative example deliberately in order to instill
in the reader the desire for opposition, for contrast.

Every human being possesses a hidden need to see relationships
within his environment visually expressed in terms of oppositions. It is
upon this need that the very right of expressing relationships in archi-
tecture is based (the plastic element). The need for contrasts between
space and natural objects manifests itself as soon as the demand arises
for differentiating furniture from walls through colour by means of
either painting, coloured textiles or coloured planes, which do not blend
with one another. The fact that colours range from quite grey or neutral
(visually inarticulate) to clearly visible contrasts defines the entire
problem of colour in architecture. This range moves from the undefined
colours, which are without expression, to the well-defined, filled with
expression. (In numbers this can be expressed as follows: 0—1—2—3—
4—5 and so forth.)

This scheme is a presentation of the four phases of development
from the quite neutral (or visually inarticulate) towards the most har-
monious plastic expression of the interior and the objects which it
contains. The relationships between the latter is characterized by inter-

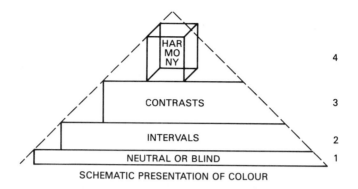

SCHEMATIC PRESENTATION OF COLOUR

vals (2) and contrasts (3). Within these four phases of development we can imagine various types of interior: for instance using phases 2 and 3, an interior can be imagined which aims at a solution by means of secondary contrasts (as is the case with many modern decorators who apply this to cinemas and coffee shops). However, this has nothing to do with the visualization of relationships through colour.

In phase 4, which is indicated with a cube, a certain neutrality has been produced. This derives in equal measure from the correct use of colour, although it is of a completely different nature from that in phase 1, because of a correct arrangement, proportion and value of the contrasting colours.

An interior which is well-defined in all its parts will present a neutral impression, since it does not possess either a particular form (representing individual caprice) or a particular colour dominating by its fascinating "effect." As long as certain details or objects attract special attention through either their form or colour, no unity has been attained. However, if a unity has been produced, then space and the objects contained within it are perceived as a unity in which each colour maintains its individual force of energy.

III. Following this more or less idealized explanation of colour as a principle in architecture, we must investigate the practical side of the subject more closely. First, we have to distinguish clearly the three main types of architecture, this being of extreme importance to the application of colour.

1. Decorative architecture
2. Constructive, solely functional architecture
3. Monumental architecture

With decorative architecture colour is used as a means to decorate the constituent planes.

Colour here remains ornamental. It does not achieve a unity with architecture and thus remains a separate element which, instead of *stressing* the architectural factor, camouflages and, indeed, ultimately destroys it (the Baroque period). Almost everything which our age has produced as examples of modern interior design can be said to belong to this class of architecture. It makes no difference whether or not one is imitating the Biedermeier style, with its motifs derived from nature, creating curved lines or producing forms stylized into rectangular planes (Biedermeier in terms of squares). In constructive architecture which serves material demands alone, colour has no other significance than to accentuate further the common architectural denominator by means of a completely neutral paint (grey, green, brown, neutral colour) and, furthermore, to protect wood or iron from the influence of humidity. Ultimately, this leads towards an anatomical constructive sterility in architecture. Functionalist architecture deals with only the practical side of life or the mechanistic function of life: living and working.

However, something exists beyond the demand for the useful, and this is the spiritual. As soon as the architect or the engineer wishes to visualize relationship—for example, the relationship between a wall and space—his intentions are no longer solely constructive but plastic as well. With the visualization or the accentuation of relationships (including the material), the aesthetic element comes into existence. The conscious expression of relationships constitutes plastic expression.

In this phase of plastic architecture, colour is a material of expression equivalent to other materials such as stone, iron or glass. In this instance, colour serves not only to orientate, by which is meant the visualization of distance, position and direction in reference to space and to the objects which it contains, but even more to satisfy a need for the visualization of mutual relationships in proportion, scale and direction. It is the arrangement of these relationships which constitutes the aesthetic goal of architecture. Once this harmony is established, it manifests style. Needless to say, this balance can be achieved only through an even distribution of tasks between the engineer, architect and painter.

With this phase, architecture has completed the period of constructive purification. No longer satisfied to demonstrate its underlying structure, it will develop into an indivisible, inspired totality.

Notes

1. Theo van Doesburg, *De Stijl*, Series xii 6–7, 1924, pp. 78–83, reprinted in Joost Baljen, *Theo van Doesburg*, New York: Macmillan Publishing Co., p. 147.

"The Quarrel with Realism, the Destiny of Painting" 1930s

LE CORBUSIER

In the utopian world of machine-made civilization which Le Corbusier envisages in 1932, architects will create a new life, a "symphony" of physical and intellectual beauty. Painting as creation of images will be out of date and superfluous. Abstract painting, which Le Corbusier calls "concrete art," will be used to help architects produce three-dimensional "plastic" harmony and to increase the dimensions of architectural spaces. Le Corbusier is also open to the possibility that artists should produce murals for architects, either photographed or painted, so long as they are created with restraint and clarity.

The utopianism of the generation of the 1920s toward "modernizing" urban planning, domestic interiors, and even popular values was very much an extension of the Enlightenment tradition, as critics like Theodor Adorno pointed out at the time.

Already at that time, the translation of these issues into real planning was problematical. The "dream" modernist space became a paradigm for the upscale (not the democratic) modern life, in movie sets, for example.

Still, the 1920s and early 1930s were a seed time for modernist urban planning. From Los Angeles to Moscow, utopian schemes for multileveled city centers were being imagined in great detail, as part of the utopian spirit of the era. By the 1970s, city centers very similar to these functionalist models had actually been built and came under considerable criticism as dehumanizing and short-sighted, as citadels of what was suddenly abhorrent in modernism. The ghost of functionalist architecture continued for generations, however, in the cheap stucco dingbat architecture used in less expensive suburbs, and in the older wooden frame houses of the inner cities. By the late 1980s, however, even in the echo of distant suburbs, the issue of functionalism had been

transformed into another ornament in the pluralist architectural menu of postmodern design.

* * *

Is it painting itself which concerns us today, among the anxieties which surround us everywhere, or the fate of the painters who are out of work?

I think that, in this discussion, we are concerned with painting. The question to be answered is: realism or not realism, and by that it would seem that we mean the life or the death of painting. Words perhaps! for in reality the discussion only admits of nuances extending from one extreme to the other.

The painting which has been transmitted to us by history is, in part, figurative or documentary painting. It was right that it should have been documentary because no specialized organization, no mechanism could improve on what the dexterity of the brush could produce.

Painting played a very important part for thousands of years. On the one hand, it constituted documentary archives or perpetuated a sermon, a speech, or recorded in forms more or less cryptic a thought or a doctrine. It transformed a fleeting event into a permanent fact. But, while doing all this and quite independent of these utilitarian tasks, painting—and this is its real vocation, its destiny—recorded forms conveying lyricism. When painting was good, this lyricism was specifically that of the forms. Plastic harmony, infinitely variable and varied. It could then touch sensitive and sane spirits, and evoke poetry—the definite aim of painting and the arts.

Today—as Fernand Léger has said—we are inundated with images. The objective, impassive machine has outstripped the human retina; a machine fears neither heat nor cold; it is never tired; it thus has the advantage of exceptional sight, so that its productions are a revelation to us. It permits us to penetrate the mysteries of the cosmos by means of investigations to which our human capacities could never aspire.

We are, then, inundated with images—in the cinema, the magazine, the daily paper. Is not therefore a great part of the tasks of painting accomplished? When a period is almost at an end, when a common incentive no longer animates it, men indulge in soft intimacy and tenderness. It is natural that, at such a time, painting should reap a rich harvest, and innumerable painters should find employment and good remuneration. But this page has been turned—it had to happen one day, and it has happened now—we are entering a collective period; painting

Note: This article is a translation of an address given at a discussion on "Painting and Reality," in which Le Corbusier, Léger, and Aragon took part.

has lost some of its *raison-d'être,* and the painters have lost their patrons. That is their tragedy at the present time—the anguish of being useless and unemployable. Times have changed; the great army of painters, with their public and their patrons, with tasks to accomplish, are now without employment. Before considering whether it is possible to save them, let us try to decide whether the fate which has overtaken painting is retrograde or progressive.

When a period becomes collectivized or acquires undeniable common needs, such as those to which the last hundred years have led up, suitable systems must be established, both social and authoritative—with new ideas and, above all, new equipment.

It is useless to try to imagine what the mechanical revolution of the last hundred years really is; it has invaded the whole world; it has upset everything, disturbed everything, battered everything, but, at least for those capable of reading between the lines, it brings also the certainty of speedy deliverance from these misfortunes and crises.

With the wonderful tool which in future will replace the toil of our hands and the sweat of our brow—the machine—we will be able to equip ourselves adequately, not only for comfort—a wide and healthy comfort—but also, this new époque of machine-made civilization will give us happiness and a greater individual liberty, combined with the most complete greatness and collective vitality.

I refer to impending works—the equipment of the country, of all countries, of the world—towns, roads, villages, farms, ports, everything where men live or pass through, whether on the earth, or braving the perils of the seas or the air. A vast animation has seized the whole world and has placed us face to face with tasks never before contemplated.

For architecture, this equipment opens up a new field. The word is with the architects, if I may be pardoned for saying so. The other day, my friend Elie Faure could state that, from an historical standpoint, in the time of stress the last word was with the architects. I think this is clear.

Thus, in this era of construction, it is architecture which concerns us most. It will not bring us the delight of an intimate nature such as easel-painting could bring us; but it will put us in the way of a new life in which the chief factor will be the sun, nature, the cultivation of the body, the cultivation of the mind—a kind of new selection intervening in the human race. A new life—just imagine it—a life of splendour and physical and intellectual beauty. Another field open in world-consciousness.

But what will become of painting and sculpture? It would seem that these two major arts should accompany architecture; there is room for them there. Let me describe what architecture really is in these modern

times: it does not consist only of our own works published in reviews; these are merely the expression of a *carte-forcée,* programmes of doubtful interest which, nevertheless, have allowed us to approach the study of man, his spiritual and physical needs. A new start from the very beginning—a sweeping away of ballast full of errors, deformities, academic sloth. What modern architects have accomplished hitherto is but trifling. It has been all the same a successful revolution.

If we attempt to visualize the great enterprises of modern times, we will find that certain aesthetic pursuits are out of date. Other tasks on a new plane are apparent. We are entering an epic cycle which makes its appeal to the spirit of art, of course, and for this reason, to intelligent artists; but of what transcending quality!

Certain painters and sculptors are speaking of it. In order that the significance which I attach to these considerations should not be misunderstood, I would mention that my best friends are among them, not by force of circumstances only, but because my ideas are fully in accord with theirs. Rather because I extend my ideas of architecture to the phenomena of general culture—to those who express the spirit of a period. And the higher arts are the revealers.

I know painters and sculptors well. I am not an iconoclast, as some would have it. I know the paintings and sculpture of the world because I have travelled everywhere in order to study them. I love them at heart and I live only by the comfort which they give me. This being so, I must confess that I speak here of a certain quality in pictorial and plastic art which alone has the right to intervene in the great architectural symphony of the new era.

In order to feed this emotion, will we evoke only the Gothic or the Egyptians? Should we not rejoice—all who are present here, that we have been able to participate in the terrific expansion of the most liberating movement in painting which has taken place for a long time— a movement in art which has re-united us with the great periods of thought and art across countries and ages—which brings unequalled possibilities for the future, at the very moment when painting and sculpture had lost all style and had sunk into bourgeois stagnation—a decadent art, nationalized by Ministries of Fine Arts and Academies.

I refer here to the cubist movement which, with its droll title, burst on us like a liberation. This deliverance was so powerful that I would see in it a great and spontaneous explosion taking place somewhere in the world when, all of a sudden, by some means and in some place, the safety-valve opens and the thing happens.

This revolutionary event was produced with clarity and with vision. It was the artists who started it, like a shell at the end of its trajectory. I do not think that, when a discussion has begun so high, we should let it descend to mean considerations or money interests or vanity. We must

realize what the advent of cubism meant, twenty years ago; the result, let it be understood, of the labour of our predecessors, perhaps the direct work of a few great seekers of the nineteenth century. A great historical event unquestionably.

It is suggested today that we should repudiate this event, renounce the greatness of this conquest! This art which is called abstract through a disquieting misunderstanding of its meaning (when a name has to be given to anything in art, idiotic terms are dug out—it is always enemies who give them), this art is concrete and not abstract. In France, this concrete quality could not escape the fate of the spirituality of the country, that is to say, a fundamental objectivity.

At the basis of international production is French art, which, abstract in name, is really concrete. It is essentially concrete. It contains realism. It proceeds in deep layers towards an organic equilibrium. The origin, the roots, the key is to be found in each of its elements. Perhaps the Nordic races—the Anglo-Saxons or the Germanic peoples—allowed themselves to indulge in abstractions. It is of little consequence, however; others will decide one day. We are now in a position to use this art. In what synthesis will it be possible? Here I will again make a confession. I am an architect, but I am just as much a painter—a painter by trade. I have two hearts, as in the song, two home-lands. As architect and painter, every day I find myself absorbed in this problem; can the plastic arts be accommodated harmoniously in the architecture of today with a sufficient understanding of present reality?

The question is important. It is a phenomenon profoundly organic. It is no longer a matter of combining painting and sculpture with architecture, as has been done quite happily sometimes at certain periods, principally in times of pomp and frivolity, from the Renaissance to our own day (you have a bad example in this hall—poor remnant of an art which is, moreover, full of ambiguity).

I believe that we are entering on a period infinitely more serious, when we shall no longer have the right to stick things on something, but when the pure, regenerating spirit of modern times will be expressed by organisms with a mathematical interior, comprising precise and inherent places where the work of art will be given its full value in exact accord with the potential forces in the architecture.

Let me—as an architect—affirm this: architecture is an event in itself. It can exist quite independently. It has no need either of sculpture or of painting. Architecture provides shelters. These shelters supply a human need, from the dwelling to the building erected for civic, intellectual or mystic purposes, etc.

It has been customary for the last twenty years to assert that our houses require art and artists. Some would like to see a dining-room decorated with a basket of fruit painted or carved on a beam. I think

that a good leg of mutton on the table would supply this want better. And here I stop short in the discussion. Give me your attention; do not let us bring the commercial system into this debate. The house requires lots of other things more urgently. I refer to the tradition handed down to us in prints or by other witnesses of the past; they show us life in the home at the time of the kings and of a luxury said to have been general. There was no decoration in the houses; people lived with a robust simplicity—proof of their moral wholesomeness. As to the luxury, it was often composed of very bad elements. The lapse of time and the patina alone have obscured things. After the revolution of '89, they wanted to create a bourgeois king; then a workman-king. Léger has spoken truly. It was not the fault of the artists; it is their education which was wrong.

I think that painting and sculpture will find a place in architecture, starting again at zero, organizing everything anew, from the skeleton to the flesh. Loving this skeleton—architecture, which has raised up a real symphony by means of light and the way in which this light illumines the walls, whose lyricism is composed of things intensely real, psycho-physiological—this architecture, the result of mathematics—and here mathematics are invoked as beauty and not as an imposition—this architecture, the hub of which is proportion, the human race is ready to accept, and to listen to carefully chosen discourses in places perfectly in harmony with them. We shall have the desire to call in the painter or the sculptor.

When we arrange matters so as to collaborate with the painter and the sculptor, we have no intention of asking only trifles of them. When we invite into our house a worthy, dignified and able guest, whom we respect, we do not make a noise near him; we listen, and he speaks amid silence because he has something to say. In the collaboration of the major arts and of architecture, dignity is not an empty claim.

The conclusion becomes clear. Such an art requires elevation of character and of temperament. Who is ready for this immediate task? Excuse me if I speak frankly. I will not hesitate to do so, for it is necessary. I fear this immense artistic production which is quite indifferent to the advent of contemporary architecture. I love walls beautifully proportioned and I dread to see them given over to minds unprepared. For, if a wall is spoilt, if it is soiled, if the clear, sane language of the architecture is ruined by the introduction of inappropriate painting or sculpture, if the artist is unable to enter into its spirit or goes against its spirit, it is like so many crimes of deceit.

There are two methods of applying painting. There is the purely utilitarian method; I was years before I discovered it. I have gradually observed that the great change in the modern technique of building has produced houses whose interior is surprisingly complex. This complexity of modern planning brings us into conflict with the classic square room

of the past. Sometimes, because of the biological necessities of the plan, wall-surfaces, curved or oblique partitions are necessary, even if contrary to our desire for plastic purity—intrusive presences in the architectural whole.

Léger has evoked the formidable dynamic power of colour. It is by means of polychromy that a thrill of excitement may be introduced into the house, a coloured epic, soft or violent. I have been engaged for a long time in defining the wonderful resources of colour; and taking advantage of the organic necessities of the modern plan, I saw that we could restrain confusion by colour, create lyrical spaces, bring out its order, increase its dimensions and make the spirit of architecture rejoice.

This is not yet painting. It is not necessary. It is architectural polychromy. I can, then, when a wall or a partition presses down on me, burst them open by means of an appropriate colour. But I can also, if the place is suitable, call in a painter and ask him to register here his plastic thoughts and at one blow open all the doors to the deep land of dreams—especially there, where there is no real depth.

Here, then, is an exceptionally favourable opportunity to collaborate with the painter. It is camouflage placed at the service of thought. With the same object in view, recourse may also be made to photography—photographic setting.

The second method of association with painting admits of a more preconceived intention. The architect can arrange his plans with the desire—at a given moment—of introducing the note of plastic lyricism. It is then a combination of deep harmony. But there is always the danger of the dualism of two plastic arts out of tune with one another: heterogeneous architecture and painting.

In the collaboration visualized here, mural painting and sculpture with the architecture, restraint is necessary, special qualities of monumentalism and careful preparation. In this—because the dinner plate is the architecture of modern times—I do not see that we can go back to anything in the past, neither to Rembrandt or Rubens, nor to the Quattrocento or the Gothic.

I said before that cubism had opened the gates to the universality of the great periods of art. We must see in this fact only encouragement to go forward. What they expressed was the strength of geometry, symbolism, anthropocentric powers, and their expression was pushed to the limits of clarity.

I have finished. I would close on this note: if we are misjudged now in our manifestations of renewal, if the contemporary arts, painting, sculpture and even architecture are only tolerated with a certain reserve, it is that we have never had the opportunity to create anything—I mean just as much a small house as a part of a town—or the surroundings have been unsuitable. We have always been pushed to one side

because the ground was occupied by vestiges of the past—good or bad. We are in the proportion of 1 percent modern spirit to 99 percent ancient environment. Nothing was elevated, everything was against harmony, and our part was always to appear like boors, our feet covered with mud or manure, appearing to state our views in an elegant and tranquil society. Our manners have, therefore, sometimes been insolent, in spite of ourselves. When harmony will have attained sufficient dimensions, the emotions of the people, of the masses, will be stirred. And, as Léger has said, in very welcome, very optimistic words, at that moment the people will not be wrong. They will say: "It is well."

It will not be necessary for them to know the paths which have led to this result; but they will feel the harmony, the power and the clarity which we have introduced.

When circumstances are at length favourable to the shaking off of depressing reversals, now in fashion; when people stop looking behind them and leaning on the Renaissance and the splendours of the past— many of which are doubtful—but instead go forward to construct something whole and entire, then we are certain to meet with unanimous approval.

"Agit-Prop Art: The Streets Were Their Theater" 1980

SZYMON BOJKO

After the Russian Revolution of October 1917, agit-prop art was a kind of street theater which became one important way in which the values of the new Bolshevik government were conveyed to the often illiterate populace. Szymon Bojko traces the varied roots of agit-prop in the European avant-garde, Russian folk culture, the Russian Orthodox Church, and in popular spectacles like firework displays. The diversity of styles and forms of agit-prop paralleled the diversity of its antecedents and of the social confusion of the moment.

Coming out of the economic and political upheavals of the years after 1917, agit-prop influenced theater and cinema in the Soviet Union and Germany, particularly the work of Brecht. The term itself, *agitation and propaganda,* was supposed to suggest that the role of art in a politically traumatic era must be to agitate the audience into immediate action.

Strategies similar to agit-prop have frequently appeared since, in mime theater or guerilla TV during the Viet Nam era in America, and in relatively sedate borrowings from Black street culture (graffiti, rap music, and so on) in the gallery world of the 1970s and 1980s. Agit-prop tends to originate with marginalized groups, under fire, on the threshhold of war or police action, particularly at moments of civil war, revolution, or foreign invasion. It has become a staple for the way that modernism creates a public art, as a performance, as a community, as a living newspaper, and as political activism.

* * *

The overthrow of the aristocracy in Russia, the revolutions of February and October 1917, a bloody civil war, foreign intervention and the

blockade it introduced; destruction and hunger on one hand, the toil and pathos of creating the foundations of a new system on the other—all this had drawn vast human masses into participating in politics. Throughout the immense territories of the former empire, the illiterate, bullied peasants were suddenly uprooted from their patriarchal existence, from a state of degradation, and thrown into a whirl of events whose mechanism was unfamiliar to them. The peasants were part of a gigantic theater in which life itself was often at stake. This theater never allowed for nuance, individualization, or psychological interpretation, encouraging instead a strict categorization. One either talked of the "reds" or of the "whites." Activities consciously intended to awaken emotional states in the masses, to encourage them to become involved, were based on contrasts and simplified truths. A specific kind of expression was born: inspired from without, it resulted from the hybridization of art, theater, proletarian poetry, folklore, music, dance, and films. It was called "agit-prop," and in fact it laid the foundation for popular and populist culture.

Time—pitiless as a rule to works originating from summary public commissions and from the centers of power—has been lenient to the art that brought relief during the Revolution. It did not deprive it of permanent artistic values or of humanism. History has ennobled the mass-meeting style of Maiakovsky's poetry, the agitational range of Vertov's film-truth, the tendentious impact of Meierkhold's and Tairov's staging, the agitational blatancy of the "Rosta windows" posters, as well as the many unrealized artistic ideas of the monumental propaganda plan.

By using art in an educational or didactic manner, for political reasons, the artists were not guilty of compromise; in fact, this may have been regarded as a virtue. The concurrence of art and revolution had formed a base for joint action. Lunacharsky, the People's Commissar for Education, had such an arrangement in mind when he wrote, "If the Revolution can give art its soul, then art can endow the Revolution with speech." But to create significant works of art within the framework of agit-prop was more complicated than Lunacharsky had suggested it would be on various occasions. Artists pursued their own aims, stemming from immanent laws of art and from its internal development. They did not always have to be identified with views held by politicians on what art of the new community should be. It is generally known how distrustful Lenin was of non-realist art, with what reluctance he tolerated Lunacharsky's sympathies for the innovators, and how soon the Bolsheviks limited the influence of the advocates of Futurism on cultural developments. Yet, after all, it was exactly these artistic groups that provided the ideas that ensured the popularity of agit-prop, thereby raising the prestige and attractiveness of the Revolution itself.

There were numerous sources for the evolution of the agit-prop. Many scholars in the West mistakenly give sole credit to the avant-garde

for creating mass art. The powerful language of the agit-prop—its syntax, articulation, and iconography—had many roots: historic and contemporary, traditional and innovative, secular and religious.

The Folk Source

The society was rural, deeply bound to the rhythm of work in nature, with peasant customs, legends, and a naive belief in the salvation of the world. Apart from a love for rich ornamentation, Russian folk art had a tendency to moralize. Functioning within a peasant community, it posed questions about the ethics of existence. It contained as much good nature, nostalgia, and melancholy as it did sheer vitality. Heroes of the *lubok*—people and animals drawn from life, from fables, and from history handed down from generation to generation—appeared as models for morality, with an element of burlesque laughter added. A sense of community and freedom, of robust and coarse laughter, stifled and covered with a layer of puritanism and officialdom, inhered very strongly in the cultural tradition. Buffooneries, carnival processions, jesters, and masqueraders were introduced during the reign of Peter I and continued to appear in folk interludes and carnival shows. The figure of Petrushka is proverbial; he was the chief persona in the puppet theater, a guide in the world of laughter who provided Stravinsky with a ballet theme.

An opinion persists concerning the lack of humor in the Revolutionary period, of an absence of the comic arts, based on a conviction that revolutionary asceticism dominated the world of politics and ideology in the 1920s. Such an opinion has not been shaken by the literary works of Babel, Zoshchenko, Ilf, and Petrov, nor by films such as the fairytale-like comedy directed by Lev Kuleshov in the style that parodied the American western *Mister West v strane bolshevikov (Mr. West in the Land of the Bolsheviks)*. Nor was humor to be found in cabarets, propaganda shows, living newspapers such as the *Siniaia bluza (Blue Blouse)*, and the intimate theaters where the eccentric talents of Eisenstein and Yutkevich reigned.

In the journal *Zhizn iskusstva (Life of Art)* of September 18, 1923, however, an article by its editor entitled "The Foxtrot—a New Kind of Pornography" stated: "The European bourgeosie has invented a new kind of pornography—in the form of a fashionable dance, the Foxtrot....This yellow epidemic of the European bourgeoisie has gradually dominated our theaters, just as it had previously conquered the restaurants. As long as the plague has not penetrated deeply into our theatrical life and struck root there, and so long as it has not yet contaminated our art, we should put a stop to it; that is, we should forbid the performance

of these disgusting dances. There is no place for them in the revolutionary republic."

Recently Maria Siniakova (a member of the Futurist circle and friend of Khlebnikov and Maiakovsky) and her sister Oksana (widow of the poet Aseyev) recalled the events of a New Year's Eve party in 1925–26.[1] The party was given in Maria's studio in the attic of a multistory building in Moscow. There was no elevator, the staircase was unlit, and the food and wines were very frugal. Yet the piano resounded with the syncopated rhythm of a foxtrot and everybody danced—the young and the old, artists, directors, poets, painters, musicians, and political figures—including Tyshler, Sterenberg, Roskin, Maiakovsky, Aseev, and Eisenstein and his cameramen. All the revolutionary young people of Moscow were seized by a rage for the foxtrot. It appealed to them: it was resiliently rhythmical, light, and gay. The women exposed their legs with their short skirts and bared their neck, arms, and backs; one could say it was Art Deco of a poor sort, full of coarse simplicity and resourcefulness. "Inside us," said Maria, "we had youth and joy. We lived on art. Those were times of hope and fantasy." This account by the painter, one of the few living artists of the epoch, provokes reflection. In apartments and studios of the intellectual and artistic elite of the Revolution, just as once in literary salons of the progressive Russian intelligentsia, standards were established and spiritual values were chosen. Those values maturing within the avant-garde would soon reach a mass audience through innumerable invisible channels. The intellectuals and artists set on a revolutionary course had decidedly rejected the cultural residue and the middle-class ideals of the old Russia; without hesitation they referred to the authentic cultural achievement of the rural population and of the proletariat.

The Sanctum

Christendom and the Russian Orthodox Church, liturgy, the heritage of theological thought, and the visual symbols of faith consolidated by generations—these presented inexhaustible strata of emotional behavior and models to be adapted by the avant-garde and its agit-prop. One cannot understand the tensions, obstinacies, and accumulation of class hatred—and at the same time the heroism—that were let loose among the masses without realizing the whole weight of mysticism and religious ecstasy contained in the Orthodox Church. The icon, for example, one of the most common images, related to every vital event in communal and private life. It embodied the beginning and the end of all temporary things. According to elaborate rules, the painter of an Old

Russian icon embodied ritual and carnal purity. Not surprisingly, the metaphysics of the icons fascinated generations of artists, including the avant-garde. Malevich mentions in his autobiography that it was due to this type of painting, which did not recognize linear perspective or illusory space, that he understood in his youth the emotional peasant art. He noticed clearly two lines in Russian art—one, the courtly, originating from ancient times, and the other, a peasant one, leading from the icons to decorated utilitarian objects. The interaction of the sanctum and of plebeian mythology, of the irrational and of peasant sobriety, was developed and transformed in later agitational activities, on posters, and in decorations for manifestations and marches. In visual agitation we often find figures readily transferred from icons, such as St. George on horseback meting out proletarian justice, with only a change of dress and accessories from the original. In verbal slogans we discover Gospel texts, adapted by the people as banal truths. Thus the phrase from the Epistle of St. Paul to the Thessalonians, "He who does not work, does not eat," plebeian and moral, was quoted anonymously in the First Constitution of the Russian Federation. Goncharova's fascination with the spiritual culture of the people, national and sovereign, independent of foreign influence, was combined with granting superiority to art that had sacred foundation. She maintained that "religious art and art glorifying the state were always the most perfect, largely because they sprang from tradition and not from theoretical premises." The attitude of the painter, who herself came from a rural family, reflected the state of mind of the educated community. A discovery of one's own geneaology in a naive, peasant viewpoint on the one hand, and an Eastern mysticism on the other, as an antidote to Western rationalism, led to a quaint mixture of notions, simultaneously progressive and conservative.

As one of the supports of the Old Russian culture, the Sanctum appeared in mass art in the form of popular myth bound to the partriarchal system of ethical norms. The plebeian soil of Orthodox religion was still so untainted by dead dogma, so alive and capable of regeneration, that it was impossible to reject. Mystical and religious thinking, which has for centuries formed the spiritual image of the nation, did not stop on the threshold of October 1917. Church banners, crosses, and portable icons were replaced with red flags, carried at first in a way reminiscent of a religious rite. Though the songs chanted during the marches had nothing in common with Orthodox church singing, the exalted fervor of the singers was similar. Though public manifestations established their own lay ritual, they still had for a long time an aura of the religious procession.

Yet the internal interlacing of the two worlds, based on custom and tradition, had another side—more manifest, aggressive, and blasphemous. Religious cult elements had penetrated mass cultural activities

with negative and caricatured intentions when, as a result of class division, the clergy took to the Counter-Revolutionary side of the barricade. The struggle against the clergy took a particularly drastic form, appealing to intolerance and an instinct for violence, insulting both the faithful and persons of a critical disposition. On the artistic level, however, the anticlerical agit-prop did not propose anything of value.

Prototypes of the Agit-Prop

Popular art immediately following the Revolution, transforming town space into symbolic space, drew its origin from historic sources, both national and foreign. The latter can be traced to the era of the French Revolution, which for the first time in modern Europe had associated art with the dynamics of assemblies, marches, and feasts. By 1918 a Russian translation appeared of an authoritative study by Julien Tiersault on songs and celebrations of the French Revolution. Large spectacles produced according to scenarios by French artists (some were even designed by David) appeared to contain the origins of later allegories and symbols. The example of Jacobin France helped to illustrate the principles of crowd participation in paratheatrical projects, as well as the ability to merge various media into one style in a spectacle.

Among the archetypes of Russian spectacles are eighteenth-century firework displays and celebrations of the three-hundredth anniversary of the rule of the Romanov dynasty. Pyrotechnics had reached a high level of artistry during the reign of Peter I, who had rightly judged its propagandistic and entertainment values. Firework displays and illuminations were integrated with presentations of allegorical programs and paintings of a political nature. Such scenes, recorded in numerous etchings, were invaluable material in designing similar mass activities in Petrograd on the anniversaries of the Revolution. On the other hand, references to the example of occasional decorations, made by order of the Court and overloaded with ornament, were made at first reservedly. As time went by, it was exactly this baroque and veristic style prone to theatrical pomp that ironically became a characteristic of the visual taste of the worker and peasant authority. Only the avant-garde, however, conscious as it was of the destructive possibility of art, was opposed from the very beginning to the baroque, classicist, and pompous tendencies threatening art and culture in general. Nor did it join the stream of demystification of the Sanctum. Two small antireligious books written and illustrated by Maiakovsky in 1923 could have been accepted by the believing rural reader, since they contained popular wisdom and plebeian humor, allowing for a fraternization of man and God. It was only from the avant-garde circles that warnings emanated against any

sanctification of revolutionary ceremony and abuse of the cult of a leader. When a newspaper ran an advertisement urging the sale of mass-produced busts of the deceased Lenin, the *Lef* magazine (No. 1, 1924), edited by Maiakovsky, reprinted the advertisement in full, giving it a title "Do Not Traffic in Lenin" and adding a commentary "We are against it" (this page was later removed from library collections in the Stalinist period).

Additional prototypes were furnished in publications established by workers' organizations which developed increasingly at the end of the nineteenth century in Germany, England, France, and the United States. This movement brought the nuclei of socialist iconography, allegories, and symbols of the revolutionary outlook to Russia. They were created by anonymous draftsmen and leftist artists: Steinlen, Grandjouan, Heine, and Biro, with Kollwitz, Grosz, Masereel, and Gropper following in the early twentieth century. The antibourgeois ideal of life was propagated by illustrated reviews such as *Simplicissimus, L'asiette au beurre,* and *Le petit sou.* In Russia, due to tsarist censorship, ideograms of the workers' movement came to light only in the wake of the 1905 revolution, although instances of political satire occurred earlier. In spite of their short lives, magazines (*Satirikon, Strely, Ahupel, Adskaia pochta,* etc.) became a platform for satirical drawings, preparing the ground for agit-prop. Satire taken from life, such as that found in the spoken word, in writing, drawing, or song, appeared as archetypes of political nomenclature, serving as the raw material for productions and activities of the agit-prop. As with any convention, this one also quickly lost its freshness. Yet before this happened, examples of class interpretation of events, attitudes, and behavior managed to stir emotions—to achieve an artistic synthesis of the changing world. This was accomplished by the imagination of artists, by their real concern for the fate of their country, and, what is most essential, by the possibility of expression in practically any visual style.

It is sufficient to compare typical agit-prop works of the period— posters by Maiakovsky, Moore, Lissitzky, and Lebedev, occasional decorations by Altman, Chagall, Malevich, Puni, and the Stenberg brothers, "radio announcers" (mechanical objects) by Klucis, and paintings on propaganda trains—with analogous works of visual propaganda of World War II in order to notice the stereotyped aesthetic uniformity of the latter. Opposing artistic trends—Realism, Cézannism, Colorism, Cubism, Futurism, Suprematism, and Constructivism—defined in their own language of form their relation to reality. "The revolution of substance—Socialism, Anarchism—is unthinkable without the revolution of form—Futurism," wrote Maiakovsky in "An Open Letter to Workers." In agit-prop art, plebeian, conservative, innovative, and moderate tendencies interacted. For that reason one can speak of a new faction of artists who did not consider themselves as the avant-garde and were not

included with the "left." Agit-art sought contact with the public in all areas. Making use of the traditional media, it approached new and more dynamic ways of intensifying visual-motive-and-audio sensations, anticipating many later media and methods. A simple enumeration of the most important forms in which art appeared gives an idea of its scope:

Banners; stenciled posters ("Rosta Windows"); prints—lithographed posters, postcards, cartoons, and press illustrations; paintings on moving objects—trains, steamers, trams, roundabouts; paintings on utensils—propaganda plates, fabric featuring ideograms of a new way of life; wall paintings—public buildings, exhibition pavilions; monumental sculpture—monuments, commemorative sites, necropolises; townscape decor—street and square decorations, masking of tsarist monuments, marches, festivals, and carnivals; occasional spatial constructions—speakers' tribunes, kiosks, commercial stalls, tram stops, propaganda stands; theatrical and paratheatrical spectacles—satirical stage shows, masque theaters, puppet shows for adults, "living newspapers," open-air spectacles; "film-truth"; music-massed industrial sounds—blasts of factory sirens, rhythmic machine noises. Not counting the documentary film, the popular art closest to contemporary understanding was probably the spectacular in which the boundaries between art and nonart, or audience and actors, professional or amateur, were blurred. While making room for audience participation, for the identification of one person with a group, the spectaculars were like the medieval mystery plays. They contained the nucleus of the open theater in its present-day sense, foreshadowed the programmed "son et lumière" spectacular, as well as continued the tradition of Russian folk shows (*balagan*) and attempted to theatricalize life itself—an idea of the reformers of the Russian theater.

Apart from Meierkhold and Tairov, these reformers included Nikolai Evreinov, forgotten by now, an enthusiast of the theater, a director, playwright, theoretician, writer, and the moving spirit of the spectacular *The Storming of the Winter Palace*. For Evreinov, man's whole life and the history of mankind made great theater. *Homo ludens* developed in play-theater or amusement-theater, and in folk rituals shaped several thousand years ago. "When I use the word *theater*," wrote Evreinov, "I imagine first of all a child, or a savage man, and everything that is inseparable from their insatiable hunger for transformation, from that which proves that they do not agree with the everyday world, alien to them, and out of which results the change of this world for another, creatively conceived and accepted by them of their own will."

It was after many years that Evreinov returned, in a published letter to a Polish writer, Anatol Stern, to his thesis on the theater of life. "Hasn't the world literally become a theater for war action, where mad directors tell tragic actors, sometimes playing their parts against their

will, to kill people?...After all, it was Marcus Aurelius who said of life that it was a play which one can leave before the end of the spectacle, but it is not easy. Why? Because man pays too much for the possibility of taking part in it."[2]

Notes

1. In conversation with the author, winter 1978.
2. Noted in Anatol Stern, *Legendy nashykh dnei* (Legends of Our Days), 1969.

Translated from the Polish by Andrzej Wojciechowski

"Film Directors, A Revolution" from *Lef*, 1923

DZIGA VERTOV

Russian filmmaker Dziga Vertov, writing in *Lef* (Left Front of the Arts, the foremost publication of the Russian avant-garde) argues that the cinema eye should not replicate the human eye. The cinema eye is a mechanical eye which can transcend space and time through the use of montage and editing. Visual juxtaposition documents the world in a fresh and vital manner, creating its own meaning and truth.

As one of the originators of modernist techniques in documentary film, Vertov's work and writing have influenced experimental cinema for generations. His influence appeared most strongly during the 1960s, in the cinema and television of Jean-Luc Godard and the circle of young French filmmakers who worked with him from 1968 to the early 1970s.

Vertov represented, of course, only one position among many in the Soviet film movements of the 1920s. The variety and disagreements among the various Russian masters of montage serve as a reminder that the term *modernism* could rarely fit under a single dictionary definition but rather always appeared in a range of very different voices. A few essential strategies were agreed upon, but even there, modern artists rarely agreed exclusively on how these strategies were to be applied, or on how they affected their audience. Among the Russian avant-garde, the use of fast-cut editing techniques under the generic label *montage* was supported; however, the use of character and fictional narrative were not. Vertov and Eisenstein, in particular, disagreed publicly on what constituted the proper format for montage. Vertov's emphasis on the "cinema-eye" was emphatically self-reflexive. He also doggedly avoided melodramatic characterization in his films. In this document, Vertov explained, once again, how ideology and film aesthetics were linked in his work.

* * *

Looking at the pictures that have come to us from the West and from America, and bearing in mind the information we have about the work and experiments abroad and at home, I arrive at this conclusion:—

The death sentence passed by film-directors in 1919 on every film without exception is effective to this very day.

The most thorough observation reveals not a single picture, not a single experiment directed, as they should be, towards the *emancipation of the film-camera,* which remains wretchedly enslaved, subordinated to the *imperfect,* undiscerning human eye.

We are not protesting at the *undermining* of literature and the theatre by the cinema, and we fully sympathise with the use of the cinema for all branches of science, but we define these functions of the cinema as side-lines diverging from the main line.

The basic and most important thing is:
CINEMA-PERCEPTION OF THE WORLD.

The starting-point is: *use of the film-camera as a cinema-eye, more perfect than the human eye for fathoming the chaos of those visual phenomena which evoke spatial dimension.*

The cinema-eye lives and moves in time and space, apprehends and fixes impressions in quite a different way from that of the human eye. The position of our bodies at the moment of observation, the number of features perceived by us in one or another visual phenomenon in one second of time is not at all binding on the film-camera, which, the more perfect it is, the more and the better will perceive things.

We cannot make our eyes better than they are already made, but we can perfect the film-camera without limit.

Up to today the film-cameraman has many a time suffered rebukes about a running horse which on the screen moved unnaturally slowly (rapid turning of the film-camera handle), or, conversely, about a tractor which ploughed a field too quickly (slow turning of the film-camera handle) and so on.

These are accidents, of course, but we are preparing a system, a contrived system of cases like these, a system of *apparent* irregularities which probe into and organise phenomena.

Up to today we *have coerced the film-camera and made it copy the work of our own eyes.* And the better the copying, the more highly was the shot considered.

From today we are liberating the camera and making it work in the opposite direction, furthest away from copying.

All the weaknesses of the human eye are external. We affirm the *cinema-eye, that gropes in the chaos of movements for a resultant force for its own movement, we affirm the cinema-eye with its dimension of time and space, growing in its own strength and its own resources to reach self-affirmation.*

...I force the spectator to see in the way most advantageous for me to show this or that visual phenomenon. The eye is subordinated to the will of the film-camera and directed by it onto those consecutive moments of action, which in the briefest and clearest way lead the cinema-phrase to the heights or depths of resolution.

For example: a shot of boxing, not from the point of view of a spectator present at the match, but a shot of the consecutive movements (methods) of the boxers. or: a shot of a group of dancers—but not from the viewpoint of a spectator sitting in a hall with a ballet on stage in front of him.

It is known that a spectator at a ballet watches haphazardly sometimes the general group of dancers, sometimes separate dancers at random, and sometimes somebody's feet:—*a series of incoherent impressions, different for each single spectator.*

We must not present the cinema audience with this. The system of consecutive movements demands shots of the dancers or boxers as an exposition of the tricks presented one after the other, with the *forced* transference of the spectator's eyes onto those successive details which must be seen.

The film-camera drags the eyes of the audience from hands to feet, from feet to eyes, and so on in the best order possible, and organises details into a regular montage-study.

You can be walking along the street in Chicago today, in 1923, but I can make you bow to the late comrade Volodarsky, who in 1918 is walking along a street in Petrograd, and he will return your bow.

Another example: the coffins of national heroes are lowered into their tombs (taken in Astrakhan in 1918), the tombs are filled in (Kronstadt, 1921), a gun salute (Petrograd, 1920) eternal remembrance, hats are removed (Moscow, 1922)—such things can be fitted together even from thankless material which was not specially filmed (see *Kino-Pravda* No 13). A further example of this is the montage of the greetings of the crowd and the montage of the salute of the vehicles for comrade Lenin (*Kino-Pravda* No 14), taken in different places, at different times.

The cinema-eye—the montaged 'I see!'

...I am the cinema-eye. I am a constructor.

I have set you down, you who have today been created by me, in a most amazing room, which did not exist up to this moment, also created by me.

In this room are 12 walls filmed by me in various parts of the world.

Putting together the shots of the walls and other details I was able to arrange them in an order which pleases you, and which will correctly construct by intervals the cinema-phrase, which is in fact a room...

I am the cinema-eye, I create a man more perfect than Adam was created, I create thousands of different people from various preliminary sketches and plans.

I am the cinema-eye.

I take from one person the strongest and deftest hands, from another I take the strongest and swiftest legs, from a third the most beautiful and expressive head and I create a new, perfect man in a montage....

...I am the cinema-eye. I am a mechanical eye.

I, a machine, can show you the world as only I can see it.

From today I liberate myself for ever from human immobility. *I am in perpetual motion,* I approach and move away from objects, I creep up to them, I climb onto them, I move alongside the muzzle of a running horse, I tear into the crowd at full speed, I run before the fleeing soldiers, I tip over onto my back, I ascend with aeroplanes, I fall and rise together with falling and rising bodies.

Here am I, the camera, rushing about guided by a resultant force, manoeuvring in the chaos of motions, fixing motion from motion in the most complex combinations.

Freed from the obligation of 16–17 frames a second, freed from the limits of time and space, *I can contrast any points in the universe,* wherever I might fix them.

My way leads to the creation of a fresh perception of the world. And this is how I can decipher anew a world unknown to you.

...Once again let us settle one thing: the eye and the ear.

The ear does not spy and the eye does not eavesdrop.

A division of functions:

The radio-ear—the montaged 'I hear!'

The cinema-eye—the montaged 'I see!'

This is for you, citizens, for a start, instead of music, painting, theatre, cinema and other castrated effusions.

Amid the chaos of motions rushing past, rushing away, rushing forward and colliding together—into life comes simply *the eye.*

The day of visual impressions has passed. How can a day's impressions be constructed into an effective whole in a visual study?

If everything that the eye saw were to be photographed onto a film there would naturally be confusion. If it were artistically assembled, what was photographed would be clearer. If the encumbering rubbish were thrown out, it would be still better. We shall obtain an organised manual of impressions of the *ordinary eye.*

The mechanical eye—the film-camera refusing to use the human eye as a crib, repelled and attracted by motions, gropes about in the chaos of visual events for the path of its own motion or oscillation, and experiments by stretching time, breaking up its motions, or, vice versa, absorbing time into itself, swallowing up the years, thereby schematizing prolonged processes which are inaccessible to the normal eye....

...To the aid of the machine-age comes the *cinéaste-pilot,* who not only controls the motions of the camera, but who *trusts* in it during spatial experimentation, and the *cinéaste-engineer,* who controls the cameras at a distance.

The result of this sort of combined action of the liberated and perfected camera, and of the strategic brain of man directing, observing and taking stock of things, is a noticeably fresher, and therefore interesting, presentation of even the most ordinary things....

...How many people are there thirsting for spectacular shows that wear out their trousers in the theatres?

They flee from the daily round, they flee from the prose of life. And yet the theatre is almost always just a wretched counterfeit of that very same life plus a stupid conglomeration of the affectations of ballet, musical squeaks, lighting effects, decorations (from the daubing-type to the constructive-type) and sometimes the excellent work of a literary master, perverted by all the rubbish. Certain masters of the theatres are destroying the theatres from the inside, breaking the old forms and declaring new slogans for work in the theatre; brought in to help this are bio-mechanics (a good exercise in itself), the cinema (glory and honour to it), writers (not bad in themselves), constructions (there are good ones), motor-cars (how can one not respect a motor-car?), and gun-fire (a dangerous and impressive trick in the front rows), but in general not a single feature stands out in it.

Theatre, and nothing more.

Not only not a synthesis, but not even a regular miscellany.

And it cannot be otherwise.

We, the film-makers, are determined opponents of premature synthesis ('to synthesis as the zenith of achievement!'), and realise it is pointless to mix up fragments of achievement: the poor infants immediately perish through overcrowding and disorder. And in general—

THE ARENA IS SMALL

Please let's get into life.

This is where we work—we, the masters of vision—organisers of visible life, armed with the ever-present cinema-eye.

This is where the masters of words and sounds work, the most skilful montage-makers of audible life. And I venture to slip in with them the ubiquitous mechanical ear and mouthpiece—the radio-telephone.

It means **THE NEWSREEL FILM**

and **THE RADIO NEWSREEL**.

I intend to stage a parade of film-makers in Red Square on the occasion of the *Futurists'* issuing of the first edition of the montaged radio-newsreel.

Not the "Pathé" newsreel-films or Gaumont (a newspaper-type "newsreel") and not even *"Kino-Pravda"* (a political "newsreel"), but a genuine cinema newsreel—*a swift review of VISUAL events deciphered by the film-camera, pieces of REAL energy* (I distinguish this from theatrical energy), *brought together at intervals to form an accumulatory whole by means of highly skilled montage.*

This structure for the cinema-thing allows any theme to be developed, whether comic, tragic, contrived or anything else.

The whole trick lies in this or that juxtapositioning of visual features, the whole trick lies in the intervals.

The unusual flexibility of the montage-construction permits any political, economic, or other motifs to be brought into the cinema-study. And that is why

FROM TODAY neither psychological nor detective dramas are needed in the cinema

FROM TODAY theatrical productions taken onto film are not needed

FROM TODAY neither Dostoyevsky nor Nat Pinkerton need be scripted

Everything can be included in the new concept of the newsreel film.

These two things now make a decisive entry into the muddle of life:

1. the *cinema-eye,* which disputes the visual presentation of the world by the human eye, and presents its 'I see!' and,
2. the *cinéaste-montageur,* who organises moments of life-construction now seen in *cinema-eye* fashion for the first time.

"Topography of Typography" 1923, "Typographical Facts" 1925, "Our Book" 1926

EL LISSITZKY

El Lissitzky emphasizes the relationship between optics, the visual form of printed information, and effective conceptual understanding. Active, articulated patterns of elementary letter forms on a letterpress can communicate new "thought patterns." Through an understanding of typography, the book becomes a widely disseminated work of art. El Lissitzky looks forward, however, to the day when communication will take place electronically, by "sound recordings or talking pictures."

El Lissitzky is often presented in university classes as a father of modern design. At the same time he is classified in art history classes as an important painter and theoretician of the Soviet avant-garde of the 1920s. Certainly in his work, problems of graphic design and studio art integrate very closely, as with many of the Soviet modern artists of the 1920s. El Lissitzky worked in oil painting, exhibition design, book design, museum display, and advertising, in what we might interpret as a very wide range of markets. As architect and artist—"constructor" as he called himself—El Lissitzky also lectured extensively in western Europe in the early 1920s, and worked on a variety of projects with modern artists there. He was involved in establishing practical applications for graphic abstraction and in defining codes for its use with a whimsy and an elegance that have been copied widely during the revival of interest in his work since the 1960s.

* * *

Topography of Typography* 1923

1. The words on the printed sheet are learnt by sight, not by hearing.
2. Ideas are communicated through conventional words, the idea should be given form through the letters.
3. Economy of expression—optics instead of phonetics.
4. The designing of the book-space through the material of the type, according to the laws of typographical mechanics, must correspond to the strains and stresses of the content.
5. The design of the book-space through the material of the illustrative process blocks, which give reality to the new optics. The supernaturalistic reality of the perfected eye.
6. The continuous page-sequence—the bioscopic book.
7. The new book demands the new writer. Inkstand and goose-quill are dead.
8. The printed sheet transcends space and time. The printed sheet, the infinity of the book, must be transcended.
 THE ELECTRO-LIBRARY.

Typographical Facts* 1926

ABCDEFGHIJKLMNOPQRSTUVWXYZInordertocommunicateyourth
oughtsinwritingyouhaveonlytoformcertaincombinationsfromthesesym
bolsandstringthemtogetherinanunbrokenchain.
but—NO.

YOU see here that the pattern of thought cannot be represented mechanically by making combinations of the twenty-six letters of the alphabet. Language is more than just an acoustic wave motion, and the mere means of thought transference. In the same way typography is more than just an optical wave motion for the same purpose. From the passive, nonarticulated lettering pattern one goes over to the active, articulated pattern. The gesture of the living language is taken into account.
E.g.: the Hammurabi tablets and modern election literature.

YOU have divided up the day into twenty-four hours. There is not another hour for extravagant effusion of feelings. The pattern of speech becomes increasingly concise, the gesture sharply imprinted. It is just the same with typography.
E.g.: Prospectuses, advertising brochures, and modern novels.

*From *Merz*, No. 4, Hanover, July 1923.

*From *Gutenberg-Festschrift,* Mainz, 1925.

YOU are accompanied from your first day onwards by printed paper, and your eye is superbly trained to find its way about in this specific field quickly, precisely, and without losing its way. You cast your glances into these forests of paper with the same confidence as the Australian throws his boomerang.
E.g.: the page of a large daily paper.

YOU ask for clear patterns for your eyes. Those can only be pieced together from plain elements. The elements of the letters are:

the horizontal	–
the perpendicular	I
the diagonal	/
the curve	C

These are the basic line-directions on the plain surface. Combinations occur in the horizontal and perpendicular directions. These two lines produce the right (unambiguous) angle. It can be placed in alignment with the edges of the surface, then it has a static effect (rest). It can be placed diagonally, then it has a dynamic effect (agitation). These are the axioms of typography.
E.g.: this page.

YOU are already overcoming the prejudice which regards only letter-press-printing (from type) as pure typography. Letterpress belongs to the past. The future belongs to photogravure printing and to all photo-mechanical processes. In this way the former fresco-painting is cut off from the new typography.
E.g.: advertisement pillars and poster-walls.

YOU have observed that in an organic pattern all the facets exhibit the same structural unity. Modern typography is improving its structural unity.
E.g.: The paper (art paper), the type (absence of flourishes), the ink (the new spectrum-clear products).

YOU can see how it is that where new areas are opened up to thought- and speech-patterns, there you find new typographical designs originating organically. These are: modern advertising and modern poetry.
E.g.: Some pages of American and European magazines and technical periodicals. The international publications of the dada movement.

YOU should demand of the writer that he really presents what he writes; his ideas reach you through the eye and not through the ear. Therefore typographical form should do by means of optics what the voice and gesture of the writer do to convey his ideas.

E.g.: As you have more faith in your grandparents' generation, let us consider this small example by Master Francis Rabelais, abstractor of the quintessence:

> *O, i?...am the great tamer of the Cimbri*
> *::;.ted through the air, because the dew annoyed him.*
> *he appeared, went putting clods in the troughs.*
> *!of fresh butter, which with great tubs;*
> *Gargantua, Book 1, Chapter 2.*

Our Book* 1926

Every invention in art is a single event in time, has no evolution. With the passage of time different variations of the same theme are composed around the invention, sometimes more sharpened, sometimes more flattened, but seldom is the original power attained. So it goes on till, after being performed over a long period, this work of art becomes so automatic-mechanical in its performance that the mind ceases to respond to the exhausted theme; then the time is ripe for a new invention. The so-called 'technical' aspect is, however, inseparable from the so-called 'artistic' aspect and therefore we do not wish to dismiss close associations lightly, with a few catchwords. In any case, Gutenberg, the inventor of the system of printing from movable type, printed a few books by this method which stand as the highest achievement in book art. Then there follow a few centuries which produced no fundamental inventions in our field (up to the invention of photography). What we find, more or less, in the art of printing are masterly variations accompanied by technical improvement in the production of the instruments. The same thing happened with a second invention in the visual field—with photography. The moment we stop riding complacently on our high horse, we have to admit that the first daguerreotypes are not primitive rough-and-ready things, but the highest achievements in the field of the photographic art. It is short-sighted to think that the machine alone, that is to say the supplanting of manual processes by mechanical ones, is fundamental to the changing of the appearance and form of things. In the first place it is the consumer who determines the change by his requirements; I refer to the stratum of society that furnishes the "commission." Today it is not a narrow circle, a thin upper layer, but "All", the masses. The idea which moves the masses to-day is called materialism, but what precisely characterizes the present time is dematerialization. An example: correspondence grows, the number of letters increases, the amount of paper written on and material used up swells, then the telephone call relieves the strain. Then comes further growth of the communications network

*Abridged from *Gutenberg-Jahrbuch*, Mainz, 1926–27.

and increase in the volume of communications; then radio eases the burden. The amount of material used is decreasing, we are dematerializing, cumbersome masses of material are being supplanted by released energies. That is the sign of our time. What kind of conclusions can we draw from these observations, with reference to our field of activity?

I put forward the following analogies:

INVENTIONS IN THE FIELD OF THOUGHT-COMMUNICATION	INVENTIONS IN THE FIELD OF GENERAL COMMUNICATION
Articulated speech	Upright walk
Writing	Wheel
Gutenberg's letterpress	Animal-drawn vehicle
?	Motor-car
?	Aeroplane

I submit these analogies in order to demonstrate that as long as the book is of necessity a hand-held object, that is to say not yet supplanted by sound recordings or talking pictures, we must wait from day to day for new fundamental inventions in the field of book-production, so that here also we may reach the standard of the time.

Present indications are that this basic invention can be expected from the neighbouring field of collotype. This process involves a machine which transfers the composed type-matter onto a film, and a printing-machine which copies the negative onto sensitive paper. Thus the enormous weight of type and the bucket of ink disappear, and so here again we also have dematerialization. The most important aspect is that the production style for word and illustration is subject to one and the same process—to the collotype, to photography. Up to the present there has been no kind of representation as completely comprehensible to all people as photography. So we are faced with a book-form in which representation is primary and the alphabet secondary.

We know two kinds of writing: a symbol for each idea = hieroglyph (in China today) and a symbol for each sound = letter. The progress of the letter in relation to the hieroglyph is relative. The hieroglyph is international: that is to say, if a Russian, a German, or an American impresses the symbols (pictures) of the ideas on his memory, he can read Chinese or Egyptian (silently), without acquiring a knowledge of the language, for language and writing are each a pattern in itself. This is an advantage which the letter-book has lost. So I believe that the next book-form will be plastic-representational. We can say that

1. the hieroglyph-book is international (at least in its potentiality),
2. the letter-book is national, and

3. the coming book will be anational: for in order to understand it, one must at least learn.

Today we have two dimensions for the word. As a sound it is a function of time, and as a representation it is a function of space. The coming book must be both. In this way the automatism of the present-day book will be overcome; for a view of life which has come about automatically is no longer conceivable to our minds and we are left suffocating in a vacuum. The energetic task which art must accomplish is to transmute the emptiness into space, that is into something which our minds can grasp as an organized unity.

With changes in the language, in construction and style, the visual aspect of the book changes also. Before the war, European printed matter looked much the same in all countries. In America there was a new optimistic mentality, concerned with the day in hand, focused on immediate impressions, and this began to create a new form of printed matter. It was there that they first started to shift the emphasis and make the word be the illustration of the picture, instead of the other way round, as in Europe. Moreover, the highly developed technique of the process block made a particular contribution; and so photomontage was invented.

Postwar Europe, sceptical and bewildered, is cultivating a shrieking, bellowing language; one must hold one's own and keep up with everything. Words like "attraction" and "trick" are becoming the catchwords of the time. The appearance of the book is characterized by: (1) fragmented type panel, (2) photomontage and typomontage.

All these facts are like an aeroplane. Before the war and our revolution it was carrying us along the runway to the take-off point. We are now becoming airborne and our faith for the future is in the aeroplane—that is to say in these facts.

The idea of the "simultaneous" book also originated in the prewar era and was realized after a fashion. I refer to a poem by Blaise Cendrars, typographically designed by Sonia Delaunay-Terk, which is on a folding strip of paper, 1.50 metres in length; so it was an experiment with a new book-form for poetry. The lines of the poem are printed in colours, according to content, so that they go over from one colour to another following the changes in meaning.

In England during the war, the Vortex Group published its work BLAST, large and elementary in presentation, set almost exclusively in block letters; today this has become the feature of all modern international printed matter. In Germany, the prospectus for the small Grosz portfolio *Neue Jugend,* produced in 1917, is an important document of the new typography.

With us in Russia the new movement began in 1908, and from its very first day linked painters and poets closely together; practically no book of poetry appeared which had not had the collaboration of a painter. The poems were written and illustrated with the lithographic crayon, or engraved in wood. The poets themselves typeset whole pages. Among those who worked in this way were the poets Khlebnikov, Kruchenykh, Mayakovsky, Asseyev, together with the painters Rozanova, Goncharova, Malevich, Popova, Burlyuk etc. These were not numbered, de luxe copies, they were cheap, unbound, paperbacked books, which we must consider today, in spite of their urbanity, as popular art.

During the period of the Revolution a latent energy accumulated in our young generation of artists, which merely awaited the great mandate from the people for it to be released and deployed. It is the great masses, the semi-literate masses, who have become the audience. The Revolution in our country accomplished an enormous educational and propagandistic task. The traditional book was torn into separate pages, enlarged a hundred-fold, coloured for greater intensity, and brought into the street as a poster. By contrast with the American poster, created for people who will catch a momentary glimpse whilst speeding past in their automobiles, ours was meant for people who would stand quite close and read it over and make sense out of it. If today a number of posters were to be reproduced in the size of a manageable book, then arranged according to theme and bound, the result could be the most original book. Because of the need for speed and the great lack of possibilities for printing, the best work was mostly done by hand; it was standardized, concise in its text, and most suited to the simplest mechanical method of duplication. State laws were printed in the same way as folding picture-books, army orders in the same way as paperbacked brochures.

At the end of the Civil War (1920) we were given the opportunity, using primitive mechanical means, of personally realizing our aims in the field of new book-design. In Vitebsk we produced a work entitled *Unovis* in five copies, using typewriter, lithography, etching and linocuts. I wrote in it: 'Gutenberg's Bible was printed with letters only; but the Bible of our time cannot be just presented in letters alone. The book finds its channel to the brain through the eye, not through the ear; in this channel the waves rush through with much greater speed and pressure than in the acoustic channel. One can speak out only through the mouth, but the book's facilities for expression take many more forms.'

With the start of the reconstruction period about 1922, book-production also increases rapidly. Our best artists take up the problem of book design. At the beginning of 1922 we publish, with the poet Ilya

Ehrenburg, the periodical *Veshch* ("Object"), which is printed in Berlin. Thanks to the high standard of German technology we succeed in realizing some of our book ideas. So the picture-book "Of Two Squares" which was completed in our creative period of 1920, is also printed, and also the Mayakovsky-book, where the book-form itself is given a functional shape in keeping with its specific purpose. In the same period our artists obtain the technical facilities for printing. The State Publishing House and other printing-establishments publish books, which have since been seen and appreciated at several international exhibitions in Europe. Comrades Popova, Rodchenko, Klutsis, Syenkin, Stepanova and Gan devote themselves to the book. Some of them work in the printing-works itself, along with the compositor and the machine (Gan and several others). The degree of respect for the actual art of printing which is acquired by doing this is shown by the fact that all the names of the compositors and feeders of any particular book are listed in it, on a special page. Thus in the printing-works there comes to be a select number of workers who cultivate a very conscious relationship with their art.

Most artists make montages, that is to say, with photographs and the inscriptions belonging to them they piece together whole pages, which are then photographically reproduced for printing. In this way there develops a technique of simple effectiveness, which appears to be very easy to operate and for that reason can easily develop into dull routine, but which in powerful hands turns out to be the most successful method of achieving visual poetry.

At the very beginning we said that the expressive power of every invention in art is an isolated phenomenon and has no evolution. The invention of easel-pictures produced great works of art, but their effectiveness has been lost. The cinema and the illustrated weekly magazine have triumphed. We rejoice at the new media which technology has placed at our disposal. We know that being in close contact with worldwide events and keeping pace with the progress of social development, that with the perpetual sharpening of our optic nerve, with the mastery of plastic material, with construction of the plane and its space, with the force which keeps inventiveness at boiling-point, with all these new assets, we know that finally we shall give a new effectiveness to the book as a work of art.

Yet, in this present day and age we still have no new shape for the book as a body; it continues to be a cover with a jacket, and a spine, and pages 1, 2, 3...We still have the same thing in the theatre also. Up to now in our country, even the newest theatrical productions have been performed in the picture-frame style of theatre, with the public accommodated in the stalls, in boxes, in the circles, all in front of the curtain. The stage, however, has been cleared of the painted scenery; the painted-

in-perspective stage area has become extinct. In the same picture-frame a three-dimensional physical space has been born, for the maximum development of the fourth dimension, living movement. This new-born theatre explodes the old theatre-building. Perhaps the new work in the inside of the book is not yet at the stage of exploding the traditional book-form, but we should have learnt by now to recognize the tendency.

Notwithstanding the crises which book-production is suffering, in common with other areas of production, the book-glacier is growing year by year. The book is becoming the most monumental work of art: no longer is it something caressed only by the delicate hands of a few bibliophiles; on the contrary, it is already being grasped by hundreds of thousands of poor people. This also explains the dominance, in our transition period, of the illustrated weekly magazine. Moreover, in our country a stream of childrens' picture-books has appeared, to swell the inundation of illustrated periodicals. By reading, our children are already acquiring a new plastic language; they are growing up with a different relationship to the world and to space, to shape and to colour; they will surely also create another book. We, however, are satisfied if in our book the lyric and epic evolution of our times is given shape.

"Rules About Typography" 1924

KURT SCHWITTERS

Kurt Schwitters examines typographic values which express the "pushing and pulling forces" of the text. Typography, like other artistic media, can either hinder or facilitate communication, depending on the artist's understanding of its principles.

As a pioneer of collage techniques, including the application of collage to installation environments and to poetry, Schwitters remains a unique figure in modern art after the First World War. He was both an internationalist and a "one-man band." He worked in advertising as typographical consultant for the city of Hanover while he remained committed to his alliances with the avant-garde.

The subject of this article may seem marginal within the "heroic" context of modern art but, in fact, typography was central to modern art theory in the 1920s in ways similar, while also considerably different, to the use of printed text by postmodernists. Print was the primary code for entertainment and promotion in that culture; it was both abstract and functionalist, manipulative and omnipotent. The intersection of text with cinema in silent movies may seem to us today the beginning of the end of print dominance, but that comes with our 20/20 hindsight and was not then clearly appreciated in that way.

* * *

Kurt Schwitters
Rules about Typography (1924)[1]

On typography, uncountable rules are written. The most important one is: don't ever do it the way somebody has already done it. Or, one can

298

also say: make it a rule to make it always different than others have done it. For the beginning, some general rules on Typography:

1. Typography may be art.
2. Fundamentally there is no parallel between the content of the text and its typographic form.
3. Configuration is the essence of all art; the typographic configuration is not the illustration of the contents of the text.
4. The typographic configuration is the expression of the pushing and pulling forces (tensions) of the contents of the text. (Lissitzky)
5. Also, the negative parts of the text—that is to say—the negative spaces of the printed page are typographical positive values. Any part of the material is a typographic value, i.e., letter, word, part of the word, number, punctuation, line, trademark, illustration, space between, and the entire space.
6. From the standpoint of artistic typography, it is the interrelationship of typographic values that counts, whereas the quality of the type style and the typographic value (by itself) is not important.
7. From the standpoint of type itself, the type quality is of crucial importance.
8. Type quality means: simplicity and beauty. The simplicity includes clarity, lack of ambiguity, and appropriate configuration, renunciation of all superfluous decoration, and of all additional forms that are superfluous in context with the essence of the type. Beauty means a good balance between the various relationships. The type you reproduce is clearer and therefore better than the drawn one (hand-drawn).
9. Advertisements or posters put together from existing print are as a rule simpler and therefore better than a handmade (drawn poster). Also, impersonal type (printing type) is better than the individual printing of an artist.
10. The demand of the contents versus typography is such that the purpose for which the content is printed should be stressed.

Notes

1. Reprinted from (journal) *MERZ*, Typoreklame issue, 1924, Hannover, Germany p. 91.

"Inspiration to Order" 1932

MAX ERNST

Max Ernst describes Surrealist practice in ways similar to contemporary advertising: the bringing together of two unrelated objects or events in an incongruous situation. Ernst's own Surrealist invention, *frottage,* defamiliarizes everyday appearances by producing what he calls a *similacrum* of familiar objects. (The term *similacrum* reappeared in the early 1980s as an important concept in postmodern criticism, especially through the writing of Jean Baudrillard).

The contrast between Surrealism in the fine arts and popular surrealism continues. The adjective *surreal* has entered popular journalism, standing in for "dreamy" settings. Surrealist artists, however, were not nearly as singular in their interest in dream moods as one might expect. Breton was an admirer of Freud, but not all the Surrealists followed as avidly. The use of, and belief in, automatist techniques varied from one Surrealist to the next, even from one generation to the next, as one might expect of any career in the arts.

Popular surrealism also has roots that antedate the Surrealist movement itself, coming out of circus imagery, poster art, cinema, penny arcades, and advertising. The nineteenth-century sources for Surrealism, so carefully annotated by Breton, also suggest mass cultural prototypes; for example, from wax museums to popular ghost stories, vampire melodramas and operas, musical hall magic and puppet shows. Thus, Surrealism can be studied as the aesthetics of the fantastical in daily life, including mass culture, and of the disjunctions commonly experienced in modern life. Surrealist imagery resembles the experience of consumer reverie, of shopping, of the invasion of private life by advertising and electronic media, of the hyper-real look of consumer fantasy spaces, even of theme parks. It belongs as much to the aesthetics of postmodernism as to modernism, in many respects; and indeed the

Parisian Surrealists, even those as committed to high literary imagery as Ernst was, remained very much aware of the pluralist element of mass culture in their work.

<p style="text-align:center">* * *</p>

Since the becoming of no work which can be called absolutely surrealist is to be directed consciously by the mind (whether through reason, taste, or the will), the active share of him hitherto described as the work's "author" is suddenly abolished almost completely. This "author" is disclosed as being a mere spectator of the birth of the work, for, either indifferently or in the greatest excitement, he merely watches it undergo the successive phases of its development. Just as the poet has to write down what is being thought—voiced—inside him, so the painter has to limn and give objective form to *what is visible inside him.*

Upon the publication of André Breton's *Manifesto of Surrealism,* sceptics and humorists alike asserted that to produce works in this way could only be within the power of mediums, visionaries, and in general those endowed with second sight. "Everybody now knows that there is no *surrealist painting.* Neither the pencil lines drawn by chance movements, nor the pictures reproducing dream images, nor imaginative fancies, can of course be so described." It was in this strain that in number three of *La Révolution Surréaliste* (April 1925) one of the editors, M. Pierre Naville, sought to discourage us. Yet at the very time he was thus prophesying, the "unconscious" had, as one could easily establish, already made a dramatic appearance in the practical realm of painted and drawn poetry.

Thanks to studying enthusiastically the mechanism of inspiration, the surrealists have succeeded in discovering certain essentially poetic processes whereby the plastic work's elaboration can be freed from the sway of the so-called conscious faculties. Amounting to a bewitching of either reason, taste, or the will, these processes result in the surrealist definition being rigorously applied to drawing, painting, and even to some extent photography; and although some of them—*collage,** for instance—were being used before our advent, surrealism has so systematized and modified them that it is now possible to photograph either on paper or on canvas the amazing graphic appearances of thoughts and desires.

Being called upon to give here some idea of the first process to reveal itself to us and to put us on the track of others, I am inclined to say that it amounts to the exploiting of *the fortuitous encounter upon a*

*The cutting-up of various flat reproductions of objects or of parts of objects and the pasting of them together to form a picture of something new and odd.

nonsuitable plane of two mutually distant realities (this being a para-
phrase and generalization of the celebrated Lautréamont quotation,
"Beautiful as the chance meeting upon a dissecting table of a sewing-
machine with an umbrella") or, to use a more handy expression, the
cultivation of the effects of a *systematic putting out of place,* on the lines
of André Breton's theory which he expounds as follows:

> Super-reality must in any case be a function of our will to put everything
> completely out of place (and of course (*a*) one may go so far as to put a hand
> out of place by isolating it from an arm, (*b*) the hand gains thereby *qua* hand,
> and (*c*) in speaking of putting out of place we are not referring merely to the
> possibility of action in space).[1]

The way in which this process is most commonly carried out has led to
its being currently described as *collage.*

Thanks to using, modifying and incidentally systematizing this
process, nearly all the surrealists, painters as well as poets, have since
its discovery been led from surprise to surprise. Among the finest results
they have been fortunate enough to obtain, one must mention the
creation of what they have called *surrealist objects.*

Let a ready-made reality with a naïve purpose apparently settled
once for all (i.e. an umbrella) be suddenly juxtaposed to another very
distant and no less ridiculous reality (i.e. a sewing-machine) in a place
where both must be felt as *out of place* (i.e. upon a dissecting table), and
precisely thereby it will be robbed of its naïve purpose and its identity;
through a relativity it will pass from its false to a novel absoluteness,
at once true and poetic: umbrella and sewing-machine will make love.
This very simple example seems to me to reveal the mechanism of the
process. Complete transmutation followed by a pure act such as the act
of love must necessarily occur every time the given facts make conditions
favourable: *the pairing of two realities which apparently cannot be
paired on a plane apparently not suited to them.* Speaking in 1921 of the
collage process, Breton wrote:

> It is the wonderful power to grasp two mutually distant realities without
> going beyond the field of our experience and to draw a spark from their
> juxtaposition; to bring within reach of our senses abstract forms capable
> of the same intensity and distinctness as others; and, while depriving us
> of any system of reference, to put us out of place in our very recollection—
> this is what, at the moment, he is concerned with.[2]

And he added prophetically: "May it not be that we are thus getting
ready to break loose some day from the law of identity?"

An analogous mechanism to that of *collage* can be detected by the
reader in the imposing image contained in the following proposal by Dali
for a *surrealist object:*

Let some huge motor-cars, three times as big as actual ones, be made in plaster or onyx with a thoroughness of detail greater than the most faithful moulds, let them be wrapped in women's underwear and buried in a graveyard, the spot being indicated merely by a thin yellow-coloured clock.[3]

In the hope of increasing the fortuitous character of elements utilizable in the composing of a drawing and so increasing their abruptness of association, surrealists have resorted to the process called "The Exquisite Corpse." The large share chance has in this is limited only by the role played for the first time by mental contagion. On the strength of the results obtained (see the reproductions in *La Révolution surréaliste,* Nos. 9 and 10, and in *Variétés* for June 1929), we may consider that this process is particularly well suited for producing strong and pure surrealist images in accordance with the criteria laid down by Breton as follows:

That, to my mind, [the surrealist image] is strong in proportion to the degree of arbitrariness it displays, I do not conceal; I mean the image which it takes longest to describe in concrete words, either because it secretes an enormous amount of apparent contradiction, or because one of its terms is strangely lacking, or because while promising to be sensational it appears to unravel weakly (or closes the angle of its pair of compasses suddenly), or because it affords of itself only a ridiculous *formal* justification, or because it is of the hallucinatory kind, or because with the concrete it quite naturally only masks the abstract, or because inversely it would imply the negation of some elementary physical property, or because it is funny.[4]

In the days when we were most keen on research and most excited by our first discoveries in the realm of *collage,* we would come by chance, or as it seemed by chance, on (for example) the pages of a catalogue containing plates for anatomical or physical demonstration and found that these provided contiguously figurative elements so mutually distant that the very absurdity of their collection produced in us a hallucinating succession of contradictory images, super-imposed one upon another with the persistence and rapidity proper to amorous recollections. These images themselves brought forth a new plane in order to meet in a new unknown (the plane of non-suitability). Thereupon it was enough either by painting or by drawing to add, and thereby only obediently reproducing *what is visible within us,* a color, a scrawl, a landscape foreign to the objects depicted, the desert, the sky, a geological section, a floor, a single straight line expressing the horizon, and a fixed and faithful image was obtained; what previously had been merely a commonplace page of advertising became a drama revealing our most secret desires. To take another example, a Second Empire embellish-

ment we had found in a manual of drawing came to display as we considered it a strong propensity to change into a chimera, which had about it something of bird and octopus and man and woman. Here we are seemingly already in touch with what Dali was later to call "the paranoiac image" or "multiple image." His words are as follows:

> The way in which it has been possible to obtain a double image is clearly paranoiac. By a double image is meant such a representation of an object that it is also, without the slightest physical or anatomical change, the representation of another entirely different object, the second representation being equally devoid of any deformity or abnormality betraying arrangement.
>
> Such a double image is obtained in virtue of the violence of the paranoiac thought which has cunningly and skilfully used the requisite quantity of pretexts, coincidences, etc., and so taken advantage of them as to exhibit the second image, which then replaces the dominant idea.
>
> The double image (an example of which is the image of a horse which is at the same time the image of a woman) may be extended, continuing the paranoiac advance, and then the presence of another dominant idea is enough to make a third image appear (for example, the image of a lion), and so on, until there is a number of images limited only by the mind's degree of paranoiac capacity.[5]

May it not be that in this way we have already broken loose from the law of identity?

It remains to speak of another process in resorting to which I have been brought under the direct influence of the information concerning the mechanism of inspiration that is provided in the *Manifesto of Surrealism.* This process rests on nothing other than the *intensification of the mind's powers of irritability,* and in view of its technical features I have dubbed it *frottage* (rubbing), and it has had in my own personal development an even larger share than *collage,* from which indeed I do not believe it differs *fundamentally.*

Being one rainy day in an inn at the seaside, I found myself recalling how in childhood an imitation mahogany panel opposite my bed had served as optical excitant of a somnolence vision, and I was struck by the obsession now being imposed on my irritated gaze by the floor, the cracks of which had been deepened by countless scrubbings. I thereupon decided to examine the symbolism of this obsession and, to assist my meditative and hallucinatory powers, I obtained from the floor-boards a series of drawings by dropping upon them anyhow pieces of paper I then rubbed with blacklead. I emphasize the fact that the drawings thus obtained steadily lose, thanks to a series of suggestions and transmutations occurring to one spontaneously—similarly to what takes place in the production of hypnagogical visions—the character of

the material being studied—wood—and assume the aspect of unbeliev-
ably clear images of a nature probably able to reveal the first cause of
the obsession or to produce a simulacrum thereof. My curiosity being
thus aroused and marvelling, I was led to examine in the same way, but
indiscriminately, many kinds of material happening to be in my field of
vision—leaves and their veins, the unravelled edges of sackcloth, the
palette-knife markings on a "modern" picture, thread unrolled from its
spool, etc., I have put together under the title of *Natural History* the
first fruits of the *frottage* process from *Sea and Rain* to *Eve, the Only
One Remaining to Us*. Later on, it was thanks to restricting my own
active participation ever more and more, so as thereby to increase the
active share of the powers of the mind, that I succeeded in looking on
like a spectator at the birth of pictures such as: *Women Shouting as They
Ford a River, Vision Provoked by the Words: "The Immovable Father,"
Man Walking on the Water, Taking a Girl by the Hand and Shoving Past
Another; Vision Provoked by a Sheet of Blotting-Paper*, etc.

At first it seemed as if the *frottage* process could be used only for
drawing. If one takes into consideration that it has since been success-
fully adapted to the technical media of painting (scratching of pigments
on a ground prepared in colors and placed over an uneven surface, etc.)
without the slightest liberty being taken with the principle of the inten-
sification of the mind's powers of irritability, I think I am entitled to say
without exaggeration that surrealism has enabled painting to travel
with seven-league boots a long way from Renoir's three apples, Manet's
four sticks of asparagus, Derain's little chocolate women, and the
Cubists' tobacco-packet, and to open up for it a field of *vision* limited
only by the *irritability capacity of the mind's powers*. Needless to say,
this has been a great blow to art critics, who are terrified to see the
importance of the "author" being reduced to a minimum and the concep-
tion of "talent" abolished. Against them, however, we maintain that
surrealist painting is within the reach of everybody who is attracted by
real revelations and is therefore ready to assist inspiration or make it
work to order.

We do not doubt that in yielding quite naturally to the vocation of
pushing back appearances and upsetting the relations of "realities," it
is helping, with a smile on its lips, to hasten the general crisis of
consciousness due in our time.

Notes

1. André Breton, Foreward to Max Ernst, *The Hundred Headed Woman* Editions du
 Carrefour Paris, 1929; English translation by Dorothea Tanning, New York. George
 Braziller, 1981.

2. Catalogue of exhibition held May 3– June 3, 1921, at Sans Pareil (gallery) Paris entitled "Exposition Dada: Max Ernst."

3. (journal) *Le Surréalisme au Service de la Revolution* (Paris) No. 3, 1931 (André Breton, editor)

4. André Breton, *Manifesto of Surrealism: Soluble Fish* Paris: Simon Kra, 1924.

5. (journal) *Le Surréalisime au Service de la Revolution* (Paris) No. 1, 1930 (Andre Breton, editor)

"New Thoughts on the Plastic Arts in Mexico" 1933

DAVID SIQUEIROS

While rejecting what he calls "snob art," Mexican muralist and painter David Siqueiros attacks "picturesque" art as well as "Mexican Curious" popular art, which caters only to the tourist trade. While acknowledging the need to be "modern and international," he supports art which is both "physical and metaphysical," like native Indian sculpture. Artists should express the desires of the proletarian masses, but at the same time produce good art as judged by an educated minority.

Siqueiros (1896–1974) was a veteran of the Mexican Revolution, where he served under Carranza. He was a staff officer by the age of seventeen, then a military attaché in Paris at twenty-one, with a checkered political career afterward, from political imprisonment to exile to service in the Spanish Civil War. His commitment to an art that expressed these political experiences ran into many contradictions, particularly the colonialist implications of primitivisms in modern art. These problems still continue, in varying degrees, as the links between folk craft and fine art remain ill defined, even awkward, for museums, journals, and artists alike.

* * *

(1) Painting and sculpture are professional crafts for mature people

For the last ten years it has been said that painting and sculpting are crafts. This was the opinion of the Syndicate of Painters and Sculptors. Other people feel that they are professions, like any other profession; this is the opinion of the older Mexican painters. I maintain that painting and sculpture are professional crafts and I use both these terms in their commonly accepted sense.

They are crafts because the work is done with the hands and is subject to the material laws of experience.

They are professions because they require objective scientific knowledge.

Of course all this refers to externals and not to the subjective emotional factor which produces the creative impulse that makes use of the material means available; this is a completely personal, congenital factor.

It could be said that if experience is the fruit of practice and artistic know-how is only acquired by methodical application, then a work of art can only be produced after many long years of hard work, when the painter or sculptor attains his creative maturity after sufficient practice in making use of the means of expression. Before this, his work will have been the work of a beginner, showing an incomplete, heterogeneous personality and will therefore be inferior as a work of art, no matter how great the artist's talent.

(2) Spontaneous, intuitive works of art produced by children, youth and dilettantes are only of relative value and this must be made clear in order to put an end, once and for all, to the dangerous fetishism which has grown up about them

The painting and sculpture of children, youth and dilettantes is of great interest as an expression of the primary, aesthetic values of a given social, geographical or racial moment; but that is all. It may be of some value to the professional painter as a source of aesthetic elements worthy of further development, but it can never be considered representative of a period or of a nation. To believe otherwise is a transitory kind of *snobbishness.*

(3) The professional craft of painting and sculpture can only be taught through apprenticeship to a master

A painter or sculptor who does not produce any work cannot teach. Painting and sculpture cannot be taught theoretically, no matter how good an artist the teacher is. For the last century, the Academy has applied a fatally bad method in attempting to teach art pedagogically in preference to the age-old method of practical apprenticeship in the private studio of a master.

We must return to this system, and without any mystification. All Diego Rivera really did was to change the name of the old Academy of San Carlos, when he renamed it the School of Plastic Arts. The pedagogical system continued as before, and in fact continues to exist in the School, and a pedagogical system of teaching art is the equivalent of an

Academy. The pupils are taught to manufacture their colours and prepare their canvases; but this cannot be taught in the abstract because it is intimately connected with the technique of the master who each apprentice chooses. The quality and nature of the colours and the canvases, etc., are of the utmost important in the generation of a work of art. There is as much variety of materials and techniques as there is of aesthetic styles. It is a great mistake to suppose that the materials and techniques of art can be chosen according to an invariable recipe.

But how could we put this system of teaching art into practice? How can we put an end to the mystification which exists in the so-called School of Plastic Arts and Related Subjects?

The School of Plastic Arts should be turned into a museum. The department of the Ministry of Public Education which is in charge of drawing should disappear. The "open air schools" have no reason to continue. Artistic drawing should no longer be taught in either primary or secondary schools. The School of Plastic Arts is not only useless to its students, but it is also deadly to those artists who teach there. Magnificent painters turn into magnificent bureaucrats. There is nothing worse for the success of the plastic arts in Mexico than to reward its great painters and sculptors by giving them teaching posts, which is a death sentence to their art. The painter or sculptor who becomes a teacher has to spend two or three hours a day teaching and another eight hours a day fiercely defending the bureaucratic post he occupies. An artist thrown the "bone" of a teaching post becomes an ineffectual teacher and a full time defender of the bone.

Therefore we must put an end to this situation. The two and a half million pesos which are spent at the present time on art teaching in Mexico should go into a reserve fund which would periodically buy the paintings and sculptures produced by Mexican artists. Those who are fortunate enough to have their work purchased in this way would have to set up their own studio-workshops and accept those pupils who choose them to be their masters.

Let us suppose that at the present time there are forty painters and ten sculptors who could set up and direct their own studios. That would make fifty studios. Let us suppose that the master of each studio must take ten students. We would thus have 500 students. Supposing that the Government buys ten works a year from each master at a cost of one thousand pesos each. Each master would annually receive 10,000 pesos and the government would pay out a total of 500,000 pesos. For even the most voracious of artists in Mexico, 10,000 pesos is a magnificent income and enough to cover the expenses of running a studio. There would be enough left to carry out public works of art, which would again benefit the studios. The students' work would also be purchased at

exhibitions which would be held from time to time. And the masters would still be able to do private work.

And what should the government do with the work it acquires? It would go to enrich the collection of the School of Plastic Arts, and could be hung in galleries set aside for modern art. Secondary schools and universities could have art galleries attached to them. Exhibitions could travel all over the Republic and be sent abroad.

In short, my suggestion shows how we could create the studio-workshops we have been talking about for so long and expenses would be no higher than they are now. I am certain that all those painters and sculptors who feel they are still capable of producing good work will realise the advantage of this form of work and teaching. The only opposition will come from those who have already become bureaucratic fossils.

(4) Artistic drawing should not be taught as a separate subject in primary and secondary schools

Constructive geometrical drawing should be taught in primary and secondary school classes rather than artistic drawing. This would be of great use to those children who are going to become workers or technicians. Constructive drawing is indispensable for all kinds of work, from the simplest to the most complicated. The conditions of life both today and in the future make this a vitally needed subject. As for artistic drawing, pupils should have the materials readily available and the right to use them whenever they want. But it would be a recreational activity. Group teachers should be able to give whatever guidance is needed. They should limit themselves to drawing the children's attention towards nature and away from the bad influences of newspaper drawings, magazines and book illustrations. Furthermore, children's drawings are always of interest.

Those children who have an inclination for art, those who wish to become professional painters and sculptors, are sure to apprentice themselves to master artists. The children must have the right to choose the master whose work they most admire.

(5) Some art is imitatively, descriptively or anecdotally picturesque; some is essentially picturesque

There is a great deal of confusion about what is truly picturesque. Some works of art can be picturesque because they are weakly imitative or descriptive, or because the anecdotal content is more important than the plastic structure. But it is not only imitation or anecdote which are

picturesque; an abstract work of art, devoid of imitation, description or anecdote, novel in form and of Pure Art tendency, can also be picturesque. This is twice as bad because it is an organic defect. The picturesqueness appears in weak plastic concepts, small, dispersed proportions, in puerile detail and in *snobbish* eccentricities. There are Cubist and Surrealist pictures which are as organically picturesque as the worst anecdotal or descriptive painting. The choice of artistic object, whether a theme or an anecdote, or in their place abstract forms, lineal rhythm and a simple correlation of values, does not add up to a work of art unless they are worked out by the artist with constructive energy, emotion and strength of mind. Of course, the danger of picturesqueness is much greater when popular themes and well known stories are used, as we shall see further on.

(6) The exaltation of popular art was a natural reaction against the aristocratic, European art of the Porfirio Diaz period

This exaltation was good in some ways, but it has acquired a dangerous direction, not only for those painters and sculptors who follow it; it can also harm the manifestations of popular art. We must therefore define what is meant by popular art and its importance for professional painters and sculptors. Popular art, although it has accumulated a great deal of technique and experience, is really the manifestation of a race or people who have been slaves for centuries and have therefore lost the possibility of expressing themselves in monumental terms as they did when they were flourishing. This is why popular art, although undoubtedly beautiful, is invariably picturesque.

For professional painters and sculptors, popular art is in the same category as the art of children, youth and dilettantes: it constitutes an important document which reveals geographical, social and racial values which allow the professional artist to revise his aesthetic principles. In popular art the professional artist may find the seeds which he can develop into a work of art; but nothing more. To make a fetish of popular art and children's art is not only very dangerous to the formation of an artist, but also for popular art itself.

(7) The greatest danger to the modern Mexican art movement is to be found in the painting called "Mexican Curious"

This type of painting increases in direct proportion to the tourist trade in Mexico. It is one of the effects of Yankee imperialist penetration. Consciously or subconsciously, most of Mexico's painters and sculptors are influenced by this tendency. It is in fact part of the popular art fetish.

It manifests itself as a tendency to paint the typical picture that the tourist wants. Modern art is thus ceasing to be an organically aesthetic expression of geography, social environment and Mexican tradition; instead it becomes folk art for export. All this *"Mexican Curious"* art, produced in industrial quantities, is structurally an alien art dressed up in Mexican clothes. Both famous and mediocre artists paint pictures of this type, some to a greater extent, some to a lesser. Cornejo paints like this all the time, Diego Rivera only half, but the facts are significant. We must put all conscientious Mexican painters and sculptors on their guard against this, otherwise our movement, with all its great potential, will sooner or later become a school of folk art instead of remaining faithful to the enormous and monumental artistic values vital to all important movements. We should see less of popular art and more of the work of the Indian masters, both of Mexico and the rest of America. Their work expresses clearly and gently, what folk art expresses in immature language. If we want to learn to draw and compose, they can teach us better than anyone. If we wish to avoid puerile trivialities, we should look to their works, because they will teach us to understand the great essential masses, the primary forms. We shall also find in the work of the American Indians the metaphysical complement inherent to the masterpiece of all the world and all the ages. By studying their works we shall understand clearly that art is not only a problem of the me-chanics of composition, it is also a problem of state of mind. Indian traditional painting will make us ratify what we ourselves have pro-duced in the same geographical conditions. We can see how in their painting our regional flora is not reproduced descriptively but is used to create equivalent plastic forms. In a word: we have nothing here which can teach us to paint or sculpt better than our Indian sculptures and pre-Cortesian monuments.

There has been too much made of popular art and this is because young painters and sculptors are more concerned with Posada, votive offerings and tavern paintings than the works bequeathed to us by the Indian masters.

The importance of Mexican indigenous tradition for us does not mean that we should ignore the other important traditions of the world. Nor should we exchange *"Mexican Curious"* art for archaeological art; nor should our artistic production be limited to a national scale. We must be modern and international first and foremost, but we must contribute artistic values of our own to world aesthetics.

(8) In escaping from folk art we must not become snobbish

Some of our artist comrades, in trying to escape from the influence of *"Mexican Curious"* art, unfortunately fall into a type of snob art which

is totally alien to our own geographical reality. They believe that *"Mexican Curious"* is something more than an imitation of popular art; that it accepts popular art as its point of departure and is organically weak, because it concentrates on the picturesque external aspects; they believe that *"Mexican Curious"* art is also under the influence of archaeological art, and this is a very grave mistake. They do not understand that archaeological works of art produced at a time when American indigenous art was flourishing have no connection with the picturesque elements of modern popular art. It is extremely easy to imitate popular art, and there are many imitators. We can only understand the plastic values of the ancient Indian masters after years of detailed study. This shows the distance which separates it from the petty, degraded popular art of today.

The snobbish trend has been increasingly noticeable in Mexico in the last five years. It is a logical reaction against Diego Rivera's prolific production of *"Mexican Curious."* But we must find the right way, which is not to be found in European painting and sculpture. Contemporaneous painting and sculpture is becoming more and more a kind of cerebral masturbation, both characteristic and representative of the decadent bourgeois classes. I repeat, that this does not mean that I think we should isolate ourselves from European art trends. On the contrary, I believe we should be thoroughly informed of everything that is happening outside Mexico, but I also believe that a set of circumstances (tradition, geography, race and social conditions) have given us the possibility of accomplishing something which would be a real contribution to universal beauty, and yet be alien to the snobbism so characteristic of European culture today.

(9) Mural painting must complement architecture

Good mural painting is very far from being simply the painting of panels, however important these may be as individual works of art. Murals require an ornamental style which will provide a connection between the panels and the architectonic whole.

There are, furthermore, logical principles which will not permit pictures to be painted in places where they cannot be appreciated. Simple, quiet colour schemes are required which do not destroy the unity of the walls and the whole structure. Mural painting simply to cover the walls, as though one were merely trying to paint very large pictures, would reflect very detrimentally on the quality of the mural.

Neither is it acceptable to paint a motley of brightly coloured objects, people, etc, in the manner of the detestable mural paintings of the late eighteenth and early nineteenth centuries.

Many of the Renaissance masters both cannot and should not be considered good mural painters. The best mural painting was produced

in Europe by the pre-Christian civilisations and the early Christian schools. From Giotto onwards there is clear evidence of decadence in the ornamentation of buildings.

The most recent examples of incomparably magnificent work in the interior and exterior ornamentation of monuments was done by American civilisations before the Conquest.

What I have just said should show how necessary it is to put an end to the system of decorating public buildings with murals of variable artistic value. We have not yet built in Mexico one unit of real worth. Everything that has been done so far will pass into history as a mediocre example of mural decoration. And since we in Mexico have a chance to decorate buildings, we must learn by our experiences of the past ten years and produce something better.

(10) We must return to formal painting and keep right away from the puerile work of the contemporary art snob

None of the ancient masters, or the masters of the great periods of art, would ever have presented a preliminary study, as a finished work of art. All the great masters, the great painters and sculptors of all times have always worked on the basis of a series of studies in preparation for a big work. They would never have dreamed of exhibiting these studies. The drawings of the Renaissance painters were never regarded, either by themselves or their admirers, as great artistic achievements, but as stages of varying importance which they achieved in the process of producing a work of art.

In the main it has been the French modern painters who have extolled the virtues of the initial study, to which they have sometimes given greater importance than to the greatest efforts of the master. Matisse is an eloquent example of this trend. Idolatry for work realised with the minimum of effort has been topical in Europe over the last few years. They have a name for this kind of work; they call it: intimate, essential, a work with the concentrated essence of a larger work. But in fact, this doctrine is evidence of impotence and, in general, a proof of capitalist decadence.

We must flee from this tendency. Our work must be as transcendent as we can make it, as elaborate and as complete. Our work must be replete with artistic values. It must be both physical and metaphysical, and as methodically and seriously constructed as the best work of the best artistic periods.

(11) Portrait painting is also a good art form, although some would say it is not

Modern painters often speak derogatively of portrait painting. A portrait—they say—is a psychological problem, and psychology and art are two separate things. In my opinion a portrait presents the painter or sculptor with a subject of great plastic complexity, from which he can produce an integral work of art.

I have already said that painting and sculpture require not only a knowledge of art mechanisms, but also metaphysical expression, and portrait painting emphasises this, because all the factors required for a complete work of art appear in a portrait.

I also believe that a portrait requires a high level of plastic gymnastics, since it places the painter and sculptor first and foremost on an objective plane. We must finish with false theories and advise the new Mexican painters and sculptors to paint portraits as well.

(12) Who can criticise the plastic arts?

Some maintain that only professional critics should speak about the arts. Others say that the only valid criticism is that of the general public. I maintain that the only people who can contribute adequately and in a way that will be useful to both artists and to culture in general are those persons (bourgeois or proletarian) who can be considered, on account of their education and artistic experience, to be both more perceptive and of better taste than most of the intellectual public and the popular masses. The truth is that there have never been professional art critics. Those who called themselves art critics, have really been exaggerated eulogists of one school or another. There is no doubt that in emotional matters where individual sensitivity and sensuality count for most, phlegmatic eclecticism is impossible. Most of the so-called contemporary art critics are grandiloquent poets who use painting and sculpture as a pretext to write beautiful poems. As for the masses: the bourgeoisie is characteristically *nouveau riche;* the middle classes or petty bourgeoisie have been educated by the bourgeoisie; and the proletariat is the final receptacle of the bad taste of the classes which exploit them and dominate them. The proletariat owes to the bourgeoisie not only its economic oppression but also its abominable aesthetic taste. The radio playing the songs of Agustin Lara, the gramophone and Yankee cinema are the spiritual food of the masses: how then can they have other than bad taste? Only the peasants still have traditional good taste, because they are closer to our older cultures and further from modern bourgeois culture.

In spite of everything, it is only the educated minority who can adequately evaluate the plastic arts. It has always been so and so it remains.

(13) Social art or pure art

Intellectuals all over the world are divided on this question. Those who favour Pure Art affirm that there is nothing more divorced from the class struggle than the arts. They say it is possible to produce a work of art in our present society, and that art is an individual, organic expression and that nothing can perturb its creative process. They also maintain that social art is necessarily anecdotal and political and therefore inferior as a total art expression.

Those who favour social art, on the other hand, say that artists must put their work to the service of the proletariat in its struggle against capitalism. We are living in times of bitter class war, in imperialist times, in the final stages of the capitalist regime, they say. The artist has only one possibility: he must make up his mind to serve either the bourgeoisie or the proletariat.

I support this latter theory, but would like to clear up a few points.

I believe that painting and sculpture should serve the proletariat in their revolutionary class struggle, but I believe that the theory of pure art is the ultimate artistic objective. I should add that there has never at any time or place in the world been a manifestation of such art, and it could only exist in a society with no class struggle, with no politics; in a completely communist society.

I fight for this type of society because in doing so I am fighting for pure art. I also believe that a painter or sculptor should not subordinate his aesthetic taste to that of the revolutionary proletarian masses, because, as we have already seen, the taste of the masses has been perverted by the taste of the capitalist class. In his painting or sculpture the revolutionary artist should give expression to the desires of the masses, their objective qualities and the revolutionary ideology of the proletariat; he must also produce good art. Serge Eisenstein, the great film maker, put this very clearly when, on opening the exhibition of my work, he said: "The great revolutionary painter is a synthesis of the ideas of the masses and their representation by an individual."

(14) The duty of painters and sculptors in society today is to collaborate aesthetically and personally with the class historically destined to change the old society for the new

The painters and sculptors of today cannot remain indifferent in the struggle to free humanity and art from oppression.

"Painting After the War" 1936

AMBROISE VOLLARD

The famous French dealer Ambroise Vollard describes the Parisian art world after the First World War, one which is not unlike that of today. It is characterized by speculation, competition, and precipitous price increases. The dealer as hero has entered the canon of modern art, much as the artist has. But behind the process lies the singular fact of art marketing, quite naive, by Vollard's account, compared to the much expanded international brokage of art objects one finds today. Yet the same principles can be found in both, and much the same mixture of high ambition and careful cultivation of clients.

The history of the dealer system for the gallery world is as good a barometer for studying economic history and macroeconomic institutions as any other large international industry. Of course, the complex links between individual strategies of artists, their merchandise for sale, and the increasingly multinational system that sells them, give the product and process of art a unique place in the world of business—one not exclusively about profit, but certainly not exclusively about process either.

* * *

After the War, the enthusiasm for painting did not die down. Everybody went on buying and selling pictures. Galleries sprang up like mushrooms. Over the length of whole streets, every shop-window was the show-case of a picture dealer. To say nothing of private traders. One day my attention was drawn to a little lady going by with canvases under her arm. It appeared she had complained that her husband's pay did not allow her to have two servants, and someone had said to her: "There's nothing like buying and selling pictures nowadays, if you want to make

money." A friend of the family, who had confidence in the lady's business capacity, advanced her a few thousand francs, which she spent on having everything knocked down to her, at the Kahn sale, that "did not go too high." In this way she acquired some Cubist paintings, which at that time had gone down a great deal in value, but went up again soon after. She got her two servants straight away, then her car, and then her "At Home" day.

But if the picture dealers prospered, they were very soon faced with the growing demands of the painters, all anxious to share their prosperity.

One day I met one of my colleagues, who said to me:

"I've just been with So-and-so" (mentioning one of his "colts"). "Only a year ago I had to give him a Talbot, and now he wants to touch me for a Packard."

I had occasion to visit this same colleague a few months later.

"Is M. A....in his office?" I asked the lady secretary.

"You've come at an unlucky moment, M. Vollard! The boss is in such a state!...X....has just been here."

The name was that of the Packard man.

"Just fancy! He came in like a whirlwind, and without saying a word, rushed up to a *Nude* of his own—a painting for which we had refused seventy-five notes, *oui, Monsieur!* Before he could be stopped, the picture was...Look, that's all that's left of it, those scraps in the corner over there. 'That picture is no longer worthy of my reputation!' he shouted to us as he went away. And he carried away a piece of the woman's belly, to make sure the canvas shouldn't be repaired. All that after the Packard he's cost us! A painter, too, that the firm has actually made, you might say. Not three years ago he was swearing to the boss: 'You can count on my eternal gratitude.' "

I myself was caught by the general fever. One day I thought I had stumbled on a good thing. In a dealer's window I saw a picture of a cathedral, signed Utrillo, a name unknown to me. "Aha!" I said to myself, "there's a painter to take up."

I went in and asked the price.

Fifty thousand francs.

I was too late. Only a few years earlier, I was told, Utrillo's work was to be found hung out in the open, at the junk-dealers' on the Boulevard Clichy, or in eating-houses, where the artist had left them with the proprietor for the price of a meal.

It was much the same with another artist, Modigliani, an exhibition of whose work, in the rue Laffitte itself, had attracted my attention by its strangeness. Out of curiosity I had bargained for one of his paintings, although I rebelled somewhat against his figures, which had necks so long that they looked as though they had been dragged out.

"Three hundred francs, that's dear for such stuff!" I thought at the time.

A few years later, walking along the rue de la Boétie, I noticed a *Nude* by this artist, which recalled the rather mannered grace of certain Japanese prints. But what a voluptuous texture he had given to the skin! I said to myself: "Only four years ago the biggest Modiglianis were priced at three hundred francs. They're not likely to want more than three thousand for this."

"How much?" I asked.

"Three hundred and fifty thousand. But there's an option on it already. And we have every reason to believe that the traveller who has taken it is acting on behalf of Mussolini!"

The post-war period saw the rise to popularity of the cafés on the Boulevard Montparnasse. On the terraces, and within-doors, people pointed out to one another the new groups of painters and their models. The latter, convinced that they had film faces, all dreamed of appearing on the screen. There was no resemblance to the old Montparnasse. Nothing of the Good-natured Artist, smoking his pipe before a sparkling *bock* and announcing jubilantly: "Things are moving, I've got one of my pictures on show in the rue Laffitte." An anecdote that I had from Guillemet is characteristic of that period. One day when he had gone to see Corot, the latter said: "What! You tell me an *amateur* has given you thirty louis to buy two pictures for him, and that if I were not Corot you would have come to me? But, my boy, thirty louis is a good sum. We'll choose two paintings for this Mæcenas straight away."

The new Montparnasse was a Babel, where the painters for the most part talked in dollars, piastres, pesetas, kroner, pounds sterling. What a contrast with their elders, who painted simply for the joy of painting!

But it is not easy to work with pleasure when everything conspires to disturb your peace. It was not only the snobs and profiteers who had "gone in for painting," the more enlightened collectors were no less ardent in their pursuit of the artists. Only one means of escape from such a conspiracy remained: running away. Running far away. Fleeing to places where there was no railway. Alas! villages, even the most remote, are not safe from the motor, and the painter had hardly settled into the retreat where he thought himself to be undiscoverable, when he was tracked down.

"We happened to be coming your way..."

And besides these confirmed admirers, there were insolent individuals to be dealt with, who, as soon as the "Master's" removal was rumoured, rushed in pursuit of him. In vain did the artist, to secure a peaceful seclusion, put up notices at his gate, such as "Wolf-traps" or

"Beware of the dog," they always found means of forcing his door. "Monsieur," the maid would come and say, "there are three very respectable-looking gentlemen at the gate. They are giving Black sugar, and he is licking their hands." A fresh lot of intruders were attempting to corrupt the dog so as to get in.

Who would suspect the chauffeur, come to ask for help in a breakdown? The help obtained, a lady would get out of the sumptuous limousine and insist on thanking the painter for his kindness. Of course it was quite by chance she had discovered it was to the "Master" Renoir that she owed the possibility of continuing her journey. Yet as she knew that Renoir had once said nothing was so difficult, and at the same time so exciting, to paint, as white on white, everything in the lady's get-up would be white, from the hat to the shoes. And Renoir, greatly struck, would exclaim: "I have no luck: for once that I see a good portrait to paint, of course the model must escape me." Then, by mere chance again, it would turn out that the lady was staying quite close by. She would offer to come back—"only too happy to be of use in her turn to the 'Master'." Before she had got back into the car, a day would have been fixed for the sitting. And after the portrait she would want a bunch of flowers, a landscape "that would remind her, when she was back in Paris, of the silvery olive trees she loved so much."

Two gentlemen left the train one day at Cagnes.

"Now we must get at Renoir," said one.

"I'd give a thousand francs to anyone who would introduce us," declared the other.

"Is that serious?" asked a fellow who had overheard them. "I can easily introduce you to Renoir, I know him quite well."

So he did, but merely from having seen him go by.

Having duly pocketed the thousand francs, he took the others to the painter's house, and persuaded the maid to fetch him. When Renoir asked what was wanted of him:

"M. Renoir," said the fellow imperturbably, "allow me to introduce M. So-and-so and M. So-and-so," and decamped.

Renoir could not even get rid of importunates by telling the maid to say he was out, since in a village one is always to be found. It is easier to escape from visitors in Paris. One day at an artist's house I suddenly saw his little boy run into the hall and pick up his father's coat, hat and stick. I was puzzled. "Didn't you hear?" said the painter. "There was a ring at the door. It may be a visitor for my wife, but it may also be someone for me."

What a contrast with prewar days, when people of fashion were far from caring to be taken for connoisseurs of painting!

When the *Gioconda* was stolen from the Louvre, I came upon a lady of my acquaintance one day, standing before a kiosk.

"Who was Mona Lisa?" she asked me, showing me, in an illustrated paper, the portrait of a man, entitled, "The husband of Mona Lisa."

"She was the *Gioconda,* of course!"

"The *Gioconda?*"

"Why, yes. You know, Leonardo da Vinci's masterpiece!"

"Leonardo da Vinci?"

"Have you never been to the Louvre?"

"To the *Magasins,* often. To the Museum, *ma foi,* no! It would mean crossing the rue de Rivoli. I have never had time."

Yet this was the person of whom Forain, at one of my dinner-parties in the "Cellar," had said to me: "If you want to give me a treat, put me beside Mme Z....I love hearing her talk. She has ideas."

She had taste as well. I came across her another time in a friend's drawing-room, seated beside a member of the Académie des Beaux-Arts, whose formal mien recalled that of an English lord, and with whom she was carrying on a very animated conversation. When he had gone, I said:

"You seem to find that gentleman profoundly interesting?"

"We were talking painting. He wanted me to explain why I like those *Women bathing* so much. You know—in the hall."

This was a water-colour by Cézanne. I did not think it a good time to ask the lady for her reasons, but I promised myself that when I saw the academician again, I would lead the conversation to the water-colour in question. When we did meet, however, before I could open my mouth, he exclaimed:

"What a painter's eye that pretty woman has that I was sitting beside the other day, at the X.'s! With my craze for always talking shop, I asked her if she cared for painting.

" 'When I was taking my cloak off in the hall,' she replied, 'I saw a picture of some women bathing. Now I call that really pretty.'

" 'What! That thing that looks like a cheese with big white maggots coming out of it!' I cried, like the bloody fool that I am..."

(I thought it my duty to protest against this description of himself.)

"Shut up....You think worse of my painting even than that," said he.

"The lady," he went on, "retorted: 'I get the same pleasure from it as I should from a beautiful piece of china.' Well, that opened my eyes to Cézanne. So that now, when I sit at my easel, in front of my little pink bottoms and waxen breasts, all those horrors that got me into the Institute, they make me feel sick."

"It's a different art," I ventured.

"It's muck. But I'm trying to turn over a new leaf. At the moment I'm studying Picasso and Matisse, before making a serious attempt at Cézanne."

A Cézanne, a Matisse, a Picasso are not merely a joy to the eye, they may procure one advantages of another sort. I knew a big Jewish banker who wanted at all costs to get into the Faubourg Saint-Germain set, of which one of the most representative personalities, in his eyes, was Baron Denys Cochin. He opened his batteries by buying an estate alongside the Baron's, but in spite of his advances, he could never get anything out of him, socially speaking, beyond a visiting-card. Whereas if he had possessed a few Cézannes, M. Denys Cochin might very well have been the first to make advances.

And besides fine acquaintance, one may even derive lasting profit from the fact of having a collection and allowing it to be seen. I knew a collector whose modest means only permitted him to buy sketches. One day I found him engaged in showing some paintings to an individual with a patronising air, whom he was trying to persuade to admire them.

"Oh, of course," I heard the visitor say, "I don't know anything about it, but you will never convince me that any of this stuff is serious painting."

At that moment the maid came in:

"They have sent to tell Monsieur that the Prince of X..., who was to have come at ten o'clock, cannot get here till half-past. The Prince hopes it will not put Monsieur out."

The visitor stood agape:

"What! The brother of the King of...is coming here?"

"Oh, yes! Whenever he goes through Paris he comes to see my little gallery."

"Look here, my friend, I'm a plain-dealing man. I know you're in love with my daughter. I have never encouraged you to propose. Well! put it there! Only let me stay here when the Prince comes. I should so love to be able to say I had had a *tête-à-tête* with the brother of a king! Of course I don't expect you to introduce me straight away. But you might say, for instance, referring to that picture over there: 'My dear father-in-law, would you mind helping me to take down that picture? I want the Prince to look at it more closely.' "

So there was an *amateur* whose collection helped him to a brilliant marriage.

A certain financier, too, owed his salvation to the portrait a famous artist painted of him.

I was in John Lewis Brown's studio when someone came in, and seizing both the artist's hands, cried:

"Do you know you have positively saved me from ruin?"

"I?" exclaimed the artist.

"Do you remember my asking you one day to get Bonnat to do a sketch of me for ten thousand francs? How did that strike you at the time?"

"I said to myself: 'How rich he must be to fork out ten thousand francs like that!' "

"What would you have said, my good Lewis, if you had known the fix I was in? I was literally at the end of my tether. I expected to go smash from one minute to the other, when the idea came to me of bluffing with that portrait by Bonnat....*Coup de théâtre:* when they read in the *Figaro* and the *Gaulois* that the eminent painter of the Presidents and other big-wigs of the Republic was at work on a portrait of the 'great banker,' you can imagine it gave all the people who were preparing to hang me something to chew! I immediately found all the money I needed to set myself afloat again."

"Well," said Brown, when the other had gone, "now you see the true uses of painting."

"Yes, I see. Why don't all the manipulators of capital buy pictures, and the company promoters, and the States that are in debt—everybody, in fact, who wants to restore public confidence?"

Seeing the *amateurs* "stocking" pictures as though they were shares that promised to go up, the dealers themselves, convinced that prices would continue to rise, formed a reserve stock, and when a chance customer, attracted by some picture in the window, asked: "How much is that *Snow Scene* by Monet?" he was told: "Not for sale."

"That Derain, then?"

"Not for sale either!"

Dumbfounded, he might still persist:

"And that big Matisse?"

"Everything in the window belongs to the boss's private collection."

I did not go so far as to refuse to sell, but it might well be said that the way I conducted business at that time was not calculated to make the customer buy.

"How much are those three sketches by Cézanne?"

"Do you want one, two, or three of them?"

"Only one."

"Thirty thousand francs, at your choice."

"And if I take two?"

"That will be eighty thousand francs."

"I don't understand. So then, all three would be...?"

"All three, a hundred and fifty thousand francs."

My customer was flabbergasted.

"It's perfectly simple," I said. "If I sell you only one of my Cézannes, I have two left. If I sell you two, I have only one left. If I sell you all three, I have none left. Do you see?"

My man was more and more perplexed. Suddenly he tapped his forehead:

"You've given me a jolly good lesson!"

And he ran off in a hurry. He thought he had discovered that, in any kind of business, the more people buy of you, the more you should put your prices up. Unfortunately for him, his trade was in shoes.

Amateurs and dealers, hanging on jealously to their treasures, had reckoned without the Slump.

What a far cry now to the time when buyers came as suppliants! There was the American who persisted: "Come, M. Vollard, be a sport! It's for the United States! Let me have that Renoir." Deaf to that pathetic appeal, confident in the continuance of the rise, I did not sell him the picture. I still have the Renoir, but I have not seen the American again.

In spite of everything, we all try to persuade ourselves that the bad time will be over some day, and that money, sooner or later, will begin to circulate again. We go on confidently expecting the customer. The bell rings. The door opens. Suppose it were He! It *is* an *amateur,* but...he has merely brought something to sell!

"My Life in London" 1946

PEGGY GUGGENHEIM

In this excerpt from her autobiography, Peggy Guggenheim describes
the opening of her art gallery in London in 1938, as well as her relation-
ship with author Samuel Beckett and her friendships with Marcel Du-
champ, Vassily Kandinsky, and Hans Arp.

The relationship of art production to high society remains a critical
factor in understanding the shifts in aesthetics that occur from year to
year. The gallery world is not directly part of high fashion but since the
late 1930s, and even earlier, fashionable celebrity and modern art were
brought together often.

* * *

My life in London was hectic. There was so much work to be done, I don't
know how I survived. To begin with I had to refurnish my flat, since I
had given Garman all the furniture. Then I had to open the gallery, and
obtain the names of hundreds of people to invite to the opening, and
have a catalogue and invitations printed and sent out. Luckily Mary
Reynolds and Marcel Duchamp flew over for the opening and Marcel
hung the show and made it look beautiful.

Cocteau sent me about thirty original drawings he had made for
the décor of his play *Les Chevaliers de la Table Ronde.* I had also
borrowed the furniture which he had designed for it, and he especially
made some dinner plates which were in the same spirit. He also made
some drawings in ink in the same spirit as the others, and two on linen
bed sheets that were especially done for the show. One was an allegorical
subject called *La Peur donnant ailes au Courage,* which included a
portrait of the actor Jean Marais. He and two very decadent looking
figures appeared with pubic hairs. Cocteau had pinned leaves over these,

but the drawing caused a great scandal with the British Customs, who held it up at Croydon. Marcel and I rushed down to release it. I asked why they objected to the nude in art, and they replied it was not the nude but the pubic hairs which worried them. On promising not to exhibit this sheet to the general public, but only to a few friends in my private office, I was permitted to take it. In fact, I liked it so much that in the end I bought it.

This was before I was thinking of collecting. But gradually I bought one work of art from every show I gave, so as not to disappoint the artists if I were unsuccessful in selling anything. In those days, as I had no idea how to sell and had never bought pictures, this seemed to be the best solution and the least I could do to please the artists.

The opening of Guggenheim Jeune in January 1938 was a great success, but what pleased me most was receiving a wire of *auguri* signed "Oblomov."

I called Beckett Oblomov from the book by Goncharov that Djuna Barnes had given me to read so long before. When I met him I was surprised to find a living Oblomov. I made him read the book and of course he immediately saw the resemblance between himself and the strange inactive hero who finally did not even have the will power to get out of bed.

Conversation with Beckett was difficult. He was never very animated, and it took hours and lots of drink to warm him up before he finally unraveled himself. If he ever said anything to me which made me think he loved me, as soon as I taxed him with it he took it back by saying he had been drunk at the time. When I asked him what he was going to do about our life he invariably replied, "Nothing."

As soon as we could leave London, Mary, Marcel Duchamp and I went back to Paris. Beckett was now out of the hospital and was convalescing in his hotel. I took a room there but I don't think that pleased him at all. My sister Hazel had a wonderful flat on the Ile Saint-Louis which I was able to borrow. It had no furniture, only a big bed and lots of her own paintings (she was a good primitive painter). I tried to take Beckett to live with me on the island, but he refused to remain there all the time. He came and went and always brought champagne to bed.

Beckett had a friend called Brian Coffey. He was a little dark man, a sort of dried-up intellectual and a Thomist. He tried hard to attach himself to me, and I used to tease Beckett about him with great tactlessness. I often said I wanted to sleep with him. Beckett had an inferiority complex, and as I had talked to him so passionately about John Holms, and also made fun of Humphrey Jennings to him, he conceived the idea that he really was not at all the man I wanted. One day he announced that he was never going to sleep with me again and

told me to have Brian, for then at least I might be satisfied. I was so infuriated by this proposition (though I now realize it was entirely my stupidity that made Beckett suggest it) that I went and slept with Brian. Beckett looked dignified and sad as he walked away from us, knowing what was going to happen. The next day Beckett asked me if I liked Brian, but I must have said "No," because Beckett came back to me. We were very happy together for twenty-four hours, and then everything was ruined. We met Brian for lunch and he asked Beckett if he were interfering in his life, as he had only just realized that I really belonged to Beckett. To my great surprise Beckett gave me to Brian. I was so horrified I rushed out of the café and walked all over Paris in despair. I went to Beckett's hotel and made a terrible scene, but it did no good. He said he was no longer in love with me.

Even if our sex life was over nothing else was. Our relationship continued unchanged in every other respect. We were perpetually together, and I felt the same ecstasy in his society as I had previously. At night he walked me home over the bridge behind Notre Dame. When we reached my front door Beckett went through the most terrible agonies trying to decide what to do. But he always ended up by pulling himself together and running away. This caused me incalculable misery and I spent nights lying awake, longing for his return.

Beckett had little vitality and always believed in following the path of least resistance. However, he was prepared to do anything for Joyce, and he was always leaving me to see his great idol. I was very jealous of Joyce. I think Joyce loved Beckett as a son.

In February 1938 Joyce had his fifty-sixth birthday. Maria Jolas gave him a dinner party at Helen Joyce's. Beckett was in a state of great excitement about suitable presents. He went with me and made me buy a blackthorn stick. God knows why. As for his own gift he very much wanted to find some Swiss wine, Joyce's favorite beverage. I remembered that John Holms and I once years before had dined in a Swiss restaurant with Joyce, and I went back to the Rue Ste. Anne, found the place and asked them if they would sell some wine. Of course they consented when I told them whom it was for. Beckett went to get it and was very happy. At the dinner party Joyce offered a hundred francs to anyone who could guess the title of his new book (*Finnegans Wake*), which was just about to be published. Beckett I am sure won the bet. At the party were present only Joyce's sycophants. I met again Herbert Gorman, whom I had not seen for years. The table was decorated with a plaster model of Dublin through which ran a green ribbon representing Joyce's beloved Liffey. Joyce got very tight and did a little jig by himself in the middle of the room.

Marcel sent me to see Kandinsky. He was a wonderful old man of seventy, so jolly and charming, with a horrid wife some thirty years

younger called Nina. Everybody adored him and detested her. I asked him if he wanted to have an exhibition in London, and as he had never shown there he was delighted. He had a friend in England who owned a lot of his pictures, Sir Michael Sadleir.

Kandinsky, who was upset by my uncle Solomon Guggenheim's supplanting him by Rudolf Bauer, his third-rate imitator, claimed that though he had encouraged my uncle to buy Bauer's paintings now that Bauer had taken his place he never told my uncle to buy Kandinsky's paintings. He wanted me to get my uncle to buy one of his early works. It seems that it was one my uncle had wanted for a long time. I promised to do my best, never dreaming of the result.

Kandinsky and his wife arranged the whole London show themselves. It included paintings from 1910 to 1937. I merely sent them a plan of the gallery and they even decided where each picture was to be hung. They were very businesslike. No one looked less like an artist than Kandinsky, who resembled a Wall Street broker. Mrs. Kandinsky behaved horribly and I am surprised they ever sold any pictures: she was so grasping. At the end of the show, I bought one of the 1937 period and none of the marvelous early ones. Later in New York I bought many others, but I wish I now had several that were in my show.

One day, during the exhibition, an art teacher from a public school in the north of England came to the gallery and begged me to allow him to show ten Kandinskys to his pupils at the school. I was delighted with the idea and wrote to Kandinsky for his permission. He wrote back that he was very much pleased but with his usual businesslike attitude added that the pictures should be insured. When the show was over my schoolmaster came and strapped ten canvases on to his car and drove away with them. I am certain Kandinsky had never been so informally treated before. When the schoolmaster brought back the paintings he told me how much they had meant to the school.

As I had promised Kandinsky, I wrote to my uncle asking him if he still wanted to buy the painting that he had so long desired. I received a friendly answer saying that he had turned the letter over to the Baroness Rebay, the curator of his museum, and that she would reply herself. In due time I received this extraordinary document:

Dear Mrs. Guggenheim "jeune"

Your request to sell us a Kandinsky picture was given to me, to answer.

First of all we do not ever buy from any dealer, as long as great artists offer their work for sale themselves & secondly your gallery will be the last one for our foundation to use, if ever the need to get a historically important picture should force us to use a sales gallery.

It is extremely distasteful at this moment, when the name of Guggenheim stands for an ideal in art, to see it used for commerce so as

to give the wrong impression, as if this great philanthropic work was intended to be a useful boost to some small shop. Non-objective art, you will soon find out, does not come by the dozen, to make a shop of this art profitable. Commerce with real art cannot exist for that reason. You will soon find you are propagating mediocrity; if not trash. If you are interested in non-objective art you can well afford to buy it and start a collection. This way you can get into useful contact with artists, and you can leave a fine collection to your country if you know how to choose. If you don't you will soon find yourself in trouble also in commerce.

Due to the foresight of an important man since many years collecting and protecting real art, through my work and experience, the name of Guggenheim became known for great art and it is very poor taste indeed to make use of it, of our work and fame, to cheapen it to a profit.

Yours very truly,

H. R.

P.S. Now, our newest publication will not be sent to England for some time to come.

During the Kandinsky show Brian came to visit me in London. We did nothing but talk about Beckett, whom we both adored. I think Brian wanted to marry me, but I had no such desire. It was a great relief when he returned to Paris after a week.

Cedric Morris, one of my oldest friends, was a painter of flowers who had an iris farm and a school of painting in Suffolk. He wanted to have a show in my gallery, but he did not want to exhibit his beautiful flower pictures for which he was famous. Instead he wished to exhibit some fifty portraits he had done of London celebrities. The portraits were in most cases nearly caricatures, all of them on the unpleasant side. There was no reason for showing them in any Surrealist and Abstract gallery, but Wyn and I loved Cedric so much that we could not refuse. He covered the walls three rows deep. I think he must have hung nearly one hundred of them. One evening during the exhibition we gave a party to stir up a little trade. The result was most unexpected. All we stirred up was a terrible row. One of the guests, an architect I shall call Mr. Silvertoe, so much disliked the portraits that in order to show his disapproval he started burning the catalogues. Cedric Morris, naturally infuriated, hit Mr. Silvertoe and a bloody battle took place. The walls of the gallery were spattered with blood. The next day Cedric phoned to apologize and offered to remove his paintings. Of course we did not let him.

A few months later Arp came to visit me. Marcel Duchamp had helped me arrange a show of contemporary sculpture, and Arp who was one of the exhibitors came over to further it himself. Arp was very domestic about the house. He got up early and waited impatiently for me to wake up. He served me breakfast every morning and washed all

the dishes. We had so much fun together and were so gay that it really was a delightful week. We went to Petersfield. Arp was enthusiastic about the English countryside and loved the little Sussex churches. He went back to Paris with a porkpie hat and a bread box under his arm. He knew only one word of English, "candlesticks." His vocabulary did not increase during his stay.

During Arp's visit I was invited by Jacob Epstein to go and see his work. Of course I took Arp with me. This greatly enraged Epstein who barely wished to admit Arp until we protested that he was a great admirer. Epstein hated the Surrealists and thought Arp should not be interested in his work. But on the contrary Arp was fascinated by the strange things we saw, among them the enormous figure of Christ lying entombed. Epstein's portraits are miraculous. They certainly are as good as anything done in the Italian Renaissance; but I hate his other concoctions.

I soon got into trouble again with the British Customs. Marcel Duchamp had sent me from Paris a sculpture show, consisting of works by Brancusi, Raymond Duchamp-Villon, Antoine Pevsner, Arp, his wife, Henri Laurens and Alexander Calder. Henry Moore was to represent England. But the Customs would not admit the show into England as an art exhibition. J. B. Manson, the director of the Tate Gallery, had not passed on it, and therefore it could enter the country only if the exhibits were admitted as separate pieces of bronze, marble, wood, etc. This would have meant my having to pay heavy duty on them, which I would have done had it come to the worst. This was because of a stupid old law which existed to protect English stonecutters from foreign competition. It rested with the director of the Tate Gallery to decide in such cases what was art and what wasn't. Mr. Manson, the director, abused his privilege and refused to pass my show, which he declared was not art. This was really so scandalous that Wyn Henderson got all the art critics to sign a protest against this verdict. As a result, my case was brought up in the House of Commons and we won it. Mr. Manson not only lost his case, but pretty soon his job as well. I thus rendered a great service to foreign artists and to England.

All the papers immediately took up the story and the exhibition became famous. Brancusi's Sculpture for the Blind was reproduced in Tom Driberg's column in the *Daily Express*.

At this moment what I had told Garman a year before to tease him actually came true. Harry Pollitt, having read so much about my success in my battle against Mr. Manson, decided that I was much too important a person to have lost. He sent for me, telling me that he was certain he could fix up all my difficulties about Communism in ten minutes. I wrote back and said I was much too busy to go to him but that he "should come

up and see me some time." He never did. By this time Garman was living with Paddy. Later he married her.

One day Edgell Rickword invited me for dinner and asked me if I would render a great service to the Communist Party. They wanted to borrow my flat for Louis Aragon and a whole convention of Communist writers who were coming to London. They needed a very chic apartment, as when the English writers had been invited to Paris they had been royally received at a hotel on the Avenue de l'Opéra. I protested, saying my flat was not nearly grand enough as it was on the third floor without a lift and was a modest little affair in Bloomsbury without servants. The Communists had to look elsewhere...

"The Creative Act" 1957, "Apropos of 'Readymades' " 1966

MARCEL DUCHAMP

Marcel Duchamp presents his version of "reception aesthetics," where the viewer creates the power of the work as much as the artist. The art piece can only be realized *after* the creative act is completed, *after* the spectator receives it.

As so often with Duchamp, his theories on the role of art point toward both modernist and postmodernist practice, as if in his career two traditions functioned simultaneously. There is a profound link between Duchamp and Pop Art in the 1960s, even with postmodern art of the 1970s and 1980s. The contemporary blend of consumerism and the fine arts began in the 1920s and has since grown more important, even dominant in the gallery world today.

* * *

Let us consider two important factors, the two poles of the creation of art: the artist on one hand, and on the other the spectator who later becomes the posterity.

To all appearances, the artist acts like a mediumistic being who, from the labyrinth beyond time and space, seeks his way out to a clearing.

If we give the attributes of a medium to the artist, we must then deny him the state of consciousness on the esthetic plane about what he is doing or why he is doing it. All his decisions in the artistic execution of the work rest with pure intuition and cannot be translated into a self-analysis, spoken or written, or even thought out.

T. S. Eliot, in his essay on "Tradition and the Individual Talent," writes: "The more perfect the artist, the more completely separate in him will be the man who suffers and the mind which creates; the more

perfectly will the mind digest and transmute the passions which are its material."

Millions of artists create; only a few thousands are discussed or accepted by the spectator and many less again are consecrated by posterity.

In the last analysis, the artist may shout from all the rooftops that he is a genius; he will have to wait for the verdict of the spectator in order that his declarations take a social value and that, finally, posterity includes him in the primers of Art History.

I know that this statement will not meet with the approval of many artists who refuse this mediumistic role and insist on the validity of their awareness in the creative act—yet, art history has consistently decided upon the virtues of a work of art through considerations completely divorced from the rationalized explanations of the artist.

If the artist, as a human being, full of the best intentions toward himself and the whole world, plays no role at all in the judgment of his own work, how can one describe the phenomenon which prompts the spectator to react critically to the work of art? In other words how does this reaction come about?

This phenomenon is comparable to a transference from the artist to the spectator in the form of an esthetic osmosis taking place through the inert matter, such as pigment, piano or marble.

But before we go further, I want to clarify our understanding of the word "art"—to be sure, without an attempt to a definition.

What I have in mind is that art may be bad, good or indifferent, but, whatever adjective is used, we must call it art, and bad art is still art in the same way as a bad emotion is still an emotion.

Therefore, when I refer to "art coefficient," it will be understood that I refer not only to great art, but I am trying to describe the subjective mechanism which produces art in a raw state—*à l'état brut*—bad, good or indifferent.

In the creative act, the artist goes from intention to realization through a chain of totally subjective reactions. His struggle toward the realization is a series of efforts, pains, satisfactions, refusals, decisions, which also cannot and must not be fully self-conscious, at least on the esthetic plane.

The result of this struggle is a difference between the intention and its realization, a difference which the artist is not aware of.

Note: Text of a talk given by Duchamp in Houston at the meeting of the American Federation of the Arts, April 1957. Duchamp, who labeled himself a "mere artist," participated in a roundtable with William C. Seitz of Princeton University, Rudolf Arnheim of Sarah Lawrence College, and Gregory Bateson. Reprinted from *ART-news*, Vol. 56, no. 4 (Summer 1957). The French translation, done by Duchamp himself, appeared in *MDS*.

Consequently, in the chain of reactions accompanying the creative act, a link is missing. This gap which represents the inability of the artist to express fully his intention; this difference between what he intended to realize and did realize, is the personal "art coefficient" contained in the work.

In other words, the personal "art coefficient" is like an arithmetical relation between the unexpressed but intended and the unintentionally expressed.

To avoid a misunderstanding, we must remember that this "art coefficient" is a personal expression of art *"à l'état brut,"* that is, still in a raw state, which must be "refined" as pure sugar from molasses, by the spectator; the digit of this coefficient has no bearing whatsoever on his verdict. The creative act takes another aspect when the spectator experiences the phenomenon of transmutation; through the change from inert matter into a work of art, an actual transubstantiation has taken place, and the role of the spectator is to determine the weight of the work on the esthetic scale.

All in all, the creative act is not performed by the artist alone; the spectator brings the work in contact with the external world by deciphering and interpreting its inner qualifications and thus adds his contribution to the creative act. This becomes even more obvious when posterity gives its final verdict and sometimes rehabilitates forgotten artists.

Apropos of "Readymades"

In 1913 I had the happy idea to fasten a bicycle wheel to a kitchen stool and watch it turn.

A few months later I bought a cheap reproduction of a winter evening landscape, which I called "pharmacy" after adding two small dots, one red and one yellow, in the horizon.

In New York in 1915 I bought at a hardware store a snow shovel on which I wrote "In Advance of the Broken Arm."

It was around that time that the word "readymade" came to mind to designate this form of manifestation.

A point which I want very much to establish is that the choice of these "readymades" was never dictated by esthetic delectation.

This choice was based on a reaction of visual indifference with at the same time a total absence of good or bad taste…in fact a complete anesthesia.

One important characteristic was the short sentence which I occasionally inscribed on the "readymade."

That sentence instead of describing the object like a title was meant to carry the mind of the spectator towards other regions more verbal.

Sometimes I Would add a graphic detail of presentation which in order to satisfy my craving for alliterations, would be called "readymade aided."

At another time wanting to expose the basic antinomy between art and readymades I imagined a "reciprocal readymade": use a Rembrandt as an ironing board!

I realized very soon the danger of repeating indiscriminately this form of expression and decided to limit the production of "readymades" to a small number yearly. I was aware at that time, that for the spectator even more than for the artist, art is a habit forming drug and I wanted to protect my "readymades" against such contamination.

Another aspect of the "readymade" is its lack of uniqueness...the replica of a "readymade" delivering the same message; in fact nearly every one of the "readymades" existing today is not an original in the conventional sense.

A final remark to this egomaniac's discourse:

SInce the tubes of paint used by the artist are manufactured and ready made products we must conclude that all the paintings in the world are "readymades aided" and also works of assemblage.

Note: Talk delivered by Duchamp at the Museum of Modern Art, New York, Oct. 19, 1961. Published in *Art and Artists* (London), 1, no. 4. (July 1966), p. 47. The original text is in the Simon Watson Taylor collection.

"The Avant-Garde and Kitsch" 1939

CLEMENT GREENBERG

Writing in 1939, Clement Greenberg makes very firm distinctions be-
tween "true genuine culture" and "popular art." In pure art, form is
content, "the arrangement of spaces, surfaces, shapes, colors," whereas
kitsch merely provides easily consumed diversions. Kitsch appropriates
the techniques of high culture and turns them into formulas for mass
consumption (a very debatable issue indeed). Greenberg then discusses
the uses of kitsch by totalitarian regimes in the 1930s, appropriating
art and spectacle for the mass public in order to secure political power,
as in the official state cultures of Nazi Germany and Fascist Italy.

This argument is very characteristic of the late 1930s, under the
threat of world war, when a common image of mass culture was the Nazi
Nuremburg Rally in 1934 and mass culture was often defined as total-
itarian. By the 1950s, mass culture was more often defined as the truest
gift of a democracy. Consumer goods, from televisions to refrigerators,
were cited in speeches by Presidents as proof that America was freer
than Russia.

Was mass culture trustworthy? In the mid-1930s, these issues were
debated in Europe as well, between Adorno and Walter Benjamin in
Germany, for example.

But in New York, this particular article served as something of a
manifesto. It announced the shift away from social realism, from social-
ist commitment among New York artists (during the WPA years), away
from trust in the Soviet policies in Europe, from the populist commit-
ment to mass culture of the early 1930s.

As one of the most important documents defending what came to
be called the Abstract Expressionist movement, it may be the single most
quoted and discussed article in American art criticism. In the early
1980s, another flurry of debate was begun at a conference in Vancouver

on the history of Modernism, and it continued for another five years or more, in journals and at other conferences. The term *greenbergian* entered the language of the arts more than ever before, as defined to a large extent by this text. Greenberg gives the traditional belief in mutual isolation between modern art and modern commerce a new twist, not based on art for art's sake, but by contrasting the art of totalitarian duplication (mass culture) with the art of artistic freedom (modern abstraction). This document remains essential to the canon of modernism (a term initiated by Greenberg as much as any other critic of this century). The relationship between mass culture and the fine arts seems more problematical now, of course, than in 1939, but once again the virtues of hindsight can also camouflage historical moments. As a new world conflict was emerging, much of the criticism in America emphasized which lines had to be drawn and which enemy had to be firmly identified.

* * *

One and the same civilization produces simultaneously two such different things as a poem by T. S. Eliot and a Tin Pan Alley song, or a painting by Braque and a *Saturday Evening Post* cover. All four are on the order of culture, and ostensibly, parts of the same culture and products of the same society. Here, however, their connection seems to end. A poem by Eliot and a poem by Eddie Guest—what perspective of culture is large enough to enable us to situate them in an enlightening relation to each other? Does the fact that a disparity such as this within the frame of a single cultural tradition, which is and has been taken for granted—does this fact indicate that the disparity is a part of the natural order of things? Or is it something entirely new, and particular to our age?

The answer involves more than an investigation in aesthetics. It appears to me that it is necessary to examine more closely and with more originality than hitherto the relationship between aesthetic experience as met by the specific—not the generalized—individual, and the social and historical contexts in which that experience takes place. What is brought to light will answer, in addition to the question posed earlier, other and perhaps more important questions.

I

A society, as it becomes less and less able, in the course of its development, to justify the inevitability of its particular forms, breaks up the accepted notions upon which artists and writers must depend in large part for communication with their audiences. It becomes difficult to assume anything. All the verities involved by religion, authority, tradition, style, are thrown into question, and the writer or artist is no longer

able to estimate the response of his audience to the symbols and references with which he works. In the past such a state of affairs has usually resolved itself into a motionless Alexandrianism, an academicism in which the really important issues are left untouched because they involve controversy, and in which creative activity dwindles to virtuosity in the small details of form, all larger questions being decided by the precedent of the old masters. The same themes are mechanically varied in a hundred different works, and yet nothing new is produced: Statius, mandarin verse, Roman sculpture, Beaux-Arts painting, neorepublican architecture.

It is among the hopeful signs in the midst of the decay of our present society that we—some of us—have been unwilling to accept this last phase for our own culture. In seeking to go beyond Alexandrianism, a part of Western bourgeois society has produced something unheard of heretofore:—avant-garde culture. A superior consciousness of history—more precisely, the appearance of a new kind of criticism of society, an historical criticism—made this possible. This criticism has not confronted our present society with timeless utopias, but has soberly examined in the terms of history and of cause and effect the antecedents, justifications and functions of the forms that lie at the heart of every society. Thus our present bourgeois social order was shown to be, not an eternal, "natural" condition of life, but simply the latest term in a succession of social orders. New perspectives of this kind, becoming a part of the advanced intellectual conscience of the fifth and sixth decades of the nineteenth century, soon were absorbed by artists and poets, even if unconsciously for the most part. It was no accident, therefore, that the birth of the avant-garde coincided chronologically—and geographically, too—with the first bold development of scientific revolutionary thought in Europe.

True, the first settlers of bohemia—which was then identical with the avant-garde—turned out soon to be demonstratively uninterested in politics. Nevertheless, without the circulation of revolutionary ideas in the air about them, they would never have been able to isolate their concept of the "bourgeois" in order to define what they were *not*. Nor, without the moral aid of revolutionary political attitudes would they have had the courage to assert themselves as aggressively as they did against the prevailing standards of society. Courage indeed was needed for this, because the avant-garde's emigration from bourgeois society to bohemia meant also an emigration from the markets of capitalism, upon which artists and writers had been thrown by the falling away of aristocratic patronage. (Ostensibly, at least, it meant this—meant starving in a garret—although, as we will be shown later, the avant-garde remained attached to bourgeois society precisely because it needed its money.)

Yet it is true that once the avant-garde had succeeded in "detaching" itself from society, it proceeded to turn around and repudiate revolutionary as well as bourgeois politics. The revolution was left inside society, a part of that welter of ideological struggle which art and poetry find so unpropitious as soon as it begins to involve those "precious" axiomatic beliefs upon which culture thus far has had to rest. Hence it developed that the true and most important function of the avant-garde was not to "experiment," but to find a path along which it would be possible to keep culture *moving* in the midst of ideological confusion and violence. Retiring from public altogether, the avant-garde poet or artist sought to maintain the high level of his art by both narrowing and raising it to the expression of an absolute in which all relativities and contradictions would be either resolved or beside the point. "Art for art's sake" and "pure poetry" appear, and subject matter or content becomes something to be avoided like a plague.

It has been in search of the absolute that the avant-garde has arrived at "abstract" or "nonobjective" art—and poetry, too. The avant-garde poet or artist tries in effect to imitate God by creating something valid solely on its own terms, in the way nature itself is valid, in the way a landscape—not its picture—is aesthetically valid; something *given,* increate, independent of meanings, similars or originals. Content is to be dissolved so completely into form that the work of art or literature cannot be reduced in whole or in part to anything not itself.

But the absolute is absolute, and the poet or artist, being what he is, cherishes certain relative values more than others. The very values in the name of which he invokes the absolute are relative values, the values of aesthetics. And so he turns out to be imitating, not God—and here I use "imitate" in its Aristotelian sense—but the disciplines and processes of art and literature themselves. This is the genesis of the "abstract."[1] In turning his attention away from subject matter of common experience, the poet or artist turns it in upon the medium of his own craft. The nonrepresentational or "abstract," if it is to have aesthetic validity, cannot be arbitrary and accidental, but must stem from obedience to some worthy constraint or original. This constraint, once the world of common, extroverted experience has been renounced, can only be found in the very processes or disciplines by which art and literature have already imitated the former. These themselves become the subject matter of art and literature. If, to continue with Aristotle, all art and literature are imitation, then what we have here is the imitation of imitating. To quote Yeats:

Nor is there singing school but studying
Monuments of its own magnificence.

Picasso, Braque, Mondrian, Miró, Kandinsky, Brancusi, even Klee, Matisse and Cézanne derive their chief inspiration from the medium they work in.[2] The excitement of their art seems to lie most of all in its pure preoccupation with the invention and arrangement of spaces, surfaces, shapes, colors, etc., to the exclusion of whatever is not necessarily implicated in these factors. The attention of poets like Rimbaud, Mallarmé, Valéry, Éluard, Pound, Hart Crane, Stevens, even Rilke and Yeats, appears to be centered on the effort to create poetry and on the "moments" themselves of poetic conversion, rather than on experience to be converted into poetry. Of course, this cannot exclude other preoccupations in their work, for poetry must deal with words, and words must communicate. Certain poets, such as Mallarmé and Valéry,[3] are more radical in this respect than others— leaving aside those poets who have tried to compose poetry in pure sound alone. However, if it were easier to define poetry, modern poetry would be much more "pure" and "abstract." As for the other fields of literature—the definition of avant-garde aesthetics advanced here is no Procrustean bed. But aside from the fact that most of our best contemporary novelists have gone to school with the avant-garde, it is significant that Gide's most ambitious book is a novel about the writing of a novel, and that Joyce's *Ulysses* and *Finnegans Wake* seem to be, above all, as one French critic says, the reduction of experience to expression for the sake of expression, the expression mattering more than what is being expressed.

That avant-garde culture is the imitation of imitating—the fact itself—calls for neither approval nor disapproval. It is true that this culture contains within itself some of the very Alexandrianism it seeks to overcome. The lines quoted from Yeats referred to Byzantium, which is very close to Alexandria; and in a sense this imitation of imitating is a superior sort of Alexandrianism. But there is one most important difference: the avant-garde moves, while Alexandrianism stands still. And this, precisely, is what justifies the avant-garde's methods and makes them necessary. The necessity lies in the fact that by no other means is it possible today to create art and literature of a high order. To quarrel with necessity by throwing about terms like "formalism," "purism," "ivory tower" and so forth is either dull or dishonest. This is not to say, however, that it is to the *social* advantage of the avant-garde that it is what it is. Quite the opposite.

The avant-garde's specialization of itself, the fact that its best artists are artists' artists, its best poets, poets' poets, has estranged a great many of those who were capable formerly of enjoying and appreciating ambitious art and literature, but who are now unwilling or unable to acquire an initiation into their craft secrets. The masses have always remained more or less indifferent to culture in the process of

development. But today such culture is being abandoned by those to whom it actually belongs—our ruling class. For it is to the latter that the avant-garde belongs. No culture can develop without a social basis, without a source of stable income. And in the case of the avant-garde, this was provided by an elite among the ruling class of that society from which it assumed itself to be cut off, but to which it has always remained attached by an umbilical cord of gold. The paradox is real. And now this elite is rapidly shrinking. Since the avant-garde forms the only living culture we now have, the survival in the near future of culture in general is thus threatened.

We must not be deceived by superficial phenomena and local successes. Picasso's shows still draw crowds, and T. S. Eliot is taught in the universities; the dealers in modernist art are still in business, and the publishers still publish some "difficult" poetry. But the avant-garde itself, already sensing the danger, is becoming more and more timid every day that passes. Academicism and commercialism are appearing in the strangest places. This can mean only one thing: that the avant-garde is becoming unsure of the audience it depends on—the rich and the cultivated.

Is it the nature itself of avant-garde culture that is alone responsible for the danger it finds itself in? Or is that only a dangerous liability? Are there other, and perhaps more important, factors involved?

II

Where there is an avant-garde, generally we also find a rear-guard. True enough—simultaneously with the entrance of the avant-garde, a second new cultural phenomenon appeared in the industrial West: that thing to which the Germans give the wonderful name of *Kitsch:* popular, commercial art and literature with their chromeotypes, magazine covers, illustrations, ads, slick and pulp fiction, comics, Tin Pan Alley music, tap dancing, Hollywood movies, etc., etc. For some reason this gigantic apparition has always been taken for granted. It is time we looked into its whys and wherefores.

Kitsch is a product of the industrial revolution which urbanized the masses of Western Europe and America and established what is called universal literacy.

Prior to this the only market for formal culture, as distinguished from folk culture, had been among those who, in addition to being able to read and write, could command the leisure and comfort that always goes hand in hand with cultivation of some sort. This until then had been inextricably associated with literacy. But with the introduction of universal literacy, the ability to read and write became almost a minor skill like driving a car, and it no longer served to distinguish an

individual's cultural inclinations, since it was no longer the exclusive concomitant of refined tastes.

The peasants who settled in the cities as proletariat and petty bourgeois learned to read and write for the sake of efficiency, but they did not win the leisure and comfort necessary for the enjoyment of the city's traditional culture. Losing, nevertheless, their taste for the folk culture whose background was the countryside, and discovering a new capacity for boredom at the same time, the new urban masses set up a pressure on society to provide them with a kind of culture fit for their own consumption. To fill the demand of the new market, a new commodity was devised: ersatz culture, kitsch, destined for those who, insensible to the values of genuine culture, are hungry nevertheless for the diversion that only culture of some sort can provide.

Kitsch, using for raw material the debased and academicized simulacra of genuine culture, welcomes and cultivates this insensibility. It is the source of its profits. Kitsch is mechanical and operates by formulas. Kitsch is vicarious experience and faked sensations. Kitsch changes according to style, but remains always the same. Kitsch is the epitome of all that is spurious in the life of our times. Kitsch pretends to demand nothing of its customers except their money—not even their time.

The precondition for kitsch, a condition without which kitsch would be impossible, is the availability close at hand of a fully matured cultural tradition, whose discoveries, acquisitions, and perfected self-consciousness kitsch can take advantage of for its own ends. It borrows from it devices, tricks, stratagems, rules of thumb, themes, converts them into a system, and discards the rest. It draws its life blood, so to speak, from this reservoir of accumulated experience. This is what is really meant when it is said that the popular art and literature of today were once the daring, esoteric art and literature of yesterday. Of course, no such thing is true. What is meant is that when enough time has elapsed the new is looted for new "twists," which are then watered down and served up as kitsch. Self-evidently, all kitsch is academic; and conversely, all that's academic is kitsch. For what is called the academic as such no longer has an independent existence, but has become the stuffed-shirt "front" for kitsch. The methods of industrialism displace the handicrafts.

Because it can be turned out mechanically, kitsch has become an integral part of our productive system in a way in which true culture could never be, except accidentally. It has been capitalized at a tremendous investment which must show commensurate returns; it is compelled to extend as well as to keep its markets. While it is essentially its own salesman, a great sales apparatus has nevertheless been created for it, which brings pressure to bear on every member of society. Traps

are laid even in those areas, so to speak, that are the preserves of genuine culture. It is not enough today, in a country like ours, to have an inclination towards the latter; one must have a true passion for it that will give him the power to resist the faked article that surrounds and presses in on him from the moment he is old enough to look at the funny papers. Kitsch is deceptive. It has many different levels, and some of them are high enough to be dangerous to the naive seeker of true light. A magazine like the *New Yorker,* which is fundamentally high-class kitsch for the luxury trade, converts and waters down a great deal of avant-garde material for its own uses. Nor is every single item of kitsch altogether worthless. Now and then it produces something of merit, something that has an authentic folk flavor; and these accidental and isolated instances have fooled people who should know better.

Kitsch's enormous profits are a source of temptation to the avant-garde itself, and its members have not always resisted this temptation. Ambitious writers and artists will modify their work under the pressure of kitsch, if they do not succumb to it entirely. And then those puzzling borderline cases appear, such as the popular novelist, Simenon, in France, and Steinbeck in this country. The net result is always to the detriment of true culture in any case.

Kitsch has not been confined to the cities in which it was born, but has flowed out over the countryside, wiping out folk culture. Nor has it shown any regard for geographical and national-cultural boundaries. Another mass product of Western industrialism, it has gone on a triumphal tour of the world, crowding out and defacing native cultures in one colonial country after another, so that it is now by way of becoming a universal culture, the first universal culture ever beheld. Today the native of China, no less than the South American Indian, the Hindu, no less than the Polynesian, have come to prefer to the products of their native art, magazine covers, rotogravure sections and calendar girls. How is this virulence of kitsch, this irresistible attractiveness, to be explained? Naturally, machine-made kitsch can undersell the native handmade article, and the prestige of the West also helps; but why is kitsch a so much more profitable export article than Rembrandt? One, after all, can be reproduced as cheaply as the other.

In his last article on the Soviet cinema in the *Partisan Review*,[4] Dwight Macdonald points out that kitsch has in the last ten years become the dominant culture in Soviet Russia. For this he blames the political regime—not only for the fact that kitsch is the official culture, but also that it is actually the dominant, most popular culture, and he quotes the following from Kurt London's *The Seven Soviet Arts:* "...the attitude of the masses both to the old and new art styles probably remains essentially dependent on the nature of the education afforded

them by their respective states." Macdonald goes on to say: "Why after all should ignorant peasants prefer Repin (a leading exponent of Russian academic kitsch in painting) to Picasso, whose abstract technique is at least as relevant to their own primitive folk art as is the former's realistic style? No, if the masses crowd into the Tretyakov (Moscow's museum of contemporary Russian art: kitsch), it is largely because they have been conditioned to shun 'formalism' and to admire 'socialist realism.' "

In the first place it is not a question of a choice between merely the old and merely the new, as London seems to think—but of a choice between the bad, up-to-date old and the genuinely new. The alternative to Picasso is not Michelangelo, but kitsch. In the second place, neither in backward Russia nor in the advanced West do the masses prefer kitsch simply because their governments condition them toward it. Where state educational systems take the trouble to mention art, we are told to respect the old masters, not kitsch; and yet we go and hang Maxfield Parrish or his equivalent on our walls, instead of Rembrandt and Michelangelo. Moreover, as Macdonald himself points out, around 1925 when the Soviet regime was encouraging avant-garde cinema, the Russian masses continued to prefer Hollywood movies. No, "conditioning" does not explain the potency of kitsch.

All values are human values, relative values, in art as well as elsewhere. Yet there does seem to have been more or less of a general agreement among the cultivated of mankind over the ages as to what is good art and what bad. Taste has varied, but not beyond certain limits; contemporary connoisseurs agree with the eighteenth-century Japanese that Hokusai was one of the greatest artists of his time; we even agree with the ancient Egyptians that Third and Fourth Dynasty art was the most worthy of being selected as their paragon by those who came after. We may have come to prefer Giotto to Raphael, but we still do not deny that Raphael was one of the best painters of his time. There has been an agreement then, and this agreement rests, I believe, on a fairly constant distinction made between those values only to be found in art and the values which can be found elsewhere. Kitsch, by virtue of a rationalized technique that draws on science and industry, has erased this distinction in practice.

Let us see, for example, what happens when an ignorant Russian peasant such as Macdonald mentions stands with hypothetical freedom of choice before two paintings, one by Picasso, the other by Repin. In the first he sees, let us say, a play of lines, colors and spaces that represent a woman. The abstract technique—to accept Macdonald's supposition, which I am inclined to doubt—reminds him somewhat of the icons he has left behind him in the village, and he feels the attraction of the familiar. We will even suppose that he faintly surmises some of the great

art values the cultivated find in Picasso. He turns next to Repin's picture and sees a battle scene. The technique is not so familiar—as technique. But that weighs very little with the peasant, for he suddenly discovers values in Repin's picture that seem far superior to the values he has been accustomed to find in icon art; and the unfamiliar itself is one of the sources of those values: the values of the vividly recognizable, the miraculous and the sympathetic. In Repin's picture the peasant recognizes and sees things in the way in which he recognizes and sees things outside of pictures—there is no discontinuity between art and life, no need to accept a convention and say to oneself, that icon represents Jesus because it intends to represent Jesus, even if it does not remind me very much of a man. That Repin can paint so realistically that identifications are self-evident immediately and without any effort on the part of the spectator—that is miraculous. The peasant is also pleased by the wealth of self-evident meanings which he finds in the picture: "it tells a story." Picasso and the icons are so austere and barren in comparison. What is more, Repin heightens reality and makes it dramatic: sunset, exploding shells, running and falling men. There is no longer any question of Picasso or icons. Repin is what the peasant wants, and nothing else but Repin. It is lucky, however, for Repin that the peasant is protected from the products of American capitalism, for he would not stand a chance next to a *Saturday Evening Post* cover by Norman Rockwell.

Ultimately, it can be said that the cultivated spectator derives the same values from Picasso that the peasant gets from Repin, since what the latter enjoys in Repin is somehow art too, on however low a scale, and he is sent to look at pictures by the same instincts that send the cultivated spectator. But the ultimate values which the cultivated spectator derives from Picasso are derived at a second remove, as the result of reflection upon the immediate impression left by the plastic values. It is only then that the recognizable, the miraculous and the sympathetic enter. They are not immediately or externally present in Picasso's painting, but must be projected into it by the spectator sensitive enough to react sufficiently to plastic qualities. They belong to the "reflected" effect. In Repin, on the other hand, the "reflected" effect has already been included in the picture, ready for the spectator's unreflective enjoyment.[5] Where Picasso paints *cause,* Repin paints *effect.* Repin predigests art for the spectator and spares him effort, provides him with a short cut to the pleasure of art that detours what is necessarily difficult in genuine art. Repin, or kitsch, is synthetic art.

The same point can be made with respect to kitsch literature: it provides vicarious experience for the insensitive with far greater immediacy than serious fiction can hope to do. And Eddie Guest and the *Indian Love Lyrics* are more poetic than T. S. Eliot and Shakespeare.

III

If the avant-garde imitates the processes of art, kitsch, we now see, imitates its effects. The neatness of this antithesis is more than contrived; it corresponds to and defines the tremendous interval that separates from each other two such simultaneous cultural phenomena as the avant-garde and kitsch. This interval, too great to be closed by all the infinite gradations of popularized "modernism" and "modernistic" kitsch, corresponds in turn to a social interval, a social interval that has always existed in formal culture, as elsewhere in civilized society, and whose two termini converge and diverge in fixed relation to the increasing or decreasing stability of the given society. There has always been on one side the minority of the powerful—and therefore the cultivated—and on the other the great mass of the exploited and poor—and therefore the ignorant. Formal culture has always belonged to the first, while the last have had to content themselves with folk or rudimentary culture, or kitsch.

In a stable society that functions well enough to hold in solution the contradictions between its classes, the cultural dichotomy becomes somewhat blurred. The axioms of the few are shared by the many; the latter believe superstitiously what the former believe soberly. And at such moments in history the masses are able to feel wonder and admiration for the culture, on no matter how high a plane, of its masters. This applies at least to plastic culture, which is accessible to all.

In the Middle Ages the plastic artist paid lip service at least to the lowest common denominators of experience. This even remained true to some extent until the seventeenth century. There was available for imitation a universally valid conceptual reality, whose order the artist could not tamper with. The subject matter of art was prescribed by those who commissioned works of art, which were not created, as in bourgeois society, on speculation. Precisely because his content was determined in advance, the artist was free to concentrate on his medium. He needed not to be philosopher, or visionary, but simply artificer. As long as there was general agreement as to what were the worthiest subjects for art, the artist was relieved of the necessity to be original and inventive in his "matter" and could devote all his energy to formal problems. For him the medium became, privately, professionally, the content of his art, even as his medium is today the public content of the abstract painter's art—with that difference, however, that the medieval artist had to suppress his professional preoccupation in public—had always to suppress and subordinate the personal and professional in the finished, official work of art. If, as an ordinary member of the Christian community, he felt some personal emotion about his subject matter, this only contributed to the enrichment of the work's public meaning. Only with

the Renaissance do the inflections of the personal become legitimate, still to be kept, however, within the limits of the simply and universally recognizable. And only with Rembrandt do "lonely" artists begin to appear, lonely in their art.

But even during the Renaissance, and as long as Western art was endeavoring to perfect its technique, victories in this realm could only be signalized by success in realistic imitation, since there was no other objective criterion at hand. Thus the masses could still find in the art of their masters objects of admiration and wonder. Even the bird that pecked at the fruit in Zeuxis' picture could applaud.

It is a platitude that art becomes caviar to the general when the reality it imitates no longer corresponds even roughly to the reality recognized by the general. Even then, however, the resentment the common man may feel is silenced by the awe in which he stands of the patrons of this art. Only when he becomes dissatisfied with the social order they administer does he begin to criticize their culture. Then the plebian finds courage for the first time to voice his opinions openly. Every man, from the Tammany alderman to the Austrian house-painter, finds that he is entitled to his opinion. Most often this resentment toward culture is to be found where the dissatisfaction with society is a reactionary dissatisfaction which expresses itself in revivalism and puritanism, and latest of all, in fascism. Here revolvers and torches begin to be mentioned in the same breath as culture. In the name of godliness or the blood's health, in the name of simple ways and solid virtues, the statue-smashing commences.

IV

Returning to our Russian peasant for the moment, let us suppose that after he has chosen Repin in preference to Picasso, the state's educational apparatus comes along and tells him that he is wrong, that he should have chosen Picasso—and shows him why. It is quite possible for the Soviet state to do this. But things being as they are in Russia—and everywhere else—the peasant soon finds the necessity of working hard all day for his living and the rude, uncomfortable circumstances in which he lives do not allow him enough leisure, energy and comfort to train for the enjoyment of Picasso. This needs, after all, a considerable amount of "conditioning." Superior culture is one of the most artificial of all human creations, and the peasant finds no "natural" urgency within himself that will drive him toward Picasso in spite of all difficulties. In the end the peasant will go back to kitsch when he feels like looking at pictures, for he can enjoy kitsch without effort. The state is helpless in this matter and remains so as long as the problems of production have not been solved in a socialist sense. The same holds true, of course, for

capitalist countries and makes all talk of art for the masses there nothing but demagogy.[6]

Where today a political regime establishes an official cultural policy, it is for the sake of demagogy. If kitsch is the official tendency of culture in Germany, Italy and Russia, it is not because their respective governments are controlled by philistines, but because kitsch is the culture of the masses in these countries, as it is everywhere else. The encouragement of kitsch is merely another of the inexpensive ways in which totalitarian regimes seek to ingratiate themselves with their subjects. Since these regimes cannot raise the cultural level of the masses—even if they wanted to—by anything short of a surrender to international socialism, they will flatter the masses by bringing all culture down to their level. It is for this reason that the avant-garde is outlawed, and not so much because a superior culture is inherently a more critical culture. (Whether or not the avant-garde could possibly flourish under a totalitarian regime is not pertinent to the question at this point.) As a matter of fact, the main trouble with avant-garde art and literature, from the point of view of fascists and Stalinists, is not that they are too critical, but that they are too "innocent," that it is too difficult to inject effective propaganda into them, that kitsch is more pliable to this end. Kitsch keeps a dictator in closer contact with the "soul" of the people. Should the official culture be one superior to the general mass-level, there would be a danger of isolation.

Nevertheless, if the masses were conceivably to ask for avant-garde art and literature, Hitler, Mussolini and Stalin would not hesitate long in attempting to satisfy such a demand. Hitler is a bitter enemy of the avant-garde, both on doctrinal and personal grounds, yet this did not prevent Goebbels in 1932–1933 from strenuously courting avant-garde artists and writers. When Gottfried Benn, an Expressionist poet, came over to the Nazis he was welcomed with a great fanfare, although at that very moment Hitler was denouncing Expressionism as *Kulturbolschewismus*. This was at a time when the Nazis felt that the prestige which the avant-garde enjoyed among the cultivated German public could be of advantage to them, and practical considerations of this nature, the Nazis being skillful politicians, have always taken precedence over Hitler's personal inclinations. Later the Nazis realized that it was more practical to accede to the wishes of the masses in matters of culture than to those of their paymasters; the latter, when it came to a question of preserving power, were as willing to sacrifice their culture as they were their moral principles; while the former, precisely because power was being withheld from them, had to be cozened in every other way possible. It was necessary to promote on a much more grandiose style than in the democracies the illusion that the masses actually rule. The literature and art they enjoy and understand were to be proclaimed

the only true art and literature and any other kind was to be suppressed. Under these circumstances people like Gottfried Benn, no matter how ardently they support Hitler, become a liability; and we hear no more of them in Nazi Germany.

We can see then that although from one point of view the personal philistinism of Hitler and Stalin is not accidental to the roles they play, from another point of view it is only an incidentally contributory factor in determining the cultural policies of their respective regimes. Their personal philistinism simply adds brutality and double-darkness to policies they would be forced to support anyhow by the pressure of all their other policies—even were they, personally, devotees of avant-garde culture. What the acceptance of the isolation of the Russian Revolution forces Stalin to do, Hitler is compelled to do by his acceptance of the contradictions of capitalism and his efforts to freeze them. As for Mussolini—his case is a perfect example of the *disponibilité* of a realist in these matters. For years he bent a benevolent eye on the Futurists and built modernistic railroad stations and government-owned apartment houses. One can still see in the suburbs of Rome more modernistic apartments than almost anywhere else in the world. Perhaps Fascism wanted to show its up-to-dateness, to conceal the fact that it was a retrogression; perhaps it wanted to conform to the tastes of the wealthy elite it served. At any rate Mussolini seems to have realized lately that it would be more useful to him to please the cultural tastes of the Italian masses than those of their masters. The masses must be provided with objects of admiration and wonder; the latter can dispense with them. And so we find Mussolini announcing a "new Imperial style." Marinetti, Chirico, *et al.,* are sent into the outer darkness, and the new railroad station in Rome will not be modernistic. That Mussolini was late in coming to this only illustrates again the relative hesitance with which Italian Fascism has drawn the necessary implications of its role.

Capitalism in decline finds that whatever of quality it is still capable of producing becomes almost invariably a threat to its own existence. Advances in culture, no less than advances in science and industry, corrode the very society under whose aegis they are made possible. Here, as in every other question today, it becomes necessary to quote Marx word for word. Today we no longer look toward socialism for a new culture—as inevitably as one will appear, once we do have socialism. Today we look to socialism *simply* for the preservation of whatever living culture we have right now.

Notes

1. The example of music, which has long been an abstract art, and which avant-garde poetry has tried so much to emulate, is interesting. Music, Aristotle said curiously

enough, is the most imitative and vivid of all arts because it imitates its original—the state of the soul—with the greatest immediacy. Today this strikes us as the exact opposite of the truth, because no art seems to us to have less reference to something outside itself than music. However, aside from the fact that in a sense Aristotle may still be right, it must be explained that ancient Greek music was closely associated with poetry, and depended upon its character as an accessory to verse to make its imitative meaning clear. Plato, speaking of music, says: "For when there are no words, it is very difficult to recognize the meaning of the harmony and rhythm, or to see that any worthy object is imitated by them." As far as we know, all music originally served such an accessory function. Once, however, it was abandoned, music was forced to withdraw into itself to find a constraint or original. This is found in the various means of its own composition and performance. [Author's note]

2. I owe this formulation to a remark made by Hans Hofmann, the art teacher, in one of his lectures. From the point of view of this formulation, Surrealism in plastic art is a reactionary tendency which is attempting to restore "outside" subject matter. The chief concern of a painter like Dali is to represent the processes and concepts of his consciousness, not the processes of his medium. [Author's note]

3. See Valéry's remarks about his own poetry. [Author's note]

4. *Partisan Review,* Winter 1939. Greenberg wrote to Macdonald about the article shortly after it was published, in a letter dated 9 February 1939. Several ideas raised in the letter are discussed at greater length here. [Editor's note]

5. T. S. Eliot said something to the same effect in accounting for the shortcomings of English Romantic poetry. Indeed the Romantics can be considered the original sinners whose guilt kitsch inherited. They showed kitsch how. What does Keats write about mainly, if not the effect of poetry upon himself? [Author's note]

6. It will be objected that such art for the masses as folk art was developed under rudimentary conditions of production—and that a good deal of folk art is on a high level. Yet it is—but folk art is not Athene, and it's Athene whom we want: formal culture with its infinity of aspects, its luxuriance, its large comprehension. Besides, we are now told that most of what we consider good in folk culture is the static survival of dead formal, aristocratic, cultures. Our old English ballads, for instance, were not created by the "folk," but by the post-feudal squirearchy of the English countryside, to survive in the mouths of the folk long after those for whom the ballads were composed had gone on to other forms of literature. Unfortunately, until the machine age, culture was the exclusive prerogative of a society that lived by the labor of serfs or slaves. They were the real symbols of culture. For one man to spend time and energy creating or listening to poetry meant that another man had to produce enough to keep himself alive and the former in comfort. In Africa today we find that the culture of slave-owning tribes is generally much superior to that of the tribes that possess no slaves. [Author's note]

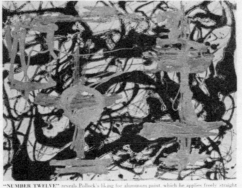

JACKSON POLLOCK

Is he the greatest living painter in the United States?

Recently a formidably high-brow New York critic hailed the brooding, puzzled-looking man shown above as a major artist of our time and a fine candidate to become "the greatest American painter of the 20th Century." Others believe that Jackson Pollock produces nothing more than interesting, if inexplicable, decorations. Still others condemn his pictures as degenerate and find them as unpalatable as yesterday's macaroni. Even so, Pollock, at the age of 37, has burst forth as the shining new phenomenon of American art.

Pollock was virtually unknown in 1944. Now his paintings hang in five U.S. museums and 40 private collections. Exhibiting in New York last winter, he sold 12 out of 18 pictures. Moreover his work has stirred up a fuss in Italy, and this autumn he is slated for a one-man show in *avant-garde* Paris, where he is fast becoming the most talked-of and controversial U.S. painter. He has also won a following among his own neighbors in the village of Springs, N.Y., who amuse themselves by trying to decide what his paintings are about. His grocer bought one which he identifies for bewildered visiting salesmen as an aerial view of Siberia. For Pollock's own explanation of why he paints as he does, turn the page.

"NUMBER TWELVE" reveals Pollock's liking for aluminum paint, which he applies freely straight out of the can. He feels that by using it with ordinary oil paint he gets an exciting textural contrast.

Life Magazine insert, August 1949. Courtesy Life Magazine. Photographs copyright Arnold Newman.

Tidbits

...with world-wide flavor

Cheese can be fun. And especially when you have an A&P Super Market nearby with wide varieties from which to make selections. The Dairy Department of your A&P Super Market offers cheeses galore ... mild, medium and sharp ... the best of American kinds, and Old World types, too. Each is sought out from the most dependable sources, expertly sampled and tested, then skilfully and carefully handled from maker to you to guarantee protection of the finest flavor characteristics.

Your A&P offers scores of cheeses ... with identifying cards or package markings to help you make selections if your knowledge of cheese lore is modest. And you can buy various sizes and weights, in a range of prices, to let you have as many different kinds as you wish for a minimum expenditure.

And, as with everything else A&P offers, values are really outstanding.

HELP US SATISFY YOU! The thousands of men and women who staff A&P Super Markets and Stores are anxious to please you. They want to know what more they can do to make your shopping at A&P more pleasant and convenient. If you have any suggestions, write CUSTOMER RELATIONS DEPT., A&P Food Stores, Graybar Building, New York 17, N. Y.

ROMANO, PROVOLONE and GORGONZOLA in Italian types ... and EDAM in Holland style ... promise exotic flavors for your favorite dishes and snacks.

A&P Super Markets

A&P

1859 - 1949

90ᵗʰ YEAR OF SERVICE

BLEU and CAMEMBERT, first created by France, are ideal for canapes or may be served for dessert. LIMBURGER, originally from Belgium, has long been called "A man's cheese."

MUENSTER and LIEDERKRANZ, German styles ... and SWISS ... are sandwich favorites. They are hearty in flavor ... delicious!

★Many of the cheeses illustrated were formerly made only in Old World countries but are now also produced in the U.S.A.

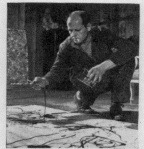

POLLOCK DROOLS ENAMEL PAINT ON CANVAS

HOW POLLOCK PAINTS

(with enamel, sand and a trowel)

Jackson Pollock was born in Cody, Wyo. He studied in New York under Realist Thomas Benton but soon gave this up in utter frustration and turned to his present style. When Pollock decides to start a painting, the first thing he does is to tack a large piece of canvas on the floor of his barn. "My painting does not come from the easel," he explains, writing in a small magazine called *Possibilities 1.* "I need the resistance of a hard surface." Working on the floor gives him room to scramble around the canvas, attacking it from the top, the bottom or the side (if his pictures can be said to have a top, a bottom or a side) as the mood suits him. In this way, "I can . . . literally be *in* the painting." He surrounds himself with quart cans of aluminum paint and many hues of ordinary household enamel. Then, starting anywhere on the canvas, he goes to work. Sometimes he dribbles the paint on with a brush (*above*). Sometimes he scrawls it on with a stick, scoops it with a trowel or even pours it on straight out of the can. In with it all he deliberately mixes sand (*below*), broken glass, nails, screws or other foreign matter lying around. Cigaret ashes and an occasional dead bee sometimes get in the picture inadvertently.

"When I am *in* my painting," says Pollock, "I'm not aware of what I'm doing." To find out what he has been doing he stops and contemplates the picture during what he calls his "get acquainted" period. Once in a while a lifelike image appears in the painting by mistake. But Pollock cheerfully rubs it out because the picture must retain "a life of its own." Finally, after days of brooding and doodling, Pollock decides the painting is finished, a deduction few others are equipped to make.

HE APPLIES SAND TO GIVE ENAMEL TEXTURE

"Jackson Pollock, Is he the greatest living painter in the United States?" 1949

LIFE MAGAZINE

This article appeared in the August 8, 1949 issue of *Life Magazine* and made Pollock a celebrity on a level that virtually no other artist of his generation achieved. Reporting on his career became a particular fascination in *Time Magazine* as well (another Luce publication), where he was dubbed "Jack the Dripper," and the "Champ" of American avant-garde painting.

This peculiar link between the art world and mass celebrity has continued, certainly in the career of Warhol but also in the look of art journals, of art marketing, of the processing of art personalities at openings and in press releases. The business of celebrity is a vital feature of late modernist aesthetics (as much as it was disclaimed by critics and artists alike in the late 1940s), and has simply come out into the open more directly since the 1960s.

The business of celebrity can involve mythic stories about the mortifications of the artist, about Pollock as the rugged American hero, about Miltonian falls, or about becoming a copy of one's earlier work or reputation. Pollock was deeply affected by this pressure, impressed by the power it gave him, and he was suffocated by the image he had to compete with when he worked. Articles and biographies on the "fall" of Pollock in the 1950s have a tone similar to the martyrdom of many "antiheroes" of that era, like James Dean or Charlie Parker, who both died tragically within months of Pollock's final crackup. Pollock's reputation in the world, the stories about his alcoholism, and the existential process identified with his work all joined into a myth that continues, even for contemporary artists, who try to cope under similar pressures with the melodrama of celebrity.

The business of celebrity can also bring on peculiar ideological bedfellows, from the advertising laid beside an article on the arts to the politics of the magazine itself. In the case of *Life Magazine,* its publisher Henry Luce was an arch anticommunist and was actively allied with the State Department in promoting the Cold War in 1949, particularly the "proper" slant on the Chinese Civil War. Thus Pollock, who saw himself as a relatively apolitical figure, if anything a lapsed leftist, was suddenly given accolades on behalf of the same forces that sponsored McCarthyism. But more confusing to Pollock was the attention he received among friends, even among shopkeepers he knew. *Life Magazine* was a particularly far-reaching source for disseminating cultural celebrity in 1949. Before the age of television and even into the 1950s, it served as a conduit into millions of American homes, bars, and barber shops. The weekly subscriptions brought photos and sparkling text about cultural figures otherwise unknown to the average American, like Virginia Woolf (cover story in 1937), or Surrealists in 1936, and the New York School in 1948.

After this article, Pollock asked friends about what his new status meant, about how to act out his enlarged image. Unfortunately, when he did act out, the results were sometimes very self-destructive and aggravated his drinking problem.

Today, the celebrity machine has been internationalized far more than in Pollock's era. It has become more dispersed, much larger and much more difficult to pinpoint the transfer from gallery fame to world celebrity. This article from 1949, however, did focus attention in precisely that way. Not that fame for the artist was something new (one is reminded of Byron's sudden fame 140 years earlier, not unlike a rock star today, or Picasso's god-like mystique by the 1930s). But this sort of attention—equating Action Painting with movie stardom, or becoming a poker chip in the intrigue of the Cold War—was new for modern art in America.

* * *

Recently a formidably high-brow New York critic hailed the brooding, puzzled-looking man shown above as a major artist of our time and a fine candidate to become "the greatest American painter of the twentieth century." Others believe that Jackson Pollock produces nothing more than interesting, if inexplicable, decorations. Still others condemn his pictures as degenerate and find them as unpalatable as yesterday's macaroni. Even so, Pollock, at the age of 37, has burst forth as the shining new phenomenon of American art.

Pollock was virtually unknown in 1944. Now his paintings hang in five U.S. museums and 40 private collections. Exhibiting in New York

last winter, he sold 12 out of 18 pictures. Moreover his work has stirred up a fuss in Italy, and this autumn he is slated for a one-man show in *avant-garde* Paris, where he is fast becoming the most talked-of and controversial U.S. painter. He has also won a following among his own neighbors in the village of Springs, N.Y., who amuse themselves by trying to decide what his paintings are about. His grocer bought one which he identifies for bewildered visiting salesmen as an aerial view of Siberia. For Pollock's own explanation of why he paints as he does, turn the page.

Jackson Pollock was born in Cody, Wyo. He studied in New York under Realist Thomas Benton but soon gave this up in utter frustration and turned to his present style. When Pollock decides to start a painting, the first thing he does is to tack a large piece of canvas on the floor of his barn. "My painting does not come from the easel," he explains, writing in a small magazine called *Possibilities 1*. "I need the resistance of a hard surface." Working on the floor gives him room to scramble around the canvas, attacking it from the top, the bottom or the side (if his pictures can be said to have a top, a bottom or a side) as the mood suits him. In this way, "I can...literally be *in* the painting." He surrounds himself with quart cans of aluminum paint and many hues of ordinary household enamel. Then, starting anywhere on the canvas, he goes to work. Sometimes he dribbles the paint on with a brush. Sometimes he scrawls it on with a stick, scoops it with trowel or even pours it on straight out of the can. In with it all he deliberately mixes sand, broken glass, nails, screws or other foreign matter lying around. Cigaret ashes and an occasional dead bee sometimes get in the picture inadvertently.

"When I am *in* my painting," says Pollock, "I'm not aware of what I'm doing." To find out what he has been doing he stops and contemplates the picture during what he calls his "get acquainted" period. Once in a while a lifelike image appears in the painting by mistake. But Pollock cheerfully rubs it out because the picture must retain "a life of its own." Finally, after days of brooding and doodling, Pollock decides the painting is finished, a deduction few others are equipped to make.

"The Postwar Product: The ICA's Department of Design in Industry" 1985

DAVID JOSELIT

Using the Institute of Contemporary Art in Boston during the late 1940s and 1950s as his focal point, David Joselit examines the interplay between museums and the issues of industrial design. He demonstrates how the postwar museum mediated the conflicting demands of art education, design, mass production, and the art market. He concludes that the utopian ideals of modern art were employed, in practice, to help create a society of mass consumption in the 1950s and afterward. With this world dominated by consumer marketing and planning, the promises of modernist visionaries concerning simplified, democratic spaces in a rational urban plan dissolved into the postindustrial, decentered, electronically monitored society we live in today.

* * *

A great epoch has begun.
There exists a new spirit.
There exists a mass of work conceived in the new spirit; it is to be met
with particularly in industrial production.[1]
Le Corbusier

Closer cooperation and understanding should help the business man pro-
duce material things which are not only functional and mechanically
sound, but also artistically outstanding, and the artist in turn to share
to a greater extent in the earning possibilities which are essential for a
happy existence.[2]
Walter P. Paepcke, *Chairman of the Board, Container Corporation of America*

The conceptual distance between these two statements encapsulates a reversal of roles that dramatically affected design in the first half of the

twentieth century. In the 1920s modern artists such as Le Corbusier and Walter Gropius sought to unify culture through a radical and socially responsible utilization of the machine. By the 1950s, the businessman—and particularly the American businessman—had assumed responsibility for mass industrialization, which as a consequence lost much of its true utopian intention in favor of the economic necessity to colonize markets for the newly abundant mass-produced object. Art and artists played a part in the machinery of consumption, but this role was largely confined to the realm of advertising and, more specifically, the developing profession of industrial design. From the late 1940s through the 1950s The Institute of Contemporary Art helped define the practical and philosophical role of the artist in business through its Department of Design in Industry.

The postwar years were characterized by a multipronged rapprochement between art and industry, which can only be understood as a by-product of the explosion of advertising in American culture. By the 1950s consumption was no longer dictated exclusively by need; rather, it was stimulated by desire—and advertising was the means of provoking desire. In his study of the origins of advertising in the United States during the 1920s, Stuart Ewen explains the use of "mass psychology," as practiced by pioneering marketing expert Edward Bernays, a nephew of Sigmund Freud. He quotes Bernays's enthusiastic, if somewhat maniacal conviction: "If we understand the mechanism and motives of the group mind, it is now possible to control and regiment the masses according to our will without their knowing it."[3] Ewen establishes that this was exactly the practice adopted by manufacturers, whose ads sought to create insecurities (bad breath or expanded pores) that could be resolved only through the purchase of a product.

With mounting competition among businessmen to sell their own products—often with little substantive difference in quality or performance—the techniques of advertising became more aggressive, and yet more subtle: "On television and on the consumer market, corporately produced goods and services were being reinforced as the cohesive fiber of daily life and as objects of fantasy."[4] As advertising imagery began to have a less direct relationship with the character of a product, and more to do with the psychological manipulation of consumers, the way was paved for art to enter the field of persuasion. As James Sloan Allen writes:

> Art, especially the techniques of modernism, offered marketing many advantages. The designing of consumer products according to modern aesthetic standards...grew into an immense enterprise engaging the energies of artists, manufacturers, publicists and cultural critics alike....Because advertising aspired both to mirror and to guide the interests of

consumers through the use of psychologically subtle and historically apposite images, art became its natural ally.[5]

Artists and designers were able to provide industry with two related benefits: an edifying corporate image established through association with good design, and more attractive products that had a competitive edge in the marketplace. Walter Paepcke, the founder and Chairman of the Board of Container Corporation of America, a Chicago manufacturer of packaging materials, was a pioneer in the creation of a comprehensive corporate image. The history of his company's adoption of a policy of good design is an important example of the attitudes, and often the contradictions, that characterized corporate absorption of modernism.

In 1935 Paepcke hired a professional art director to redesign all Container Corporation's graphic imagery, from the sides of trucks to the walls of staff cafeterias.[6] In addition to this internal reorganization, Container launched an advertising campaign that incorporated images created by modern artists like Man Ray, László Moholy-Nagy, Fernand Léger, and the young Willem deKooning.[7] Although businesses had previously adopted modern art in advertising, Allen points out that "the Container Corporation was the first company to engage modern artists in a systematic and enduring campaign of institutional advertising and of corporate identification with modern art."[8]

What is significant about this liaison is the intermingling of philanthropic and commercial concerns. Paepcke had a hunch—which was later confirmed by sales figures[9]—that modern art was a useful marketing tool. When he is quoted as saying that "the techniques of modern artists would identify us with current developments in applied graphic art which were—and are—so important to packaging,"[10] it becomes clear that he was embracing modern art for its benefits to his company and its sales. This is a different vision from the one espoused by the European Modernists, who hoped for a "great epoch" resulting from the fusion of art and industry. What is unique about the timing of Paepcke's action is that the contradiction between modern utopian ideas and their commercial manifestations was not yet clear. Both artists and industrialists *believed* in the fusion of business and design. In an exhibition catalogue of Container Corporation poster designs, Fernand Léger stated:

> More and more industrialists are seeking to obtain the contribution of creative artists of their time. This is very significant and important from various points of view. First of all, because of this fact, our work can penetrate into a sphere which, in general, is not very accessible to our plastic creations.

And, then, this is of considerable interest from a social point of view. There still exists an almost complete break between popular taste, which is full of good intentions in its desire to understand, and our modern work, which is appreciated by only a minority of people.[11]

In this statement Léger expressed a sincere desire to work with industry so that modern art can reach the public. In a slightly more condescending vein, Paepcke made practically the same statement: "These are some of the things which our company is attempting to do in the struggle to prove to the great unwashed masses that we are thinking in terms of art."[12] Only in retrospect do the "we" of the artist and the "we" of Container Corporation seem to have different objectives.

The high hopes for mass production that Léger expressed are confirmed by the Museum of Modern Art itself, which established the GOOD DESIGN program from 1950 to 1955, following a tradition of exhibiting exemplary products throughout the 1940s. "NEWS from GOOD DESIGN," a 1955 press release, explained what the program involved:

The GOOD DESIGN exhibitions are selected for the Merchandise Mart, Chicago, by the Museum of Modern Art, New York. Directed by Edgar Kaufmann, Jr., they are a series of semi-annual surveys of the best new designs available on the market. Each January and June new selections are placed on view in Chicago and once a year the GOOD DESIGN show is presented at the Museum in New York.[13]

The Modern's exhibitions and a similar program administered by the Walker Art Center in Minneapolis were designed to instruct consumers and recommend products for their purchase.[14]

Involved as it was in the forms and concepts of European modernism, MoMA was guided in its evaluations of products by the hope for a "great epoch": In his booklet *What Is Modern Design?* Edgar Kaufmann wrote, "Modern life demands modern design. Not because it is cheaper to acquire or less work for housekeepers than 'period styles'...but because modern design is made to suit our own special needs and expresses our own spirit."[15] MoMA elevated exemplary household objects to the status of proto-art. In the same publication, the following caption appeared under an illustration reproducing, from left to right, a sculpture by Brancusi, a knife, and a propeller blade:

Design is related to engineering and art. The carving knife is finely balanced, its precision a junior cousin to the calculated efficiency of the propeller blade. The love of perfect shapes which Brancusi lavished on his *Bird in Flight* echoes softly but clearly in the molded knife handle and in the knife's proportion.[16]

For MoMA, good design—read as "modern design"—was a way of "softly echoing" Brancusi and his fellow Modernists in the democratized setting of the American home. Kaufmann's evaluations grew almost entirely from aesthetic judgments based on a sophisticated knowledge of progressive art. This effort to consider design squarely within the realm of art is in many ways the antithesis of Paepcke's pragmatic use of modernism to lend his company a reputation for progressive policies. Container Corporation was undoubtedly less interested in the imagery of modern art than in its image—and how this image of progressive, efficient, even socialist concern could enhance its corporate reputation.

Whatever his motives, Walter Paepcke's choice in 1935 to create an internal design department at Container Corporation was unusual for the time. It was more typical in the 1930s to hire a well-known independent designer for a specific job. Designers such as Raymond Loewy, Norman Bel Geddes, and Walter Dorwin Teague "adopted the organization and methods of the consulting agency, working for a variety of clients."[17] These men often attained the status of celebrities, and their designs came to have a special cachet with consumers.

After World War II the complexion of the industrial design profession changed. Expansion of the consumer market brought increased demand for industrial designers. According to John Heskett in *Industrial Design,* "By the late 1950s there were few firms of any size or repute, in industrial countries, that did not recognize the significance of...employing professional designers, either directly or as consultants."[18] This new demand carried with it a need for specialized educational programs. The industrial designer did not fit traditional artisan roles: his or her creative work existed between the economic demands of manufacturing and the need to satisfy the consumer's perceived desires. As early as 1946 the issue of how to train an industrial designer was discussed in the "Conference on Industrial Design, a New Profession" held by the Museum of Modern Art for the Society of Industrial Designers. MoMA brought together a group of designers, lawyers, architects, and educators in response to criticism from the Society of Industrial Designers:

> In the past, our exhibitions and our use of the term "Industrial Design" have aroused many questions. The Society of Industrial Designers kept telling us they had a really serious profession in hand and they did not feel we recognized all the implications, problems, and necessities of their profession in making our judgments.[19]

What emerged from this conference was a tension surrounding the balance of emphasis on artistic versus vocational training for the designer. This ambivalence is characteristic of the American commercial absorption of European modernist theory.

The philosophical debate between art and the economic pressures of business was not restricted to MoMA's conference; it also informed educational policies in design schools, notably at Pratt Institute, which established a pioneering program in industrial design. The primary historical model for the training of industrial designers was the Bauhaus. This was all the more evident with the emigration to the United States of Bauhauslers such as Walter Gropius and László Moholy-Nagy in the 1930s. Alexander J. Kostellow, who came to Pratt Institute in 1938 to head its Foundation Year Program (and later became Chairman of the Department of Industrial Design), recalled in 1947 the issues that arose in planning the curriculum for Pratt's Foundation Year:

> During the early meetings of this [curriculum] committee, the following questions presented themselves: How much theory in any form? Should we follow the Bauhaus and its offspring, with some variations and modifications? Such a program would possess a great deal of merit. But it is quite unsuited to our type of student who is anxious to reach economic self-sufficiency in a minimum amount of time.[20]

Pratt's policy decision exemplifies the contradictions between European modernist idealism and the exigencies of American capitalism that characterized the postwar period. But in spite of Kostellow's seeming rejection of Bauhaus pedagogy, his policies were not so divorced from the German model as he implied.

What Pratt dispensed with was more the utopian vision of Gropius and the Bauhaus than its practical educational models. In his manifesto, *The New Architecture and the Bauhaus,* Gropius summarized his hopes for his educational program:

> Thus the Bauhaus was inaugurated with the specific object of realizing a modern architectonic art, which, like human nature, should be all-embracing in its scope. Within that sovereign federative union all the different "arts" (with the various manifestations and tendencies of each)—every branch of design, every form of technique—could be coordinated and find their appointed place. Our ultimate goal, therefore, was the composite but inseparable work of art, the great building, in which the old dividing-line between monumental and decorative elements would have disappeared forever.[21]

Gropius's ultimate goal was to unify what he perceived as a fragmented culture through design. Pratt's intentions were more modest, and more commercial, but in instituting the Foundation Year curriculum, which each student had to complete before further specialized training, it found its connection to the Bauhaus:

> The non-specialized Foundation Year provides the prerequisite fundamental training for advanced study....Through a series of coordinated art experiences, the student develops a flexible creative mind capable of interpreting a specific problem in terms of appropriate materials....In the graphic and plastic representation of human, natural and man made forms stress is placed upon the elements of design types of organization, the principles of structure and an organized approach to color.[22]

This philosophy of opening the student's mind and releasing his or her creativity in advance of practical exercises is clearly indebted to Bauhaus philosophy.

As the consciousness of design as an integral element of American industry grew during the 1930s and 1940s, Container Corporation, the Museum of Modern Art, and Pratt Institute each recognized and demonstrated one widely accepted aspect of the design formula: "Artist plus industry equals benefits for each and for the general public." Walter Paepcke dramatized what design could do to benefit the corporation, MoMA established an aesthetic standard by which consumer products might be judged, and Pratt proposed a model for educating designers. In simple terms, Container represented industry, Pratt the artists, and MoMA, in making recommendations to the consumer, served the public. Although none of these players worked in isolation, each was unequipped or unwilling to synthesize the often conflicting goals and interests of the artist, the corporation, and the public. Such a synthesis was the ambitious goal of The Institute of Contemporary Art's Department of Design in Industry:

> The Institute, being a specialized organization devoted to the encouragement of creative activity in the arts, has had ample occasion to study the relationship in twentieth century America of the artist to industry....The occasional union of art and industry in the United States has most often been short-lived and stormy.
>
> In such an atmosphere both education and arbitration play a vital role; it is possible from a disinterested vantage point to dismiss such harmful allegations as "irresponsibility" and "exploitation" and to interpret each party to the other—much as labor and management so often have responded successfully to mediation.
>
> The Institute of Contemporary Art has considered that the specialized educational institution may properly occupy a position midway between art and industry, as intermediary, counselor and critic.[23]

With these words ICA Director James Plaut summarized his evaluation of The Institute's unique liaison with Corning Glass Works, which in 1948 initiated the Department of Design in Industry at The Institute of Contemporary Art.

In 1946 Plaut returned from World War II to resume his post as Director of The ICA. Among his goals for the young organization was that of creating links between art and business:

> It has been tragic that the artist with something original to say in America has had a hard time presenting his work. We feel that we must bring the artist in touch with industry which, in using his outpost, will bring him into contact with the public.[24]

It was not long before Plaut was able to put his convictions to a practical test. In January 1948, The ICA and Corning Glass Works established a Pilot Training Program, whose purpose was to prepare art school graduates to staff Corning's newly created design department. Steuben, a Corning subsidiary that produces luxury glassware in limited editions, had established a design department in the mid-1930s, but little attention had been given to the design of Corning's mass-produced household products, such as Pyrex ware. As a 1950s study of product design describes, Corning's story was typical of the late 1940s and 1950s:

> As patents expired [on Pyrex ware] and competitive mass marketing became increasingly important, Corning management began to devote more attention to the visual design of its household products. The company turned to consultant designers for help, but ultimately found that the range of its design requirements, and the need for complete familiarity with glass production techniques on the part of the designer, justified the establishment of a well staffed and equipped design department within the company itself.[25]

To build this staff, Corning approached The ICA.

In an approximation of the Bauhaus philosophy of providing general artistic training before an artist approaches practical problems, The ICA selected twelve graduates from such schools as Pratt, the Rhode Island School of Design, Cranbrook Academy of Arts, Yale University, and the School of the Museum of Fine Arts, Boston to participate in an intensive eight-week instruction in glass manufacturing. Participants worked directly with glass and were given a series of lectures and demonstrations illustrating its history and capacity as a medium. At the end of the program Corning retained seven participants as designers.

The ICA's objective in this training program was to apply its expertise in the arts and its willingness to work with corporations in an effort to reconcile art and industry through education. This effort to find a truly common ground was successful, and by 1952 it was formalized in The Institute's Associates Program, whose fourteen member companies in that year included Corning Glass Works, Elgin National Watch

Co., Congoleum-Nairn, Inc., Reynolds Metals Co., and the state of Israel, to which Plaut acted as a special consultant for design throughout the 1950s.[26] The Advisory Committee to the Department of Design in Industry included industrialists and educators, among them Alexander Kostellow of Pratt, who wrote to Theodore Jones, Director of the Department of Design in Industry, "I have read The Associates Plan and it sounds *very* good....It is my sincere hope that it flourishes because I really believe it performs a useful function in making industry conscious of aesthetic values in life."[27] By 1955 The Institute's Associate Plan guidelines listed thirty-seven companies that had worked with the program—including Container Corporation of America.[28]

The ten services offered to Institute Associates in exchange for a yearly fee of $2000 addressed design issues that had previously been the distinct and separate concerns of corporate management, the art school, and the museum. In creating this synthesis, The ICA's intention was to implement good design in industry in a way that acknowledged every element in the formula "artist plus industry equals benefits to both as well as the public." Frequent design conferences were offered to corporate management in the hopes that executives would begin to think of design not as an applied benefit, but as an integral part of their management process. In addition to these informal conferences, an annual meeting was held to evaluate the mechanics of industrial design within a company: "The Design Report Forms cover such topics as Management's Design Philosophy, Management's Participation in Design, Cost and Effectiveness of Design, Salaries of Designers and Artists, Company Design Organization and Procedure [and so on]."[29] With these programs The Institute attempted to provide executives with the aesthetic and economic tools for assessing the role of design in their companies.

Through Designer Procurement and Designer Training, The ICA sought to fill the distance between the art school and the corporate design department by identifying candidates and then helping train them to use their general design or artistic expertise in the context of a specific product. Mel St. Clair, Design Director of Plax Corporation, an Institute Associate, summarized the benefits of The Institute's capacity as liaison between designer and corporation:

> There is another valuable service and real contribution the Institute provides. It develops and trains designers and engineers to be keenly aware of the practical and financial limitations that management must meet in the successful operation of any business. The Institute also performs a valuable service in prompting management to keep designers thoroughly acquainted with the goals of the organization.[30]

In Plaut's words, The Institute sought to "occupy a position midway between art and industry, as intermediary, counselor and critic." This mediation was an important means of interpreting the different motives of artist and executive in the process of creating designs for mass production.

Like the Museum of Modern Art, The ICA evaluated product designs—but unlike MoMA's practice of lifting household objects out of commercial context for aesthetic evaluation, The ICA worked directly with manufacturers as a consultant during product development. Among the benefits for Associates were Design Research Projects, including comparative product design studies; preparation of product slide or photograph collections; design research in Europe, and studies of design trends; free consultation with The Institute's staff on any phase of a company's design program; and design evaluation and selection, in which Institute staff and outside experts would help choose among proposed designs for products in development for manufacture.[31]

It is difficult to appreciate the philosophical importance ascribed to good design in the late 1940s and 1950s without acknowledging the heroic vision postwar America had constructed of the consumer product. Le Corbusier and Gropius wished for the total infiltration of good design as a means of rejuvenating culture, and this dream actually came to fruition—if somewhat perversely—through the American mass production and mass marketing procedures established after World War II. As one writer enthusiastically declared:

> The most significant contribution to the growth of democracy made by 20th century America has been not in politics or government but in the widespread distribution of material goods. The Sears Roebuck catalogue might be called the *Magna Charta* of our civilization, and—some cynics might add—its Bible too.
>
> The forms of everyday objects are a key to the character of democratic industrial culture. If the invention, production distribution and acquisition of *things* are among the principal preoccupations of modern life, the industrial arts which give form to these things are a characteristic artistic expression of our time.[32]

Although it is indisputable that corporate culture has affected virtually every aspect of American life, the widespread idealism with which it was greeted in the 1950s has largely dissipated. It was in that context of hope for the "great epoch" of modern life through the efforts of enlightened industry that organizations as diverse in their objectives as Container Corporation of America, Pratt Institute, the Museum of Modern Art, and The ICA entered the discourse on design in industry.

It was not unusual in the postwar years for art institutions to become involved with industrial design. As a 1949 editorial in the *Magazine of Art* asserted:

> The museum may well look on industrial design as an obvious link to more direct community service, to increased attendance, to increased monetary support....Industry in turn may look to the museum for constructive public relations and disinterested evaluation of design.[33]

Although the Department of Design in Industry enjoyed all the benefits enumerated in this passage—including significant financial contributions to The Institute—The ICA gave corporations more than "public relations and disinterested evaluation of design." This characterization more aptly describes programs of the Museum of Modern Art and the Walker Art Center.

The ICA's design policies were unique in their commitment to create a synthesis of art and business both on a theoretical level and on the practical economic plane of mass production. The belief in a truly mutual relationship between artist and businessman is exemplified by a series of three yearly conferences on creativity, which The Institute sponsored between 1956 and 1958. These meetings, attended by educators, executives, and designers, were ambitious in their scope:

> The purpose of these three conferences on creativity is to observe the existence of recognizable modes of creativity by demonstrations of operational themes basic to the creative process, as exemplified in a variety of disciplines. Also, to examine the applicability of these themes to all areas of human endeavor, especially industry.[34]

By exploring the mechanics of creativity in a multidisciplinary group, The Institute hoped to show how the artist could benefit the businessman, not just by providing designs for products, but by offering industry an attitude of openness and exploration associated with creativity. The ICA asserted that the artist and businessman were not just separate but equal partners, but men and women who could work from a shared experience of culture.

Notes

1. Le Corbusier, *Towards a New Architecture*, translated by Frederick Etchells (New York: Holt, Rinehart, and Winston, 1960), p. 9. (First published in England in 1927.)
2. Walter P. Paepcke, "Art in Industry," in *Modern Art in Advertising: An Exhibition of Designs for Container Corporation of America* (Charleston, S.C.: Carolina Art Association, Gibbes Art Gallery, 1947), p. 25.

3. Stuart Ewen, *Captains of Consciousness: Advertising and the Social Roots of Consumer Culture* (New York: McGraw-Hill, 1976), p. 83. I am indebted to Ewen's analysis of the growth of corporate influence in American culture during the 1920s, which expanded significantly in the 1950s.

4. Ibid., p. 210.

5. James Sloan Allen, *The Romance of Consumer Culture: Capitalism, Modernism and the Chicago-Aspen Crusade for Cultural Reform* (Chicago: University of Chicago Press, 1983), p. 7.

6. Ibid., p. 26. Chapter I of Allen's book, "Modernist Marketing: The Consumer Revolution and the Container Corporation of America," provides a history of Container's early association with Modern Art.

7. Ibid., p. 30.

8. Ibid., p. 31.

9. Ibid., p. 32.

10. Ibid., p. 29.

11. Fernand Léger, "Relationship Between Modern Art and Contemporary Industry" in *Modern Art in Advertising: An Exhibition of Designs for Container Corporation of America* (Charleston, S.C.: Carolina Art Association, Gibbes Art Gallery, 1947), p. 4.

12. Cited in Allen, *Romance of Consumer Culture,* p. 28.

13. "NEWS from GOOD DESIGN," press release, Museum of Modern Art, New York, and the Merchandise Mart, Chicago, February 9, 1955, p. 1.

14. Beginning in 1946 the Walker Art Center, Minneapolis, published the *Everyday Art Quarterly.* The Inaugural issue in Summer 1946 proclaimed, "This Quarterly is written for the home makers, prospective home builders and for the many others faced with the problem of furnishing their living quarters and buying objects for everyday use."

15. Edgar Kaufmann, Jr., *What Is Modern Design?* Introductory Series of the Modern Arts (New York: Museum of Modern Art, 1950), p. 7.

16. Ibid., p. 6.

17. John Heskett, *Industrial Design* (London: Thames and Hudson, 1984), p. 105.

18. Ibid., p. 119.

19. "Minutes of the Conference on Industrial Design, a New Profession," held by the Museum of Modern Art, New York, for the Society of Industrial Designers, November 11–14, 1946, p. 1.

20. *Industrial Design at Pratt Institute* (New York: Pratt Institute, Department of Industrial Design, 1974), unpaginated. This passage is a quotation from Kostellow, which was originally published as "Industrial Design at Pratt Institute," *Interiors,* July 1937, p. 38.

21. Walter Gropius, *The New Architecture and the Bauhaus,* translated by P. Morton Shand, with an introduction by Frank Pick (Cambridge, Mass.: The M.I.T. Press, 1979), pp. 65–66. (Originally published ca. 1935.)

22. *Industrial Design at Pratt Institute.* This passage is quoted from a 1955 brochure, "The Art School, Pratt Institute."

23. James S. Plaut, *The Corning-Steuben Design Development Program: First Interim Report.* Boston: Department of Design in Industry of The Institute of Contemporary Art, 1949, pp. 1–2.

24. Cited in Lawrence Dame, "Plaut Plans New Era for N.E. Modern Art; Young Expert Eyes Link with Industry," *Boston Herald,* June 14, 1946.

25. Don Wallance, *Shaping America's Products* (New York: Reinhold, 1956), p. 58.

26. These companies are listed in "The Associates Plan of the Institute of Contemporary Art" (Boston, 1952), p. ii.

27. Alexander J. Kostellow to Theodore S. Jones, ICA Archive. October 14, 1952.

28. These companies are listed in "The Institute Associates: A Design Program offered to Management by the Institute of Contemporary Art" (Boston, 1955), p. 1.

29. Ibid., p. 3.

30. Ibid., p. 15. This quotation is drawn from a letter sent by Mel St. Clair to The Institute and reprinted in the Associates Plan.

31. Ibid., pp. 4–6.

32. Wallance, *Shaping America's Products,* p. 2.

33. "Industrial Design in American Museums," *Magazine of Art.* May 1949, p. 179.

34. "Foreword," Conference on Creativity as a Process, held at Arden House, Harrison, New York, October 10–12, 1956 (Boston: The Institute of Contemporary Art, 1956), unpaginated.

"One-Dimensional Society" 1964

HERBERT MARCUSE

The widespread dissemination of "higher culture" on television and in paperback books has weakened its subversive effect, according to Herbert Marcuse. Art critical of the established order is absorbed and subsumed in the marketplace. As its distance from the norm evaporates, art becomes appreciated solely for its decorative value.

Writing with the painful memories of the Second World War, at a moment when the Cold War seemed about to erupt, Marcuse's vision of collapsing boundaries suggest a revolutionary explosion to come. As one of the key members in the Frankfurt Institute of Social Research, he had seen the coming of Hitler and the crisis of emigration, anti-Semitism, and World War II. Along with other members, like Adorno and Horkheimer, he was left with a grave distrust of mass movements and perceived catastrophic linkages between American mass culture and totalitarianism. He saw coming in America what he had left in Germany, with subtle differences of course, a thin casing hiding the terror of a world about to fracture again. Later in *One Dimensional Man* (1964), he wrote:

> Auschwitz continues to haunt, not the memory but accomplishments of man—the space flights; the rockets and missiles; the "labrynthine basement under the Snack Bar"; the pretty electronic plants, clean, hygienic and with flower beds; the poison gas which is not really harmful to people; the secrecy in which we all participate. This is the setting in which the great human achievements of science, medicine, and technology take place; the efforts to save and ameliorate life are the sole promise in the disaster. The willful play with fantastic possibilities, the ability to act with good conscience, to convert illusion into reality and fiction into truth, testify to the extent to which Imagination has become an instrument of progress. And it is one which, like others in the established societies, is

methodically abused. Setting the pace and style of politics, the power of imagination far exceeds Alice in Wonderland in the manipulation of words, turning sense into nonsense and nonsense into sense.[1]

At the time this paragraph appeared, the draft for the war in Vietnam had been enacted, the cycle of urban riots in the 1960s was beginning, and the Free Speech movement in Berkeley had begun. A redefinition of modern art strategies became necessary, in part to engage the changing political climate. Marcuse was a signal influence on the New Left of the 1960s, both in political action groups and in the arts. Later in the 1960s and into the 1970s, the work of other colleagues from the Frankfurt School would also reach a much broader audience in America; in the art gallery world, they were classic texts for yet another change in political events when mass culture, the fine arts, and political advertising did indeed undergo a series of conjunctions not unlike what Marcuse describes here.

* * *

The higher culture of the West—whose moral, aesthetic, and intellectual values industrial society still professes—was a pre-technological culture in a functional as well as chronological sense. Its validity was derived from the experience of a world which no longer exists and which cannot be recaptured because it is in a strict sense invalidated by technological society. Moreover, it remained to a large degree a feudal culture, even when the bourgeois period gave it some of its most lasting formulations. It was feudal not only because of its confinement to privileged minorities, not only because of its inherent romantic element (which will be discussed presently), but also because its authentic works expressed a conscious, methodical alienation from the entire sphere of business and industry, and from its calculable and profitable order.

While this bourgeois order found its rich—and even affirmative—representation in art and literature (as in the Dutch painters of the seventeenth century, in Goethe's *Wilhelm Meister,* in the English novel of the nineteenth century, in Thomas Mann), it remained an order which was overshadowed, broken, refuted by another dimension which was irreconcilably antagonistic to the order of business, indicting it and denying it. And in the literature, this other dimension is represented *not* by the religious, spiritual, moral heroes (who often sustain the established order) but rather by such disruptive characters as the artist, the prostitute, the adulteress, the great criminal and outcast, the warrior, the rebel-poet, the devil, the fool—those who don't earn a living, at least not in an orderly and normal way.

To be sure, these characters have not disappeared from the litera-
ture of advanced industrial society, but they survive essentially trans-
formed. The vamp, the national hero, the beatnik, the neurotic house-
wife, the gangster, the star, the charismatic tycoon perform a function
very different from and even contrary to that of their cultural predeces-
sors. They are no longer images of another way of life but rather freaks
or types of the same life, serving as an affirmation rather than negation
of the established order.

Surely, the world of their predecessors was a backward, pre-
technological world, a world with the good conscience of inequality and
toil, in which labor was still a fated misfortune; but a world in which
man and nature were not yet organized as things and instrumentalities.
With its code of forms and manners, with the style and vocabulary of its
literature and philosophy, this past culture expressed the rhythm and
content of a universe in which valleys and forests, villages and inns,
nobles and villains, salons and courts were a part of the experienced
reality. In the verse and prose of this pretechnological culture is the
rhythm of those who wander or ride in carriages, who have the time and
the pleasure to think, contemplate, feel and narrate.

It is an outdated and surpassed culture, and only dreams and
childlike regressions can recapture it. But this culture is, in some of its
decisive elements, also a *post*-technological one. Its most advanced im-
ages and positions seem to survive their absorption into administered
comforts and stimuli; they continue to haunt the consciousness with the
possibility of their rebirth in the consummation of technical progress.
They are the expression of that free and conscious alienation from the
established forms of life with which literature and the arts opposed these
forms even where they adorned them.

In contrast to the Marxian concept, which denotes man's relation
to himself and to his work in capitalist society, the *artistic alienation* is
the conscious transcendence of the alienated existence—a "higher level"
or mediated alienation. The conflict with the world of progress, the
negation of the order of business, the anti-bourgeois elements in bour-
geois literature and art are neither due to the aesthetic lowliness of this
order nor to romantic reaction—nostalgic consecration of a disappearing
stage of civilization. *Romantic* is a term of condescending defamation
which is easily applied to disparaging avant-garde positions, just as the
term *decadent* far more often denounces the genuinely progressive traits
of a dying culture than the real factors of decay. The traditional images
of artistic alienation are indeed romantic in as much as they are in
aesthetic incompatibility with the developing society. This incompatibil-
ity is the token of their truth. What they recall and preserve in memory
pertains to the future: images of a gratification that would dissolve the

society which suppresses it. The great surrealist art and literature of the 1920s and 1930s has still recaptured them in their subversive and liberating function. Random examples from the basic literary vocabulary may indicate the range and the kinship of these images, and the dimension which they reveal: Soul and Spirit and Heart; *la recherche de l'absolu, Les Fleurs du mal, la femme-enfant;* the Kingdom by the Sea; *Le Bateau ivre* and the Long-legged Bait; *Ferne* and *Heimat;* but also demon rum, demon machine, and demon money; Don Juan and Romeo; the Master Builder and When We Dead Awake.

Their mere enumeration shows that they belong to a lost dimension. They are invalidated not because of their literary obsolescence. Some of these images pertain to contemporary literature and survive in its most advanced creations. What has been invalidated is their subversive force, their destructive content—their truth. In this transformation, they find their home in everyday living. The alien and alienating oeuvres of intellectual culture become familiar goods and services. Is their massive reproduction and consumption only a change in quantity, namely, growing appreciation and understanding, democratization of culture?

The truth of literature and art has always been granted (if it was granted at all) as one of a "higher" order, which should not and indeed did not disturb the order of business. What has changed in the contemporary period is the difference between the two orders and their truths. The absorbent power of society depletes the artistic dimension by assimilating its antagonistic contents. In the realm of culture, the new totalitarianism manifests itself precisely in a harmonizing pluralism, where the most contradictory works and truths peacefully coexist in indifference.

Prior to the advent of this cultural reconciliation, literature and art were essentially alienation, sustaining and protecting the contradiction—the unhappy consciousness of the divided world, the defeated possibilities, the hopes unfulfilled, and the promises betrayed. They were a rational, cognitive force, revealing a dimension of man and nature which was repressed and repelled in reality. Their truth was in the illusion evoked, in the insistence on creating a world in which the terror of life was called up and suspended—mastered by recognition. This is the miracle of the *chef-d'oeuvre;* it is the tragedy, sustained to the last, and the end of tragedy—its impossible solution. To live one's love and hatred, to live that which one *is* means defeat, resignation, and death. The crimes of society, the hell that man has made for man become unconquerable cosmic forces.

The tension between the actual and the possible is transfigured into an insoluble conflict, in which reconciliation is by grace of the oeuvre as *form:* beauty as the "promesse de bonheur." In the form of the oeuvre, the actual circumstances are placed in another dimension where the

given reality shows itself as that which it is. Thus it tells the truth about itself; its language ceases to be that of deception, ignorance, and submission. Fiction calls the facts by their name and their reign collapses; fiction subverts everyday experience and shows it to be mutilated and false. But art has this magic power only as the power of negation. It can speak its own language only as long as the images are alive which refuse and refute the established order.

Flaubert's *Madame Bovary* is distinguished from equally sad love stories of contemporary literature by the fact that the humble vocabulary of her real-life counterpart still contained the heroine's images, or she read stories still containing such images. Her anxiety was fatal because there was no psychoanalyst, and there was no psychoanalyst because, in her world, he would not have been capable of curing her. She would have rejected him as part of the order of Yonville which destroyed her. Her story was "tragic" because the society in which it occurred was a backward one, with a sexual morality not yet liberalized, and a psychology not yet institutionalized. The society that was still to come has "solved" her problem by suppressing it. Certainly it would be nonsense to say that her tragedy or that of Romeo and Juliet is solved in modern democracy, but it would also be nonsense to deny the historical essence of the tragedy. The developing technological reality undermines not only the traditional forms but the very basis of the artistic alienation—that is, it tends to invalidate not only certain "styles" but also the very substance of art.

To be sure, alienation is not the sole characteristic of art. An analysis, and even a statement of the problem is outside the scope of this work, but some suggestions may be offered for clarification. Throughout whole periods of civilization, art appears to be entirely integrated into its society. Egyptian, Greek, and Gothic art are familiar examples; Bach and Mozart are usually also cited as testifying to the "positive" side of art. The place of the work of art in a pretechnological and two-dimensional culture is very different from that in a one-dimensional civilization, but alienation characterizes affirmative as well as negative art.

The decisive distinction is not the psychological one between art created in joy and art created in sorrow, between sanity and neurosis, but that between the artistic and the societal reality. The rupture with the latter, the magic or rational transgression, is an essential quality of even the most affirmative art; it is alienated also from the very public to which it is addressed. No matter how close and familiar the temple or cathedral were to the people who lived around them, they remained in terrifying or elevating contrast to the daily life of the slave, the peasant, and the artisan—and perhaps even to that of their masters.

Whether ritualized or not, art contains the rationality of negation. In its advanced positions, it is the Great Refusal—the protest against that which is. The modes in which man and things are made to appear, to sing and sound and speak, are modes of refuting, breaking, and recreating their factual existence. But these modes of negation pay tribute to the antagonistic society to which they are linked. Separated from the sphere of labor where society reproduces itself and its misery, the world of art which they create remains, with all its truth, a privilege and an illusion.

In this form it continues, in spite of all democratization and popularization, through the nineteenth and into the twentieth century. The "high culture" in which this alienation is celebrated has its own rites and its own style. The salon, the concert, opera, theater are designed to create and invoke another dimension of reality. Their attendance requires festive-like preparation; they cut off and transcend everyday experience.

Now this essential gap between the arts and the order of the day, kept open in the artistic alienation, is progressively closed by the advancing technological society. And with its closing, the Great Refusal is in turn refused; the "other dimension" is absorbed into the prevailing state of affairs. The works of alienation are themselves incorporated into this society and circulate as part and parcel of the equipment which adorns and psychoanalyzes the prevailing state of affairs. Thus they become commercials—they sell, comfort, or excite.

The neo-conservative critics of leftist critics of mass culture ridicule the protest against Bach as background music in the kitchen, against Plato and Hegel, Shelley and Baudelaire, Marx and Freud in the drugstore. Instead, they insist on recognition of the fact that the classics have left the mausoleum and come to life again, that people are just so much more educated. True, but coming to life as classics, they come to life as other than themselves; they are deprived of their antagonistic force, of the estrangement which was the very dimension of their truth. The intent and function of these works have thus fundamentally changed. If they once stood in contradiction to the status quo, this contradiction is now flattened out.

But such assimilation is historically premature; it establishes cultural equality while preserving domination. Society is eliminating the prerogatives and privileges of feudal-aristocratic culture together with its content. The fact that the transcending truths of the fine arts, the aesthetics of life and thought, were accessible only to the few wealthy and educated was the fault of a repressive society. But this fault is not corrected by paperbacks, general education, long-playing records, and the abolition of formal dress in the theater and concert hall.[2] The cultural privileges expressed the injustice of freedom, the contradiction between ideology and reality, the separation of intellectual from mate-

rial productivity; but they also provided a protected realm in which the tabooed truths could survive in abstract integrity—remote from the society which suppressed them.

Now this remoteness has been removed—and with it the transgression and the indictment. The text and the tone are still there, but the distance is conquered which made them *Luft von anderen Planeten.*[3] The artistic alienation has become as functional as the architecture of the new theaters and concert halls in which it is performed. And here too, the rational and the evil are inseparable. Unquestionably the new architecture is better, i.e., more beautiful and more practical than the monstrosities of the Victorian era. But it is also more "integrated"—the cultural center is becoming a fitting part of the shopping center, or municipal center, or government center. Domination has its own aesthetics, and democratic domination has its democratic aesthetics. It is good that almost everyone can now have the fine arts at his fingertips, by just turning a knob on his set, or by just stepping into his drugstore. In this diffusion, however, they become cogs in a culture-machine which remakes their content.

Artistic alienation succumbs, together with other modes of negation, to the process of technological rationality. The change reveals its depth and the degree of its irreversibility if it is seen as a result of technical progress. The present stage redefines the possibilities of man and nature in accordance with the new means available for their realization and, in their light, the pretechnological images are losing their power.

Their truth value depended to a large degree on an uncomprehended and unconquered dimension of man and nature, on the narrow limits placed on organization and manipulation, on the "insoluble core" which resisted integration. In the fully developed industrial society, this insoluble core is progressively whittled down by technological rationality. Obviously, the physical transformation of the world entails the mental transformation of its symbols, images, and ideas. Obviously, when cities and highways and National Parks replace the villages, valleys, and forests; when motorboats race over the lakes and planes cut through the skies—then these areas lose their character as a qualitatively different reality, as areas of contradiction.

And since contradiction is the work of the Logos—rational confrontation of "that which is not" with "that which is"—it must have a medium of communication. The struggle for this medium, or rather the struggle against its absorption into the predominant one-dimensionality, shows forth in the avant-garde efforts to create an estrangement which would make the artistic truth again communicable...

Notes

1. Herbert Marcuse, *One-Dimensional Man* (Boston: Beacon Press, 1964), pp. 247–248.
2. No misunderstanding: as far as they go, paperbacks, general education, and long-playing records are truly a blessing.
3. Stefan George, in Arnold Schönberg's Quartet in F Sharp Minor. See Th. W. Adorno, *Philosophie der neuen Musik.* (J. C. B. Mohr, Tübingen, 1949), p. 19 ff.

PART FOUR

Revisions of Modernism

"Postmodernism in a Nominalist Frame" 1988

JOHN RAJCHMAN

John Rajchman describes the "migrations" of the concept of postmodernism between France and the United States, in the visual arts, literature, and philosophy. Written almost as parody, like an encyclopedia entry, or as a mock grammar text, this brief summary presents postmodernism as extraordinarily wide ranging, standing in for strategies of deconstruction, rejections of scientism and democracy, and as an eclectic mixing of previous art styles.

In Rajchman's terms, modernism is defined, not inappropriately, as an extension of the Enlightenment, an optimistic response to what was perceived to be the possibility of a more enlightened social order, built upon the rational and constructive power of new technology. Therefore, postmodernism can be pluralistic, markedly different, a product transformed by electronic communication, mass culture, and the development of a new economic order (a world dominated by the Pacific Rim).

The history of modern art must be simplified greatly in order for the heroic qualities of postmodern civilization to sound apt. Critics are left with an ironic choice indeed, as Rajchman's effective little sketch indicates. The critic may tend to dehistoricize modern art in order to give postmodernism a unique place in art history. However, much of what we define as postmodernism began during the modernist era, even before modern art, for that matter. One could easily argue that Manet was a postmodernist, in his borrowings from mass publishing, or that circus imagery in Degas refers to the pluralism of audience reception. And gradually, in museum shows of the late 1980s, postmodernist elements are being recovered in the Surrealist use of text and in Futurist and Dadaist use of installation.

But boundaries are essential for the art markets and for art studies. Reception theory, semiotics, poststructuralism, appropriation, and

realism all allow for clear boundaries in an art world where boundaries are more difficult to assign, all at once, between avant-garde and kitsch, and between late modernism and contemporary art. What has changed most clearly is the economic world itself, for example, in banking through capital accumulation in Asia, in the class structure in the United States, and with information technology and advertising as a kind of glue holding together multinational corporate behemoths which have grown beyond the definitions of nation state, even beyond business efficiency itself. The emergence of this new order including computers, suburbanization, super conglomerates, and franchised entertainment has indeed severed many of the connections that gave the late international style of modern art its extraordinary power. Once again, therefore, social change has brought about a determinative set of problems. And once again, the arts industry responds by simplifying the past to give orderly boundaries to present needs. Beneath these convenient models, as always, lies a simmering pot of paradoxes. The need to oversimplify is very practical, not devious. Without a rude graph, much of what we treasure in the arts would be difficult to process, or sell. However, the simple model very rarely describes the humanity, confusion, and irony that so often go into making art in the modern or the postmodern world.

* * *

The Category

In a little more than a decade, postmodernism has grown from a tentative and disputed critical category in a few obscure journals of architecture and dance into a field of academic specialization, such as the Renaissance. It has created sales, and carved a theoretical niche for itself in publishing. It has become the topic of a seemingly endless series of symposia and anthologies competing with one another for being international and interdisciplinary. It has acquired wide journalistic self-evidence. Thus it has become a rather familiar discourse. And yet it is not dominated by a single theory or theoretician. It does not comprise a School of Thought. And, increasingly, those who helped to introduce the category are becoming disagreeably surprised by its fate.

The success of the category does not derive from its coherence. On the contrary, it is used to refer to a motley and elastic range of things. The specificity of the category may be found, rather, in its history: in the way is started, evolved and took hold in so many cultural institutions. Thus the study of the category may be more revealing than the study of the thing. It may be studied in the manner of what I have called (in reference to Foucault) "historical nominalism." One would inquire

through what historical processes postmodernism as a category has managed to so populate our cultural world as to appear as its dominant one.

Dating the Category

A good date for the terminological emergence of postmodernism in its present shape is 1975–76. Of course, it had been used for various and sundry purposes long prior to that moment. But those uses had never given rise to the hybrid field of social theory, literary criticism, cultural studies and philosophy that helped turn the term into a self-evident journalistic label.

In 1975 the rejection of Mies van der Rohe and the international style attracted media attention. It was the year a few eyebrows were raised over Tom Wolfe's racy pop exposure of theoretical chic in American art. It was the year when David Salle and Eric Fischl came to New York seeking fame and fortune. In 1976 *October* was launched, a journal which was to exert a key influence in introducing new theoretical perspectives into the discussion of art in America. From several quarters then there was dissatisfaction with the category of modernism in the arts, and a desire to go beyond. Modernism appeared as a normative restrictive concept from which one sought release. A good date for the take-off of the category of postmodernism that would supercede it is 1979–80. At that time Fredric Jameson gave a larger meaning to the term, as did Jean-François Lyotard, who brought Jürgen Habermas, and eventually Richard Rorty, into the debate. Postmodernism started to become the name of conflicting social theories and philosophies, and the category began its migrations into many fields and countries.

Conceptual Migrations

A) The central theoretical influence on American postmodern discourse is the Parisian philosophical and intellectual discussions of the last twenty years. Yet Foucault rejected the category; Guattari despises it; Derrida has no use for it; Lacan and Barthes did not live, and Althusser was in no state to learn about it; and Lyotard found it in America. It is used, nevertheless, to refer to the thought of such French authors taken as a group. As such it represents a process of homogenization, a reduction of what was once original and diverse work to a few common slogans. Its acceptance is also a sign that Paris no longer controls the designation of its own thought. Postmodernism is what the French learned Americans were calling what they were thinking.

B) The category went into social theory where it is sometimes said to refer to a new stage in capitalism or to the art of the postindustrial age. It was in social theory that the category underwent one of its most startling transformations. The very idea of "modern" it was supposed to come after was changed. At first there was the idea of modern art, a movement with schools and trends that began in mid-nineteenth-century Europe and was continued in the postwar New York art; postmodern was to come after it. Then this idea of modern was confused with another—the philosophico-sociological idea. Philosophers often make modernity in their discipline start with Descartes and the rise of modern science. This was combined with the more general idea of the Enlightenment. Hegel said a modern society was the one whose values were distinguished according to the topics of Kant's *Critiques:* science, morals and art. Heidegger said modernity was instead subject-object thinking. Philosophically-minded sociologists eventually came to speak of modern as distinct from traditional societies.

This sort of modernity has little to do with that of modern art. It is not what Baudelaire meant when he used the term *modernité.* Modern art starts with Baudelaire or Manet, not Descartes or Kant, in the Nineteenth and not the Seventeenth Century. It refers to the modernity of Schoenberg's music, so influential for Adorno, and not the modernity Adorno thought Schoenberg might be dialectically negating. Adorno was important for the passage of one meaning of modernity to the other. It was in reference to his thought that the curious view emerged that postmodernism consists in a one-sided or undialectical rejection of the enlightened values of science and democracy.

C) The category also migrated in another direction; it went into what, in America, is called literary theory. It was primarily in literature departments that the French thought of the last twenty years was read and assimilated. The philosophical puzzlement over writing created a new space of academic discussion in these departments which other disciplines at first refused but later envied. The background was American "new criticism," and the central influence was Derrida. Indeed, as a ubiquitous buzzword, deconstruction may be said to precede postmodernism; the word prefigures many of the patterns of passage into common usage shown by postmodernism; and, of course, postmodernism is sometimes said to *be* the art of deconstruction. In architectural discussion, we already find talk of deconstruction as an architectural practice.

In literary theory, there had already been one use of the term postmodern. It referred to a literature about itself (as in the *nouveau roman*), which was thought to follow upon a period of high modernism. In the French sources used to make the distinction, however, the category did not occur. On the contrary, Barthes, for example, used the terms

modernité to refer to the same literature by which he meant a single movement that started in the Nineteenth Century with Flaubert.

The migration of the category from the New York artworld into literary theory did not resolve this terminological confusion. It had another effect. The literature professor began to think of himself as a cultural critic. The privilege of literature or writing as a theoretical object began to wane. Professors of literature began to interest themselves in video, film, television, or everyday life; greater attention was paid to what in Britain had been called cultural studies. The key figure in this migration of the category is Fredric Jameson: a literature professor who does Marxist social theory and writes about art shown in New York.

D) Eventually the literary and sociological meanings of the terms were combined. Then it was said that poststructuralism (another name in America for French-influenced literary theory) is the philosophical expression of postmodernism that despises the enlightened values of science and democracy. This synthesis is particularly popular among the followers of Habermas, both in America and abroad.

E) Lyotard found the term in America. He used it to sum up the condition of philosophy for the University Council of the government of Quebec. When he found it, of course, he came across something with which he was already familiar, since the category in the United States was already embued with French philosophy. Lyotard was central in bringing the term back to France; he was also important in bringing Habermas into the debate. From the European discussions, the category travelled back to America. Eventually there emerged a rather acrimonious debate over who owns the concept: German sociology, French philosophy or American pragmatism (Richard Rorty).

F) In Fredric Jameson's work, there had been two apparently conflicting interests. On the one hand, he had an allegiance to a Lukacsian or Blochian conception of artistic work as expressive of the contradictions of a society as a whole, or as the hope of a total community. On the other hand, he had an interest in French textualist theory, and in the subversive place a society would accord to a writing conceived as a linguistic structure analyzable only from itself. Jameson admired both Sartre and Barthes. In the category of postmodernism, he found a way to resolve the opposition between the two interests. He decided that French textual theory was itself expressive, in the Lukacsian sense, of a new kind of culture Lukacs had only started to contend with, a yet more advanced stage in capitalism, a stage associated with America. Thus he took French theory as reflective, in the old Germanic manner, of the emergence of postwar American culture—a culture of multinational finance and mass-mediated electronic gadgetry, that had transformed the globe and so created a new space that had to be mapped.

Writing from California, Jameson depicted us as groping about in a vast labyrinthine edifice for which he was seeking to provide a map. For whom and for what purpose was this map drawn? And when, in his travels, the postmodern cartographer encountered artworks or cultural artefacts, were they, as in the good old days, little microcosms or allegories of the whole edifice, or were they rather critical events that showed the cracks or absences in the edifice, and so the contingency of its structure? Or were they yet something else? In Jameson's mapping of the postmodern, there is some vacillation on these questions. Thus he sometimes writes as though there were a new postmodern kind of work. Jean-Jacques Beinix's *Diva,* he proclaimed, was the first postmodern movie. But, on the other hand, he writes as though the works themselves were losing their critical force and becoming increasingly fleeting or transitory occasions for a rapidly consumed intense feeling or mood, to be contrasted with the older modernist feelings of angst and alienation. Jameson started to look for critical work outside the postmodern edifice altogether, in the Third World, a place he thought must be unspoiled by our first-world modernisms, in which international capital would find its other, in which therefore the critical work of the future would be coming.

But Jameson's search for new critical work to embody his historical hopes was at odds with the meaning the term postmodern had meanwhile acquired in actual artistic practice: that of a style with an ideology.

Style and Ideology

The history of avant-gardes has made familiar—perhaps all too familiar—the sort of discourse in which art, theory and ideology all go together. The American conception of modernism had distinguished and opposed two of them: dadaism and formalism. Dadaism is nominalist. It says that the category of art itself is not real, but historically constructed; and it shows this by making artefacts that question what one is willing to count as art. Formalism is, by contrast, essentialist. It says that art, in abstracting from extrinsic content, discovers what it essentially is when left to itself, or when it has only itself, or its characteristic languages, as its object. This is shown in the process through which the arts strip themselves of all but their constituent or minimal elements. Both sorts of art relations claimed to challenge the bourgeoisie, although that claim is now reserved primarily for the Dadaist, or what, following Burger, is sometimes called the "institutional" avant-garde. Thus the formalist critic Michael Fried could say in 1982 that postmodernism was yet another name for the resurgence of the popular Dadaist avantgarde against formalism and the achievement of

abstract art. But, in fact, what came to be recognized as the postmodern style in art secreted its own ideology, neither purely formalist or Dadaist. By postmodern style is meant a flat replication and mixing of previous styles. It is presented as the negation of the formalist view according to which modernism consists in the purification of the mediums of art to their constitutive elements. It says no medium is pure. It is the art that demonstrated this proposition—the art of the impurity of the arts, of the mixing of media, the art of *bricolage,* of throwing disparate things together. It asserts that there can no longer be the isolated work of originality or genius that extends the possibilities of a medium. There can be no such originality; one cannot initiate one's work from oneself.

The demonstration of impurity in an art of appropriation or simulation then advances an ideology. The ideology takes over from modernism or formalism the idea of the increasing reduction of art to its constitutive elements. But it turns this idea around in a nihilistic or apocalyptic proclamation that the process has reached its termination. In reducing themselves to their most primitive elements they would have exhausted all possibility of further innovation: no further advance would be possible. All that would be left is quotation and patchwork offering itself as proof of what Duchamp had already called the death or end of art. Pure art can have no future, but there remains the possibility of an art of the pure simulation of what art once was. Thus art can no longer present itself as an advance notice or hope of a better civilization; but it can illustrate the certainty that such hope is no longer possible, at least in art.

It was Baudrillard who seemed to offer a general theory of this ending of the possibilities of art. It would be part of a more general ending of Reality itself in a kitsch world of endless simulation. His word "simulation" could be adopted for a simple reason. It was a concept through which things could still be *made.* It was something one could show. It was an eminently visualizable idea. It prescribed a reproducible technique for making artefacts which suppose a general theory no longer of art, to be sure, but of its end. The postmodern style of appropriation and simulation thus presents itself as the alternately depressive or exuberant affirmation that culture is over, or as the defense and illustration of the ubiquity of kitsch.

Postmodern Theory

In the American desire to go beyond modernism, one may thus distinguish two tendencies. First there emerges a style of kitsch quotation supported by an ideology of the end of art, culture and much else. And second, there emerges a general perplexity before a new American-dom-

inated culture one does not yet know how to map, and whose connection to critical artistic work is in question. On the one hand, there is work without hope. On the other, there is hope without work.

What is astonishing is that on such ideas would be erected a great international theoretical debate. A clue is perhaps to be found in the role of theory itself in this debate. One model of critical theory in art is that of attempting to formulate or resolve the questions thrown up by the art of one's time. Postmodern theory, taken as a whole, does not seem to follow this model.

A typical feature of postmodernist writing in America is to substantiate every idea by reference to some (still preferably European) authority, with little or no attention to coherence among them. The validation of the ideas of theoretical authorities is not central to their postmodern use. Rather, theory becomes an arena of authority which comprises a number of diverse vocabularies that can be brought to bear in describing events or trends.

In this respect postmodern theory resembles the anti-epistemological philosophy Richard Rorty calls pragmatism. He thinks philosophy should not be the internal development of ideas, but a "conversation" among incommensurable vocabularies: the use of whatever theories that suit one's purposes, without regard for tradition or consistency. Rorty finds this pragmatic attitude open and pluralistic, and therefore American. Rorty is a postmodern American philosophical nationalist.

But this is not the only way to see the place of America in the postmodern uses of theory. Postmodern theory exemplifies what it is about. The postmodern theorist appropriates ideas as the postmodern artist appropriates styles. Stripped from their original context, these ideas become transportable; they migrate; they are thrown together at will. Postmodernism is theoretical cannibalism; it is the supermarket approach to ideas. One jumbles together the different theoretical idioms available without commensurating them into a single coherent language.

Thus postmodern theory tends to become global. American in origin, the category of the postmodern has an intertheoretical, international elasticity which has never lost contact with the promotion of cultural products; as such it has migrated back and forth across much of the globe. It may thus be said to be a category of a world market of ideas. It is like the Toyota of thought: produced and assembled in several different places and then sold everywhere. For American modernism, Europe was still a central reference. It was the name of the site of an autonomous, cosmopolitan art and culture. Since at least de Tocqueville, in both America and Europe, the opposition between pure art and mass culture has regularly been identified with the opposition between Amer-

ican and European culture. This idea is revived in Baudrillard's account of his travels in America.

Postmodernism is a sign of the loss of the colonial model of a universal culture spread out to educate the world at large. It is rather theory for a postcolonial world of products made and sold in different places without a center. It is like the *lingua franca* of this world: it can be made and consumed everywhere and nowhere.

"What is History For?" 1989

SANDE COHEN

Historian and critic Sande Cohen examines the way art history "re-constructs" events in the past, not unlike the way advertising or political propaganda recodes events in the present. Cohen is very aware of how academic institutions set up codes for scholarship and how delimiting these codes can be. He cites terms like *masterpieces* and artistic *movements* as examples of art "historical consciousness" obfuscating events.

He is not arguing for the end of scholarship but rather for the release of the profession into a more open code for defining historical accuracy. The writing of history should be self-reflexive, the "story" of history less predetermined, less defined by secret agendas about progress and inevitability. He is arguing for more modernity in the writing of history, more concern with disjunctions that the codes leave out.

Cohen believes in changes for Academia and art history rather analogous to notions like "truth to materials" in modern art, or abstraction rather than representation. Perhaps it would be fair to say that while scholarship has recoded the "story" of modern art, it presented this story in essentially a nineteenth-century form. The assumptions for art history would undoubtedly change if Cohen's critiques were applied, as paradoxical as they may seem. On the one hand, they suggest a more anarchic structure; on the other hand, they are very orthodox, almost martyred to the process of examining the language of all historical texts very thoroughly. He offers a challenge for the art profession to examine how art is valorized and why.

* * *

Cultural Concerns

Though life can only be lived as "timed," it does not follow that the appropriate conceptualization of "time" is to be found in any of our senses of "history."

Since Vico, Western historiography has provided political and social leaders with the mythic endowment of "historical reason." Complex or simple, this has often been a fusion of Positivism, Romanticism, and Eschatologism. Among the major political groups of this century, "history" was the object of an intense competition. One thinks of Brecht's mythification of theatre as an "historical constellation," the projection that theatre/art could unify past and future. Today Habermas contends that "the project of Modernity has not yet been fulfilled."[1] "History disintegrates as a way of comprehending the world" writes Ewen in his *All Consuming Images* (1988)[2], where nostaglia for the form of "historical consciousness" implies a cultural "war" toward those who "refuse to historicize." The texts of Lyotard and Habermas/Adorno—concerning cultural strategies of assay/invention/anonymous desire/frustration of integration (Lyotard) or negation/identity/consensus/repoliticization (Habermas)—enable anyone to think what senses "history" can have in Western culture.

In my view, elementary versions of Historicism, associated with Hegel (the Cunning of Reason, historiographic Order), Marx (knowledge of matter's production, historiographic Structure), Comte (Law of Progress), Futurism (Apocalypticism) *et al.* are now formations of academic-political competition, bound to a political-economy of the university's role in managing ideological codes. There—within the University—it matters whether or not one is a particular type of, say, Hegelian/Derridean/post-deconstructionist/male/feminist *et al.*, since so much "academic energy" grounds itself in a displacement of its political formations. An Ecce Academia has an indexical value viz. a certain "disappearance" of historicist plausibility.

Indeed, today "History" can be thought of under bad signs, otiose signs. Perhaps "History" has slipped out of sensory experience and entirely into (academic) language. In terms of actual practices such as economic maximization, there are no processes or activities which in themselves are "historical." The last great poem one read, the latest stage of urban decay, the newest and greatest art-hype: is it all really "historical" just because of the perdurance of tense and aspect? "Historical writing" lives on as an academic practice because the High University is a place where the State, without real dispute, recodes social integration, social exclusions and inclusions, social implosion. Its objective is to convince others that actions connect with some "moving image

of eternity" [or not] (Plato, after Deleuze), an affirmation of *either* negation or affirmation, and may be said to work when contingency and chance are expunged or at least rendered inconsequential. One "knows" what one is living/dying for. As a negation of impossibility [the "logic" of what is = what must be possible], "history" is always about being integrated, being integratable, even when a particular narrative text focuses attention on what did not happen (e.g. new histories of social welfare are now beginning to stress that the Welfare State did not really occur, a *revisionary* strategy which expands professional "histories").

Professors associate the lack of, the absence of, the disappearance of "history" with rootlessness, the unthinkability of "our" becoming-Beirut [like]. Professor Berlowitz of the New York University Humanities Council tells us that we have a psychic-disease called "pastlessness," a "fear" that "we" are without a "usable history." "Nonhistory" is an unacceptable proposition; within a generalized academic code or allocation of academic posts—teacher, researcher, dean, provost, eccentric, etc.— "history" remains a prerequisite of "cultural duty." It serves as a criterion of an (academic) existence providing what Henry Lefebvre called a "well-stocked inventory" of references, their *infrequent exchange* (frequent nonhappening) the source of value. Even "critical" and "progressive" academics are clothed in "history" so as to sound authoritatively judgmental, in order to rank events and objects. Rosalind Krauss, one of the more energetic professors working on behalf of "recoding history," goes so far as to say that, in the instance of art, one can know "actual, material history," whose "vehicles" (artworks) of modernism are subject to the "test of their own histories." This assertion confuses "history" with everything else—"actual material event," or "actual material color," and begs a rather large question: what does "history" add to "actual," to "material"? The assertion here is really a *command, a military order.* It assumes that "historical knowing" is like the answer to a question, like a school test. Considered as a cultural template, a "history test" is a school test is a political test is a cultural test: if something is tested by what it becomes/became ("test of their own histories"), then "knowing" is reduced to "following a story," which is of course a *premodern* cultural form. The more one stresses "historical" results "in culture," the less one can actually think to possibilities of disruption, change, invention.[3] "History" is congruent with "test" to the extent that, in this case, works of art are reduced to what one can narrate—language is not defeated by artworks. Professorial language is protected. "Historical language" is a type of cultural insurance. On the whole, the profession emphasizes what the German historian Wehler has called an "effective intraacademic socialization among historians," an agreement to deny extreme conflict over knowledge.[4]

The projection of a "real history" (the correct story) is to help one possess some code of action; as a prosthesis, such possession legitimizes current activities. It is historians who have culturally empowered the central banks of the West to "cite" the Depression and the lack of governmental controls so as to "space" themselves more thickly into every life activity. Talk of "history" always opens onto "needs," i.e., an expansion of the dominant players or, alternately, "chances" for the disempowered to assert their reactivity.

Is there any mode of "history" which is not political? Politics stands for the power-trips of existing players, their br(e)aking of possibility. Politics, to continue with a remark by Arendt, means joining actions begun by others *insofar as* one's actions give way to what has irrational precedence; e.g. *nothing possible* is set forth when one consumes "unto debt" in conformity with an "historical image" of economic growth; when various existing players uniformly promote self-production as "rational," so as to control change by identifying their practices with "historical reason," the regime of signs called "history" merges with the "physics" of politics. As a sign system, "history" is thus codifiable as an ever malleable *Idea of History;* it can support politics-in-general because terms such as "progress," "decline," "stasis" can (socially) coincide with the temporalizations of politics. Thomas Krens, the director of the Guggenheim Museum, states that New York City will lose its cultural status (decline) unless it equips itself to present "definitive, historically necessary exhibitions...," which are nothing other than those which can "reinvigorate" the exhibition process.[5] "Big history exhibits = Big Returns." The logic is irrefutable. The future belongs to those who position themselves to capture it. But this future will have to look like the past. "History" means a future brought about by "political repetition," which is undoubtedly depressing, because defeatist-realist; it presupposes that somehow the past has already been importantly transferred into the future.

Any erratic, wandering, spending, and dissolving of time is cut off by comparing it to models of "tradition" where it is assumed that what has been able to survive (what is) "plays" with an advantage, namely, that new players or actors in the social system *lack* justification and must prove that their actions are *more rational* and, by that, an alternative to the "received past." This is a fantastic trick: "you lack the criteria which we have given ourselves." What rivals is required to show its competence, its negation of itself, its "overcoming" of some "lack." Because "history" is inherently "tipped" toward tradition by virtue of its commitment to both narrate and integrate, it is actually *discontinuous* to the experiences of many in the capitalized West. The "direction of things" is irrationally assumed to have come about rationally, perhaps the most iterable of "mistakes" made about "history."

The Historian's Culture

No function is more common in a "politics of history" than the suggestion of an identity between the right to change society, of being judged competent to critique it, and possessing the perspective of "historical consciousness." The art historian T. J. Clark, for example, laments what he calls the "blanking out of history" which he takes as having accelerated since the Impressionist era. "Spectacle" is the "bad" cultural form blocking "historical" knowledge. The bourgeoifying/capitalizing destruction of both the patronage system and popular culture gave rise to the consumer culture of today; while painting was "positioned" to register and resist the capitalist absorption of the possibly radical lower classes, the intellectual-painters presided over the deradicalization of the working classes, and turned into a near-impossibility a painting that would criticize the new order. In submitting to the "system" by evading the class/power axis of the capitalization of the modern city, painting "painted" the quieting and "unhistorical spectacle" of leisure and entertainment, the latter receiving the energies of urban society as a whole. Spectacle/leisure/absorption adds up to the story of the success of ideology, the failure of resistance. None of this would be comprehensible or describable, according to Clark, unless one thinks "class formation" as the causal historico-political process determining the Impressionist painters "evasion" of class conflict, and while some painters refused or negated such integrative representations, the conjunction of leisure and popular imagery was far more prevalent than the optimism of an avantgardist like Mallarmé who was mistaken, according to Clark, for modernist art "has not worn well." Clark connects the petite-bourgeoisie's (passive, castrated) experience of becoming the audience of "spectacle" with the avant-garde becoming the agent of the story of "perfect heroes and heroines of [this] myth of modernity," the foolish/mythic consciousness of a doomed social class "secreted by capitalism." Petite-bourgeois intellectuals/artists belong to the narrative "history" of social doom [triumph of spectacle = deradicalization of values = integration of petite-bourgeois intellectuals = aestheticization of art] because they did not understand the direction of the story within which they lived. Thus: at once cause and consequence, the cultural sensibilities of petite-bourgeois intellectuals and artists (e.g. Manet) precluded them from having or possessing the proper "historical consciousness" that their very existence was in "historical" jeopardy.[6] Their lack of "historical consciousness" allowed them to be "specularized." Their collective "sensibility" was a misunderstanding of their "unhistoricality" viz. the social changes they were representing. Freud is handed over to Lacan in the guise of a social history threaded by the language of lack, castration, and absence,

this *narrative history of doom* even less ambiguous than Freud's various judgments and pronouncements on "history."

The gist of Clark's argument is that artists and intellectuals—then as now—are agents of "dehistoricization" when they lack the "proper" class consciousness (= historical correctness), a practice which promotes the Bad Powers of History and negates the possibility of overthrowing reification. The "masterpieces" of modernism, e.g. certain paintings by Manet or Matisse, were part of a general "crisis" of historicism and culture, namely, how the intelligentsia could/can maintain strong, centralizing, and integrating—a counterculture—story threads which had been unravelled by the "frictions" of capital. The cultural postulate here is that "historical consciousness" alone enables one to understand what can or cannot be changed, that the "absence" of such consciousness is another victory for the ruling class. Capitulation, defeat, and closure: the possibility of social change is foregrounded in the understanding of "history."[7]

Historiographic Suspension

Imagine an hourglass set on its side, empty of sand, with its center and posts exposed. The center of the hourglass intimates "unhistoricality" insofar as this cannot function in its normal manner of representing "passing" as a "falling," neither "down" nor "away" nor "from." The "hours pass" as we fall....Historiographism analyzes the West's capacity to recode events, of passing them into a pastness, the academic task of which is to give the gloss of officiality to desire and success, failure, attempt, *et al.* The noteworthy, representative date, *ranks and selects* for integration pasts overvalued by memory. Historiographism means to be caught up in some comprehending, axiomatic or hypothetical, image of motion, such as the Revolutionary Transformation (of the Left) or the modes of Clarification essential to the Liberal myth of Enlightened Reactivity, which P. Sloterdijk has recently termed Cynicism. The Revolutionary Transformation presupposes that we can imagine an absolute end for ourselves, indulging in a form of narcissism, comparable to the Liberal tendency to counsel the hope for innumerable "beginnings," to encourage belief in the "inexhaustability" of human "spirit." The "hourglass" which does not work as one images the non use-value of "history." If one considers the latter as a sign system which reduces the realm of the decidable, making it "very slim," "history" registers the sememic defeat of possibility. The "significance" of "history" lies entirely in its *preemptive* value, which is to empty action of actions.[8] The unworking hourglass strips "history" of coding "flow." A really serious consideration of this topic might well read Levi-Strauss' *Savage Mind.*

The figure's "posts" are suggested, in part, by Lyotard's evocations about the myth of "communication," that it is neither universal nor rational and the "sublime" which displaces cultural integration by letting conception expand as it disengages from images, of jamming "interpretosis." Such "posts" are composed of expression-transformations which, considered as real acts of speaking, as illocutionary situations, enable something new to be heard; the authority of sight is displaced in favor of "hearing an other" who cannot be seized and possessed in any Odyssey of knowledge and power.[9] In addition to these "posts" being considered as activities of speech, they also convey order-words, political formations that instantaneously "officiate" over speaking.[10] Each situation or "post" is criss-crossed by multiple and diverging roles and trajectories, and can be regulated by dominant acts/statements which operate as sememic cliches. "Posts" are rigid and flexible in and of themselves. For example, in Habermas's description of modernity as a "destruction...of the communicative infrastructure of any humane form of communal life," which equates modernism with negation of the speech-post of individual reason, there is the rigid *order* addressed as the illocution (become the act) of "preserving tradition," which means to act as curator/conservator/defender toward the past and for the future to be.[11] Such posts are relays of cultural competition, and as such have no singular effect.

The "present" eludes definition; it is probably not made "for language," and any rendering of it is doubtful whenever it is too symmetrical (it does not follow that it should elude argumentation). The idea of a "historically founded" collective present verges on the hysterical; it could only result from immersion in a sort of psychological "soup," where, say, in denying the incomparability of experience, one "blends out" other presences. Left and right and center alike are prone to a frenzy of frustration viz. "history" and presence. Everyone lays claim to the latter. Just as one cannot compare without drawing upon the death-instinct, i.e., without reducing incomparables, the injustice of dominant/dominated cannot be easily reduced to a "history of injustice." Just as one cannot compare love of a parent for child with desire/satisfaction, theorizing of the present will have to fully disengage from comparative past/future, which suggests making strong present/present comparisons (e.g., rich/poor). A "present" resembles less the linearity of a typical model of becoming than it does the crisscrossing of subjective "black holes" (e.g., the child hiding in the adult who, in turn, is forced to play child at the workplace who, in turn, demands obedience from...) which may or may not intersect with instinct, with, with, with. Let the "present" be inscrutable to linearity; the latter, as "wisdom," "knowledge of consequent," and the like remains what Kant called a "principle of form under which alone something can be discerned," i.e., a Law. Such prin-

ciples are not everything; they certainly inform us of codes of cultural performativity, which are never lacking in this society.

Let us say that the past goes to the left side, "behind," and to the right side belongs a conventionally obvious "future-ahead." These sections are not presumed to only connect "at the present," but their actual connections are also not directly understandable or even recognizable; it is a remarkable feature that it is impossible for anyone to say where, or even how the nominally recent past (e.g., Watergate) shades off into an altogether different category, i.e., the absolute past perfect. We really have nothing but ideas concerning how the consequence of an event in the recent past intercalates with an event which had once not-been but has since occurred and has become "trapped," say, in the immeasurably distant past. We do not know and conceivably can never know how an event at 2:00 P. M. in the upper right quadrant of Utopia is tied to the disappearance of a cultural species at 9:00 AM in the middle of Nostaglia.

I put "historical consciousness" in the upper left post, and in order to depose it, venture a hypothesis as to what might be contrary to such "consciousness." Setting out a contrary is valuable in order to initiate the conjugation of relations, playing, as it were, with the noncoincidence of fractional differences. As "history" is perplexing, evoking both a sense of having been already "made" while it being impossible to place responsibility for its "making" entirely in the lap of recognizable social agents, to "contrarize history" is to try to isolate where "history" cannot be amalgamated with such terms. If "history hurts" as F. Jameson has [absurdly] proclaimed, what is its contrary? That "nature comforts"? Is its complementary that the past is full of "suffering" à la Hegel? While specifying a contrary is no sure guide to the comprehension of relations[12], it seems to me that a plausible contrary is "acting," already a complex term, in the same way that the term "context" is complex, as are all terms which suggest something of fully denatured signs.[13] By "acting" viz. "history" I mean first of all *activity*, what K. H. Bohrer has called "to conceive the present, to affirm the notion of the present against a falsely objectified tradition."[14] Activity, as *matter*, turns on practices which know themselves to have no givens, where acts are connected to what Lyotard calls the *disseizure* of consciousness and will, where judgments and opinions are subject to the willingness to find out what one is thinking by thinking it *out*.

To revert to the consciousness-model, "acting" is awareness of what is happening as it is happening, how something "goes down," but without lending itself to be taken as "precedence." Historians may tell us that the children used by Iran as cannon fodder is "not-new," what its "historical frequency" amounts to (infrequent in x situation, frequent in y); but the actual throwing of such bodies against adults and their weapons is stripped of its importance, its meaning, once it is amalgamated to

categories like the frequent/infrequent or other narrative properties. The "throwing of bodies" is a distinctive experience, which are more like enunciations or statements, not elements of a story or of a "history." As in any actual conversation, where the move of the hand or eye can enter into any number of possible relations with the tone, speed, inertia or tension of what is said. "Historical consciousness" can only emphasize what something looks-like, giving reality *datable and disconnectable images.* Here is the story of the face of....If this is so, "historical consciousness" is not founded in any sort of cultural "naturalism" but rather in controlling the surplus of faces and claimants, to channel actions and "unprecedented change" to serve existing players. Historians ensure that what is understood in the present has been passed on by likeness abstracted from the past.

Contrarily, "action consciousness" would be limited only by the freedom of a plurality of "language-games." One could imagine situations where the identity of nouns and verbs gave way to "well," and "can" and "if we...but...it may well be...on the other hand...". The stress does not fall on the datability-effect joined to likeness/difference, but rather opens "out of time," to the extent that saying and doing both are dispossessed—thoroughly exteriorized—in nonexchange. As Deleuze and Guattari put it, any instance of speech generates the possibility of *atypicality:* the chance that something unexpected—"unhistorical"—will occur. Action manifests a dynamic aspect of not being reducible to dates and from whose effects no single series can be established as the order-control of another series. Activity enables one to disengage from the constant reiteration of "then-before-now-after-was-has been-will be" *et al.,* of the temporal axis and its requirement for a stolid, stable, narrative sign-system. Activity is possible, conceivable, by means of what Lyotard calls a "free field...beyond the boundaries of sensible experience," where thinking begins to make thought think in ways that are connected to motorial resonance, to an other in the creation of affects which cannot be used by political factions, which dissolve the semblance of "transferential relations."[15] I am saying that "action" is the concept given to the sense that an "event" *is happening* which is not bound to the system of the datable or even the signifiable. The other positions are filled by predicating from a relation of contrariness:

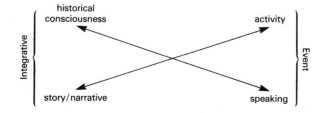

"Story/narrative" is contradictory to "activity" and complementary to "historical consciousness." While the incorporeality of some "actions" can come down anywhere (unintended directions, unanticipated speeds, rigidly cut or weird channels like the one that lets Nixon keep on coming back), "story" is unthinkable without fixed-places, which supposes a ceaseless recoding of narrative-form recalibrated with "historical consciousness"; such fixed-story-places, roles, are what historiographers call the "mediating" effect of narrative and what Structuralists focused on as the synchronic, steady-state plot-forms and logics of the signifier and signified [e.g., actantial roles]. These forms allow one to conceive events as "open to a temporality," becoming "historical," rather than, say, as hurling one to the point of desubjectifying, more like the undoing of established rules.[16] It ought to be obvious, but probably is not, that a system like Capital is both "narrative" and nonnarrative at once.

Big or little, comprehensive or narrow, (written) stories ensure the circulation of typical names, identities, situations. Written, official histories impose constancy on past actions, their redundancy-effect the triumph of resemblance's envelopment of specific differences, according to a schema by Todorov in the *Poetics of Prose.* Braudel's *Capitalism and Material Life* constantly blames the Indian-victims of the New World conquests; it constantly sets before the reader images of European interest in diversity/variety as making up a European will-to-leave-Europe, it constantly denounces the freedom-from-work of the Indians, it constantly stresses the sense of "youth" of Europe. Once an act has passed into the language of redundancy it can be narrated; once narrated, it is blendable with various ideological designs.

The last term, *speaking,* is contradictory to historical consciousness insofar as it is antithetical to the merged functions of datability, accounting, and redundancy, forms of "historical writing." "Speech" is more like a pleasure/pain actuality than a narration-presence of memory, because, as Arendt pointed out, speaking is a "borderline experience," moving and transforming us between one's subjectivity and the potency of being unrecognizable to Others. Perhaps it is better to say that in speaking one has an opportunity to "disappear from history."[17] "Speaking" is complementary to "action" because they share the attribute of initiating something; neither can claim to rest upon something already established. Any definition of genuine "speech" has to include the idea that "speaking to" someone about something is able to call into question the totality of implied relations; "speech" acts suppose plurality, as does activity, while "history" writing implies an absolutism of point of view.

If we were to plug in these "posts" with other terms from the cultural arena, I would be tempted to superimpose the role of "tradition" on "historical consciousness," "experiment" upon "activity," "integration"

and "identity" upon "narrating" and "performing" upon "speaking." The couple "tradition-history" would be typified in Habermas' exhortation to artists that they appropriate past "keyworks" and "illuminate" contemporaneity, for themselves and for others, a position which absorbs its complement, narration, placing it in a contestatory relation with the couple "speaking-performing." This version of the new/old Left emphasizes that rather than flirt with *expression,* one is to salvage a *telos,* a sense of direction, steering, consciousness, a model of cultural "opticality." "Experiment/action" is correlative, in part, with Lyotard's arguments (e.g., the Sublime as motivation) and Deleuzian ones (e.g., the work of art as "untimely," a Nietzschean adaptation) and promotes interesting work as critical, regardless of what it "looks-like"; this "post" absorbs, when it can, the roles of "speaking-performing," and is in conflict with "tradition-history" over whether "speaking-performing" ought to link up with recognizable "historical subjects," "historical problems," and the like. The present is emphasized as a territory to be expanded, not narrated.[18] In situations where the couple "speaking-performing" conflicts with other strong cultural formations (e.g., school, politics, media, public policy) in the cutting and tracing of form, rule and code, "speaking" can increase the ambiguity of meaning. When this veers toward the category of "history" as officiality, one invests "narrative" with the imaginary power of confirming an identity (e.g., on being the first woman to show at a particularly famous gallery—owned by a woman—the artist Barbara Kruger said "I'm not interested in promoting negativity around the issue...I'm interested in the really bountiful pleasures of difference," an enunciation which conflates being "first," i.e., originary with difference, where it is not clear that difference belongs with affirmation).[19]

Ecce Historia

Ecce historia was cynically put forward by Gottfried Benn in the late 1920s to mock Utopian and other schemes which domesticated "history" for the purpose of integrating social "fragments." For us an "ecce historia" arises in considering "history" as one of many ludicrous "political-forms" which cut channels of false authorities, marching orders, as the inertia of time-codes substituting for a life; it begins in contradiction and is concretized in the impasse of "historical consciousness," whose linguistic presentation has slipped into myth, the narrative form irreducibly premodern. I think it obvious that "real activities" have destroyed "history as language." The radical activities—performances—of Capital have done away with the possibility of "revolt" in the West. Nothing is more disheartening than to witness recoding (e.g., new ver-

sions of the decline of the West) in which the same old Signified ("decline") acts as a blotter for various signifiers.

At once archaic and overcoded (produced and circulated essentially among professors), unnecessarily speculative or speculative in a preposterous manner (academia presupposes the validity of a central subject, fixed positions, *et al.*), "historical thought" flips between the weirdly patriarchical (castrated?) frighteningly maternal (castrated?) (is "History" the hissing of Bad Parents?). That "past" was taken over by "history" in the overall "procesess" of modernity in the first place meant that the academic relay became a bureaucratized/cultural hinge whose promiscuity for the political spectrum is notorious; because this relay's "language of history" has favored narratives of social integration—constancy—which are "corny" and narratives whose narrowness is almost infinitely large, the profession today is bereft of its "mass audience." It deserves this "fate." It further deserves to have its *modes of appearance* (e.g., textual productions) disappear from the bloated stock of books which almost no one reads.

In any event, contrary to "history," as Nietzsche argued, there is the possibility of "unconditioned" expression, which pains us because it is so difficult to achieve. Such nonutopian, nonconsensus, nonresolving acts are difficult experiences, but preferable to what de Certeau has described as the death-wish embedded in narrative histories:

> The story which speaks in the name of the real is injunctive. It "signifies" in the way a command is issued...endless dictation, in the name of the "real," of what must be said, what must be believed, and what must be done...what can possibly be opposed to the "facts"?[20]

A choice: a "history" whose thoughts weaken the imagination of possibility or activities which make "history" impossible.

Notes

1. Jurgen Habermas, "Modernity—An Incomplete Project," in Hal Foster, editor, *The Anti-Aesthetic* Port Townsend, WA.: Bay Press, 1983 p. 13
2. Stuart Ewen, *All Consuming Images* New York: Basic Books, 1988 p. 258
3. Rosalind Krauss, *The Originality of the Avant-Garde and Other Myths*, (Cambridge: MIT, 1987), p. 4. cf. below, note #8.
4. Hans-Ulrich Wehler, "Historiography in Germany Today," in Jurgen Habermas, ed. *Observations on "The Spiritual Situation of the Age,"* (Cambridge: MIT, 1985), pp. 244–250.
5. New York Times, May 29, 1988.
6. T. J. Clark, *The Painting of Modern Life: Paris in the Art of Manet and his Followers* (Princeton: Princeton University Press, 1984), p. 15, p. 258.

7. Ibid., p. 235.

8. Deleuze and Guattari, *A Thousand Plateaus*, (Minneapolis: Univ. of Minnesota, 1987), p. 112.

9. See J. F. Lyotard, *Driftworks* (New York: Semiotexte, 1984), pp. 35–53.

10. On order-words, cf. G. Deleuze and F. Guattari, *A Thousand Plateaus: Capitalism and Schizophrenia.* Trans. by B. Massumi. (Minneapolis: University of Minnesota, 1987), pp. 75–110. Of Lyotard's many works, one might start with *Just Gaming* (1985) and the essays "The Sublime and the Avant Garde (Artforum, April 1984), "Presenting the Unpresentable: The Sublime" (Artforum, April 1982), "Introduction a une etude du politique selon Kant," in E. Balibar et al., *Rejouer le politique,* (Paris: Gallilee, 1981).

11. J. Habermas, "Introduction," in J. Habermas, ed., *Observations on "The Spiritual Situation of the Age,"* (Cambridge: MIT, 1984), p. 16.

12. Thomas Nagel, *What Does It All Mean?* (Oxford; Oxford University Press, 1986), p. 80.

13. See J. Gilbert-Rolfe, "A Thigh-Length History of the Fashion Photograph," in *Bomb,* Fall 1988, p. 80.

14. K. H. Bohrer, "The Three Cultures," in Habermas, *Observations,* p. 154.

15. J. F. Lyotard and J. L. Thebaud, *Just Gaming* (Minneapolis: University of Minnesota, 1985), p. 94. cf. Lyotard, *Driftworks,* p. 86. And Lyotard, "Freud According to Cezanne," in *Des dispositifs pulsionnels* (10/18, 1973). Also, cf. T. Todorov, *The Poetics of Prose* (New York: Cornell, 1977), p. 57.

16. Cornelius Castoriadis, *Crossroads in the Labyrinth,* translated by K. Soper and M. Ryle (Cambridge: MIT, 1984), p. 204. Deleuze and Guattari, *A Thousand Plateaus,* p. 109.

17. H. Arendt, *The Human Condition* (New York: Anchor, 1959), p. 46.

18. In his *Reading After Freud* (New York: Columbia, 1987), Rainer Nagele sees quite clearly that Historicism is implausible, but goes right ahead and repeats it; though carefully establishing links between Adorno and Lyotard's critique of "historical invariability" and the "Grand Narrative," respectively, even postulating that the secondary process [memory/language, history/narration, sign/meaning] is "deceptive" and "truth" is equivalent to the "process of hiding," Nagele still endorses the "historical constellation" of a "pathos of salvation," a tie between Utopia and social change.

19. Barbara Kruger, *New York Times,* March 20, 1987.

20. Michel de Certeau, *Heterologies: Discourse on the Other,* (Minneapolis: University of Minnesota, 1986), p. 206.

"Turning the Postmodern Corner: A Personal Epilogue" 1989

PETER HERTZ-OHMES

Peter Hertz-Ohmes describes changes in the way art has been viewed over the past twenty years, from an independent vehicle for truth to a rhetorical gesture. At the beginning of this century, art and technology were thought to be closely linked as related forms of "production" or "construction," which together could make a better world. Now, art and technology are completely separated. Art's function has become to entrench ambiguity in an indeterminate world whose truth, like that of quantum mechanics, is dependent on the interaction of the observer and the world. Hertz-Ohmes suggests that we look at art and mass culture as "cultural" quanta which undermine and "call the bluff on intrinsic values." In a sense, art theory has left the world of smokestack industries and entered the diffuse world of a service economy, in the indeterminate future where bytes of information have the same solidity as steel eye beams and glass curtain walls.

* * *

I remember Western Civilization in the sixties: two semesters of Homer, Praxiteles, Dante, DaVinci, culminating in soup cans and Marilyn. Banana peels and a tape recorder. Beckett-Warhol's Krapp. Was that the end of the line?

I remember the sixties as the breakdown. Popular shock emanating from Gödel or Heisenberg or John Cage. Indeterminacy. The breakdown of the nation-state leading to the Stoic complexity of a new Hellenistic age. Megalopoleis divided among East and West.[1] Atomic-threatened flower children, Candide's garden going to seed.

In the sixties, two semesters of Western Civ culminated in soup cans and Marilyn. Was that all there was, as Peggy Lee once asked in a popular song? Had it all been in vain, like *Waiting for Godot?*

And yet the sixties still had "truth." In those days "serious" and "real" were still serious words. There were still artists and they still insisted on "integrity." They still did "responsible" work. Or at least some of them thought they did. So why all the hyperexistential anguish?

Apparently in the sixties something fundamental differentiated technologists from artists. Was there really such a rift between them? I think there was. If perhaps they remembered they shared a common root in *techne*, it was obvious the root had branched. In those days artists condemned technology without acknowledging what they used every day and technologists condemned artists for being out of touch. There were real missles and tape recorders on the one hand, painted soup cans and hypermetaphorical banana peels on the other.

Artists and technologists pursued different ends. But their products weren't always that easy to tell apart. Duchamp's ready-mades had specifically made the point a generation earlier. In general it is well nigh impossible to distinguish art from artifacts, works of art from works of technology, on the basis of *intrinsic* characteristics alone.[2] Function is not indicative, any more than style. A work of art can function technologically, a work of technology can function aesthetically. Styles in the one reflect styles in the other. Like Greek amphorae, medieval Madonnas, or Warhol's Brillo boxes. Beautifully useful objects.

Unless of course beautiful and useful become *extrinsically* incompatible. Call it ideological legislation if you will, or simply a question of acceptability. "All that is being demanded is that you manipulate a particular language in acceptable ways. It is this which is being taught, examined and certificated, not what you personally think or believe, although what is thinkable will of course be constrained by the language itself."[3]

In general art and technology interpret stylistically, where the mark of style is the connection, in each case, between utterance and enunciation, between syntax and message, between what is shown and what is meant.[4] In the sixties the connection that is that mark of style was continually in danger of being severed. And that is why those very special Brillo boxes, which could just as easily have demystified the art of technological design, cashed in their ability to carry actual Brillo pads, while Studebakers and Redstone missles, the more efficiently mass-produced they became, traded beauty for improved performance.

"When I discovered ready-mades I thought to discourage aesthetics. They have taken my ready-mades and found aesthetic beauty in them. I threw the bottle-rack and the urinal in their faces as a challenge, and now they admire them for their aesthetic beauty."[5]

If Duchamp's urinal is admired solely for its aesthetic beauty, it will, temporarily at least, lose its ability to compromise the Pentagon's $500 toilet seats, while they in turn, seen solely as toilet seats, cannot be appreciated as desirable, hence necessarily expensive, objets d'art. The sixties wasn't having fun yet.

Neither was I. In those days I was working on Heidegger. That was no game yet either, although I enjoyed, in a serious sort of way, writing sentences like this:

Having lost its essential orientation, academic art has long ceased to entrench truth by stabilizing a contention into a configuration.[6]

That looks like quite a mouthful, and it felt like it when I wrote it. But it is circular, because it is simply a definition, or rather, the negation of the definition's effectiveness. Let's set that Heideggerian paraphrase in a larger context:

Having lost its essential orientation in *techne*, academic art has long ceased to entrench truth by stabilizing a contention into a configuration. Or if it does, the configuration, now merely a rhetorical device, is stripped of its ontological or natural bearings. No longer does the individual work of art stand independently as an autonomous self-renewable source of revelation. Instead it is situated supplementarily, which is to say representationally, in a predetermined "real" world.

Let me stress that I meant the whole thing to sound negative and it does. No more truth, just mere rhetoric, no ontological foundation, no autonomy, no revelation, just supplementary to the "real" world. The end of art. Beckett's *End Game*. That allowed me to paraphrase Heidegger in a parallel way on technology, affirming technology as the villain who was taking advantage of art's demise:

Having lost its essential orientation in *techne*, technology now threatens truth by ordering everything everywhere to stand by, to be immediately on hand in the name of standardization. In its self-consuming subservience, the individual work of technology becomes a totally dependent byproduct of the prescriptive standards which together determine the "real" world.[7]

In the sixties—this was my Heideggerian message—art had etherealized itself in moral-aesthetic contemplation while technology had materialized itself in military-industrial exploitation. This branching of *techne*, this parting of the roads, could be pretty scary. Bad enough to call for drastic responses. Those more practical than I, or at least less theortically inclined, began to call for "antiart" as a way to deaestheticize art or hippie movements as a way to destandardize technology. A rebel nostalgia, where arts and crafts

return to a more natural environment, to resolve their differences before the world blows up.

> Once upon a time, in the bright mid-sixties...But you won't remember the bright mid-sixties. Okay to be revolutionary then, quite possible to be revolutionary then. The product (let's put it in historical perspective) of temporary affluence, educational expansion and a short-term good outlook. A sort of revolution of the young...The period also of the cold war, the Cuba crisis and the intercontinental ballistic missile...technology then in its white-hot days.[8]

I had no trouble understanding the problem but I couldn't grasp the revolution. At Stanford I watched Ken Kesey from a distance but I listened to the Kingston Trio. I commiserated with Dustin Hoffman's graduate but I married Mrs. Robinson. The Establishment may have been wrong but it was also strong. How could I escape the Establishment without being forced to man the revolutionists' cultural guillotine?

After all, the sixties still believed in truth, even if there wasn't any left. Intrenched truth at that. Heidegger had said so in his definitions of art and technology. Or was it our very belief that led us astray? What about the common root? What about *technē*?

When it comes to Greek words it is best to look for Greek definitions. Since in the meantime we are again Stoics in a new Hellenistic age, I found one by Zeno the Stoic. He says, *"Technē estin hexis hodopoietike." Technē*, as art or technique, is "a fixed disposition to work out and contruct ways that oneself or others can then follow."[9] More concisely, Zeno says *technē* is a habit (*hexis*) of roadbuilding (*hodopoïetikē*). As a habit, *technē* develops constructs or methods (*metahodos*), systematic roads, roadways that lead somewhere. In so doing, the roads themselves leave recognizable traces, characteristic (and hence stylistic) designs. There is no overt mention of truth. No separation of art from technology. No anxiety or fear of domination.

Zeno's definition reminds me of that sixties classic, Kerouac's *On the Road*. Roads are a kind of intrenchment. What starts out as a path becomes a way, ways become methods, and, as the deconstructionists might say, methods become virtual leftovers or traces without origin. Thus it is entirely possible to get lost over the years, or to feel lost in the sixties. Or else I suppose we might simply hit the road for the fun of it. Pick a method, any method, and see where it gets you. As long as kicks aren't confused with truth, says Kerouac.

"I've decided that art is a habit-forming drug. That's all it is, for the artist, for the collector, for anybody connected with it. Art has absolutely no existence as veracity, as truth. People always speak of it

with this great, religious reverence, but why should it be so revered? It's a drug, that's all. A game between artist and onlooker."[10] Duchamp again. But he's right, you know.

In fact, these days I would prefer to read Zeno in a Duchampian rather than a Heideggerian mode: art is a habit (*hexis*), a habit-forming way of intrenching (*hodopoiētikē*). But rather than intrench a stabilizing configuration, art intrenches an incorporating contestation. No chance of a standardized representation masquerading as "real." Instead, the postmodern work of art constantly excludes what it tries to grasp, just as "postmodern fiction does not 'aspire to tell the truth' as much as to question whose truth gets told."[11] The languages of art constantly slip the trenches, as it were, and because art plays with the slippage of language rules, it can again become, literally, the name of the game.

Are we better off now than we were in the sixties? I think we are. Western Civ has gotten out of its bind and gone around the bend. Today at least some of us have learned to live politically in a way the sixties never could. We have learned to disdain revolutionary fervor as misapplied nostalgia. We have learned Bob Dylan's advice to appropriate ideas without stealing souls.[12] We have discovered that political action, like art, has nothing to do with logic or truth and everything to do with paralogical ambiguity. This ambiguity allows a postmodern *technē* to undermine our very real fears of technology by undermining what Anatol Rapoport has called the "technological imperative."[13]

Jean-François Lyotard reminds us that it was the desire for wealth "that initially forced upon technology the imperative of performance improvement and product realization."[14] In other words the efficient inflation of exchange values, not the conservation of intrinsic values, is the foundation of technology. Art has always called the bluff of intrinsic values and the grand narratives that legitimize them. But postmodern art makes its political move by also exposing exchange value, especially in its amorphous form as wealth, as a local rather than a universal concept.

Let's say I exhibit a specifically familiar entity and then challenge its going exchange value by paralogically altering its environment. Suddenly significant facts disintegrate into a juxtaposition of meaningless events, reassemble in various quasi-illusionary ways, and manifest in the observer a political sense of humor reminiscent of the Stoics, who habitually treated in this way their worldly resources in the midst of stereotypical adaptability.[15]

For some contemporary examples look at Claes Oldenburg's 1986 super-sculpture "The Knife Ship II," where chain-driven motors animate an enormous Swiss Army pocketknife, and its prototype actually sailed the canals of Venice. Or examine Mitchell Syrop's multi-panel photographic work, "Treated and Released," in which an egg or a book is

regarded as a "controlled substance" and a wrist watch is labeled a "mental institution."[16] Here household objects, advertisements, and political slogans metamorphose without metaphor—and hence without penalty—before your very eyes.[17]

I have great hopes that the rift that the sixties experienced between art and technology will be swallowed up by the multiple fractures that have invaded and undermined all hegemonic attempts at permanent consensus in our present political, cultural, personal, or professional dealings with one another. Far from succumbing to a relativistic world view in which we are in danger of losing our bearings, we are learning to interpret ourselves in terms of cultural quanta, each necessary and compelling while we share its presuppositions yet as fleeting and expendable as any social context tends to be. From the latter perspective the end of man and the end of the world can occur at any time in locally absolute terms, but as long as there is the habit-forming drug called *technē,* I believe the overall game of life will never lack for players.

Notes

1. See Hannes Böhringer, *Begriffsfelder: Von der Philosophie zur Kunst* (Berlin: Merve Verlag, 1985), p. 60.

2. In my article "The Public Lie, the Truth of Fiction, and *Herr Gustafsson Himself*" in *Pacific Coast Philology* (v. XVII, no. 1–2, 1982), 112–118, I discuss the impossibility of using intrinsic characteristics alone to distinguish autobiographies from novels.

3. Terry Eagleton, *Literary Theory: An Introduction* (Minneapolis: University of Minnesota, 1983), p. 201.

4. Julia Kristeva, "Psychoanalysis and the Polis," in *Critical Inquiry* (v. 9, no. 1, 1982), 88.

5. Marcel Duchamp, quoted by Edward Lucie-Smith, *Late Modern: the Visual Arts since 1945* (New York: Oxford University, 1979), p. 11.

6. See my dissertation, *Language and the Foundations of Interpretation* (Stanford: June 1967), pp 124–161.

7. Compare Martin Heidegger, "Die Frage nach der Technik," in *Vorträge und Aufsätze* (Pfullingen: Neske, 1954), pp. 13–44.

8. Graham Swift, *Waterland* (New York: Washington Square Press, 1985), pp. 17–18.

9. F. E. Sparshott, "Zeno on Art: Anatomy of a Definition," in John M. Rist, ed., *The Stoics* (Berkeley: University of California, 1978), pp. 273–290.

10. Duchamp quoted by Calvin Tomkins, *The Bride and the Bachelors* (New York: Viking, 1965), p. 18.

11. Linda Hutcheon, *A Poetics of Postmodernism: History, Theory, Fiction* (New York: Routledge, 1988), p. 123.

12. "Yes, I am a thief of thoughts not, I pray, a stealer of souls" in Dylan, *Writings and Drawings* (New York: Knopf: 1973), p. 106.

13. Rapoport quoted by Douglas R. Hofstadter, *Metamagical Themas: Questing for the Essence of Mind and Pattern* (New York: Basic Books, 1985), pp. 733–734.

14. Lyotard, *The Postmodern Condition: A Report on Knowledge* (Minneapolis: University of Minnesota, 1984), p. 45.

15. For an extended discussion of Stoic humor see Gilles Deleuze, *Logique du sens* (Paris: Minuit, 1969), soon to appear in English through Columbia University, as well as my paper "Serres and Deleuze: Hermes and Humor" in *The Canadian Review of Comparative Literature* (v. XIV, no. 2, 1987).

16. Both works were recently displayed at the Museum of Contemporary Art in Los Angeles. See their publication "The Contemporary" (Spring 1988).

17. In the Disney film "Snow White," the queen's metamorphosis into an old hag is clearly metaphorical and blows her cover. The metamorphosis of Gregor Samsa in Kafka's story is *not* metaphorical, which is why it is humorous and liberating, but metaphors—and hence penalties—are read into it by everyone, including of course the metaphor-seeking prepostmodern reader and Gregor himself. Kafka shows in his story how this reading negates the liberation and leads to death within the existing system. See Gilles Deleuze and Felix Guattari, *Kafka* (Minneapolis: University of Minnesota, 1987).

SELECTED BIBLIOGRAPHY

Primary Texts

Alquie, Ferdinand. *The Philosophy of Surrealism*. Translation Bernard Waldrop. Ann Arbor: University of Michigan Press, 1965.

Apollinaire, Guillaume. *Les Peintres Cubistes: Meditations esthetiques (1913)*. Ed. L. C. Breunig and J. Cl. Chevalier. Collection Savoir. Paris: Hermann, 1980.

Apollonio, Umbro (ed.) *Futurist Manifestos*. London: Thames and Hudson 1973. New York: Viking, 1973.

Aragon, Louis. *Les Collages*. Paris: Hermann, 1980.

———. *Pour un realisme socialiste*. Paris: De Noel et Steeld, 1935.

———. *Traite du Style*. Paris: Gallimard, 1928.

Arnaud, Noel, (ed.) *Avenir du surrealisme*. Paris: Quatre Vingt et un, 1944.

Arp, Hans. *Die Kunstiemen* (with El Lissitzky). Zurich, 1925.

Artaud, Antonin. *Oeuvres Completes*. Paris: Gallimard, 1956.

Breton, André. *Manifestes du Surrealism*. Paris: Jean-Jacques Pauvert, 1962.

———. *Position politique du surrealisme*. Paris: Editions du Sagittaire, 1935.

———. *What is Surrealism?* New York 1973 and London, 1978.

Breton, André and Marcel Duchamp. *Le Surrealisme en 1947*. Paris: Maeght, 1947.

Chipp, Herschel B., (ed.) *Theories of Modern Art*. Berkeley: University of California Press, 1968.

Le Corbusier. *The City of Tomorrow*. London: Architect Press, 1971. Cambridge, MA: MIT Press, 1971.

Dali, Salvador. *La Conquete de l'irrationnel*. Paris: Editions, Surrealistes, 1935.

De Stijl, International Maandblad Voor Nieuwe Kunst, Wetenschap en Kultuur. Theo van Doesburg, 1917–1931.

Ernst, Max. *Beyond Painting and Other Writings by the Artist and His Friends*. New York: Wittenborn, Schultz, 1948.

Lissitzky-Kuppers, Sophie. *El Lissitzky: Life, Letters, Texts*. London: Thames and Hudson, 1968.

Lista, Giovanni. *Marinetti et le futurisme: Etudes, document iconographie reunis et presentes par Giovanni Lista*. Lausanne: L'Age d'Homme, 1977.

Losfeld, Eric (ed.) *Tracts surrealistes et declarations collectives Tome 1, 1922–1939*. Paris: Le Terrain Vague, 1980.

———. Tracts surrealistes et declarations collectives *Tome 2, 1940–1969*. Le Terrain Vague, 1982.

Malevich, Kasimir. *Essays on Art, 1915–1928*. Trans. Xenia Glowachi-Prus and Arnold McMillin. Ed. Troels Andersen. Copenhagen: Borgen, 1968.
Marinetti, F. T. *Le Futurisme*. Paris, 1911.
———. *Selected Writings*. Ed. R. W. Flint. New York: Farrar, Straus, 1972.
Matisse, Henri. *Matisse on Art*. Ed. Jack D. Flam, London: Phaidon, 1973.
Michelson, Annette (ed.) *Kino Eye: The Writings of Dziga Vertov*. Berkeley: University of California Press, 1984.
Moholy-Nagy, L. *Vision in Motion*. Chicago: Paul Theobald, 1938.
———. *Von Material zu Architektur.* Munchen: Albert Langan Verlag, 1929.
Mondrian, Piet. *Plastic Art and Pure Plastic Art*. New York: Wittenborn, 1945.
Motherwell, Robert (ed.) *The Dada Painters and Poets: an Anthology*. New York: Wittenborn, 1951.
Schwarz, Arturo (ed.) *The Complete Works of Marcel Duchamp*. New York: Harry N. Abrams, 1970.
Trotsky, Leon. "Futurism." *Literature and Revolution*. New York: Russell and Russell, 1957, p. 130.
———. "Leon Trotsky to André Breton." *Partisan Review*, V1, no. 2 (Winter 1939), 123–129.
Tzara, Tristan. *An Introduction to Dada*. New York: Wittenborn Schultz, 1951.
———. *Oeuvres completes*. Ed. Henri Behar. Paris: Flammarion, 1975.
Van Doesburg, Theo. *Futurism*. Place: Amsterdam De Eenheid, 1912.
Van Doesburg, Theo. *Principles of Neo-Plastic Art*. New York: New York Graphic Society, 1966.

Secondary Texts

Ades, Dawn. *Dada and Surrealism Reviewed*. London: Arts Council of Great Britain, 1978. New York: Barron, 1978.
Andersen, Troels. *Malevich*. Amsterdam: Stedelijk Museum, 1970.
——— (ed.) *Valdimir Tatlin*. Stockholm: Moderna Museet, 1968.
Bachmann, D. and S. Piland, (eds.) *Women Artists: An Historical, Contemporary and Feminist Bibliography*. New Jersey and London: Scarecrow Press, 1978.
Baker, E. and T. Hess, (eds.) *Art and Sexual Politics*. New York: Macmillan, 1971, 1973.
Balakian, Anna. *André Breton: Nagus of Surrealism*. New York: Oxford University Press, 1971.
———. *Surrealism: The Road to the Absolute*. Chicago: The University of Chicago Press, 1959.
Bank, Mirra. *Anonymous Was a Woman*. New York: St. Martin's Press, 1979.
Barooshian, Vahan D. *Russian Cubo-Futurism, 1910–30: A Study in Avant-Gardism*. The Hague and Paris: Mouten, 1974.
Barr, Alfred H. Jr. *Picasso: Fifty Years of His Art*. New York: MOMA, 1946, revised and enlarged edition, 1974. London: Secker and Warburg, 1975.
———. *Fantastic Art, Dada, Surrealism*. New York: MOMA, 1947.
———. *Matisse, His Art and His Public*. New York: MOMA, 1974.
Barron, Stephanie and Maurice Tuchman. *The Avant-Garde in Russia, 1910–1930: New Perspectives*. Cambridge, MA: MIT Press, 1980.
Barry, J. and S. Flitterman. "Textual Strategies: The Politics of Art Making." *Screen*, vol. 21, no. 2, 1980.
Bayer, Herbert, with Walter Gropius and Ise (eds.) *Bauhaus 1919–1928*. London: Bailey Brothers and Swinden, 1959. Boston: Branford, 1959.
Berger, John. *The Success and Failure of Picasso*. London: Penguin, 1965.
Biederman, Charles. *Art as the evolution of visual knowledge*. Minneapolis, MI: Red Wing, 1948.
Bowlt, John E. (ed.) *Russian Art of the Avant-Garde: Theory and Criticism 1920–1934*. New York: Viking, 1976.

Bradbury, Malcolm and James McFarlane (eds.) *Modernism 1890–1930.* London: Penguin, 1978.

Broude, Norma and Mary D. Garrard (eds.) *Feminism and Art History: Questioning the Litany.* New York: Harper and Row, 1982.

Brown, Bernard E. *Protest in Paris: Anatomy of a Revolt.* Morristown, NJ: General Learning Press, 1974.

Buchloh, Benjamin H. D., Serge Guilbaut, and David Solkin (eds.) *Modernism and Modernity.* Halifax: The Press of the Nova Scotia College of Art and Design, 1983.

Burger, Peter. *Theory of the Avant-Garde* (1974). Transl. Michael Shaw, foreword Tochen Schulte-Sasse. Minneapolis: University of Minnesota Press, 1984.

Carrieri, Raffaele. *Futurism.* Milan: Edizione del Milione, 1969.

Carrouges, Michel. *André Breton et les donnés fondamentales.* Paris: Gallimard, 1950.

Caws, Mary Ann. "Ladies Shot and Painted: Female Embodiment in Surrealist Art." Susan Rubin Suleiman, ed., *The Female Body in Western Culture: Contemporary Perspectives.* Cambridge: Harvard University Press, 1986.

Chadwick, Whitney. *Women Artists and the Surrealist Movement.* Boston: Little, Brown, 1985.

Chipp, Herschel B. (ed.) *Theories of Modern Art.* Berkeley: University of California Press, 1968.

Clark, T. J. *The Painting of Modern Life: Gustave Courbet and the 1848 Revolution.* London: Thames and Hudson, 1973.

Conrads, Ulrich (ed.) *Programs and Manifestoes on 20th Century Architecture.* London: Lund Humphries, 1970. Cambridge, MA: MIT Press, 1970.

Cox, Annette. *Art-As-Politics: The Abstract Expressionist Avant-Garde and Society.* Ann Arbor, MI: U.M.I. Research Press, 1985.

Daix, Pierre. *The Cubist Years, 1907–1916: A Catalogue Raissone of the Paintings and Related Works.* Boston: New York Graphic Society, 1979.

Douglas, Charlotte. "The New Russian Art and Italian Futurism." *Art Journal,* vol. 34, no. 3 (Spring 1975) 229–39.

Dunlop, Ian. *The Shock of the New.* London: Weidenfield and Nicolson, 1972. New York: American Heritage Press, 1972.

Egbert, Donald Drew. *Social Radicalism and the Arts.* London: Duckworth, 1972. New York: Knopf, 1970.

Elderfield, John. *Fauvism and Its Affinities.* New York: Museum of Modern Art, 1976.

Elliott, David. *Rodchenko and the Arts of Revolutionary Russia.* New York: Pantheon, 1979.

Fine, Elsa Honig. *Women and Art, A History of Women Painters and Sculptors from the Renaissance to the 20th Century.* Montclair, NJ and London: Prior, 1978.

Frascina, Francis. *Pollock and After: The Critical Debate.* New York: Harper and Row, 1985.

Fussell, Paul. *The Great War and Modern Memory.* London and New York: Oxford University Press, 1975.

Gardiner, Stephen. *Le Corbusier.* London: Fontana, 1974. New York: Viking, 1974.

Giedion, S. *Space, Time and Architecture, the Growth of a New Tradition.* Cambridge: The Harvard University Press, 1974.

Golding, John. *Cubism: A History and an Analysis, 1907–14.* London: Faber, 1959. New York: Wittenborn, 1959.

Goldwater, Robert. *Primitivism in Modern Art.* New York and London: Harper & Brothers, 1938.

Gordon, Donald E. *Expressionism: Art and Idea.* New Haven: Yale University Press, 1987.

Gray, Camilla. *The Great Experiment: Russian Art, 1863–1922.* London: Thames and Hudson, 1962. New York: Abrams, 1962.

Green, Christopher. *Cubism and Its Enemies: Modern Movements and Reaction in French Art, 1916–28.* New Haven: Yale University Press, 1987.

Greenberg, Clement. *The Collected Essays and Criticism.* Volume 1, 1939–1944. Volume 2, 1945–1949. Chicago and London: University of Chicago Press, 1988.

Guilbaut, Serge. *How New York Stole the Idea of Modern Art.* Chicago and London: University of Chicago Press, 1983.

Harris, Ann Sutherland and Linda Nochlin. *Women Artists 1550–1950.* New York: Alfred A. Knopf Inc., 1976.

Herbert, Robert L. *Impressionism: Art, Leisure, and Parisian Society.* New Haven: Yale University Press, 1988.

Hess, Thomas B. and John Ashbery (eds.). *Avant-Garde Art.* New York: Macmillan, 1968.

Hobbs, R. C. and Gail Levin. *Abstract Expressionism: The Formative Years.* New York: Whitney Museum, 1978.

Hughes, Robert. *The Shock of the New.* New York: Alfred A. Knopf, 1981.

Hulten, Pontus. *The Machine as Seen at the End of the Mechanical Age.* New York: MOMA, 1968.

Jaffe, H. L. C. *De Stijl: 1917–1931.* Cambridge, MA: Harvard University Press, 1986.

Jean, Marcel and Arpad Meizei. *History of Surrealist Painting.* London: Weidenfeld and Nicolson, 1960. New York: Grove, 1960.

Kern, Stephen. *The Culture of Time and Space, 1880–1918.* Cambridge, MA: Harvard University Press, 1983.

Kramer, Hilton. *The Age of the Avant-Garde.* New York: Farrar, Straus, 1973.

Krauss, Rosalind. *The Originality of the Avant-Garde and Other Modernist Myths.* Cambridge and London: MIT Press, 1985.

Lane, Barbara Miller. *Architecture and Politics in Germany, 1918–1945.* London: Oxford, 1968. Cambridge, MA: Harvard, 1968.

Laurentov, Alexander. *Varvara Stepanova: The Complete Work.* Cambridge and London: MIT Press, 1988.

Leighten, Patricia. *Re-Ordering the Universe: Picasso and Anarchism, 1897–1914.* Princeton, N.J.: Princeton University Press, 1989.

Lewis, Helena. *The Politics of Surrealism.* New York: Paragon Press, 1988.

Lippard, Lucy (ed.) *From the Center: Feminist Essays in Women's Art.* New York: E. P. Dutton.

———. *Pop Art.* London: Thames and Hudson, 1967. New York: Oxford University Press, 1966: Praeger, 1969.

———. *Six Years: The Dematerialization of the Art Object from 1966–1972.* New York: Praeger, 1973.

Lodder, Christina. *Russian Constructivism.* New Haven: Yale University Press, 1983.

Lyle, Cindy, Sylvia Moore, and Cynthia Navaretta (eds.) *Women Artists of the World.* New York: Midmarch Associates, 1984.

Meyer, Ursula. *Conceptual Art.* New York: Dutton, 1972.

Milner, John. *Vladimir Tatlin and the Russian Avant-Garde.* New Haven and London: Yale University Press, 1983.

Overy, Paul. *Kandinsky: The Language of the Eye.* London: Elek, 1969. New York: Praeger, 1969.

Ozenfant, Amedee. *The Foundations of Modern Art.* New York: Dover, 1952.

Parker, Rozsika and Griselda Pollock. *Old Mistresses: Women, Art and Ideology.* New York: Routledge and Kegan Paul, 1981.

Perloff, Marjorie. *The Futurist Moment: Avant-Garde, Avant Guerre, and the Language of Rupture.* Chicago and London: The University of Chicago Press, 1986.

Petersen, Karen and J. J. Wilson. *Women Artists: Recognition and Reappraisal from the Middle Ages to the Twentieth Century.* New York: New York University Press, 1976.

Picon, Gaetan. *Surrealism 1919–1939.* London: Macmillan, 1977.

Poggioli, Renato. *The Theory of the Avant-Garde.* New York: Harper, 1971.

Raven, Arlene, Cassandra L. Langer, and Joanna Frueh, (eds.) *Feminist Art Criticism: An Anthology.* Ann Arbor, MI and London: U.M.I. Press, 1988.

Richardson, John. *Georges Braque.* London: Penguin, 1959.

Richter, Hans. *Dada: Art and Anti-Art.* London: Thames and Hudson, 1968. New York: McGraw-Hill, 1966.

Roethel, Hans K. *The Blue Rider.* New York: Praeger, 1971.

Rosenberg, Harold. *The De-Definition of Art: Action Art to Pop to Earthworks.* London: Secker and Warburg, 1972. New York: Horizon Press, 1972.

————. *Discovering the Present: Three Decades in Art, Culture, and Politics.* Chicago and London: University of Chicago Press, 1973.

Rosenblum, Robert. *Cubism and Twentieth-Century Art.* London: Thames and Hudson, 1961. New York: Abrams, 1961.

Roth, Moira (ed.) *The Amazing Decade. Women and Performance Art in America, 1970–1980.* Los Angeles: Astro Artz, 1983.

Rowell, Margit. *The Planar Dimension, Europe, 1912–1932.* New York: Guggenheim Museum, 1979.

Rubin, William S. *Dada and Surrealist Art.* London: Thames and Hudson, 1969. New York: Abrams, 1968.

————. *"Primitivism" in 20th Century Art.* New York: The Museum of Modern Art, 1984.

Schapiro, Meyer. *Modern Art, 19th and 20th Centuries:* Selected Papers. New York: Braziller, 1978.

Schapiro, Miriam, et al. *Anonymous Was a Woman.* Valencia, CA: California Institute of the Arts, 1974.

Schneider, Pierre and T. Preaud. *Exposition: Henri Matisse.* Paris: Editions des Musees Nationaux, 1970.

Schrader, Barbel and Jurgen Schebera. *The "Golden" Twenties: Art and Literature in the Weimar Republic.* Translation, Katherine Vanovitch. New Haven: Yale University Press, 1988.

Selz, Peter. *German Expressionist Painting.* Berkeley, Los Angeles, and London: University of California Press, 1974.

Shattuck, Roger. *The Banquet Years: The Origins of the Avant Garde in France, 1885 to World War I.* Revised ed. London: Cape, 1969. New York: Random House, 1968.

Short, Robert. "The Politics of Surrealism 1920–1936." *Journal of Contemporary History,* I, no. 2, 1966, 3–25.

Steinberg, Leo. *Other Criteria: Confrontations with Twentieth Century Art.* New York and London: Oxford University Press, 1972.

Szeeman, Harald (ed.) *Le Macchine Celibi / The Bachelor Machines.* Venice: Alfieri, 1975.

Taylor, Joshua C. *Futurism.* New York: Museum of Modern Art, 1967.

Tisdall, Caroline and Angelo Bozzola. *Futurism.* London: Thames and Hudson, 1977.

Verkauf, Willy (ed.) *Dada, Monograph of a Movement.* New York: Wittenborn, 1957.

Welsh, Robert P. *Piet Mondrian 1892–1944.* Toronto: The Art Gallery, 1966.

Willett, John. *The New Sobriety, 1917–1933: Art and Politics in the Weimar Period.* London: Thames and Hudson, 1978. New York: Pantheon, 1978.

ACKNOWLEDGMENTS

Grateful acknowledgment is made to the following for permission to reprint previously published material:

Alexander Rodchenko and Varvara Stepanova, "Constructivist Art," reprinted from David Elliott, editor, *Rodchenko and the Arts of Revolutionary Russia*, copyright 1979 by Pantheon Books, New York.

"What is Constructivism?" was originally published in *Blok*, Number 6/7, September, 1924; reprinted in *Contructivism in Poland 1923 to 1936*, catalogue for exhibition at Kettle's Yard Gallery, Cambridge, England; reprinted by permission of the Muzeum Sztuki, Lodz, Poland.

Gerald Silk, "Futurism and the Automobile" is from the article "Proliferation and Assimilation" which is reprinted from the book *Automobile and Culture* by Gerald Silk, published in 1984 by Harry N. Abrams, Inc., New York. Illustrations © 1984 The Museum of Contemporary Art, Los Angeles. All rights reserved.

Fernand Leger, "The Machine Aesthetic I and II, © 1965 by Editions Gonthier.

Laszlo Moholy-Nagy, *The New Vision* was published in 1946 by Wittenborn Art Books, Inc., New York.

Vladimir Tatlin, "Art Out into Technology" was first published in 1933; the text is dated 1932. The translation by Troels Andersen et. al. was published in *Vladimir Tatlin* (exhibition catalogue, Moderna Museet, Stockholm, Sweden, July-September 1968) and is reprinted here with permission. The article is reprinted in Stephen Bann, editor, *The Tradition of Constructivism* © 1974 by Stephen Bann. All rights reserved. Reprinted by permission of Viking Penguin, a division of Penguin Books USA, Inc.

Dawn Ades, "Dada-Constructivism" is reprinted by permission of the author from the catalogue for *Dada-Constructivism* 26 September-15 December 1984, Annely Juda Fine Art, London.

414

Benjamin H. D. Buchloh, "From Faktura to Factography" is reprinted from October 30, Fall, 1984, published by MIT Press, © by Benjamin Buchloh.

Paul Frankl, "The Artist and the Machine" from *Machine Made Leisure* by Paul Frankl. © 1932 by Paul Frankl; © renewed 1959 by Mary L. Frankl. Reprinted by permission of Harper & Row, Inc.

Sheldon Cheney and Martha Cheney, "Art and the Machine: Background in Art and Industry" is reprinted from Sheldon Cheney and Martha Cheney, *Art and the Machine*, reprinted by permission of McGraw-Hill, Inc.

Richard Guy Wilson, "Selling the Machine Age" is reprinted from the book *The Machine Age in America 1918-1941* by Richard Guy Wilson, published in 1986 by Harry N. Abrams, Inc., New York. All rights reserved.

Roger Cranshaw, "Noted on Cubism, War and Labour" is reprinted from *Art Monthly*, London, 1985.

Richard Hulsenbeck, "Zurich 1916, as it really was" is reprinted from *The Era of German Expressionism* by Paul Raabe. © Walter Verlag, A. G. Olten, 1965. Translation © Calder & Boyars, 1974. Published in 1985 by The Overlook Press, Inc., Lewis Hollow Road, Woodstock, New York 12498.

George Grosz, "My New Pictures," is reprinted from Victor H. Miesel, editor, *Voices of German Expressionism* © 1970. Used by permission of the publisher, Prentice-Hall, Inc., Englewood Cliffs, New Jersey.

Joachim Petsch, "The Deutscher Werkbund from 1907 to 1933 and the Movements for the 'Reform of Life and Culture' " is reprinted from Lucius Burckhardt, editor, *The Werkbund: History and Ideology 1907-1933*, published by Barron's Educational Series, 1980; first published in Italy by Gruppo Editoriale Electa, 1977.

Filippo Marinetti, "Beyond Communism" and "Portrait of Mussolini," are from *Selected Writings* by Filippo Tommaso Marinetti, translated by R. W. Flint and Arthur A. Coppoletti. Copyright © 1971, 1972 by Farrar, Straus and Giroux, Inc. Reprinted by permission of Farrar, Straus and Giroux, Inc.

Wyndham Lewis, "Guns" and "The Men Who Paint Hell" are reprinted from Walter Michel and C. J. Fox, editors, *Wyndam Lewis on Art: Collected Writings 1913-1956,* published by Funk & Wagnalls, London, 1969.

Cesar Vallejo, "Revolutionary Art, Mass Art, and the Specific Form of the Class Struggle" is reprinted from Cesar Vallejo, *Autopsy on Surrealism*, translated by Richard Schaaf and published by Curbstone Press, Willimantic, Connecticut, 1982.

Katarzyna Kobro, "Functionalism"was originally published in "Forma" magazine, Number 4, January, 1936; Wladyslaw Strzeminski, "Modern Art in Poland" was originally published in Lodz in 1934; both are reprinted by permission of Muzeum Sztuki, Lodz, Poland.

Carol Duncan, "Virility and Domination in Early Twentieth Century Vanguard Painting is © by *Artforum*, December, 1973. Reprinted in 1982 in N. Broude and

416 ACKNOWLEDGMENTS

M. Garrard, editors, *Feminism and Art History: Questioning the Litany*, published by Harper & Row, 1982.

Rozsika Parker and Griselda Pollock, "Femininity and Feminism" is reprinted from Rozsika Parker and Griselda Pollock, *Old Mistresses: Women, Art and Ideology*, reprinted by permission of Unwin Hyman Limited, London.

Theo van Doesburg, "The Significance of Colour for Interior and Exterior Architecture" is reprinted with permission of Macmillan Publishing Company from Joost Baljeu, *Theo van Doesburg*. © 1974 by Joost Baljeu.

Le Corbusier, "The Quarrel with Realism, the Destiny of Painting," is reprinted by permission of Faber and Faber Ltd from J. L. Martin, Ben Nicholson, Naum Gabo, editors, *Circle: International Survey of Constructivist Art*, first published in 1937.

Szymon Bojko, "Agit-Prop Art: The Streets Were Their Theater" is from Stephanie Barron and Maurice Tuchman, editors, *The Avant Garde in Russia, 1910-1930: New Perspectives*. Copyright © 1980 by Museum Associates, Los Angeles County Museum of Art. Reprinted by permission of the Los Angeles County Museum of Art.

Dziga Vertov, "Film Directors, A Revolution" is reprinted from *Lef*, volume 3, 1923; reprinted in *Screen* Winter, 1971-72, volume 12, number 4; reprinted by permission.

El Lissitzky, "Topography of Typography," "Typographical Facts," and "Our Book," are reprinted from Sophie Lissitzky, editor, *El Lissitzky: Life, Letters, Texts* published by Thames and Hudson Ltd, London, 1968.

Max Ernst, "Inspiration to Order," reprinted from Max Ernst, *Beyond Painting and Other Writings* published by Wittenborn Schultz, 1948.

David Siqueiros, "New Thoughts on the Plastic Arts in Mexico," published in David Siqueiros, *Art and Revolution*, translation by Sylvia Calles, published by Lawrence and Wishart, 1975.

Ambroise Vollard, "Painting After the War," reprinted from Ambroise Vollard, *Recollections of a Picture Dealer* published by Hacker Art Books, 1936.

Peggy Guggenheim, "My Life in London" reprinted from Peggy Guggenheim, *Out of this Century: Confessions of an Art Addict* © Peggy Guggenheim, 1946, 1960, 1979. Reprinted by permission of the publishers, Universe Books, New York, 1979.

Marcel Duchamp, "The Creative Act," the text of a talk given by Duchamp in Houston in April, 1957, is reprinted from *Art News*, summer, 1957.

Marcel Duchamp "Apropos of 'Readymades'" was a talk delivered by Duchamp at the Museum of Modern Art, New York, October 19, 1961.

"Jackson Pollock, Is he the greatest living painter in the United States?" is reprinted from *Life Magazine*, August 8, 1949.

Clement Greenberg, "Avant Garde and Kitsch" is reprinted from *The Partisan Review*, 1939, and is reprinted with permission of the author.

David Joselit, "The Postwar Product: The ICA's Department of Design in Industry" is a catalogue essay from *Dissent: The Issue of Modern Art in Boston* organized by the Institute of Contemporary Art, Boston, 1985.

Herbert Marcuse, "One Dimensional Society" is reprinted from Herbert Marcuse, *One Dimensional Man*, © 1964 by Herbert Marcuse, reprinted by permission of Beacon Press.

John Rajchman, "Postmodernism in a Nominalist Frame," reprinted from *Flash Art*, November-December, 1987.

INDEX

TWENTIETH CENTURY ART THEORY

URBANISM, POLITICS, AND MASS CULTURE

RICHARD HERTZ
NORMAN M. KLEIN

This overview of modern art theory and history treats modern art as a cultural, political, and social process intimately connected with larger cultural, political, and social contexts. The main sections of the book place modern art within three related conditions of modern life: 1) the promise of new technologies, 2) world wars and economic depression, and 3) the institutionalization of culture. Here, modern art is not seen as a series of "art movements," but as a very complex, pluralistic, cultural process.

Some important features include:

- a comprehensive and original compilation of writings by important twentieth century artists and critics as well as recent commentaries by contemporary theorists.
- an emphasis on how artists were vulnerable to the world at large—from the traumas to the fads—that distinguishes between what is "properly art historical" and what is "extra-art historical."
- coverage of the complexities and discontinuities in the collapse of genteel nineteenth century high culture into a pluralistic array of "culture industries."
- a discussion of architecture, design, and important areas of mass culture in addition to the fine arts.
- setting the work of modern artist within the frame of two world wars, the institutionalization of art by museums and galleries, the pressure of the machine age within industrial cities during the early twentieth century, utopian dreams of a new social order, and the invasions and alliance created by the growth of mass culture, the mass media, and the global market place.

PRENTICE HALL
Englewood Cliffs, NJ 07632

ISBN 0-13-933391-6

90000

9 780139 333910